GIFT of the GAG

The explosion in Irish comedy

Stephen Dixon
Deirdre Falvey

Paulie +
Katrina

Carry on...

Deirdre

John

Stephen Dixon

THE
BLACKSTAFF
PRESS

BELFAST

In memory of

Eamon

(The Merry Lad)

First published in 1999 by
The Blackstaff Press Limited
Blackstaff House, Wildflower Way, Apollo Road
Belfast BT12 6TA, Northern Ireland

Design by Design Image, Dublin

Printed in Ireland by ColourBooks Limited

A CIP catalogue record for this book
is available from the British Library

ISBN 0-85640-658-9

Acknowledgements and thanks

Warm thanks to the following comic talents for their generosity, time and good humour in talking to us for this book, and, where appropriate, giving us permission to use extracts from their work: Dave Allen, Eddie Bannon, Ed Byrne, Jason Byrne, Dermot Carmody, Ian Coppinger, Mark Doherty, Kevin Gildea, Noel V. Ginnity, Jeremy Hardy, Kevin Hayes, the Hole in the Wall Gang (Michael McDowell, Tim McGarry and Damon Quinn), Sean Hughes, Jimeoin, Frank Kelly, Jon Kenny, Patrick Kielty, Graham Linehan, Alex Lyons, Kevin McAleer, Karl MacDermott, Pauline McLynn, Ian MacPherson, Arthur Mathews, Andrew Maxwell, Dylan Moran, Barry Murphy, Colin Murphy, Graham Norton, The Nualas (Susan Collins, Susanna De Wrixon and Anne Gildea), Dara Ó Briain, Brendan O'Carroll, Ardal O'Hanlon, Owen O'Neill, Michelle Read, Michael Redmond, Joe Rooney, Pat Shortt, Tommy Tiernan, Paul Wonderful. Thanks also to comedians and their agents for use of photographs and illustrations.

For interviews and other help: Brian Boyd, George Byrne, Richard Cook, John Fisher, Peter Howick, Caroline Lee (Flee) of ACME comedy agency, Ferdia MacAnna (RTÉ), Peter O'Mahony of the Laughter Lounge and ACME, Dawn Sedgwick. We are also grateful to Jack Dee and *Later* magazine for letting us use his comment about Dave Allen, to Kevin Gildea for the extract from his article in *Rí-Rá* magazine, and to Dylan Moran and the *Irish Times* for an extract from his column.

Particular thanks to the following, not only for their time and thoughts, but also for loaning us personal material, including books, documents, videos, photographs and more: Billy Magra (for especially generous help, and for the germ of an idea a long time ago), Barry Murphy, Kevin Gildea, Dave Allen, Dara Ó Briain, Alex Lyons.

For help in locating and permission to use photographs: Murphy's and O'Leary PR, *Irish Times*, *Irish Independent*; for other help with photographs: Bord Fáilte, Rachel Burrowes (*Irish Times*), Caroline Cooper (BBC NI press office), Anne Coughlan and Carolyn Fisher (RTÉ press office), Ursula Curry (*RTÉ Guide*), Derek Speirs/Report, Caroline Glover and Hat Trick Productions, Polygram, Jacey Lamerton and TalkBack Productions.

For support and enthusiasm at an early stage: Kate Bowe, Ian O'Doherty (a friend to this project from the start).

We also wish to thank: Sarah Gallagher of O'Leary PR (for lots of help and goodwill), John O'Sullivan (for late night computer mercy missions), Sheila Wayman (for the loan of a laptop in a crisis), Pat Stacey (for all the laughs), Conor Goodman (*Irish Times*), Melanie Harris and Marnie Jung (both of PBJ Management). Thanks to all at Blackstaff; and to our agent, Jonathan Williams. Many thanks are also due to friends, colleagues and family – especially the Falvey clan in Galway – for tolerance, encouragement and support, and for putting up with distracted, comedy-only-track minds. Special thanks to Sara Falvey and Fiona Falvey for helping with tape transcriptions.

If we have left anyone out, please forgive us. We have endeavoured to secure any permissions required; any omissions should be notified to the publishers and may be rectified in future editions.

Deirdre Falvey
Stephen Dixon
Dublin, September 1999

Contents

The Interval

Taking the Boat

Caught in the Crossfire

The Storytellers

The Warm-up Act

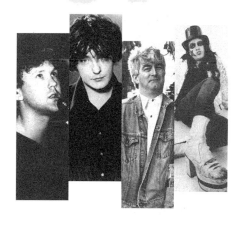

curtain up

Casey is in court charged with not supporting his wife, and the judge says to him: 'After long deliberation I have decided to award your wife £61 a week.' And Casey says: 'God bless you, your honour, and I'll try to send her a few pounds meself.'

Experts have just discovered there was no potato famine in Ireland. We just forgot where we had planted them.

My landlady told me to wear a clean pair of socks every day. By Saturday I couldn't get my wellies on.

The Irish have always been good for a joke, whether as butt or creator, and the above examples, told respectively by Hal Roach, Frank Carson and Jimmy Cricket, are typical of the kind of 'Irish' humour popular in Britain and the United States – and indeed in Ireland – for the best part of a century. Paddy the drinking man, Paddy the fighting man, Paddy the quaint, sentimental fellow with no real sense at all, at all.

With the honourable exception of Dave Allen, comics who wanted to earn a living outside Ireland adhered to the stereotype. Now there's a new breed of comedian, men and women for whom the clichés are irrelevant, and who joyfully celebrate the Irish imagination and passion for words. If they touch on the demeaning racial stereotypes of years gone by, they do so with sardonic confidence, as in Dylan Moran's suggestion that there must be a special college where Irish emigrants to Britain are trained to lurch around outside London train stations, waving bottles and shouting: 'Aaaaargh-ya-feckin-bleurrgh' at passers-by.

The past 10 years have seen an explosion of performed Irish comedy. *Father Ted* turfed conventional notions of sitcoms in the air and had cartloads of awards heaped on it. Through the 1990s a series of Irish comedians won the Perrier Award at the Edinburgh Fringe – Sean Hughes, Dylan Moran, Tommy Tiernan – and others blitzed the So You Think You're Funny? newcomers' award, too. Irish comedians are hot in British entertainment – TV, radio and live – with a diversity of styles, from Patrick Kielty's mainstream matiness to The Nualas' musical parody, to Ardal

O'Hanlon's surreal stand-up and sitcom whimsy, to Owen O'Neill's wry honesty, to Graham Norton's camp polish. Whereas only a few years ago many were working at the edges, virtually ignored, now, suddenly, they are centre-stage.

Historically, the Irish have been joked about and stereotyped on the one hand, and celebrated for their wit on the other. They are known for friendliness, good crack, informality, a sense of fun and the absurd, a love of words and being fond of the drop. These things are self-evident, but they, and the Irish literary comic tradition – from Jonathan Swift and Flann O'Brien to Roddy Doyle and Patrick McCabe – feed, along with the oral tradition, into Irish comedy.

Their nationality is no longer a defining characteristic for young Irish people who write or perform. All the same, though, the Irish tell stories, and why ruin a good story by sticking absolutely to the truth, when embellishing and exaggerating the facts makes for a better tale? The raconteur or *seanchaí* – Niall Toibin and Eamon Kelly pick up on earlier traditions – is an established Irish comic style, but storytelling and the tradition of sitting around spinning a yarn, singing, reciting, is more than folk memory, and very much a living thing; as a gift or tendency it certainly doesn't apply to all new Irish comedians, but it is a common feature.

The old gag merchants often bought their jokes. Patrick Kielty observes that 'a lot of Irish comedians are introspective in that they say: "Come into my world and I'll tell you what I'm up to." ' Indeed, 30 years ago Dubliner Dave Allen pioneered a new style of comedy on British TV: an urbane person sitting down with a glass and a cigarette, telling mostly stories, not gags, inviting the audience to share aspects of his life, personality or opinion.

And where that audience is invited to can be a peculiar place – there is often a blackness to the Irish sense of humour, and even an obsession with death and the macabre. It comes out in the darkness of the writing – witness novelist McCabe and playwright Martin McDonagh; comedians Jon Kenny and Pat Shortt were brilliantly cast in 1998 in straight acting roles as the west of Ireland brothers who

> When somebody gets very drunk, or if they have a drink problem, they will say things that nobody else is saying. Everybody in this country knows an alcoholic and most people will know an alcoholic quite well, because they could be a close friend or a member of the family. A lot of it is bound up with the individual's relationship with alcohol in the two countries. I think in England some people use alcohol as an amnesia-inducing thing from working very hard. And in Ireland people tend to use it as that, too, but it's more complicated – people use it as *another place they go to*, to get away from whatever it is they want to escape.
>
> *Dylan Moran*

hate each other with a ferocious venom in the Druid Theatre's production of McDonagh's comic-tragedy, *The Lonesome West*.

The Irish ease of conversation, and the dominance of a pub culture, are often cited as being at the root of the comedy. The British comic performer Eddie Izzard famously commented that the Irish have too much fun in the pubs to be particularly interested in comedy, that people feel they have crack in the pub, so why pay someone else to do it?

Irish people interact by slagging, joking, messing (indeed, Jason Byrne's whole career is built around messing), chatting in pubs. Irony or unspoken sub-texts are often at the base of bantering conversation, and humour is often the currency of communication.

Then there is the geography and the weather. Shaw blamed the climate for the Irish wit and humour – something to catch, like a bad cold. In an historically rural country, many current comic minds are from the countryside or small towns. Owen O'Neill: 'I think the Irish go for the more surreal ideas – country humour that's kind of mad – the Irish will go for that because in those little country places there's a lot of craziness going on which Irish audiences understand and which they don't really get in England. I think we go for the madness; we understand it better. And, of course, if you are doing material about families or alcoholism or drinking and all that, we will get that as well, because it's rife.'

Today our culture is global – we recognise and are familiar with British and American TV and popular culture. But an Irish performer brings a whole set of other reference points to material and delivery that are specific to Irish life – a society that was until recently dominated by the church, is still partially rural-based, where the pace of life is slower (but fast speeding up), where the Gaelic Athletic Association (GAA), local radio, 'Daniel O'Donnell-ism', local politics and 'cute hoors' are part of the make-up. We understand British culture; they don't understand ours unless it is watered down and simplified in TV programmes like *Ballykissangel*. According to *Irish Times* critic Brian Boyd, 'We can fit into their culture, although we're aliens – we're like sleepers, because we know all about them

I think that Ireland is more receptive to the kind of idea that 'here's one person and they'll witter on'. So while you've got the simple gag-telling tradition – the 'man walks into a bar' tradition – even those comedians tend to be personal, self-referential, biographical, with a narrative running through their material, rather than just doing one gag after another interchangeably.

English comedian Jeremy Hardy, who has a particular interest in Ireland

Derek Speirs/Report

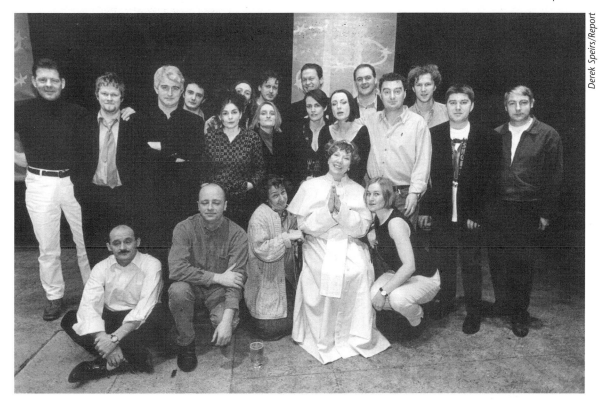

A clatter of comedians, caught at an Amnesty International fund-raising show at Dublin's Gaiety Theatre in 1991. Back row: Dylan Moran, Ed Byrne, Barry Murphy, Brendan Dempsey, Dara Ó Briain, Jason Byrne, Centre: Gerry Browne, Kevin Gildea, Dermot Morgan, Pom Boyd, Susan Collins, Anne Gildea, Karen Egan, Jon Kenny, Pat Shortt, Kevin McAleer. Front: Brendan O'Carroll, Eddie Bannon, Pauline McLynn, Rosaleen Linehan, Michelle Read.

but they don't know about us, about Fianna Fáil and the church and Bishop Casey and the GAA, so we can bring extra stuff in. Tommy Tiernan can do stuff about Navan [a small town where Tiernan and Dylan Moran grew up] being a cultureless hole of a place, and English comics can't really talk about, say, Cornwall in the same way that Dylan and Tommy can talk about Navan; it doesn't have the same resonances. Growing up in rural England is not as bad as growing up in rural Ireland for comics.'

But, all the same, broadcaster and journalist Ian O'Doherty comments: 'At the end of the day, it doesn't really matter where Dylan Moran or Tommy Tiernan come from. Navan might have given them great material, and in one way it's impossible to imagine them coming from anywhere else. But they are just brilliant comedians, full stop.'

The 'Oirish' charm is seen as a classless thing; not to say that Ireland is a classless society – far from it – but it is not class-based in the way that Britain is,

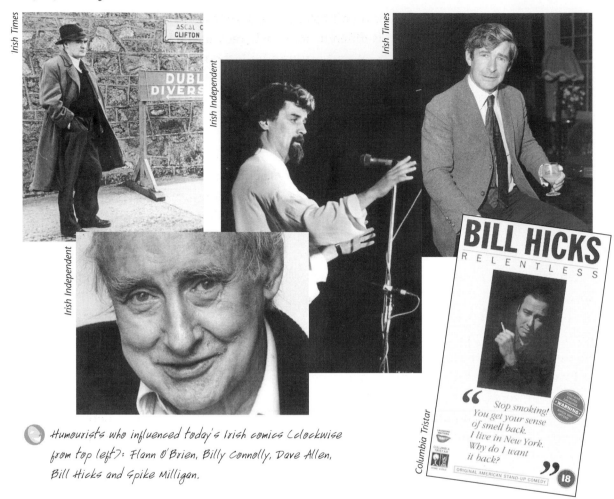

Irish Times

Irish Independent

Irish Times

Irish Independent

Columbia Tristar

BILL HICKS
R E L E N T L E S S

"Stop smoking!
You get your sense
of smell back.
I live in New York.
Why do I want
it back?"

ORIGINAL AMERICAN STAND-UP COMEDY 18

Humourists who influenced today's Irish comics (clockwise
from top left): Flann O'Brien, Billy Connolly, Dave Allen,
Bill Hicks and Spike Milligan.

and, as Graham Norton points out, an English person listening to an Irish person
does not necessarily know what class that person is. So this means a set of
antagonisms isn't set up automatically, and communication is freer. Ireland is not
a middle-class urban country at its heart; many people are one generation away
from the land, and this throws up opportunities for humour.

Also, until relatively recently there was a racial homogeneity – the Irish were
almost all out of the same genepool, nearly all white Catholics. This leads to what
Dylan Moran calls 'a tolerance for people talking, expressing themselves in their
own very individual ways', plus 'they're not worried, they're not fearful of
somebody taking over their job, or they aren't fearful about strangeness. In London
you have to deal with the fact that you are in a Babel. And you deal with it or you
become a very unhappy bigot.' Recent immigration to Ireland has, in fact, thrown
up an ugly latent racism on the one hand, and on the other a liberal recognition
that Ireland has also long been a country of emigration.

Apart from the North, Ireland is a post-colonial nation; it skipped the Industrial Revolution. Also, Irish comedy has different roots: whereas in England comedy is probably rooted in – or a reaction against – music hall, the northern clubs, *Carry On* films, seaside humour of sexual innuendo and fart jokes, Ireland's popular humour in some ways has a more literary tradition. There is a respect for words, the use of words, and all that storytelling guff, as well as the more absurd creations of Flann O'Brien and the semi-Irish Spike Milligan.

Owen O'Neill says: 'English people love stuff – and this is a sweeping generalisation – like the *Carry On* films. In Ireland they think . . . well, innuendo's OK, but we'd like something a little bit sharper.' Irish obsessions are drink, religion, politics in its most general sense and the intricacies of small-town life. And, allied to a natural bent for irony and sarcasm, Ireland has in latter years emerged from a yoke of political and religious oppression. Humour has been liberated from an era when there was a reverence for authority and a sycophancy born of a fear of speaking openly.

Both Irish and British performers point out that Irish audiences have a respect for words, and the patience to allow a story to develop and see where it will end up. Moran comments that Ireland has 'more of a regard for the power of words acting individually, rather than constructing a scenario. Irish comedians will extract more value from words, so that you are drawn into what they're saying by their choosing of a word. And in England it's based more on a traditional British sitcom – there's a kind of psyche that's behind that. A lot of an English comic's material will be about embarrassing or high-pressure situations or messing something up. And an Irish comic will often not seem to refer to the real world at all, or do it in the most oblique way and then bring it round to a real situation.'

In a country with a love of language and stories, it is no coincidence that a number of comedians have worked as journalists at some stage, that others are advertising copywriters and some have taken to fiction: Dave Allen started (as a clerk) in a newspaper, Kevin McAleer worked briefly as a journalist, Graham Linehan and Arthur Mathews began their comic life together as a writer and designer on Irish rock magazine *Hot Press,* Dylan Moran wrote a very funny regular column for the *Irish Times,* Dara Ó Briain was a journalist, the core of Dublin's Comedy Cellar club studied communications at university. And a number of comics cite the urge for self-expression as a primary motivation, over, say, entertainment, or money, or wanting specifically to be a comic.

Paradoxically, as Ireland becomes more cosmopolitan, more European, less closed, a specifically Irish comedy has bloomed. It is certainly part of the new national self-confidence, which comes partially from economic security, but also from the general opening up of Ireland, coming out from decades under a cloud of religious, social, sexual and economic oppression. Political and religious scandals

Generalisation: If 'the Europeans' are up-front and say what they mean, then the English have irony and reserve to give what they say a twist of depth – and innuendo to show the shallow needs of this depth. Then again, the Irish have a playful smile and a way with words that suggests a door to a secret place where they really live – a world of depth that may or may not exist. The English stood up, stole the world and had music hall. The Irish hid, suffered and wrote books. If someone steals your world, then you live in words that keep alive the world you hope one day to repossess. The Irish have elevated the art of beating around the bush to a level where the bush no longer exists.

Conclusion: The Irish are great crack. Their language is rich because it is the language of avoiding the subject. Humour reflects personality – ours has gnarled roots that often produce a quirky, complex fruit.

Kevin Gildea, writing in 'Rí-Rá', an Irish magazine published in London

stunned the country but have left in their wake a modern society cynical about the workings of state, church and business. Over the past decade Irish culture has bloomed on many diverse fronts – a blossoming film industry, Irish playwrights and productions winning international recognition, the *Riverdance* phenomenon, Irish music, literature. Irish comedy has earned its place in that sunny world of success, even if we are never done patting ourselves on the back about it. In the late 1990s we're in danger at times of being too delighted with ourselves entirely and ignoring the negative aspects of the Celtic Tiger and the dark, twisted past that also informs Irish humour.

More than an 'explosion' in Irish comedy, there is now a recognition of what has long been fermenting – an explosion of interest in covering it, allied to a good number of high-profile successes. This recognition may in part be a post-colonial, doff-the-cap thing – acknowledging our strengths only when others have first done so. In fact, if part of this is an Irish comedy boom in Britain, this is really just the mature stages of the second wave – the first wave was during the 1980s, when there were actually a lot of Irish acts on the British circuit: Michael Redmond, Ian MacPherson, Kevin McAleer, Owen O'Neill, Sean Hughes, Graham Norton. And they were successful, and influential, particularly MacPherson and Redmond. Then, from 1994, the second wave started to go over – O'Hanlon, Moran, Anne and Kevin Gildea, Dermot Carmody, Andrew Maxwell – and they were followed by Edinburgh Fringe successes and *Father Ted* and the Kilkenny comedy festival, and it developed from there. Comedy goes in cycles; the difference is that today it's a big business, with great appeal for young audiences, and there is more TV notice of it.

The 1980s in Ireland were depressing years of economic misery, high unemployment, a crumbling, smelly capital city, a big drugs problem, and dank, dark nights of depression – this was the dysfunctional family the new baby of contemporary comedy was born into. But as family life improved and a new Ireland – though certainly not without its faults and problems – emerged, the new comedy thrived. Part of the new self-confidence of the Cool Hibernia of economic wealth, cultural and sporting success is that it is no longer necessary to be deliberately Irish, to parade national identity as an all-encompassing badge. Sure, comic influences include Spike Milligan, Flann O'Brien and Dave Allen, but Billy Connolly and the coruscating American stand-up Bill Hicks, who died of cancer in 1994, are constantly cited, too. At the end of the millennium, Irish comedy is as likely to be influenced by *The Simpsons* and Reeves and Mortimer as by the literary tradition.

Irish Independent

Irish Independent

Funny is funny. But funny changes. If you look back at old footage of Irish variety stars like Jimmy O'Dea, Cecil Sheridan or Harry Bailey, the people the parents and grandparents of today's comedians laughed at, it's an interesting exercise in nostalgia. Some of it holds up; some is no longer funny. You look at Maureen Potter and Danny Cummins doing a ballroom dancing skit in an old black and white RTÉ clip, and you laugh. Yes, that

Still funny after all these years: Maureen Potter and Danny Cummins

was funny by any standard – and also a textbook demonstration of timing and comic precision. But the world has changed, for better and worse, and what we find amusing now is mostly very different from what was funny in the past. There are generational differences in comedy that never existed before.

The 'alternative' thing happened in the US and then in Britain, and eventually in Ireland. We're now in the age of post-alternative comedy. The more old-fashioned style of comic entertainment is still around and happily amusing many people. As in Britain and the United States, new styles and old co-exist.

If one of the defining characteristics of modern Irish comedy is a diversity in styles, are there common threads? In his definitive 1961 study, *The Irish Comic Tradition*, the academic Vivian Mercier looks for a cultural continuity in written humour (the oral heritage being more obvious than the literary, he says) and traces a bent for wild humour, a delight in witty wordplay and a tendency to regard satire as complicated. He divides written comedy into four strands, which he traces back, showing a continuous evolutionary sequence in graduating complexity – with its roots in non-verbal magic and myth, growing into verbal magic, then with the addition of wit and the poetic tradition. With apologies to the shade of Mercier for crudely simplifying the subject, the four elements or strands he identifies are:

1 **Absurd humour**, intellectually the simplest form of comedy – the untrue/irrational/exaggerated. Two identifiable sub-categories seem to be the fantastic (a late example being Flann O'Brien's *At Swim-Two-Birds*) and the macabre (Mercier instances the tradition of funeral wake games) or grotesque (especially sexual humour).

2 **Wit**, regarded as intellectually superior and complex. A witty remark is both absurd and true – in other words, a paradox – so paradoxical truth distinguishes a witty remark from the absurdity of a humorous one. Clearly, Shaw and Wilde fit into this category.

3 **Satire** is a further stage of complexity. Mercier traces satire back to a magical origin, via the poetic tradition and then personal lampooning. Satire employs other comic devices (including wit and humour) but depends on irony, so that the meaning is the exact opposite of what is said – and really subtle irony can be mistaken for literal truth.

4 **Parody**, the most advanced form of humour, makes more demands of the reader – who has to recognise the original and then see the absurdity of the parodic comparison.

Mercier looks at these four categories in relation to comic literary work and examines how each co-exists with the others and develops from the ninth century onwards. So is this categorisation of any relevance in looking at today's performed comedy? You cannot strictly apply Mercier's literary criticism, but it makes an interesting starting point in exploring the current comic dynamic, because it allows for widely diverging styles co-existing, and being fed from a central bank of funny Irish stuff. Without forcing the facts to fit the theory – and allowing for lots of 'leakage', where many performers do not fit perfectly, and others not at all, into these categories – it might be interesting to kick off on four possible examples of performers today who, at least to some extent, fit Mercier's strands.

For simple, absurd fun we could choose any of a number of current performers – the new Irish comedians sometimes seem to have a monopoly on surreal humour. Let's pick Jason Byrne. But we could have chosen Zig and Zag, particularly in their pre-Channel 4 days, or even Kenny and Shortt – their stories about funeral tricks are an update on wake games and certainly qualify for their macabre quality.

For wit, how about Dylan Moran, whose love of words extends to actually making them up? But we could equally have chosen Graham Norton, who is impressively witty either as outrageous TV host or in stand-up, or Dara Ó Briain, the genial and quick-thinking stand-up and star of RTÉ TV's *Don't Feed the Gondolas*.

For a country with a strong literary tradition of satire, which Mercier documents, we have had precious little performance satire: *Hall's Pictorial Weekly* is legendary (and a favourite with many of today's comics, remembered from childhood), and Rosaleen Linehan and Des Keogh did some marvellous revues, written by Fergus Linehan, in

Irish Independent

From the past, a face that launched a thousand quips – Harry Bailey

the 1970s. The Hole in the Wall Gang has written and performed pioneering work in the North, followed by Patrick Kielty in his Empire days, and *Short Circuit* on RTÉ radio is blazing a trail. But the late Dermot Morgan is the one who comes to mind first as a satirist for today (or at least a very recent yesterday).

And for parody – shall we choose *Après Match* for skilfully taking the mickey out of sports commentary, or the odd skits on *@ last tv*, or Mathews and Linehan's *Big Train* sketches, or the Hole in the Wall Gang for their spoof costume drama *1798*, or The Nualas' clever and witty musical creation of a nice country girl singing group? Let's opt for Paul Wonderful, who has made a career out of musical parody and sometimes musical tribute – from U2 spoof the Joshua Trio to today's Ding Dong Denny O'Reilly and the Hairy Bowsies, a republican ballad group from hell.

It's time for the first act. Send in the clown!

'The madness was just great'

You all know Jason Byrne. Of course you do. He's the boy you can't take shopping because he'll try on silly hats and make a show of you. He's the boy who farts in church. He's the boy who comes out with the devastating one-liner when you're all trying to watch *The Nun's Story* on RTÉ 1. He's the constant messer, the boy you love, but shake your head over in desperation. What will become of him? Well, he was runner-up in the newcomer So You Think You're Funny? competition in Edinburgh in 1996, was snapped up by a top London agent and in 1998 was in a version of *Alice in Wonderland* for American TV, which also featured Gene Wilder, Peter Ustinov, Whoopie Goldberg, Miranda Richardson and Robbie Coltrane. In early 1999 he toured Britain, sharing the bill with Tommy Tiernan, and filmed the series *Dark Ages* for ITV. In some ways he isn't really a comedian at all but a clown, a funny person, a messer who never stopped messing, who just picks silliness and absurdity out of nothing and makes people laugh.

At his live gigs he erupts onto the stage like a golden volcano, his gangly body galvanised with the sheer pleasure and excitement of simply being there, his exuberance infecting the dullest audience with a sense of anticipation. Those of us who have seen him before know that an array of insane, makeshift props will be to hand, and that under the baggy combats he will be quick to discard, Jason Byrne is probably wearing women's tights stuffed with a cucumber. And what follows is an hour or more of high-energy, sweat-drenched physical clowning and rapid verbal gymnastics as the props –

daft wigs, noses, hands on sticks – are brought into play and the audience becomes part of the performance. He has comic material prepared, to be sure, but he constantly extemporises around it, working the audience and testing himself. No two shows he does are ever exactly the same, and all leave Byrne and the audience exhausted. There is almost nothing he will not do on stage; he is as brave and fearless as a child.

Byrne does stand-up, but is almost always sidetracked from his material, distracted by teasing the audience or by something he finds on stage – perhaps a beer mat with a 'saw' edge, which he proceeds to use on the set behind him. And he often doesn't get back to the story or joke at all. He also does sketches, with partner-in-messing P.J. Gallagher plus comedian John Henderson as a sort of straight man, recalling a music-hall era of ensemble clowning he can never have known. Sometimes the messing can get out of hand, and the sketches occasionally disintegrate into incomprehensible self-indulgence, and then he's like a hyperactive child.

When the London *Independent* saw him, the reviewer put it like this: 'I saw Jason Byrne for the first time the other week. I had never seen him before then, but he is a star . . . at the moment a small star, but eventually he will be a star of absurd proportions . . . when he stands in front of people for more than 20 seconds they just begin to laugh out loud – and they don't stop until he goes away. Jason Byrne is such a mad hybrid, so instinctual, that above everything else you are just blown away by the sheer force of his talent and charisma.'

When Byrne tries to explain what he does, it comes out like this: 'What I do is like picking up mercury. You try and pick it up and it explodes into lots of little bits. That's what it's like in my head.'

He was born in 1972 and comes from what he describes as 'a funny family' in Ballinteer, Dublin. 'We love laughter,' he says. 'My da has a very dry wit. He will sit there and not say anything and then come up with a comment that's very funny and then he won't say anything again. But my mother is constantly hyper, and I get my hyperness from her. Mad woman, she is.

'I got into comedy through my parents. It was on the telly all the time. When I grew up in the late 1970s and 1980s there was just so much stuff on the telly. Every hour there was somebody brilliant. There was Kenny Everett, Dick Emery, Morecambe and Wise. Tommy Cooper was the one I loved, and Spike Milligan. I thought they were excellent. My da would literally turn off the news to put on a comedy show. So we weren't very well up on the news in our house. If there was a war on we wouldn't know, because we'd be watching Kenny Everett.

'I'd watch comedians all the time, and I suppose that without realising it I was learning. Just getting a love for it. And then I saw Billy Connolly live, and after I saw him that was the first time I thought "I'd love to do that for a living". A friend

and me had sneaked into a box in the Olympia Theatre . . . if anyone comes in you just turn round and look at them very posh and they don't ask any questions. We watched Billy Connolly and I just cried laughing. From the box I could see the whole audience and how he was working them. I don't remember any of the stories he told because I was crying laughing so much.'

Ardal O'Hanlon comments that 'I don't think Jason could have survived four or five years ago, or certainly seven or eight years ago, because he is a product of this new Ireland. This Ireland that even I didn't know about, an Ireland that is far closer to Britain and Europe and totally saturated in British TV comedy. We were exposed to it, and we were aware of it, but not absolutely drenched in it like young people are nowadays.'

Byrne went to Ballinteer Community School, and despite being very tall, strange, skinny and in those days bespectacled, he says 'I never got bullied, ever. If any bully came up to me, I would completely wreck his head. I was real bully material, the sort of thing bullies are taught in Bully School: "Glasses, thin – *hurt this person*!" So if they came up to me and said "I don't like you", I would just go "Why?" I'd question them, and eventually they would get bored and walk away.'

For a few years he was a quiet and industrious student, and then, when he was 15, he started to mess, and he messed and messed and messed, and he's never stopped messing. Unlike many children who grew up to be comedians, sitting quietly at the back of the class in their own world, Byrne actually *was* the class clown.

'I got a reaction, so my grades just went completely down and I thought "fuck this" and I just kept messing. I got the Leaving [Cert. Exam] just by the skin of my teeth, but I used to have great crack. I knew everybody in my year – I love popularity, I suppose. Because I could mix with all these people, my confidence was quite high when I left school. I had loads of friends. Then I went to accountancy college just to keep my mother happy. I was asked to leave because I was so disruptive. And in the summer, when I was at college, I used to work in the Braemor

From a sketch in which Jason, wearing a squeaking red nose, interrupts an 'agony aunt's' answers by roaring:

Does your epileptic *fit* . . . or will you have to take it in a bit at the sides?

Can your lepro-*sy* . . . or is it as blind as a bat?

Does your holiday *resort* . . . to violence?

Is your salmon *fishing* . . . or is it at home making the tea?

Has your bread-*bin* . . . and gone again?

Is your washing *line* . . . or is it telling the truth?

Did your micro-*phone* . . . and leave a message?

Is your aero*plane* . . . or does it have nuts in it?

With collaborator John Henderson: ensemble clowning

Rooms in Churchtown and I'd see Al Banim, Hal Roach and all these comedians. They used to do the exact same stuff and they used to swap jokes: "Are you going to do such and such? No? Well, I'll do it." And then I got into the lighting business, which was the start of everything.'

Byrne joined Lighting Dimensions, a Dublin theatre and rock concert lighting firm, on his 18th birthday for two weeks' work experience and then got a full-time job in the warehouse. There he met P.J. Gallagher, and the madness really began. 'It just became a comedy haven. It was hilarious. We started to do this double act thing. Me and the other lads used to tape him up with gaffer-tape and throw him in a skip every Friday. We'd get our work done, but the messing was immense. So one day he attacked us, and he was much bigger than us and then we never touched him any more. I used to prepare the lamps and the lights and P.J. used to fix all the cables. So I'd fix up all my lamps and then I'd come back after lunch and P.J. would have cut off all the plugs. So I'd cut up P.J.'s cables. I was Captain Lights and he was Boy Socapex. It was like I was Batman and he was Robin.

'Every Friday we had a Hat Hour from five to six, and you had to go and make a hat, and if a customer came in you weren't allowed to take your hat off. You had to pretend there was nothing on your head and say "Hello – can I help you?" And we used to wear huge big cardboard boxes with metal things stuck to them, and whoever got the best laugh got loads of drink off everyone. Once a month we did a theme day. The best one was Mexican Day. Me and P.J. went and bought these

cigars and toy guns and we made moustaches out of PVC. We got big round pieces of cardboard and we cut holes in the middle and put them on our heads, and we made bullet belts. That was where I started using props. P.J. brought in the video of *The Magnificent Seven* and we played it all day. And if customers came in we had to talk to them as Mexicans.

'The bosses used to leave us alone. We did mad, mad things. On my 21st birthday, they crucified me. They made a huge cross and taped me to it and they put pyrotechnics underneath my feet and set them off and covered me in beans and everything. It was just the maddest, best fun I've had in my life. I don't think I'll ever enjoy anything as much ever again. I was in that warehouse for four years. The madness was just great.'

Byrne was asked to compère a charity gig at the local pub. 'I was the MC, and because I had Billy Connolly's idea of comedy, I was doing dirt, but he does it in a cheeky way. But I went on and did all this genitalia stuff and my mother was there and all the neighbours with their rosary beads, and my mother was doing this kind of nervous "ha-ha-ha", and I just died on my arse. That was the first time I ever spoke into a microphone. The second half of that particular show was a raffle and I was more drunk then and I got up with no material and people were laughing as I started making stuff up off the top of my head. I was messing with the raffle and slagging the prizes.'

Dawn Sedgwick Management

Authors' collection

You need hands . . . Byrne's props hark back to music hall and the heyday of Herbert Campbell in the 1900s.

Byrne got the taste for performing to an audience, started to go to the International Bar's Comedy Cellar in Dublin and after a while plucked up the courage to ask for a spot. He was just 23 when he appeared on the stage of the Cellar for the first time. Right from the start he used the kind of props he and P.J. played with in the lighting warehouse – things you might see lying around in any industrial premises or even the kitchen. The comedy trio Mr Trellis had done daft sketches in the Comedy Cellar in the late 1980s, but nobody was doing Byrne's kind of mad, physical, prop-driven humour in 1995.

'I don't like safe comedy. I've never been a fan of safe comedy where you just go out and do your ABC material and then leave. I prefer people who come out and take a bit of a risk. I enjoy the danger, because the crowd are all "God, I hope he knows what he's doing". I've never done two shows the same, right from the day I started – I'd throw in the odd line or something extra. And I started to train my brain. Even now, I'm still as nervous as then because I don't know what I'm going to say. It can be frightening, because I'm working with me, *and me doesn't know what I'm going to say*. But I have the chunks of stuff in case – I won't go out and improvise for an hour, because that's not fair on an audience. I prefer to have loads of stuff ready and if I'm going to make things up, then let's do it really well. Because that's what a lot of people come to see me do.

'What I do with my head, and I don't know that I'm doing it – a friend pointed it out – is like building a skeleton and sticking an arm on and then going off and doing other stuff and coming back and sticking a leg on, until I've done a whole body. I pick on somebody in the audience, and if they say that their job is, say, building spaceships' – the fact that he imagines a typical member of a comedy club audience might build spaceships for a living says a lot about the way Byrne's mind works – 'then I go on and I do something else. But I remember visually where everybody is, so I can be talking about something else and about 20 minutes down the line I might say – so, we're in space, anyway, and *you* should know all about that – and people will really laugh at that when you go back to something.'

In fact, one of the funniest of Byrne's specialities is when a latecomer arrives and he does a synopsis of the show in a high-speed, two-minute version, with only a few key words discernible. 'Because everything I do is visual, I can see exactly where I've been, so I am able to do it exactly all the way back.

'People say the Irish are storytellers, and I'm not a storyteller, but the madness of an Irish man or woman is there. Because we *are* mad. We don't really care how we embarrass ourselves in front of people – we just go "Ah sure, so what?" Whereas a lot of other people could be a lot more uptight. The Irish are much more outgoing. And they do have quirky brains. You'll meet an Irish drunk in a pub and he'll just start talking about a foot that's fucking bionic, or whatever. I always see loads of madness in this country. Spike Milligan was Irish and mad. Python were English

and mad – but theirs was very perfect and upper class and controlled. It was mad, but it wasn't madness, if you know what I mean.'

Byrne's madness has him poised on the brink of stardom. When he was doing occasional gigs at the Attic, above the White Horse pub on Dublin's quays, *Father Ted* writers Graham Linehan and Arthur Mathews came to see him. 'Listen,' said Linehan. 'Don't *ever* change your stuff.' Byrne was signed up by London agent Dawn Sedgwick when he had been performing for just over a year, and as well as his success in Edinburgh he has done a number of shows for Channel 4 and appeared in several films. He has a part – as Pauline McLynn's slave – in ITV's *Dark Ages*, a medieval millennium comedy drama. 'I always knew I was going to be famous. I didn't know how or why. I used to have this dream about having a spotlight in my face and I couldn't see anything because of the light in my eyes, but I could hear loads of laughter. And that happened to me when I was doing a gig at the Olympia with Ardal.'

In late 1998 he recorded a New Year's Eve show for BBC Radio 4 – surely inhibiting for such a visual performer. 'No,' he said then, 'because I treat it as if I am in a box and I have to get stuff done and the box is almost bursting, and then when telly comes it can all explode and it will be easy. I wouldn't like to be offered a full TV series now, because there would be too much pressure. I'm not ready yet.'

Byrne may be daft and untogether, but he is confident of his talents, and recounts how Paul Jackson, the legendary BBC comedy producer, said to him when he read one of his radio scripts that it reminded him of when he had first seen *The Young Ones* scripts scribbled on bits of paper.

TV is where Byrne's ambitions lie, but it won't be any old TV. 'My dream is to do something that people will always remember forever, not just a once-off thing, a sketch show or something like that. I'm working towards the kind of thing Vic and Bob have – a big style that is hard to describe but is absolutely them. I want to do something that is me. That's why we're trying to develop the radio show into a telly idea with all these different characters.'

So, you've been sitting there chatting for a while and Jason Byrne has hardly fidgeted once. But now he is beginning to become distracted. And the way he puts it is as charming, disarming and unselfconscious as a child: 'It's the end. I have no more words in my mouth.'

wit

DYLAN MORAN

'Real life is fine, but you can only take so much of it'

'When I say real life, what I am referring to is the channel that is broadcast every morning in your head when you wake up – the fugue of images and noise that is always a bit different but comes from the same place every day, and you need to either be a very blissed-out individual, or you need to apprehend it and shape it into something that is more tolerable to yourself if you are going to get around and stay erect all day. I don't know what else to do. It does come from necessity, not in a calculated way. It serves a function. How do I explain the world to myself, how do I make excuses for myself, how do I excuse the fact that I am alive? A lot of the time I think everybody feels that they are capable of processing so much more than what's actually going on around them at the time, and that's what any picture, any song, any poem, any "made" thing does – it gives you more to process in a shorter time, if you look at it in a very mechanistic way: here's a thing – absorb it. And then if it's a really good thing, you can come back to it several times and you know you won't have exhausted all its seams.

'A lot of the desire to make people laugh arises out of boredom. I'm bored listening to myself now. Some people at this stage would take their dick out and draw on it or something. I'm not of that particular school, but you do get absolutely exasperated with yourself because you sound so prosaic all the time. It happens to everybody, for most of their lives. It's very therapeutic and gratifying to have an opportunity to escape that, and that's what being a comedian is like. Because you are a different person when you are on stage; you've got a set of pressures on you that you don't experience in everyday life. You've got a thousand people who want to laugh, and you're their main opportunity. So something happens with you – you become a conduit, you can access parts of yourself, parts of your brain that are probably relevant to everybody but aren't known until you are in that situation. Something comes into play that you can't access otherwise.'

PBJ

Dylan Moran's imaginative, meandering material seems rootless, but his impetuous style is distinctly Irish. Highly intelligent and lyrical, handsome in an untidy, dissipated way, he started his career at the Comedy Cellar, went on to win the Perrier Award in 1996 and now lives in Edinburgh. For a while he wrote a column for the *Irish Times* which was uniquely his own but nodded towards Beachcomber (J.B. Morton), the former *Daily Express* surreal humourist, whom he reveres. Moran's material often focuses on his supposedly ramshackle lifestyle in a self-deprecatory way – 'What am I? A random bag of tits. A duvet that smokes and drinks' – and his performance style is languid, almost slurry.

While his stage persona retains a slightly inebriated air – 'drinking features in every live performance except ballet, but a comedy club always seemed to me to be an extension of the pub, so there was never any reason not to have a drink in your hand' – in person he has a fluent articulacy and breadth of reference, discussing various other unusual personal icons and influences, such as Michael Frayn, Damon Runyon and Max Wall. In any case, the facts speak for themselves: nobody as unstable as Moran affects to be could have accomplished so much – brilliant, ever-changing material; excellent journalism; a starring part in a highly praised BBC TV series – in so short and meteoric a career. His conversation is effortlessly witty and his manner louche, rich in careless, fluid gestures as he observes you from under arched eyebrows with amiable cynicism. He is sometimes a difficult interviewee, either taking the piss or, more usually, disdainfully rambling off the point for his own amusement. 'Talking to Dylan,' observes his friend Tommy Tiernan, 'is like trying to catch fog.'

You tend to lie a lot as an adult. It's part of your means of getting around. You know, when you're late and you arrive and say: 'I'm so sorry. Traffic. Traffic was terrible. And there was a fire as well. A small boy – I had to give him an eye operation and all I had was a spatula and a banana.' You should just tell the truth. You should just walk in and say: 'I knew you were here. I knew you were waiting. I was at home and do you know what I did? I had a bun. And it was delicious. Because I knew you were waiting. I'll have a glass of wine – thank you very much.' And people do that as well when they break up. People always try and bullshit one another. 'I'm leaving you because you're such a nice person. Because you're such a good person. I'm not worthy. I have to go and live under a bridge.' Just tell the truth. Grab them by the teeth, hold them to you and say: 'I'm leaving you because you are the most boring fucker I've ever met in my whole life. I hate you so much it gives me energy. You remember that crazy sound you used to hear when you were going to sleep? That was me, chewing the bed.'

from Dylan Moran's stand-up act

He is the most writerly of Ireland's comedians – more so even than those who have already published fiction – and his flights of fancy often soar into the stratosphere. No one but Dylan Moran would describe the early days of the Comedy Cellar (basically a bunch of penniless embryo comics struggling to find their voices) thus: 'It was like Berlin cabaret in the 1930s. Someone would go up and sing a song and kill a swan; somebody else would go up and play a chocolate piano.'

More recently he has turned to acting and writing for TV, although he remains defiantly himself whatever part he is required to play. When he starred in the first series of BBC2's offbeat comedy *How Do You Want Me?* in 1998, for which he won a British TV Comedy Award, he played a London-Irish comedian turned photographer feebly trying to come to terms with life in the English countryside after marrying the daughter (Charlotte Coleman) of a rich farmer (Frank Finlay), and he had the audacity and confidence to change the lines written for him by Simon Nye, of *Men Behaving Badly* fame. 'Simon was very generous and gave me a free hand with customising the lines, and because I didn't know much about TV I didn't realise how generous it was at the time.' The second series was made in 1999.

He deals with his success by mostly ignoring it. 'What you're really talking about is money. More suits with heftier pens poised over creamier chequebooks. It's not a pressure to me because I don't give a flying fuck about it.'

Moran, who has a great comedy career whether he likes it or not, loftily dismisses the very notion of comedy as a career. 'If you look at a comic like Jackie Mason – that's someone with natural ability, but the approach to the whole thing is very careerist, cravenly so, in fact – because that is the environment in America, where if you don't make it you're dead. You've got to make it big or you are nobody, and there is all this pressure about profile and things that are tangential to what's funny. Maintaining a career and that kind of thing, which I think is always detrimental to being "a laugh". It's bad for comedy in general, whether it's Irish comedy or not, because the whole point of comedy is that it's an interruption, it's a rebellion, and for it to be structured is a nonsense and a betrayal of the principles of why you do it in the first place.

'And you don't even have a principle when you do it in the first place – it's like a growl or a howl against what's around you. Like when somebody's drunk and they say "Ah fuck off". It is the same impulse, the same intolerance of decorum. The point where your absorbency for the conventions of getting around during the day escapes you and you have to suddenly . . . it's quite primal, a sort of scream. Any art is. I've just said comedy's art, and I didn't mean to, but anything you make is generally a statement on what's around you. But I never usually do interviews about this. I always want to *not* talk about it: that's what I want to do. Now, serious and sincere thought is all very well, but comedy is really not that at all. Somebody

interviewed me for an English paper and they were talking about analysing comedy and I told them it was like vivisecting a fairy.'

Nevertheless, he can be coaxed into a certain amount of analysis, for example on the subject of the differences between comedy in England and Ireland. 'Comedians have become a medium for social interaction in pubs in England. You are a shaman and you can say anything because there's a lot of things certain people won't be saying on the night in their own groups, or between couples. So you are the man who has a licence to say anything, which acts as an ice-breaker for everybody in the room within their own evenings and what they're going to do later

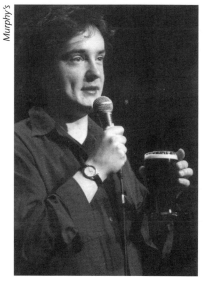

Murphy's

on. That's not needed in Ireland because when, for example, somebody in Ireland says "Oh, he's a real character", often what they mean is that he's a congenital drunk and that he will say things nobody else is saying. I think people are more used to that kind of explosive quality in social situations in Irish pubs and in Irish families – that somebody will suddenly go: "You're all talking shite and I'm going to tell you why. For the next hour." They do it all the time. And that doesn't happen so much in England.

'There's a wonderful joke Kevin McAleer does about going out and looking at the stars, taking a walk in a quiet country lane and wondering who he is and where he's from and all this stuff and then a British Army patrol stops him and asks him exactly the same questions. The word surreal

A familiar pose . . . pint in hand

is bandied about, but it doesn't really describe what is going on. What Kevin is doing there is opening something up – a philosophical realisation or an epiphany or some huge question, and then bringing it right down to the most basic political and personal situation, and marrying the two and making it funny because they'd never really come together in real life.

'But, then again, explications and examinations of humour always sound as dull as fucking ditchwater because the working comic does not, if he or she has any sense, get too involved in all that. It takes the mystery out and it takes the attraction of the thing away for the comedian. It's not like playing a harpsichord, where you know what key you are in and what note you are going to end on – you want to find out what you are doing as you are doing it. With Irish comedians there's not necessarily an end to the whole thing.

'When I was young, there were old relatives who would tell me stories and they might be funny or they might bore the arse off me. There's a danger of romanticising these things. The thing you do see in Ireland is that there's great tolerance of "the character". People say "Ah, don't mind Jimmy – he always wears a bag on his head." And in England these people are anathema, they're pariahs,

you cross to the other side of the street because they get in the way of your day and fuck it up. But here there is that tolerance for people talking, for people expressing themselves in their own very individual ways.'

Dylan Moran is an only child, born in Navan, Co Meath, in 1972. His father was a carpenter (which may be why Dylan sometimes gives the impression that he thinks he can walk on water) and his mother wrote poetry. There were always books in the house, and his parents fostered the imagination and love of words that have won him such acclaim. He often seems mildly irritated, but one subject galvanises him into something like rage: his schooldays in Navan. 'I was very unhappy at school and tremendously unacademic and depressed by the priestly omnipresence. I'm still quite angry about all of that, because not only did they not have any imagination, they resented anything resembling imagination from anybody else. They resented any single voice saying anything, so you see – laughter comes out of tension, and that was the tension. These people were saying "stop it, don't, put it down, sit down, be quiet". If you are not homogenised, you are dirt. Unless you are getting good academic results, they were saying your career options were "You could be a mugger. Or you could be a drug dealer. It's up to you." That's the kind of perspective they had. I have infinite pity for those people. They weren't all priests. Some of them were respectable pillars of the community, and they did untold damage to generations of Irish schoolchildren. My school was not unique; it was just a leader in its field.'

It was while he was at school that he discovered Beachcomber – whose 'By the Way' column is acknowledged to have influenced Flann O'Brien's 'Cruiskeen Lawn' column in the *Irish Times* – whom Moran describes as 'the comic writer of the century, appallingly unrecognised. Most of his work is out of print. He wrote a column for the *Daily Express* that hardly any of the readers ever understood. Beaverbrook tried to fire him several times. He wrote it in longhand and he would give it to this particular woman on the *Express* who would type it up for him. It ran six days a week for 50 years. He was a friend of Hilaire Belloc. His stuff is absolutely, transcendentally funny. It's the presupposition of an insane thing being entirely normal. There's a running series he had called 'Trousers over Africa', which is this colonial figure called Carstairs, who is some kind of minor attaché or military figure constantly waiting for dinner trousers to be flown over and dropped so that he can go down to dinner. And this goes on for weeks, and he comes down in converted hammocks and things, and everybody stops and stares at him and he has to go away again. It's insane! But it's delivered with this air of there-you-areness. It's very solemn, and that prefigures Milligan and the Goons and Python by a long way. That, and Damon Runyon – they are my heroes, not so much actual working comics, although I have great respect for a lot of them – Billy Connolly, for example – but they are the business as far as I am concerned. And Michael Frayn

23

did great stuff for the *Guardian* in the 1960s. I am a bit of an anorak about that kind of thing.'

He was asked to leave school when he was 16 and his worried parents sent him to a college in Newcastle, Co. Down, to sit A-level exams. It was not a happy time. 'I remember as a kid thinking I might be an actor, or a painter. I drew cartoons for a long time and seriously wanted to be a cartoonist when I was 13, 14, 15 and doing them all the time. I just knew that I wanted to make stuff. But instead I smoked dope. I smoked dope on many levels.'

When he left school, he became interested in comedy through, as he puts it, 'a mixture of unemployment and getting bored with dope'; a visit to the Comedy Cellar opened his eyes to another world. 'I never wanted to be a comedian really. When I saw the Cellar, there were Barry Murphy and Ardal O'Hanlon and Kevin Gildea and Dermot Carmody, and maybe Alex Lyons and Morgan Jones and so on, and I remember walking in and thinking "this will be shit; this will be like a student revue, some kind of sub-Pythonesque thing" and sitting down, an aggressive,

First, I awoke as usual at the crack of noon with no unlit cigarettes in my mouth. So I had to get up. Exercise before meditation always throws my system into revolt; I stood at the head of the stairs facing backwards and propelled myself with a single cough.

I was scanning the kitchen frantically for fags when I saw the wasp. Now autumn wasps, as you all know, are the most dangerous, delirious and resentful now that all the children have gone back to school. My usual technique for dealing with nature creeping into my home is to tackle the matter head-on and move to another flat. Since this was not possible on Friday, I stared at it for an hour or so, deciding to whom I should distribute my worldly effects . . .

. . . Stuffing your face is relatively virtuous when you compare what the food fetishists get up to. Their weird menus fill you with fear. *Teeny woodland animals' hearts blowtorched in front of their families in dolphin's eye sauce.* Or make you feel ignorant: *Gratin of frimpet simmered in borridge and masle, on a bed of micklebrush, kuppies and shuntynuts. May contain small bones.*

So here are some foolproof recipes for those of you who understand the true function of food.

BEAN TREAT

Gingerly pour four fluid ounces of beans or something into a jug. Cry. Eat the beans from the jug and pour the rest from the can down your throat. N.B. These taste better if they belong to somebody else in your house.

PAIN AU DUNK

Fists of bread, rent from the loaf and dunked into anything runnier than bread. Should eat at least six of these because . . . you should. Don't toast the bread. Toast is cookery.

from Dylan Moran's column in the 'Irish Times', 19 October 1996

defensive young man – "come on, then", like a typical bastard punter, and I laughed my arse off. I couldn't believe it – I was doubled up, I was crying. I didn't know that my peers could be so funny and be organised about it. Before that it was always on a Friday night, when you were coming home from the pub and you fell down, or broke into a shop and stole a deer, or whatever, all that stuff, but to see people who actually knew what they were doing was wonderful. And they were young and they didn't have anybody telling them what to do and they just decided to do it. A year passed – that was the year I *wanted* to do it, although I didn't sit in a room for a year and plot. And when I did go up on stage at the Cellar, if you had seen it written down on paper you would say "What the fuck is this?" It was like a fax from one asylum to another. But I went again.

'It was great. I remember some of what I said, and it was pure nonsense. You cannot even begin to explain it. I've got a lot of respect for good jokes, and I didn't have anything that resembled a joke. In retrospect it seemed like an exercise in timing. That's what it was. I understood there was a certain tension needed to make people laugh, so I created the tension and built it to a point at which they laughed and then I went down and did it again and they laughed and I knew instinctively, not consciously at all, that's what happened. But it wasn't the material. That was a load of old piss, but it worked.

'I can't even begin to describe the feeling of making that room laugh and knowing you were going to do it and then doing it. It's like an ego looking at itself in the mirror, and the mirror is specially lit to see it in its own best light, and you know it's going to happen. It's the anticipation, the foreknowledge of what's going to happen, and the knowledge while it's going on that you are absolutely right and that nothing can go wrong. It is heaven. And it's also infantile in the sense that the infant is completely happy in its own universe and, if it falls, somebody is going to catch it, so nothing can go wrong for this lucky infant.'

After a couple of years in Dublin, earning a growing reputation as an exciting, if unpredictable, new talent, Moran moved to London. 'I had to make some money, I had to earn a living. So I thought "I've been having a great time playing with mud pies, but will anybody buy them?" And that's why I went to London. And it was pretty grim for a young Irish boy – the shock of London; I mean, it's an age-old story, as old as the times when people started to go to London to look for work. And a lot of the people who were my peers when I went over are still doing the circuit, and that's hard. That's not because they are bad; it's something to do with their lack of ability to perceive what is going on around them. I gave myself a deadline – if it wasn't working on a certain level by so-and-so, I'm out of here. I wasn't going to end up in my 40s doing the clubs. I'd be a fucked-up human being. I knew that I'd have to keep moving all the time, had to not have to do things I didn't want to do. It had to gather pace as it went, and it did.'

After he won the So You Think You're Funny? competition in Edinburgh in 1993, Moran began the slog of travelling the length and breadth of Britain doing shows. 'When I was doing the circuit, people would say to me "you must have an unbearably fascinating life" and the reality was that it felt like total drudgery at the time – you were going up to Northampton and back to London and then to Scunthorpe or wherever.'

Tommy Tiernan recalls Dylan's days on the circuit: 'I think he drank his way through it! He was oblivious to the actual parameters. He has a special talent. He also has the ability to ignore things he doesn't want to do.'

The Perrier Award in 1996 changed all that, enabling him to fill big theatres and to headline at top clubs. 'In the beginning you are firing on you don't know what; you don't know where it's coming from, you don't know what it is. Then you turn pro, and you walk into the Olympia and it's full and you think "Well, all the lights have to work tonight. I have to work. The thing has to be turned on and everybody has to go home happy, otherwise I've fucked up a thousand people's evenings." And you can't do that and walk away with a good conscience. Nobody can do that. You have to work; the show has to happen. But, psychologically, people have paid their money and gone into a theatre – and as far as they are concerned they've had half a good time already. All you have to do is give the second half. Somebody has got a babysitter or put the alarm on, left the house, travelled into town, so you have to do quite a lot of work to fuck that up. That's why it's such a bad thing when you do fuck up, because I've done it. That's why it's a big deal. That's why you get a bad review – and why the bad reviews are the only ones you keep. I saw some clippings over the past year and they were generally more negative than they have ever been before and that wasn't really news to me because I had a need to go away and write a new show.' He said, just before moving to Edinburgh in January 1999, 'I need to go away and harvest something and bring it back again. You can only get by in your old jalopy for so long before it starts to fall apart.'

When Moran is on form, he is brilliant. But there is, indeed, another side. At the 1999 Edinburgh Fringe, he behaved so strangely on stage one night that *Scotsman* reviewer Dan Rider was almost fearful for him. 'Something, somewhere, had gone very badly wrong. Here was a man apparently on the point of a genuine nervous breakdown,' he wrote. 'For, while his act has always been shambolic, this went far beyond. So lost was he in himself, so destructive was this material that there was no pretence at disguising it with *faux* the-show-must-go-on professionalism. There were some desperate pin-dropping pauses early on, before Moran, with a weary but barely-caring apology, produced his cheat notes from a pocket.

'What followed proved painful for nearly everyone present. Sure, the diehards continued to bray appreciatively, but Moran had lost it and he knew it. As the silences became more acute and the material more offensive and palpably

unfocused, the dark side took over – bestiality, terminal illness – long, rambling and often offensive monologues that alarmingly appeared not to be part of the show but more one man's private, very troubled stream of consciousness, accidentally aired in front of hundreds of barely believing witnesses.'

'Some comics are very good at making a not very successful night work,' says Moran, 'and some comics are good at making a good night better, and I've always been one of the latter. I can't make a bad night work; I can't do it – it takes a different set of abilities. If I'm at a dinner party and I decide that everybody there is a complete fuckwit, then I'm not going to make any effort. But if somebody is saying something remotely interesting, then I can talk. But I need something to work off – a full room or whatever. If you don't like the audience, sometimes you dig your heels in and make it worse. You will be talking about wolverines eating chicken wire and then say it was raspberry-flavoured chicken wire just to piss them off more. If you just decide you don't like these people – which happens – even though you can't see their faces, you have decided that you know them; they're all shits. They all work in the same insurance company. I hate them all. Fuck 'em. And then sometimes, as Max Wall used to say – Thank you very much, ladies and gentlemen, you've been 50 per cent.

'There's one thing people often forget to mention about performance, and that is that it is a physical thing. There was a time when the only actual exercise I ever got was performing. That was the most moving I did all day – to keep talking and moving around the stage. And acting reminds me of the importance of actually being able to get erect in the morning, to be able to breathe and talk and clean the snot and sleep from your face before you go out there. There are very simple things like that that are glossed over. People talk about the background, and what's rising up out of the subconscious and so on, and what possible elements are you struggling with that mint this material that you come out with, but a lot of it is simply about how many pints you've had, or whether you had a curry an hour before.'

Working in TV, where his immediate future seems to lie – as well as starring in *How Do You Want Me?*, he also co-wrote *Black Books* with Graham Linehan for Channel 4, starring Moran and English stand-up Bill Bailey as booksellers – gives him a stability his life lacked before. His long-term future could go in any one of a number of creative directions. More stability came from his marriage in 1997 (in a peculiarly Dylanesque scenario, the wedding was in London while the Princess of Wales's funeral was going on around the corner) and the birth of his daughter.

He has accomplished a lot in a very few years, but nothing has equalled the thrill of those first days in Dublin. 'The most fun I had, the most pleasure, was in the early Comedy Cellar days. And what matters to me is being able to still walk into the Cellar and make people laugh.'

Satire
DERMOT MORGAN

Ireland's comedy terrorist

'The level of fucking buffoonery in our national and political life is frightening, and it's on a scale that you don't find anywhere else. Senators with bad wigs, sneaky showband managers in shiny suits, apemen who think and speak like something that crawled out from under a stone in the land that time forgot. Too much ill-disguised charlatanism, cronyism, theocracy and malevolence. Too many gobshite politicians kissing the holes of guys in braided frocks. And there are some areas I haven't even got into yet. What about the fucking morons going around shooting 65-year-old men in the name of Irish freedom? All this blood sacrifice, 1916 shit. There's a whole expanse of savage stuff to be done about the Provos and their fucking fellow-travellers, and I want to get stuck into that.'

That was Dermot Morgan talking to *Hot Press* in 1991. Doesn't sound much like Fr Ted, does it? Yet the actor who became famous in Britain as Craggy Island's harassed, devious, eager-to-please priest in Channel 4's surreal sitcom was always best known in his own country as a comedy terrorist. Morgan could be a savage and uncompromising political and social satirist, with

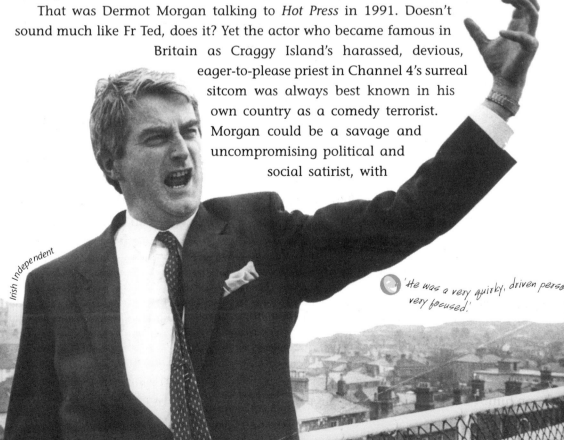

Irish Independent

'He was a very quirky, driven person, very focused.'

a lively – sometimes mischievous, sometimes manic – imagination. He was a writer, a stand-up comedian with an outstanding talent for mimicry and even a hit recording artist, spending much of his career awkwardly walking a tightrope with artistic integrity at one end and cosy showbiz acceptance at the other. He was not Lenny Bruce, nor was he Bill Hicks. But he *was* a sometimes lone voice operating courageously in a country of vested interests, mostly in the 10 years before the 'new comedy' got a hold in Ireland. He liked his showbiz buddies, too, and he liked to schmooze. As his *Father Ted* co-star Ardal O'Hanlon says: 'Dermot was just as interested in fine food and high society parties as social justice.'

Almost everybody in the Dublin media knew Dermot Morgan. You would run into him often, professionally and socially, and it was always memorable, always a pleasure. He didn't just turn on the comedy for his audiences but as a companion was endlessly entertaining, full of impressions and ad-libs. But there was still that anger. In the same 1991 interview he said of his satirical targets: 'I'm not going to give you any nice guy shit about how, deep down, I really like these people. That's not how it is. I am, as a person, quite angry about how this country has been kept in the dark ages for so long, and a lot of that anger does come out in the comedy.'

When he died of a heart attack on 28 February 1998, just a few weeks away from his 46th birthday and two days after shooting the final scenes for the last episode of the third series of *Father Ted*, a shock wave ran around Ireland. And because of *Ted,* the startling news made the front pages of British papers.

A product of the Dublin middle classes he was later to lampoon, Dermot Morgan read English at University College Dublin and became a teacher. 'I was as interested in dossing as the kids were,' he said of his schoolteaching days, 'and I was trying to teach them and I felt a fraud. I found it funny and the kids found it funny, which is why I got out of it.'

Always a natural performer, he 'got out of it' by sending scripts and ideas to *The Live Mike*, a popular comedy show on RTÉ TV, hosted by Mike Murphy. The material was used, and in the early 1980s Morgan started to get spots on the show, playing a variety of characters of his own invention. There was The Man with the Hurley, a demented bogman who rushed up from the audience onto the stage and started to demolish the set (occasionally, to Murphy's horror, not the bit he was supposed to demolish). There was the shady politician and the pompous rugger bugger type. Best of all, though, there was Fr Trendy, a glib, ingratiating priest who spouted absurd aphorisms and prided himself on his knowledge of popular culture and his ability to relate to young people, but who was really hopelessly out-of-touch. Perhaps the character owed a little to Alan Bennett's famous vicar monologue ('I often think that life is rather like a tin of sardines'), but Morgan put his own spin on him. The character of Fr Ted wasn't written specifically for Morgan, but Linehan

29

and Mathews remembered the well-meaning but ineffectual buffoon when the show was being cast years later – although Ted differs from Trendy when it comes to religion itself, which he doesn't seem to be at all interested in.

Remembering his work on *The Live Mike* for a tribute in the *Sunday Times* in 1998, producer John Keogh said: 'His greatest difficulty was in putting pen to paper. He had a constant torrent of ideas, but it was as if once he had talked them through, his mind wanted to move on to the next idea. That was why the flexibility of radio suited him much more than TV did.'

RTÉ attempted to capitalise on Morgan's growing fame, but a nine-part sketch show was eventually edited into a one-hour special. Keogh was the producer of that, too: 'I had been telling RTÉ for a long time that if they were serious about developing comedy, they should give Dermot a shot at a series. The series was approved, Dermot was commissioned to write the scripts, but he didn't deliver. It was like pulling teeth. I used to go up to his house on a Sunday and beg him and stand over him until he had written it. I persevered with Dermot because when he was good he was better than anyone else, but at times it was farcical. I remember the shoot on location being held up while Dermot sat in a car writing a sketch we had discussed five months earlier. The crew and extras were standing around waiting. There were elements in the programmes that RTÉ frankly did not want to transmit. I stuck by the series and I was removed from it. The problem was that comedy as RTÉ understood it was traditional stand-up stuff, not the hardcore revue material Dermot wanted to do. The management said that a lot of the material was unsuitable for transmission and not funny. That was subjective and could not be argued against. Dermot was very bitter.'

His friend and close colleague Gerry Stembridge, writing in the *Sunday Tribune* in 1998, asked: 'Did any executive in RTÉ ever say to himself: "I was wrong, and Dermot Morgan was right"? I am not asking for any excess of humility, only wondering did any of those who thought he wasn't worth the trouble ever acknowledge, even in a tiny private moment, the fact that when it came to comedy, when it came to gauging the popular pulse, when it came to contributing meaningfully and hilariously to the ongoing national conversation, when it came to having the courage of his convictions to the bitterest end, Dermot was right, and they were wrong?'

Before he became known on TV, Morgan had been a stand-up comedian by night and a teacher by day: 'Being a comedian in Ireland in 1977 was very grim. There were no outlets. I don't know how I cobbled together enough gigs or appearances to get on a ladder towards something comedy-wise. It wasn't a particularly hospitable environment. I went to trade union clubs, all sorts of places, to get a start. They were crap and so was I, to be honest with you. I was trying to find my metier.'

Now, smarting from his encounter with RTÉ, Morgan went back to gigging around the country as a stand-up, more successfully this time. Then, in September 1990, he contacted writer and producer Stembridge with the idea that was to become the hugely successful radio satire show *Scrap Saturday*. It was, said Morgan, going to be different to the way RTÉ had traditionally handled political satire – no parody songs or 'funny' names, like Gerald FitzGarret or Charles Hockey. It was going for the throat. Stembridge said that was all right by him. With a small cast – Morgan, Owen Roe, Pauline McLynn and occasionally Stembridge himself – the show took as its targets lazy, self-serving and sometimes corrupt politicians, plus, Morgan being such a brilliant mimic, an assortment of instantly recognisable media, sporting and church figures. As Stembridge has pointed out, Morgan was central to *Scrap*, both as writer and performer, and was the only one of the team who was indispensable. And Morgan knew that he had found a soulmate

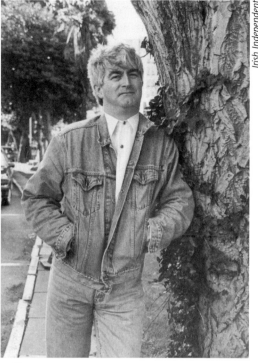

Irish Independent

'I am, as a person, quite angry about how this country has been kept in the dark ages for so long.'

in Stembridge. 'Gerry is a very, very sick boy, thank God,' he told *Hot Press* in 1991. 'His input into the show has been really important. We complement each other and inspire each other to even greater heights of sickness and depravity. We're a pair of dirtbirds, basically.'

Morgan and Stembridge shared the writing on *Scrap Saturday*. 'Mind you,' as Pauline McLynn points out, 'any of the fantastic monologues that Dermot had he did himself. Dermot, because he had been a teacher, and was really interested in history, was far more knowledgeable about stuff – real things – and when it emerged that Haughey, spookily, was related to everyone else in the whole of the world, Dermot was the brilliant one who could do it because he knew all about the history of Europe. You could fling any country at him and he'd know what to say about it.'

The show was such a hit that at times it seemed as if Ireland came to a standstill for half an hour on Saturday mornings. The jokes and routines were roared over in pubs at night. Morgan and Stembridge had broken the mould, and the respectful attitude to 'our betters' was irretrievably dented.

After three series it was dropped at the height of its popularity following, it has been hinted, political pressure. RTÉ has always denied this – the mercurial Morgan

was notoriously difficult to work with, it said, and was constantly pushing at deadlines with dodgy material and, anyway, the show had come to the end of its life. But former Controller of Programmes Muiris Mac Conghail is in no doubt. 'Well, of course RTÉ axed the show,' he told the *Sunday Times*. 'The damage had been done. The politicians had to be let off on their own to finish the job, and they are still producing the scripts. Dermot Morgan's exile had to be, because the sole national broadcaster could not find a place for him in its schedules. RTÉ created a Kafkaesque environment for him. They gave him no security. But the blame is not to be laid entirely at the door of RTÉ. This is a small island, and people with talent have to get away from its shadowy tyranny.'

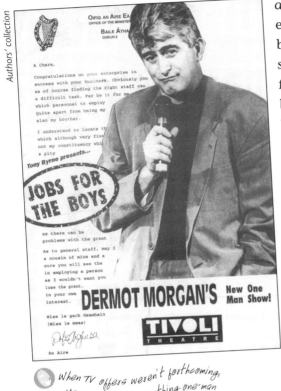

When TV offers weren't forthcoming, Morgan took his scathing one-man shows on the road.

The easygoing McLynn remembers the programme's demise as being rather more mundane: 'What happened was that we'd stopped doing it at the end of a series and RTÉ just never picked it up again when it was offered to them. We had actually stopped. Gerry and Dermot were finding it very difficult to write two series back-to-back. You'd do the pre-Christmas and then after Christmas the Dáil [the Irish parliament] would break and there would be less political stuff to be at, and with a big run and only a few weeks off at Christmas they were really exhausted, so when we went back to it again we just did up to Christmas. Then Haughey resigned and we had to bring out a cassette about that, and then RTÉ just never picked it up again. It was put about by people in RTÉ that it had gotten personal, and it never had. There were childish reasons why it was never taken up again, but it was always blocked. Dermot would offer it to them every season, knowing that they would never take it back. He'd ring and say "I've offered it to them again" but you'd know they wouldn't take it and there were reasons like – oh, the slot is gone, whatever. But in a way we were glad that they hadn't picked it up again, because we could all look back on it as a perfect moment in time.'

All the same, Morgan was enraged. He was also resigned – he knew RTÉ's attitude to comedy of old. 'The studios of Montrose are not easily confused with those of Mack Sennett,' he observed in a letter to the *Irish Times*.

Dermot Morgan was nobody's fool. He knew that the public wanted more *Scrap Saturday*-type entertainment, so he took to the road with vicious, bitter, funny one-

Gerry Stembridge

Because he is a writer, producer, director and sometime performer, nimbly manoeuvring his awesome bulk between film, TV, radio and stage, straddling comedy and tragedy with equal ease, it is tempting to call Gerry Stembridge a Renaissance Man. 'That phrase has been used,' he told Michael Dwyer of the *Irish Times* in 1995. 'Well, it's more complimentary than being called Jack of all trades and master of none.'

That was the year his acclaimed movie *Guiltrip*, featuring old friend and *Scrap Saturday* performer Pauline McLynn, won top awards at the Amiens Film Festival and the Thessaloniki Film Festival, and his BBC radio play, *Daisy: The Cow Who Talked*, won a Writers' Guild Award. In 1998 he wrote one of the three films based on the life of Martin Cahill, the Dublin crime boss known as the General.

Gerry Stembridge, producer and, with Morgan, co-writer of *Scrap Saturday*, has many other comedy credits, from directing some of the TV stand-up shows recorded at Belfast's Empire Comedy Club to director of the Barabas Theatre Company's innovative and imaginative stage production of Lennox Robinson's *The Whiteheaded Boy*, which toured the US in late 1999.

Stembridge was born in Limerick in 1958, one of six children of a builder's driver. He went to University College Dublin on a scholarship in 1976 to study English and History; there he appeared in drama society productions. He was a prominent debater, bending the rules of the form with his irrepressible humour. He did an MA on playwright Tom Murphy's work and was immensely popular on campus, where he zoomed around on a Honda 50. After college he taught then did an RTÉ producer/director training course in 1984. 'I owe a great debt of gratitude to RTÉ because they trained me very well,' he said in the same interview.

Scrap Saturday suited him so well because of what he – and others, it has to be said – perceived as the essential absurdity of Irish public life. 'The country is mad! It seems to constantly produce and re-produce these outrageous situations. And I think it's partly to do with the fact that we elect loads of loonies, these characters who open their mouths, insert both feet in them and just dive in.'

Certainly, some of the politicians' utterances went beyond parody – or perhaps Fine Gael's Michael Noonan, for instance, was himself parodying the parody when he so memorably said: 'The Minister and the Government are going on a picnic. But have they got a tin-opener?'

Although he often comes across as an easy-going, untidy, sociable sort of character, Stembridge is highly disciplined in an unstressed, ad hoc kind of way. 'Gerry never makes plans; it interferes with his thinking on his feet,' a friend told the *Irish Times* in 1991. 'The most important thing about him is the way he believes that comedy is the most effective way to make a serious point.'

man shows like *Jobs for the Boy*; the title speaks for itself. They were enormously successful.

RTÉ and Morgan tried one last time to get along with each other. *Newshounds* was to have been an Irish version of the BBC's *Have I Got News For You*, with Morgan hosting and dispensing plenty of one-liners about dirty doings in public life. RTÉ once again pulled the plug almost on the eve of broadcast. Morgan, who had put everything he had into it, wept when he got the news, devastated by this latest slap in the face. Producer Philip Kampff told the *Sunday Times*: 'The show wasn't pulled because it was good or bad. RTÉ unfortunately don't pull shows because they are bad. If RTÉ spend tuppence on a show, they put it out. It was scrapped because of corporate timidity. Dermot was considered dangerous. He was a problem because he was popular and because his trade was satire, which makes RTÉ uncomfortable. I called Dermot into the office and broke the news to him. He was deeply upset and

Irish Independent

With Pauline McLynn, his friend and co-star from 'Scrap Saturday' and 'Father Ted'

ran out of the building saying, "I can't believe they've done this to me, they said they wouldn't do this to me." He knew it was the end of the road with RTÉ.'

For Morgan, it seemed as if his career in Ireland was over. He began to look towards England, and then he was sent a very strange script, the like of which he had never seen before. It was, at that stage, to be called *The Father Ted Crilly Show*. A delighted Morgan told the authors just before going to London to start filming: 'There's a wonderful madness about it. The quality papers will be reaching for words like Beckettesque and surreal, but really it's a laugh a minute.'

The success of *Father Ted* culminated personally for Morgan with Best Comedy Actor at the British Comedy Awards in 1997 (he also won a posthumous award for the third series in 1999). He loved the fame, the money and the recognition of his talent. But even on *Father Ted*, a show in which he had no hand devising or writing, he was his usual edgy, difficult, controlling self. He annoyed the producers and he sometimes annoyed the cast, including the gentle and usually unflappable Frank Kelly, who played Fr Jack.

'He was a quirky, driven person, very focused,' says Kelly. 'In hindsight, there seems to have been some innate feeling that he'd never have accomplished

everything he wanted to do. He was always in a terrible hurry. He was a late-ish entrant into the business and it was a horrible irony that he died when everything seemed to be coming to the boil for him. He was a very stressed man, and he had a short attention span, which made it seem as if he could be dismissive. I didn't care, because if I'm working and someone is difficult or abrasive with me, I don't let it get to me, because it makes me bad on the studio floor and then I'm really annoyed with myself because then I've really lost. So I don't have rows. Dermot had this abrasive sort of quality, but the extraordinary thing is that if he was abrasive with you he came back unerringly about three or four days later and said "Do you remember last Tuesday when I was talking to you – I hope you didn't think I was being discourteous. Actually, I was thinking of something else . . ." And he'd explain it to you, and he would be very concerned that he might have stood on your toes in some way. And that was such a redeeming thing.'

Frank Kelly comforts a relative at Dermot Morgan's funeral in Dublin in 1998

Away from the cameras Morgan was a devoted father, ceaselessly encouraging his two teenage sons, Don and Bobby, from his marriage to Susanne. He was devoted to Ben, his child with Fiona Clarke. And all of them – partner, ex-wife and sons – can be proud of his legacy as Ireland's greatest political satirist. The three boys wrote a poignant and charming tribute book about him, *Our Father*, in 1998.

The last time we personally saw Dermot was when he drew up alongside us at traffic lights on Dublin's Merrion Road in early 1998. He was in a big, shiny car – happy, singing and drumming his fingers on the wheel. He was living the good life – a top TV series and the professional respect he had always craved. He looked over at us and nodded. We smiled back and waved. He was only 45 – how could we have known that we were waving goodbye?

Frank Kelly: 'The best measure of Dermot as a person is that when he died we were all absolutely grief-stricken. That doesn't happen every day of the week. People have died whom I've worked with and I've had to feign mourning, but Dermot just left us gobsmacked. Pauline's a tough cookie and so is Ardal and so am I . . . but the tears just ran. It was just a spontaneous eruption. It was a measure of the huge force that he was, and how much we really loved him without knowing it.'

At the 1998 British Comedy Awards there were three nominees for Best TV Male Comedy Performer: Dermot Morgan (posthumously) and Ardal O'Hanlon for *Father Ted*, and Steve Coogan for *I'm Alan Partridge*. It was won by Coogan, the most acclaimed comic talent of his generation, and in his acceptance speech he said: 'This is a bit embarrassing. I didn't expect to get this. And I'm embarrassed because of Dermot, really. I think he should have got this because it was a real, sad loss to the world of comedy when he died, and I'm humbled to be compared to him.'

Where has all the satire gone?

For a country with a long literary tradition of satire and, latterly, a healthy cynicism and disregard for authority, why does Ireland have so little satirical performance comedy?

On the one hand, there is plenty going on – whether on the world stage or at home, where investigative tribunals seem to be breeding, where the disparity in wealth is ever-widening, where Irish cities, especially Dublin, are rife with gangland warfare and drugs, where Ireland has dealt shamefully with immigration issues. On the other, the 1990s have seen a general disenchantment with political and public life, and a retreat into the personal. Perhaps the bombardment of news in this information age has had a wearying effect. The concentration on the idiosyncratic and surreal in comedy can be seen in the context of information overload, and this retreat to the personal – a focus in some media on human interest and gossip rather than hard news; the dominance of biography in reading tastes – means people are fascinated by individually interesting people like Tommy Tiernan and Owen O'Neill who, because of their backgrounds, are able to hold up a mirror to ourselves.

The only true satire in Britain today, as many comics point out, is a satire of the media and information machine itself: Chris Morris and his innovative, dangerous (in the best sense of the word) series *Brass Eye* being the strongest example. In Ireland it is not long since what Frank Kelly describes as 'an era of over-reverence'. Rumours persist about political interference in *Scrap Saturday* (though others say it was a financial decision; and that the dropping of *Newshounds* was also financial –

a fear of libel – as much as anything else on RTÉ's part). Indeed, whenever there's anything faintly controversial, the twitching hand of the über-zealot can be felt.

Ireland is still dominated by clientelism, and is a small country to boot, where politicians are often known personally to their constituents, and in that context perhaps really biting satire is difficult, although in the late 1990s RTÉ radio's *Short Circuit* has taken up some of *Scrap*'s mantle. Ardal O'Hanlon, himself the son of Fianna Fáil politician Dr Rory O'Hanlon, comments that we have never had an equivalent of Bill Hicks. 'I am a huge admirer of Bill Hicks, but you can't work like that here because in the South you don't have extreme politics. We live in a very mediocre society, I think. There's a kind of casualness about Irish politics, and a mediocrity, that doesn't lend itself to satire. That's one of the reasons none of the comedians I knew were attracted to it. Paddy Kielty was doing that successfully up North, before he started winking at audiences. I was a huge fan of Paddy's because he was really on the edge. Brilliant. There was nothing like it down here, but how could there be anything like it down here? We're pathetic, really. We don't have snakes, we don't have extreme weather, we don't have a foreign policy; how can we have satire? Journalists seem to be doing the job of satirists by bringing corruption to the public's attention very effectively. Dermot was more savage than, say, Rory Bremner is in England, but ultimately what he was doing flattered the politicians. It was all part of the same thing. In Weimar Germany a satirist was a genuinely dangerous beast and there was a case for it there, but at this point in our history it's difficult. There are other ways of dealing with it.'

Former comedy promoter and performer Billy Magra argues that 'there's nobody here with the capabilities of a Lenny Bruce or a Bill Hicks. They all hide in crazy voices, they all plug into "the other figure".' Also, 'you don't get on to RTÉ if you go out there and take on politicians or judicial inquiries or gangland killings'. He points out that subversion isn't sexy, doesn't lend itself to TV or radio coverage, to glamour, or to attracting an agent in the new big business that comedy has become.

People of the new smug and affluent Ireland are too busy patting the Celtic Tiger to have space for satire. Belfast satirists the Hole in the Wall Gang agree that the new national self-confidence is part of the reason why there is little satire in the Republic – and they do a scathing take on observational comedy: 'We're all doing very well, thank you, so we'll talk about what's in the fridge,' says Tim McGarry. 'Why are poor people dirty? You know when you buy your third car. . .?' says Damon Quinn. Michael McDowell: 'Did you ever get papaya, and you get it home and it's rotten?' But they do point out that satire comes in waves, and that it will return in Britain, for example, with the end of Blair's extended honeymoon.

Comedian Dara Ó Briain, a team leader in the newsy RTÉ TV show *Don't Feed the Gondolas*, says: 'I think that most of the people who are currently involved in

comedy writing and performance don't have a particular interest in current affairs. The reference range for most stand-ups is very much geared towards human interaction. We regard ourselves as an intelligent people, but I think my generation is not interested much. Broadly based, people aren't, I think. It is something I'd like to do, but if my level of political knowledge is regarded as high in Ireland, then that's appalling. We're in a disgraceful state.'

But what is satire anyway? The edges of everything have become blurred – between old and new comedy, mainstream and alternative. If the dictionary definition of satire is 'a composition in verse or prose holding up vice or folly to ridicule, or lampooning individuals; use of ridicule, irony, sarcasm in speech or writing for the ostensible purpose of exposing and discouraging vice or folly', while there's precious little political satire around, plenty of comedy holds things or people up to ridicule – whether it's the way we were taught in school or the idiosyncrasies of personal relationships, or the hypocrisies of religion or Kevin McAleer linking the personal and political. Indeed, someone like Jason Byrne casts everything into chaos by making it seem ridiculous. As Ardal O'Hanlon says: 'I also think that a good observational comic is not just going to talk about mundane everyday things but will deal with human behaviour in a much deeper way. Ultimately, that's where I'd like to be. I don't think I'm there yet and won't be for many years to come. To become a good comic it takes many, many years.'

But all the same, says Ian O'Doherty, 'it is a pity that many Irish comedians just don't seem to be able to make the leap from being charming to being bloody funny. If we were to get one incendiary Irish comedian who actually got angry at something, and managed to be funny at the same time, it could lead to a whole new era of Irish stand-up.'

PAUL WONDERFUL

'The Craic We Had the Day We Died for Ireland'

He was the creative force behind 1970s spoof band the Glam Tarts and, in collaboration with Arthur Mathews, U2 take-off the Joshua Trio. He can still very occasionally be spotted as Dublin wedding singer Tony St James, but these days he is more often to be found in the dreadful disguise of Ding Dong Denny O'Reilly, the drunken, vomiting, pot-bellied, republican lead singer with traditional ballad group the Hairy Bowsies. Ding Dong is trying to re-establish the values for which we are best known: 'Fighting, puking, spitting, singing, hating the English, drinking and incest . . . the things that define us as a nation.' Offstage he is an unassuming, rather intense Dubliner known as Paul Wonderful, and for 20 years he has been Ireland's leading musical parodist.

Paul Wonderful, lead singer with the Glam Tarts

Many comic performers have used musical humour as part of their act – Frank Kelly, Paul Malone and Dermot Carmody are just three – but until the emergence of The Nualas in the mid-1990s, Wonderful was the only artist working almost exclusively in the field. He says of Ding Dong: 'I wouldn't be republican politically, and in many ways I don't want to be making points, but I had this character and the songs just came out of the character. Although people wouldn't approve of Ding Dong, in some ways I find that I sympathise with him. He's a rogue. I find it easier to write for Ding Dong than other things. I dunno – and I shudder to think – but maybe he's closer to myself than I would like.'

That thought would make you a bit nervous if you didn't know that the diffident and teetotal Wonderful (his real name is Paul Woodfull) was joking. Here's a sample of some of Ding Dong's opinions – Wonderful usually

Paul Wonderful

does interviews as one or other of his characters – gleaned from a 'drunken' session with Jonathan O'Brien in *Hot Press*: 'My favourite drink is the stout. But sometimes the stout is not enough and you need the whiskey as well. I've tried drugs, but after enough gargle you find you hate the Brits more, you puke more, you spit more, you fight more.'

He elaborates on his drug experiences: 'Whenever I got tired of drinking – which wasn't often – I tried all kinds of drugs, no word of a lie to yeh. I even took E. I've written a song about it, 'A-Raving We Will Go'. I don't like heroin, except I think it's great for small children. It quietens them down grand; they get a lovely glow off them. The worst child in the world can be a beautiful child with heroin on him. Maybe I just got given a bad assignment of LSD, but it was absolute shite. I didn't like it at all. My map of Ireland started turning into England. I nearly went mad. And when I took E, I found that you started loving things other than Ireland, and that is not good.'

As the mention of his association with Arthur Mathews indicates, Wonderful is another veteran of *Hot Press*. Mathews was art director, and Wonderful joined the magazine as his part-time assistant in 1987 while he was studying graphic design at Dublin's National College of Art and Design. 'They thought they were hiring a shit-hot young layout guy,' says writer and broadcaster George Byrne, who already knew Wonderful from a band they had both been involved with in the late 1970s, 'and what they got was a madman.'

Mathews and Wonderful were not the only funny people in the office; they were part of a writing and production team that included Liam Fay, Damian Corless, Liam Mackey, Fiona Looney, Declan Lynch and Byrne. Fay, Lynch, Mackey and Corless are still among Ireland's wittiest commentators, Looney went on to create RTÉ radio's Monica Moody, and Byrne, who can prove that U2 are less Irish than The Smiths under FIFA parentage rules, remains a most chucklesome rock critic. 'Production weekends at *Hot Press* were like open mic. sessions,' he says.

Inevitably, Wonderful and Mathews found they had more in common than design skills. 'Arthur and I just seemed to be imitating different people's voices and talking to each other as various characters all the time. Because of U2, there was a kind of reverence in the music scene, but everybody in the *Hot Press* production office at that time, with the exception of Liam Fay, would have been very much into the punk scene. I had been in bands of one sort or another and I would probably have been a bit more musical than the rest of them in that I probably did more gigs.

'I've always been in jokey bands and I've always had some trouble taking myself seriously. And in *Hot Press* there was a certain attitude – a cynicism, a sarcasm, a satirical edge to everything. We'd be giving out about Sting and all the po-faced rock music that was around at the time – Peter Gabriel and Bono as well

Does anyone out there remember the old *seanchaí*? Years ago all the children would gather in the one house and the *seanchaí* would tell them stories of ghosts and them sort of things – heroes and magical places, and I can tell you, a shiver would run up your spine as he slipped his hand down your trousers. Old Father Breffni, the *seanchaí* . . .

as Sting. But, of course, a music magazine couldn't take the stance of being *against* everything – it had to sell. So there was an element of us being bold children. I always had the feeling that it was a bit childish, but I rather liked that, and that was where The Joshua Trio came out of.'

The Joshua Trio comprised Wonderful, Mathews and Ciaran, Paul's brother, and specialised in daft, easy-listening versions of U2's more overwrought songs. Graham Linehan – who went on to write *Father Ted* with Mathews – became involved and the humorous banter between the songs started to harden up. Tony St James, the Afro-haired, droopy-moustached, white-flared-trousered sex machine, started as Wonderful's supporting act for The Joshua Trio. 'I used to play in wedding bands when I was in college, so I got some of my ideas for Tony St James from playing those gigs – that kind of cabaret thing. So I knew all the songs to sing, and the particularly bad way that people sang them. Tony St James was just a bad wedding singer who really fancied himself. He claimed he had been in Las Vegas, but it turned out that he was on the topless bar circuit in between the acts.

'It was at the Tony St James gigs that Arthur would come on and give a sermon. Sometimes people thought he was a real priest and would tell him to fuck off. He'd bring his portable confession box, and he was more surreal, or camp, than the eventual TV Fr Ted. It was more like the priest Graham Norton did in *Father Ted*: "Oh, it's great, we'd go down to the youth club and have a sing-song and play the guitar. Simon and Garfunkel – fantastic! Of course, the lads arrived at 11 o'clock with the cans of beer and all and I'd had enough by half-eleven but, sure, they would go on until *one o'clock*!" '

Wonderful has worked full-time in entertainment since 1993. He helped form tribute bands based on Abba and Thin Lizzie, and gigged regularly as Tony St James and with the Glam Tarts. Ding Dong Denny and the Hairy Bowsies began as an idea in 1995, when the Glam Tarts split up for a while and Wonderful was working with Joe Rooney of the comedy duo the Quacksquad, who now plays Ding Dong's most trusted companion, Scribbler O'Donoghue. Both felt that the time was right for a humorous take on bands such as the Wolfe Tones and the even harder-line the Irish Brigade.

Paul Wonderful

Ding Dong Denny enjoys a quiet nap

Ding Dong may be ludicrous, but the Bowsies are a fine band. Wonderful: 'I know a lot of musicians, and after a while you know how to get a good band together rather than a bad one, and I've been quite lucky. The Hairy Bowsies don't need much rehearsal because you explain what you want and they just do it. They're young guys and they get into the spirit of the thing and dress up, and some of the ideas would come out of the things they suggest.'

An evening with Ding Dong Denny O'Reilly and the Hairy Bowsies – the line-up includes Napper Tandy Jr and Céilí Minogue – tends to be a somewhat chaotic meld of fights, step-dancing, invective, trouser-dropping and projectile vomiting competitions. The Dinger himself is an awesome sight – puke-stained shirt over greying string vest, dirty, too-short trousers and grey-white slip-on shoes, stout-encrusted moustache, reddened eyes and puffy, bruised cheeks. The voice is particularly clever: that carefully enunciated, precise, gravelly wheedle some hard-drinking Dubliners adopt when they are trying to appear sober. Then there are the songs, which include 'The Craic We Had the Day We Died For Ireland', 'Spit at the Brits', 'The Ballad of Jaysus Christ', 'My Heart Gets So Full You'd Swear I Had Tits' and the moving evocation of Famine times, 'The Potatoes Aren't Looking the Best'.

Paul Wonderful is the original magnificent showman. At one Ding Dong show at Whelan's in Dublin, he introduced New Kids in the Block, three youths in combats and balaclavas. As two of them mimed shooting at the audience and at each other, the third sang 'INLA' to the tune of Village People's 'YMCA'. While some of the audience were open-mouthed at this spectacle – as in the 'Springtime for Hitler' sequence in Mel Brooks's movie *The Producers* – raucous laughter began when a Gerry Adams lookalike bopped onto the stage and started to breakdance. The number ended with an explosion in the drum kit.

Wonderful usually strips down to Ding Dong's grimy Y-fronts at some point – and he has been known to go further. Dublin comedian Eddie Bannon comments: 'Paul's great because he tries so many new things and he taps in to very old-style ways of doing them. And he doesn't care if he has to get all his clothes off just to do one gag, and it's not the fact that he's showing his cock, it's just that it's part of what the gag is about. He does really good characters.'

Generally, Wonderful would rather be with musicians than comics. 'A lot of comedians seem to be quite comfortable on their own, gigging all over the country, but I like to be in a band because I enjoy the company of musicians, and that's why I gravitate towards doing these comedy bands. I like the atmosphere around a band and the frankly laddish behaviour. I can't say I'm averse to that kind of thing, and you don't really get it with comedians. I find that people in bands are less ambitious; comedians are always ambitious, always interested in their reviews and status. In bands guys seem to be more spaced-out. They are into the music and they have a belief in it – it's an emotional attachment rather than a means to an end.'

That's how Ding Dong Denny O'Reilly came into being, according to his creator, who hasn't the slightest interest in politics except as a subject for humour. But we prefer Ding Dong's own version: 'Ding Dong Denny O'Reilly is as synonymous with Dublin as coddle, stout and being held up with a syringe. His love of Ireland was evident at an early age from his pathological hatred of all things British. At the age of six he would steal all the red buses from the toyshop and smash them with a lump hammer.

I want to talk to you a little bit about vomiting. In case you don't know, vomiting is the true mark of an Irishman, because when you've puked about 15 times, the last thing to come out is always green. And aren't we Irish like puke ourselves? People have tried to keep us down for years, but we wouldn't fucking stay down. Every time I see a puddle of vomit on the floor I think of 1916 and the Rising . . . the green the lining of your stomach, the white the milk you drank to try and stop you puking, and the orange of the carrots.

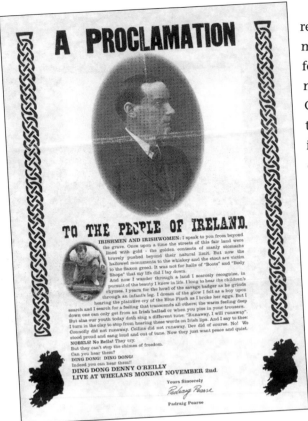

A PROCLAMATION

TO THE PEOPLE OF IRELAND.

IRISHMEN AND IRISHWOMEN: I speak to you from beyond the grave. Once upon a time the streets of this fair land were lined with gold - the golden contents of manly stomachs bravely pushed beyond their natural limit. But now the hallowed monuments to the whiskey and the stout are victim to the Saxon greed. It was not for halls of "Boots" and "Body Shops" that my life did I lay down.

And now I wander through a land I scarcely recognise, in pursuit of the beauty I knew in life. I long to hear the children's rhymes. I yearn for the howl of the savage badger as he grinds through an infant's leg. I dream of the glow I felt as a boy upon hearing the plaintive cry of the Blue Finch as I broke her eggs. But I search and I search for a feeling that transcends all others; the warm feeling deep down one can only get from an Irish ballad or when you piss in your trousers. But alas our youth today doth sing a different tune. "Runaway, I will runaway". I turn in the clay to stop from hearing these words on Irish lips. And I say to thee: Connolly did not runaway. Collins did not runaway. Dev did of course. No! We stood proud and sang loud and out of tune. Now they just want peace and quiet.

NOBELS! No Bells! They cry.

But they can't stop the chimes of freedom.

Can you hear them?

DING DONG! DING DONG!

Indeed you can hear them!!

DING DONG DENNY O'REILLY

LIVE AT WHELANS MONDAY NOVEMBER 2nd.

Yours Sincerely

Padraig Pearse

Padraig Pearse

Padraig Pearse speaks from beyond the grave to put a word in for Ding Dong Denny

'He was incarcerated at the age of 11 in reform school and it was here that his musical career began, banging the drum for a splinter outfit from the main school marching band known as the Red Hot Chilli Pipers. The three years he spent there were during the halcyon days of the institute before the Brother Seán scandal and the numerous Channel 4 and *World in Action* documentaries. Ding Dong's violent nature and hatred of all things British made him a star with the Christian Brothers who ran the place. Upon coming out of reform school, Ding Dong realised he could do more for his country through his music than he could through his admirable violence skills. However, he failed to realise that drinking alcohol every minute of every day was likely to slow his progress.'

I love the Irish language. And I love it most of all because it reminds me of puking.

Father Ted

Absurd humour . . . absolutely. Wit . . . certainly.
Satire . . . in a completely silly sense. Parody . . .
lots of it embedded there. Each of the four strands to
some extent came together in what was the most
successful Irish comedy phenomenon of the 1990s . . .

ARTHUR MATHEWS
AND
GRAHAM LINEHAN

They have been described as acting like an old married couple and, indeed, there is something strange and appealing about the creative coupling of Arthur Mathews and Graham Linehan. 'I don't know what the exact chemistry of their relationship is from a writing point of view,' says Frank Kelly, 'but I have seen them, and they're like two Hollywood gag writers. It's the funniest thing you've ever seen. They fight and argue and walk up and down the room scribbling on envelopes, and then one of them runs at the word processor and beats the shit out of it. Then they read it and argue again. It's absolutely wonderful, it's pure Hollywood. It's Jack Lemmon and Walter Matthau.'

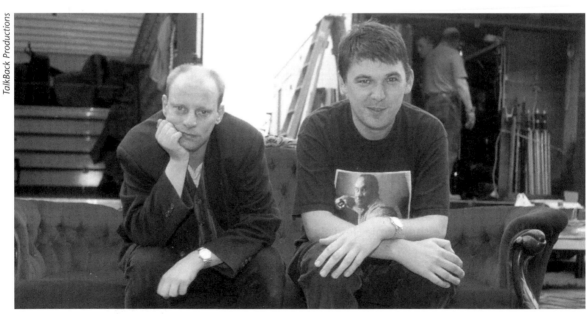

TalkBack Productions

Fathers of Ted: Arthur Mathews (left) and Graham Linehan

They are an odd couple all right. Mathews, 40ish, balding, donnish and laid-back except for the manic cackle that erupts from time to time; Linehan, 10 years younger, very tall, dark-haired, more focused, more intense, more prepared to

explain and analyse. What they share is a delicious sense of the absurd that made them just about the hottest writing team in British TV in the 1990s.

They obviously have the greatest respect for each other, personally and professionally. A conversation with them is rich in jokes and bizarre images as they chat away entertainingly about all sorts, interrupting each other, deferring to one another, one finishing the other's train of thought, the words tumbling out, the whole punctuated by guffaws from Linehan, reclining expansively in his chair, and explosive giggles from Mathews, leaning forward with his elbows on the table.

'I'm the blank generation, and Graham's the slacker generation,' says Mathews. Linehan, typically, draws on a movie analogy to describe the difference in temperament. 'I'm more ambitious. You,' he tells Mathews, 'want to relax. You're Dean Martin.'

Mathews: 'Oh, very much, yes.'

Linehan: 'I'm the Jerry Lewis. I hate being the Jerry Lewis, though. Dean was far cooler because he didn't care. He didn't give a fuck.'

Mathews: 'And I'm Dean Martin! I like it!' (*wild cackle*).

Linehan: 'I wish I was Frank Sinatra. But I think I'll end up being Jerry Lewis. I've got the hair. Arthur's just happy to drink his martinis and go, whereas I am probably overly aware that we have built up a reputation and I feel that we have to keep it maintained, that we can't get lazy – not that Arthur is lazy – but I just have to be there to make sure everything's right, because there are people who just don't get things right.'

They are a true example of Ireland's real coming of age. There are no chips on their shoulders about their Irishness; nor do they see themselves as *specifically* Irish comedy writers by definition – their points of reference are international popular culture. 'Our background is British TV, American movies, rock music,' says Linehan. 'We never saw *Ted* as being specifically Irish. It's certainly not aimed at a British audience. I'll tell you who it's aimed at – people who like the same things we like.'

Working together is like a relay race, says Linehan. 'We sit down together to work out the plot, and talk about it for about two hours. Then we rewrite the plot, then start trying to write the script. He'd sit down and write a scene and I'd look at it and add or take away, and he'd do the same to me. It just goes on like that. It's

Dougal:	God, I've heard all about those cults, Ted. People dressing up in black and saying Our Lord's going to come back and save us all.	
Ted:	No, Dougal, that's us. That's Catholicism.	
Dougal:	Oh, right.	

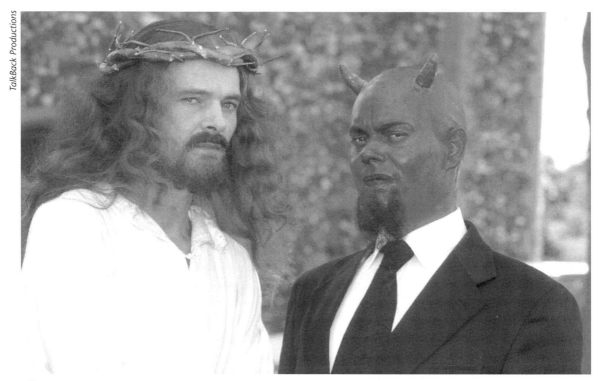

A confrontation between Jesus (Kevin Eldon) and the Devil (Mark Heap) in Mathews and Linehan's 'Big Train'.

great.' What Frank Kelly humorously interpreted as 'fighting' is just part of an adrenalin-charged creative process. 'I just try to make things as pleasant as possible for Arthur,' says Linehan fondly. 'We're not aggressive people. If we were, we'd fight.

'All the ideas we have just make us laugh, and once you have an idea you write it down very quickly. If Arthur had an idea and started writing it down and I said something that was wrong, Arthur would immediately be able to say "This isn't that kind of joke", or whatever, and that makes things very easy to write, because there are rules that you have to stick to.'

We're chatting over drinks in a pub in London's Camden Town; Mathews and (especially) Linehan have been busy in the post-production stages of one of their TV series – Linehan often likes to take the director's reins. They look over at a bunch of nondescript men standing at the bar. 'There's nothing funny you could say about that group of disparate people over there,' says Linehan. 'But if they were all dressed as policemen, there would definitely be something there. If this was near a police station, and they all came in here in their uniforms for a drink, there would be a funny sketch in there somewhere.'

Mathews: 'Uniforms are funny. Don't know why.'

What else is funny?

Mathews: 'Monks. Clergy are funny. I just watched *Rattle and Hum* again and then a video of the documentary about [the late Dublin archbishop] John Charles McQuaid. It was a perfect Saturday evening's viewing. I remember a thing on TV about the annual blessing of the jets at Dublin Airport in about 1963, and there were these massive jets and priests blessed them, and that was followed by the annual blessing of the scooters.'

Linehan: 'People think we'd make something like that up. I wonder what it was like flying in the first plane that wasn't blessed. They used to bless planes . . . er, religiously, and I wonder if they told people when they stopped blessing them.'

The multi-award-winning *Father Ted* may be their best-known creation, but their script-writing CV includes work for some of the sparkiest comedies of the last few years: *The Fast Show* (they created the characters of Ralph, the lovelorn aristo, and Ted, the embarrassed gardener who is the object of his affections), *Harry Enfield and Chums*, *Coogan's Run*, *Brass Eye*, *Never Mind the Horrocks*, *The Day Today*, *The All New Alexei Sayle Show* and *Friday Night Armistice*. In late 1998 their sketch show series, *Big Train*, went out on BBC2 and a second series is planned for 2000.

'I grew up in Meath, the comedy capital of Ireland,' says Mathews. 'Not Navan, but near enough to it. Castletown. I was born there and then we moved to Rush for a year and then we moved to Termonfeckin when I was eight, nine.'

Linehan: 'I very much like the way that Elvis was from Tupelo, Mississippi. I find all this very much like that.'

Mathews: 'I'm from Castletown, Co. Meath, and my Memphis is Termonfeckin.'

Linehan is a Dubliner. 'Castleknock. A bit of the southside that's been planted on the northside. Like the island in *The Prisoner*.'

In the mid-1980s Mathews joined *Hot Press* as art director. But his visual skills were not the most potent reason he was hired. Writer Declan Lynch apparently said: 'There's this guy, Arthur Mathews, and I don't care if he can write or design or do anything, but you must give him a job, because you've just got to have him around the office, he's so funny.'

The late rock journalist Bill Graham was indirectly responsible for Linehan also working for the magazine. 'I got into *Hot Press* through Bill Graham, who wrote a big piece on *NME*, which was my music paper of choice. I was sick one day and my parents, by mistake, bought me a copy of *Hot Press*, which I hated, but I read this brilliant piece and I wrote a letter about it and they printed it as Letter of the Week. So I went to Damian Corless, who was teaching at my communications college at Coolock, and he suggested I bring in a few pieces to *Hot Press*.'

Mathews: 'A few guns?'

Linehan: 'Yeah, a .45, a luger and a . . . and I told them I had all these things

written and I hadn't, so I went home and wrote them. So I lied and it worked.'

Before long Linehan was the magazine's film critic and was earning a reputation as one of the funniest journalists in town. He and Mathews made each other laugh from their first meeting. 'The reason you [Arthur] used to be so funny when you and Paul were laying out the pages was the sheer fucking tedium of the job, because it was before the days of computers. That kind of tedium. So what Arthur's done is he's kept all the nonsense and thrown away the tedium. I just had the nonsense. I used to like coming in because of the laughs.'

Mathews: 'Production weekends were great. We used to have great fun thinking up headlines for the various articles. I remember this photographer used to come in named Declan Kelly and he always wanted to be credited for his photographs. And occasionally we would use a photograph from space of, like, the Earth, and put underneath "Pic: Declan Kelly". And the famous scene of John Lennon and Yoko Ono making love naked – "Pic: Declan Kelly". They were very funny people. George Byrne once said: "This pencil would be great for a detective." "Why's that?" "Because it contains three leads." ' He cackles at the childishness.

The humour spilled out of the office and into the pubs and clubs with the Joshua Trio, and the added attraction of Mathews's monologue as Fr Ted Crilly, one of the characters he had created in the office to amuse his colleagues.

The key to the success of Mathews and Linehan is almost absurdly simple and obvious, and is something each has said many times: 'We have the same sense of humour.' From the *Hot Press* and Joshua Trio days, they knew they could work together, and they even attended script-writing conferences for an RTÉ sketch show that never happened. Comedy involving RTÉ did not look like a viable prospect, and Linehan moved to London in 1990 to write for *Select* magazine. He persuaded Mathews, who had been drawing a strip cartoon for *NME* and writing for *Viz* comic when he wasn't working for *Hot Press*, to follow in 1991, and they submitted ideas to TV shows. Their first broadcast sketch was for *Alas Smith and Jones* – about a serious, pitch-perfect opera singer who ended every phrase with the word 'wank'. They wrote for other comedy shows, forming a strong bond with surreal TV anarchist Chris Morris. The first show they wrote on their own was Channel 4's *Paris*, a sitcom starring Alexei Sayle, but it was a discouraging flop in the ratings. Yet the comparative failure of *Paris* was soon to be eclipsed by the brilliance of a show that turned conventional TV sitcom on its head. Its creators made no great claims for it other than hoping that it was funny and very silly. It didn't set out to say anything important, but some viewers detected a deeper significance. 'I thought *Father Ted* was great,' Dave Allen told us. 'I loved it. To me, it could be Ireland in its way; it could represent what Ireland is. You've got this one sane man surrounded by all these strange rules and attitudes. I think it is a very profound show.'

Mrs Doyle *(while Ted is trying to eat a sausage)*:
Oh, it's a filthy, dirty business, sex. Can you imagine, Father? Your husband, standing over you with his *lad* in his *hand*, wanting you to *degrade* yourself. I want you to get a good clear picture.

The original idea was for a one-off joke documentary, with Mathews's old Fr Ted Crilly character travelling around Ireland meeting various demented priests he had studied with at the seminary, but producer Geoffrey Perkins suggested turning it into a series instead. And so, in 1994, began the saga of the three priests and their housekeeper on Craggy Island. Although it contained elements of the violence and inconsequential silliness of Vic Reeves and Bob Mortimer, and the physical impossibilities of the old Warner Brothers cartoons, there had never been anything quite like it on TV before and viewers fell upon the series with gratitude. By the third series it was just behind *Brookside* as Channel 4's most-watched programme.

Linehan: 'We drew on the priests we knew, but not in a negative way. The priests who taught us were fine, very pleasant. The reason we used priests is because of the mysterious thing religion is: you can make things up and spoof people. We have no idea about the technical things about being a priest, but we know Dougal could never have really been one.'

Mathews wonders at how priests are 'the messengers of the most extraordinary, supernatural phenomenon' but often prefer to talk about 'horse racing, TV and cups of tea . . . priests are very practical, generally speaking'.

Linehan: '*Father Ted* is very much an Irish sitcom, but when we started writing it, we didn't write "an Irish priest walks into a room and there are three Irish nuns in it". As far as we are concerned, they are just characters. But they had to be Irish because they speak the kind of language that we understand. Our aim, though, was just to write something that was funny and surreal. Both Arthur and I have this feeling that small countries tend to get nervous when they're made fun of. Bigger countries don't care. If you slag off English people they don't care, but if you slag off Irish people they get scared. We're very delicate and self-conscious. And we thought that one thing that would slightly beat this feeling was to do something where everyone in it is Irish, and you don't give a fuck about what people think. That was important to us – to do a show that pretended that we were like any other country in the world. When *Ted* first came out in Ireland, there was this great worry: will people think we are stupid? And the thing is, here are these Irish comedians and these Irish writers and an Irish director [Declan Lowney] and we thought people should be proud of it.'

Big Train, made by TalkBack Productions for BBC2 in 1998, was their first shot at a sketch show, and had the novel idea of treating comedy rather like documentary, or fly-on-the-wall material. There were no jokes as such; just silly ideas with a small team of actors extemporising around the basic notion.

Paul Wonderful spoke to us about the way Arthur Mathews can pluck seemingly unconnected comic ideas out of thin air, and much of *Big Train* seemed to be like that. A herd of horseless jockeys is being stalked by the Artist Formerly Known As Prince. 'After feasting greedily on the carcass,' intones the narrator (Chris Morris), 'the Artist will sleep . . . it will be two days before he hunts again.' In another sketch the Devil and Jesus work together in the same office and, naturally enough, don't get on. An evil science fiction despot, costumed like Ming the Merciless in the old *Flash Gordon* serials, is seen watching TV and vacuuming his flat after a hard day ordering people to be flung into bottomless pits etc. The Bee Gees get into a violent, spaghetti-Western-style gunfight with Chaka Khan. The staff in a small office are outraged when the manager bans wanking at work. A group of show-jumpers is allowed by real firemen to 'have a go' at putting out a fire.

Linehan: 'We did think we had something to offer in terms of the sketch show, because *The Day Today* and *Brass Eye* were using naturalism to parody the news or programmes like *Panorama*, but we thought we could use naturalism in sketches. Nothing to do with parodying the news or whatever – just silly ideas that are presented in a realistic way. We used a lot of the techniques of *The Day Today* and shot it in a loose, hand-held style, so we probably have added something new to the comedy genre, but only because of people who passed through the area before.'

Mathews: 'The pioneers, we call them.'

Linehan: 'Yes, we're the sidekicks. When the wagons thunder through, we're the guys behind on the donkey, rattling all over the place.'

Mathews: 'And when everyone else is killed, we're the only ones left alive.'

They did the sketch show as a buffer between *Father Ted* and their next project, *Hippies* – a sitcom about hippies working on a 1960s magazine, for BBC broadcast in autumn 1999 – because they felt unfair comparisons would otherwise be drawn. Mathews describes it as about a group of people working for *Mouth* magazine who 'get involved in rock musicals and sex and the occasional drug-induced deaths'. And while the setting is a million miles from Craggy Island, he reckons that stylistically, and in terms of its pace and surreal quality, it is 'quite *Ted*-like'.

What else do they think the future holds for them? 'Oh, I dunno. I want enough money to live OK and fuck the people who fucked me over and get back at all the bastards who fucked me over and all the cunts who didn't believe in me,' says Linehan mischievously. 'What about you, Arthur? As far as I'm concerned, having written *Ted* and another couple of things is really good because we have already proved ourselves to some extent, and now we can just work.'

Mathews: 'If I ever said something like that, you would say "Oh no, we have to do better and better things".'

Linehan: 'I certainly believed that, with *Ted*, you always had to do a better series, but that was the only way of ensuring that you had a series that was as good as the previous one, or better. But if you have a story that you are interested in, and you tell it as best you can, then it will be good. And if you stick to your principles about that particular story, it will be good naturally, and you don't really have to knock yourself out trying to be original or interesting because you will be, almost by mistake, if you follow the plot.'

Mathews: 'But everything that's happened to me seems to be completely accidental.'

Linehan: 'The same with me. I had no idea that I'd end up writing sitcoms.'

Mathews: 'Especially about priests.'

Linehan: 'Whenever there was any mention of a priest in *Hot Press*, I'd say "Everything is about priests. We're Irish, so we have to talk about priests." And we've written 25 episodes about priests!'

Mathews: 'Because we hate things about priests.'

It seems unlikely that someone as ambitious as Graham Linehan will 'end up' writing sitcoms. They both created the new hippies series, with Mathews writing and Linehan as script editor, and they will write the next *Big Train* together. But in the meantime separate projects figure: Linehan is writing *Black Books* with Dylan Moran; he has experience as a director, a good knowledge of film language and latterly has been working on some film projects. Mathews is writing a novel, 'which, I hasten to add, is a very unserious, stupid one'. It is, he says solemnly, about the life of an Irish civil servant in the twentieth century, who is 'very Catholic and republican' and who has spent his life working for the Censorship Board.

Mathews, the gentle magician who can pluck ideas out of the air, sometimes seems most content back in Dublin with his old *Hot Press* mates, maybe watching a football match. He doesn't think in terms of a structured career or even a structured life. Through his remarkable eyes, just about everything is funny. In conversation Linehan often defers to Mathews, while Mathews gently teases Linehan, and we suspect that although he has the greatest affection and respect for his writing partner, as far as Arthur Mathews is concerned, everything, everyone, even Graham Linehan, is part of some secret Big Joke. A last word on that working relationship, lads?

Linehan: 'Fraught.'

Mathews: 'Frightening. Anything beginning with "fr". Fraudulent.'

Linehan: 'No, actually it's . . . frocious.'

It's a priest thing . . .

'What I think we've managed to do is get something that's really mad and give it a strong logical base'

Father Ted has gone to sitcom heaven, where it shares the very best cloud with a select few other immortals – *Fawlty Towers*, *Dad's Army*, *Cheers*. Its earthly tenure was but a few short years – 1995 to 1998 – but it changed the lives and careers of those associated with it irrevocably, and meant that for the first time the three words 'Irish', 'TV' and 'comedy' did not in themselves constitute a joke when used in relation to each other.

It is set on the otherworldly Craggy Island, somewhere off the west coast of Ireland. Handy as a comic creation, that: to have an island with its own logic and rules, and to locate there four odd people, assorted bizarre locals and a huge number of visiting priests. The titular character is Fr Ted Crilly, who practises as a priest but seems to have no actual interest in religion. He has been banished to Craggy Island for a misdemeanour involving church funds for a Lourdes trip that were found 'resting in his account'. While rational compared to his colleagues, and in some respects a straight man for them, he is prone to unpriestly daydreams about showbusiness and being surrounded by glamorous women.

His curate is Fr Dougal Maguire. 'Got that, Dougal?' 'I have, Ted – the lights are on, but nobody's home.' A young, gormless, innocent, guileless eejit, it is unclear how Fr Dougal became a priest, or why he is allowed to remain one. He doesn't really understand the concept of religion and never seems quite sure what a priest is meant to do. All the same, whatever it is, it's fine with him – 'it's great being a priest, Ted'. He has a tenuous grasp of reality and is easily led. He likes to wear a dated red sleeveless jumper over priestly black, and in bed a football shirt and

Ted:	Dougal, you can't sit around here watching TV all day – chewing gum for the eyes.
Dougal:	Ah no thanks, Ted, I've got these crisps here.

54

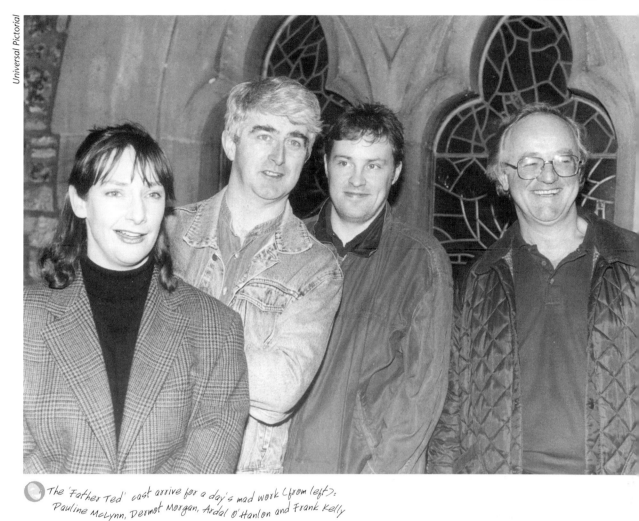

The 'Father Ted' cast arrive for a day's mad work (from left):
Pauline McLynn, Dermot Morgan, Ardal O'Hanlon and Frank Kelly

pyjama bottoms. Dougal seems to have been sent to Craggy Island because of some stupidity which led to a mysterious incident that put the lives of hundreds of nuns in danger.

Fr Jack Hackett is described by Ted and Dougal, in alternate sentences, thus: 'Mid-50s to mid-80s. Tremendous smell of vegetables off him for some reason. Angry man, very angry. Hates children. Likes a drink.' The last comment is a wild understatement – Fr Jack roars constantly for drink and if denied alcohol will swig down Toilet Duck, Harpic, floor polish or brake fluid. He enjoys throwing whiskey bottles at the TV screen and was the first priest to denounce The Beatles. You can make candles from his earwax and he has half a million pounds stashed away in a bank account, saved through his incredible meanness. He once ran off with Sister Imelda, 'the Blue Nun'. He becomes violent if provoked, punching people in the face, but most of the time dozes in his armchair, dreaming of drink and schoolgirls.

The quartet is completed by Mrs Doyle, the housekeeper, who is subservient and tea-obsessed, with a mania for making vast mounds of triangular sandwiches. She will not take no for an answer – spawning the catchphrase 'Ah go on, go on, go on, go on' – and is probably the most put-upon domestic servant in the world: Ted comes down one night and finds her in the dark, teapot at the ready, in case anybody wakes up. As well as looking after the trio's domestic arrangements, she mends the roof and digs silage pits. Sometimes she gets confused: 'Won't you have some cake, Father? It's got cocaine in it! Oh no, hang on, it's not cocaine, is it? What

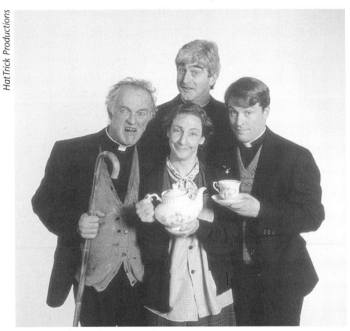

From left: Frank Kelly as Jack, Dermot Morgan as Ted, Ardal O'Hanlon as Dougal. Front: Pauline McLynn as Mrs Doyle

do I mean, now? The little things . . . *raisins!*' Although she is usually obsessively prudish, she did form an unlikely liaison with Pat Mustard, the lustful milkman.

A brilliant cast was assembled by Hat Trick Productions for the Channel 4 show. Dermot Morgan was the obvious choice for the wily and harassed Ted, though his acting experience was limited. Comic actor Frank Kelly, whose unrestrained style had been familiar to RTÉ viewers for 20 years, was fondly remembered from various shows by the writers and contracted to play the monstrous Fr Jack. Mathews and Linehan had seen Ardal O'Hanlon performing stand-up and suggested that he audition for Dougal. Pauline McLynn, an experienced stage and TV actor, was chosen to play the housekeeper and tea fetishist. The interiors were recorded in London and the exteriors mostly around Ennistymon, Co. Clare.

There were numerous bizarre subsidiary characters, such as the demented Fr Noel Furlong (Graham Norton) and his cowed St Luke's Youth Group; the deeply unpleasant Fr Fintan Stack (Brendan Grace), who plays jungle music and drills holes in the walls of the house in the middle of the night – 'he's worse than Hitler or one of those lads,' says Dougal; the terminally boring Fr Stone (Michael Redmond); Tom, the island psychopath (Pat Shortt); and Fr Larry Duff (Tony Guilfoyle), who in many episodes perishes (and, like a cartoon character, returns the next week) while trying to answer his mobile phone – he variously drives off a cliff, is injured in a knife-throwing act, is savaged by Rottweilers, trampled by donkeys and buried in an avalanche.

Dougal: What's going on?
Priest: I think Ted has a plan.
Dougal: No. I mean in general.

Mathews and Linehan say that the main characters being three priests and their housekeeper is in some ways irrelevant – just the classic comic structure of a set of characters interacting in an unusual framework. This is perhaps somewhat disingenuous. The trio are ridiculous, offensive, idiotic and couldn't be priests in the real world. Thus, there is a heightened reality where in some ways the presentation of the three priests could be seen as a surreal lampooning (as opposed to satirical critique) of the priesthood in an era of unprecedented revelations about the real horrors perpetrated by princes of the church. What stronger way to criticise or dismiss than simply not to take any of the nonsense remotely seriously?

To add to the essential nature of priesthood – celibate males without usual family relationships, living alone or with a couple of others, performing weird rituals in funny costumes and often offending with their uncomprehending attitudes to normal life – add a dash of exaggeration and nuttiness and what do you get? You could argue that there really is no greater insult than to treat priests as barely human cartoon characters. (Mind you, everyone else in *Father Ted* is pretty cartoony too.) But despite the fact that priests (and hundreds of them must have appeared in or have been referred to in the series) are portrayed as pompous, greedy, deluded to the point of insanity, self-regarding, sexist, hypocritical, when they're *all* doing it you can't take it seriously, and it just becomes surreal.

Frank Kelly contends that *Father Ted* 'is not a lampoon of the church at all. It's a dysfunctional little family, and it's a very convenient umbrella to bring these people together under. Ted is a guy who is really trying to do it properly. He's very flawed, because he's greedy and has a background of some embezzlement; he's weak. Ardal is a dum-dum, which you will get in any job. I mean, they're extreme because they're caricatures – it's very much *Beano* comic land. The bomb almost has "bomb" written on it in *Father Ted*. But my character is an exaggeration of a problem that exists within the church: superannuated, alcoholic, ancient clerics who have to be looked after by younger men.'

A couple of episodes in the first series of six were so sublime they sailed TV humour into hitherto uncharted waters. It was a success, critically and in the ratings; the seeds were sown and a second series, of 10, was commissioned. Then there was a Christmas special, and a third eight-part series. Somewhere along the

line an odd thing happened: Ted heads or Tedites – serious fans in the anorak category – started emerging, complete with encyclopaedic knowledge of the series, the plotlines, the characters. Internet sites were set up – from the thrown-together nut-vehicles to the unofficial *Craggy Island Examiner* site, endorsed by the writers. Blackmarket t-shirts appeared, and then licensed merchandising. Who could ever have predicted that teenagers would be wandering around with huge pictures of Frank Kelly on their chests? Children's playgrounds, campuses and pubs – in Britain and Ireland – rang to cries of 'Feck! Arse! Drink! Girls!' and 'Go on, go on, go on, go on, go on!' Some of the audience arrived at the London studios for the recording of the interior scenes dressed as priests and nuns. Mathews and Linehan gave a masterclass in sitcom writing during the Galway Film Fleadh in 1996.

And *Ted* fever spread. It was probably too off-the-wall to take off in a big way in America, but the series has been sold to TV stations in at least 36 countries. RTÉ bought the programme after some initial reluctance in 1996 (it was never offered the script), but it had already been widely seen in multi-channel Ireland. In Britain, audiences regularly topped four million – significant in the context of Channel 4, where the viewership is smaller than that of BBC or ITV channels.

| Jack | (asked to guess what the next panel on the Advent calendar is): A PAIR OF FECKIN' WOMEN'S KNICKERS! |
| Dougal | (opening the panel): Aah! Brilliant. A load of people in a stable! It's the one thing I didn't expect. |

The revered fathers of modern comedy scriptwriting, Ray Galton and Alan Simpson – they defined Tony Hancock's radio and TV personality in the 1950s and went on to write *Steptoe and Son* – were asked in 1996 to list the top current comedies. 'Father Ted,' they chorused. '*Father Ted, Father Ted, Father Ted* and *Father Ted*.' An article on *Father Ted* in the *Washington Post* reported that 'they're crazy for it in Britain, Ireland, France, New Zealand and Scandinavia', and went on to warn that American viewers might not fancy the show, 'if you are offended by bad language or full posterior nudity, or by lighthearted treatment of feminism, alcoholism, cigarette addiction, paedophilia, old people, dumb people, Catholic people, the Irish, the Pope and God'. Quite.

And then there were the awards: a British Academy of Film and TV Award for best TV comedy in 1996, many British Comedy Awards (best new TV comedy, best

The demented Fr Noel Furlong (Graham Norton) shares a caravan with Ted and Dougal

TV comedy actor and actress for Dermot Morgan and Pauline McLynn, top TV newcomer for Ardal O'Hanlon, best Channel 4 sitcom), a Screenwriters' Guild honour, an Emmy nomination in the Popular Arts category, a Palme d'Or at Montreux, a second BAFTA for the third series in 1999.

Father Ted was not everybody's cup of tea, of course, and the show had to take a certain amount of flak and begrudgery. Media priest Fr Brian D'Arcy criticised the show for stereotyping alcoholic old priests and naïve young ones (with wonderful irony, D'Arcy had years before probably partially inspired Dermot Morgan's Fr Trendy character). 'We were trying to create characters that are funny, not because they are Irish but because of some quirk they have in their personality; the fact that they're Irish is just incidental,' Linehan told us soon after the second series had gone out. Mathews: 'No way would we have written it any other way if by any millionth of a chance RTÉ produced it. We try and go out of our way to make it as unethnic as possible; we'd hate to be that kind of ethnic programme, so we worked to make it as un-Irish as possible. And yet everybody tells us we haven't succeeded! It's set in Ireland, but the sound of the uilleann pipes, say, on any programme – well, I hate all that stuff.'

The more perceptive commentators realised what Mathews and Linehan were on about. In *Uncut* magazine (April 1998, shortly before the third series went out) Stephen Dalton – perhaps slightly over-the-top – wrote: 'This cult comedy remains one of the best adverts for Irish culture ever made. Not the sentimental Irishness of shamrock-scented beer adverts, but the culturally rich fantasy island where Beckett's apocalyptic absurdism meets Flann O'Brien's rural whimsy, all wrapped up in the lilting postmodern show tunes of the Divine Comedy. *Father Ted* is a product of a sophisticated, Euro-centric Ireland, as much a child of *The Young Ones* or *The Simpsons* as any homegrown ancestors.' In the same article Mathews and Linehan defended their stance. Linehan: 'I do honestly think that, in general, it's a sympathetic portrayal of priests. It just shows them to be human. The thing about Ted as a character is that he doesn't have any interest in religion – and most priests *do* have an interest in religion. And the fact that Dougal is too stupid to even do a Mass – all this is patently stuff that couldn't happen.'

Mathews (left) and Linehan outside the house in Co. Clare where 'Father Ted' was filmed

They always said they would go out with a bang. Even when they were making the second series, Mathews and Linehan reckoned they would do a third and possibly call it a day. As they were filming the location scenes for the second series on Co. Clare, Linehan said: 'I want to do one more series of *Ted*. It's very easy to write – it's got a life of its own. If we could do one more series, we could really crack it, and have something to be proud of for the rest of our lives. Comedy goes out of fashion. It could easily happen to us, but if we have something like *Ted* under our belts, we could be very happy.'

However, before the third series was broadcast, Mathews and Linehan denied they would definitely be pulling the plug afterwards, and clarified earlier comments that they wanted to quit while they were ahead. 'Nothing has been decided. There is every possibility we will write a fourth series.' But they maintained that 'we're at a stage when all we can do with *Ted* is keep our head above water. If there's a

chance of it getting worse, then we're not interested. What we've always said, despite reports, is that we might not do another series. I just don't want people to go "I forgot to tape *Father Ted* . . . ah fuck it".'

Of course, though no one could have known it at the time of filming, that third series was in fact going to be the last of *Father Ted*, whether anyone liked it or not. On the morning of Sunday, 1 March 1998, as all the Irish Sunday newspapers published big features about the new series of *Father Ted*, due to start the following Friday, radio delivered the shocking news of Dermot Morgan's death. After consultation with the family, the series was postponed for a week as a mark of respect. It is a tribute to all concerned, especially Morgan, that the third series transcended the death of its star and was consistently funny. Just before the final episode was broadcast, Graham Linehan told us: 'We were going to make the decision whether or not to do another series . . . To be honest, I would have been prouder of ourselves deciding not to do it if Dermot hadn't died. It's just very pure. Some of my favourite bands broke up before they made arses of themselves. They chose not to go on and on and on. In one way I feel sad because it was so important to our lives for so long. And obviously when Dermot died it was such a huge shock. But also the characters – we feel strongly about the characters; they're like friends, almost. It's a strange thing that it's coming to an end and we won't be able to occasionally drop in on them.'

But of course we can. Linehan was talking of possibly being unable to do anything further with the characters he and Mathews had created. But an archive of hilarity – 25 episodes – remains. To quote the last-ever line in *Father Ted*, from Dougal after Ted changes his mind about moving to America: 'You'll stay with me and Fr Jack and Mrs Doyle for ever and ever and ever.' And there they remain, locked in time and comedy history, waiting for us to visit them on Craggy Island whenever we want to.

Frank Kelly

'Drink! Arse! Feck! Girls!'

Veteran funnyman Frank Kelly seems to have been around forever – he is certainly the only living link between the era of music hall stars such as Jimmy O'Dea, Jack Cruise and Cecil Sheridan and the 1990s comedy of Ardal O'Hanlon, Tommy Tiernan and *Father Ted*. Fr Jack Hackett was just another job for this busy and talented actor, who, although he has performed stand-up in his solo shows and as a 'feed' for some of the great names of the past, was never tempted into comedy full-time. 'Basically, I'm an actor, not a comedian, and I dislike the profession of comic *per se* because it's a very lonely, isolating one. But I've been doing comedy since I was 19. I've been doing it 38, 39 years. It's always been a good string to my bow. At the moment I think what I do would be considered a bit old hat because it is fairly standard structures of jokes, disguised as my own. All comics do that. I don't think it's true that there's only so many jokes in the world because then there could only be so many ironies. And I think ironies are almost infinite. BBC Radio 4 did a very interesting thing on the history of the joke and they went back to things like scenes on Roman or Minoan pottery, and it was very funny to a Roman soldier if his friend was cut in half in battle. He wouldn't weep about it, he'd stand around and laugh, because the irony was that this towering, fit, physically strong, all-powerful person was sliced in half, and that is what the joke is about.'

Frank Kelly's roles in Irish life have varied over the years. He studied law at University College Dublin, where he spent much of his time with the Drama Society. As a young, out-of-work actor in the early 1960s he was offered some casual journalism work in the *Irish Press* and later the *Irish Independent* and a staff job on the *RTÉ Guide*. He

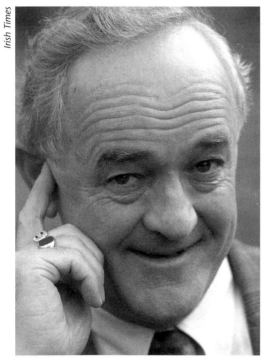

Listen... Frank Kelly

We have had glimpses of earlier incarnations of Fr Jack – for example, when he was teaching. Ted says 'He's given so much of his life to the church and he was such a wonderful teacher', and there's a flashback of him kicking this child to death on the floor. And we also see him taking a gym class: the Reverend Mother tells all the schoolgirls that Fr Hackett has said that, as a special treat, because the day is so warm, they may take their gym tops off. Fr Jack Hackett is not a man I would leave in charge of my children! Nobody knows the physiology of Fr Jack. I don't think he has the same DNA as us. I think he's probably an extra-terrestrial.

Frank Kelly on Fr Jack Hackett

enjoyed the work but realised: 'I'm permanent and pensionable and I've got a wife and kids and I'll never get out if I don't resign, because I want to be an actor.'

Because of his flair for comedy, he gravitated towards the popular stage rather than the classics. There was work in Old Time Music Hall at Dublin's Eblana Theatre with Cecil Sheridan, four years as Jack Cruise's 'feed', stints with Jimmy O'Dea, panto, summer revues, tours, straight acting in between. Gradually, TV – a medium he loves – played a greater part in his career, first with *Newsbeat*, a news/satirical magazine programme, then *Hall's Pictorial Weekly*, which ran for 12 years from 1970. It is from this period, and the *Glen Abbey Radio Show*, that many of Kelly's early creations emerged: his Jack Lynch, Gobnait O'Lunacy (who later released the 'Comedy Countdown' single, which made it to *Top of the Pops* and still gets an airing in Ireland every Christmas) and the one-sided telephone conversations: 'Lissen . . . guess who?' They were more innocent days.

As with most jobbing actors, he has had lean periods in his career, but he is resourceful and adaptable – in 1999, for example, he made his début as stage director and starred in the RTÉ agri-soap *Glenroe*. He has performed consistently on stage (from *Educating Rita* to *Da*), radio (*Only Slaggin'* plus numerous dramas, ads and voiceovers) and has even written a comic novel, *The Annals of Ballykilferret*.

Urbane, articulate, thoughtful, fit, he is charming company, full of stories that are punctuated by bursts of laughter. But it would be a mistake to dismiss him as a genial showbiz 'luvvie'; he is also serious, passionate and analytical. He realised when he saw the first *Father Ted* script that Fr Jack's alcoholism would draw critics. 'I know, we know, the writers knew, there's nothing funny about alcoholism – there's nothing funny about anything that's one-dimensional. It is the context in which you put things that creates the ironies or the possibility of embarrassment or farce. And for anyone to single out one aspect of something like that and say there's nothing funny about alcoholism, well, I couldn't agree more, but you couldn't write

a comedy series about alcoholism alone. It's the juxtaposition of one thing that's unlikely against another which creates irony, which creates humour.'

The makeup for Fr Jack took two hours to apply. 'They put a special lens in one eye, and it was a very discommoding kind of thing. They used oatmeal and glue and rubber stuff on my face. They used Vaseline and something else to make these awful things for my mouth and my ears and so on. It was quite stressful to wear, because it's an instinctive thing – you don't want something in your mouth. It was a very *itchy* part.'

Pauline McLynn

'Can I interest you in a cup of tea, Father?'

Nobody is too surprised that Pauline McLynn, far from being a crazed and wart-encrusted old troll, is in person an attractive woman still in her mid-30s. But it *is* amazing that after three series as Mrs Doyle, she can still stand the taste of tea. 'I'm almost afraid to order it, really. Never get a catchphrase if you're in a show. That's the only advice I have for anyone,' she says, twinkling. 'If I had a pound for every time I've heard "Ah go on, go on, go on" or "You will, you will, you will", I'd be rich.'

She twinkles a lot. Chatty, warm and occasionally outrageous, she is a versatile actor who plays many serious roles but has a gift for comic ones. The *Father Ted* producers were lucky that McLynn is nearer to 35 than whatever age Mrs Doyle is supposed to be. That in reality she is the antithesis of the priests' housekeeper meant she could cheerfully fall off as many window ledges as Linehan and Mathews decreed.

'I wish *Ted* hadn't ended the way it did,' she says. 'Who would have thought Dermot was going to be so *emphatic* about it? He said "no" and he really meant it! Now it's gone, it has freed me up to all kinds of other work. We don't have massive things to show for *Father Ted*. Our salaries were tiered, depending on how much experience you had or who knew you. So there was Dermot and Frank, and then myself and Ardal. I don't know how much Dermot and Frank were on, and Ardal

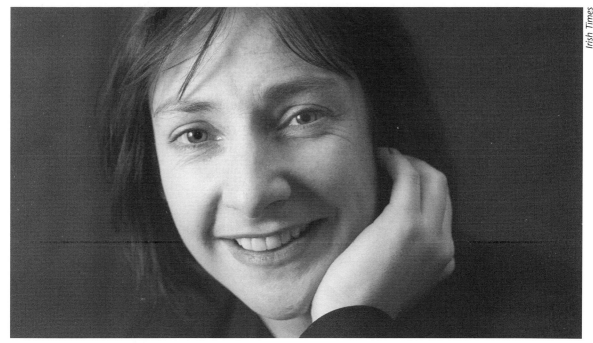

Pauline McLynn: 'never get a catchphrase . . .'

told me he was on the same as me, and then we took a 10 per cent raise for each series. But the company made millions and we don't get anything when it's sold around the world. We do get something from video sales – I think it's about two pence per video!'

Pauline McLynn was born in Sligo but grew up in Renmore, in Galway city, in what she describes as a 'leftie' family. Her father sells motor parts, and although her mother is 'arty', there was no tradition of acting in the family. She stays with a brother when she's working in England (which is frequently – among other things, she hosts a radio show in London) and is 'the mad aunt in the basement' . Home, however, is also in Dublin, where she has a house, and Kilkenny, where her husband Richard Cook – Bickerstaff Theatre Company director and the man behind the Murphy's Cat Laughs Comedy Festival – lives and works.

Her professional association with Dermot Morgan predates *Scrap Saturday* and *Father Ted*; they worked together years before on trade videos – for 'washing powder and ferry companies and that sort of thing. And when *Scrap Saturday* came along, he called me.' She also had strong early connections with *Scrap* co-writer and producer Gerry Stembridge. 'In the beginning it started with Stembridge and the supposed career guidance series, *Nothing To It*.'

The programme, ostensibly outlining the choices available to Irish youngsters, was an anarchic affair that looked as if it had somehow sneaked into the RTÉ TV

schedules. She and Stembridge had been part of an especially productive theatre generation emerging from college in the early 1980s, 'though I didn't go to college at the same time as him – and we went to different colleges as well. So it's a miracle that we got to know each other at all. He was just leaving UCD when I was knocking around Trinity College. He was reviewing for the *Irish Press* at the time and that's how we met. And he's the reason a lot of things happened for me.'

Nothing To It, written and directed by Stembridge, had the trappings of a serious programme and was broadcast at teatime. 'The bit we always hated doing was the few minutes of serious career guidance in each programme, and in the final programme we didn't bother at all, except we advised all the young people to leave the country, which at the time was the best advice we could possibly give. And that's how Dermot discovered Stembridge. He spotted *Nothing To It* and thought "What's going on? Has RTÉ not noticed what's going on there?" So after that he asked Stembridge to start writing things with him and out of that came *Scrap Saturday*. I got a phone call from Dermot about it. They needed to get a woman in and said – let's get Pauline.'

Away from the madness of *Father Ted* and the boldness of *Scrap Saturday*, McLynn has an impressive acting pedigree – theatre roles in plays such as *The School for Scandal, Absurd Person Singular, Antigone, Yerma, The Trojan Women, Our Country's Good* . . . in Gate, Abbey, Rough Magic productions. On film she has acted in *Guiltrip*, and more recently, *Angela's Ashes*.

She enjoys a busy, creative life of much diversity. She is in ITV's *Dark Ages*, the medieval millennial TV comedy with Jason Byrne. And most recently she has been writing – a novel about an Irish detective called Leo Street, and she is committed to a second one. But she will always be remembered as the unhinged old housekeeper who, in an episode in the third series of *Ted*, when the island's amorous milkman wants a place to store some machinery, tells the priest so memorably: 'Pat was just wondering if he could put his massive tool in my box.'

She calls the shots. Mrs Doyle decides whether they get their cups of tea or not. It is fatal to get on her wrong side. She is committed, but she is no pushover! Corporate people often want me to be Mrs Doyle and, happily, I can't because I don't have the copyright on the character, which is great, because I'd never have got away from her otherwise. Not that she isn't a fantastic character, and I have to say that in the third series they just couldn't have gone any further over the top. You know when they say: Less is more? Not on *Father Ted*! But because *Ted* is like a cartoon anyway, you could do all that.

Pauline McLynn on Mrs Doyle

In the Beginning Was the Word

What was then called 'alternative comedy' started to arrive in Ireland in 1979 from America, via London. Peter Rosengard, a former insurance salesman, was on holiday in Los Angeles in 1978 when he saw acts at the city's Comedy Store which dealt with humour that was stylistically as well as geographically half a world away from the antics of Benny Hill and the *Carry On* funsters back home. He

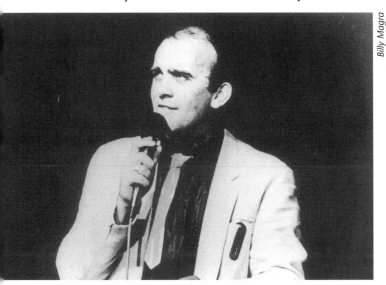

Billy Magra

Promoter Billy Magra was a pretty good stand-up, too

realised that a new generation in Britain would be hungry for the kind of angry, contemptuous, socially aware, non-racist, non-sexist material he had so admired. Next door to a strip club on Soho's Dean Street, Rosengard and his partners launched Britain's first alternative comedy club, also named the Comedy Store, in 1979. Those who were to get their big break there included Rik Mayall, Ade Edmondson, Jo Brand, Jack Dee, Dawn French, Jennifer Saunders, Ben Elton, Nigel Planer, Arnold Brown and Alexei Sayle, the club's first compère.

In the same way that Rosengard went to LA and liked what he saw there, a young Dublin rock promoter, Billy McGrath, also known professionally as Magra, visited the London club in its early months and visualised a brave new world of daring comedy that he could bring to an Ireland still in the shadow of President de Valera and Archbishop McQuaid. Magra knew that the new-style comedy had already tentatively dipped a warm toe into the icy Liffey waters – performance artist Oscar McLelland, a Scot, had done some pioneering work at a short-lived club in Harcourt Street, and Tony Allen, a stalwart of the London Comedy Store, came over to do a few shows – but Magra felt that it needed proper organisation. 'I did not start alternative comedy in Ireland, but I picked up the baton and ran with it.'

Magra played a huge part in making Ireland comedy-conscious, sticking to his convictions and following his instincts. Time eventually proved him right, but it was a long and sometimes dispiriting struggle. He was the first person to bring a sense of order and planning to the scene, skills he learnt managing bands such as the Atrix in the late 1970s, and he approached comedy in much the same way as he dealt with rock. 'I watched the London scene and the early days of Ade Edmondson and Rik Mayall, who were punks working under the name the Dangerous Brothers. But they and Ben Elton and French and Saunders had no connection with the conventional comedy industry – comedy was a kind of afterthought to the punk side of things: if you want to do it, just go out and do it – in punk you don't have to learn your instruments, and so for them they didn't need to know the finer points of comedy technique or anything. Find your own venue, and if you're exciting enough and can offer something, then people will follow, and if you're not exciting enough and you don't deliver and you short-change your audience, and your material is not in tune with that audience, then you will disappear.'

Magra was conscious that Dublin in 1979 hadn't the performers or the audience to sustain weekly comedy in a regular venue, so he tried it out in various places – a show could turn up anywhere it might succeed: four weeks late night at the Project Arts Centre, then the Sportsman's Inn on Dublin's southside, then somewhere else. Sometimes it was called the Comedy Store, sometimes Comical Manoeuvres or Corny Comedy. Around him he gathered a nucleus of talent. Dermot Morgan did gigs for Magra, as did Michael Redmond, Helen Morrissey, Kevin McAleer, Mannix Flynn, Ian MacPherson, actor Owen Roe as 'Ronald Raygun', impressionist Gerry Lavelle and others. Magra, a competent comic himself, was often MC, and had his own solo show, *An Otter You Can't Diffuse*.

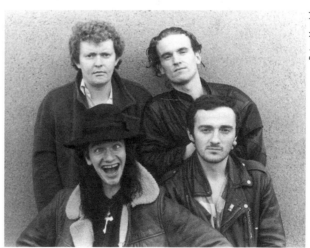

Evening Herald journalist Peter Howick, who in those days had comic aspirations, remembers Magra as an inspirational figure: 'Billy was doing his Comedy Store thing and we'd go up there and there might be only 20 people in the audience and it was very hit and miss, but the sight of people going up on stage and doing things puts the idea in your head – why don't you give it a lash? So some friends and I put together a sketch show called *God Aid*, which ran for a

Peter Howick (top left) tried his hand at comedy with friends (clockwise) Mark Price, Cormac Lucey and Niall MacAnna.

Peter Howick

69

Funny folk wanted – Magra advertised for talent in the early 1980s

couple of nights at the Project and it was packed out. Billy had done shows at the Project where he got people from the audience to go up on stage, and I went and did a Garret FitzGerald impression, and Billy told me it was great and could I come back and do it again. I didn't have any jokes or proper material and it was all a bit of a farce, but I think people were beginning to pick up on the coupling of comedy with rock and roll.'

Although Magra persisted with his comedy ideas, they were not to come to full fruition until later when he opened the Gasworks comedy club in the Waterfront Rock Café, a nightclub on Sir John Rogerson's Quay in Dublin, and also worked in TV. But back in 1983 he lamented to Fintan O'Toole in the *Sunday Tribune*: 'The problem at the moment is that Irish comedy has tended to be at two ends of the scale. It's either Sheridan and Wilde and Joyce or else it's Hal Roach in Jury's Cabaret. There's been very little in between. Everybody talks about the wit and natural humour of the Irish and you

go into pubs and there it is, but it's a different story when they're on their own on stage. It's always been character comedy, with the comedian adopting a role. That's really false . . . And they become stuck in those roles . . . I think there's a far more dangerous element to it. There has to be.'

And there was.

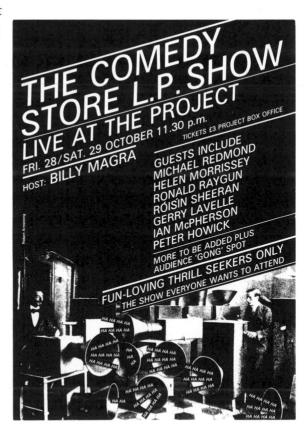

Billy Magra

Well . . . almost everybody wanted to attend – a typical Billy Magra bill

Kevin McAleer

Telling it like it wasn't in the good old days

Aye, well. Yes. That's it. His, what is it now they call it? His name, yes, that's it, his name. His name is Kevin McAleer. And he's from . . . oh yes, he's from there all right. Where is it now? On the tip of my tongue. Omagh. Yes, that's it. Kevin McAleer, that's it, he's from where they call Omagh, in the county – what is it? – the County Tyrone. Aye.

The figure on stage is short and broad, in his early 40s, with a northern accent and a slow, halting delivery. He stands awkwardly, his left arm hooked behind his body, like a strange, grey-haired child. But the character he plays is no child. Sometimes it is a version of himself, telling a version of a life story, but it merges often with his best-known persona, almost an alter ego: a nameless auld fella (although he has an ageless quality). The character is a *seanchaí* of sorts with an askew vision of the world, jumbling together a stream of insane, rambling anecdotes and non-sequiturs in a matter-of-fact monotone. He talks about his family, all 17 of them, sitting around in their ramshackle farmhouse staring at the TV for hours on end, smoking marijuana, until his grandmother suggests turning the set on; about how his grandfather would ask for another slab of Moroccan to be thrown on the fire. According to the material, his entire family appear to spend their lives zooming around the back roads on their Harley Davidsons or wandering about in a stoned haze where everything is slightly off-kilter.

All this is delivered in the same slow, deliberate drone, with frequent pauses and repetition, the mode of an oral historian telling tales of a bygone era. His face hardly moves, and he talks out of the side of his mouth, his tongue occasionally flickering over his lips. The effect is disconcertingly lizard-like, an impression

Authors' collection

71

underlined by his darting, hooded eyes. But this *seanchaí* is telling it like it wasn't, in an alternative existence, a twilight zone, a virtual reality before the term became common currency. So the content deviates from the style, and comedy is created in

Murphy's

the incongruity. The auld lad talks about the neighbours down the road – little Neil Armstrong who went to the moon, and Jimmy Bond with the fountain pen that would turn into a double-barrelled shotgun, and the big, hairy chest on him. He relies on very few one-liners.

Funnily enough, McAleer says he never knew any rural storytellers, and that his material is a mutated version of the way things really happened. 'The thing I do about the TV is half-true because we didn't have TV ourselves until 1970. I used to look at the programmes in the paper, so I'd know what was on, and I could go to school and drop them into the conversation so that I wouldn't look like a fucking bogman, you know?'

The style has resonances for Irish audiences, but is accessible to others, too; oral storytellers are a familiar type. McAleer is swift to deny a specific identification with the ancient tradition: 'I've had no experience of it. It's obviously in the back of my head somewhere but I don't have any experience of that

An impression underlined by his darting, hooded eyes . . .

tradition and I don't have any particular interest in it, either.' There could be another explanation – Flann O'Brien, whose books *The Poor Mouth* and *The Hard Life* exist in a world not dissimilar to McAleer's, also came from Co. Tyrone: 'Well, he was born not that far away from me, so it must be something in the water.'

Kevin McAleer comes from a small dairy farming family five miles outside Omagh, a town now tragically associated with devastation and horror. Far from being one of 17 children, he has, in fact, three sisters. 'I was the natural heir, the only son, so I should have taken over the farm. But you couldn't get me out of the house at all.' He left Omagh at the first opportunity, studied journalism in Dublin, dabbled in it a bit, travelled a lot – the Indian subcontinent, America. It was in 1980 or 1981, after coming back from San Francisco, that he first got up on stage in the

club on Harcourt Street. He had been to comedy clubs in San Francisco but had never got round to trying an open spot. That first night on stage he didn't have any material. 'I just wanted to see what it was like to hold a microphone. I was very pissed, you know; I went about four weeks in a row before I ventured up on stage and I lasted a minute or two before the big gong went off at the side of the stage that meant they'd had enough of you. I lasted long enough to get a taste for it, so I went back the following week with 10 minutes of material. I wasn't particularly bothered about pushing it. I never thought I was going to be a comedian or make my living at it. I just kind of drifted along.'

However, he made a profound impression on Peter Howick, who remembers: 'He wasn't doing the stuff he does now; he was Beckettian in his brilliance. He was so offhand. One night he delivered all his material from a bike, cycling round the stage. Another time he did his act from inside a sleeping bag. So there was this sleeping bag on stage from which you heard this disembodied voice. The guy really stood out, and I think he's one of the formative people in Irish comedy, and I don't think he's credited with that now.'

On the advice of a more experienced friend, who had contacts on the London club circuit, McAleer drifted to England with his wife, built up more material and started to make a little money, but it was all very random: 'I wouldn't really say I was a professional. I was still signing on and doing the odd gig here and there.'

The big breakthrough came with *Nighthawks*, the late night comedy/music/satire show that brought his 'auld fella' character before a wide Irish audience. The seminal late-1980s RTÉ programme was a casual chat-and-music-in-a-bar format, with Shay Healy, former Eurovision songwriter, as host. McAleer landed a regular spot on the show where he would do three to four minutes against a black background, basically telling his strange, otherworldly stories about the stoned old days. It was a format and style that perfectly suited TV, and the exposure grabbed the attention of a wide cross-section of age groups. '*Nighthawks* was a big, huge explosion for me. Suddenly, people wanted to see me live, and I wasn't aware of this for a few months because I was living in London and just flying over for the shows. I came back to do an Arts Festival show in Galway and they told me it had been sold out for four months or something, so I put a tour of Ireland together. I had to sign off, because they might recognise me in the dole office.'

And that bizarre set-up seems to have become the key to his career for several years following – a big name in Ireland, where he could sell out theatres such as the 1,200-seater Olympia in Dublin for a two-and-half-hour show, but living in relative anonymity in London with his wife and three children. He did gig about, doing spots on the London circuit for a while, but he had acquired an understandable taste for big solo shows in Ireland and wasn't interested in club work.

His shows were not solely the skewed *seanchaí* character and his rambling stories; early on he developed his 'slide show', a comic commentary based on various oddball slides which he projected onto a screen behind him. Always fascinated by technology (maybe through TV deprivation as a child), he expanded the slides notion into video, editing old and new material for comedy purposes with his own digital editing system. 'I'm very interested in the visual side of comedy. It's added an extra dimension. Instead of collecting pictures, I started collecting bits of video, re-editing them and showing it as part of my live show.'

The idea was a natural for TV, but *Kevin McAleer's Alternative History of Ireland* was not a great success. Far better was his witty and astute commentary on northern comedy, with John Byrne, on *The Empire Strikes Back*, a TV special, and his video *Turn It On*, a permanent record of the best of the auld fella's ramblings. He has also moved into gallery art, providing the video element in a performance art show at the Belltable Arts Centre, Limerick, in 1998. He turns up from time to time on BBC Northern Ireland programmes, providing more of the auld fella's off-the-wall insights or occasionally doing the links, in his own voice, for comedy shows. He also wrote an animated series for the BBC, and has used his auld fella persona in radio ads.

And that, essentially, is that. In some ways McAleer did not develop his core live act for years, except for his video experimentation; there might be new material – at one point he became fairly political – but he stuck with the goose that laid the golden egg. As far back as December 1993, he acknowledged in interviews that he needed a new basic format, but in late October 1998 he was still relying on material from the early 1990s. The 'auld fella' is still popular, but McAleer has said he thinks he should vanish back into the Celtic mists. 'He's probably about to gasp his last breath,' he told the authors back in 1993. 'I think this is his farewell tour.' And the same year he declared: 'I definitely feel I have taken this character about as far as he can go. I can feel it already that there's a cul-de-sac ahead when it comes to new material for him. And I'd kinda like to have him depart from this world with even just a smidgin of credibility and respect left.'

In some respects the public has trapped him into his 'auld fella' persona: 'Sometimes people shout up the bits that you haven't done, almost as if they were favourite songs. It's a bit confusing if you are trying to do new stuff and they're complaining that you haven't done the old stuff. You know: "Me and my friend drove 40 miles to see you do Kojak, and you didn't do it." The other side of it is that I was doing a show in Sydney and a fella came up to me afterwards and said he'd seen the whole show in Dundalk two years ago. So you get a range of reactions.'

He was back in a regular slot on RTÉ in *Nationwide* for a year (1997–98), rounding up the regional news coverage for mostly comic effect. In late 1997 he moved back to Omagh, 23 years after having left. 'My dad died a few years ago and

the house was just sitting there. We were living in London and it just occurred to us to move back there. It's still run as a farm, but not by me – the land is rented off. It seemed very natural to move to Omagh; the shocking thing about it is that I've just taken back to it like a duck to water. The children have taken to it as well, so we have a great time there . . . apart from the bomb going off. I never thought I'd go back because I hated growing up there. Up until a few years ago it was the last place in the world I thought I'd live. I wouldn't dream of bringing my kids into a violent situation, and sometimes you wonder where your optimism comes from. But I'm still following my nose, you know.'

Michael Redmond

People often say to me . . . 'Hey you – what are you doing in my garden?'

Possessor of comedy's most mournful moustache, just about the last thing sad-eyed, silver-haired Michael Redmond resembles is an accountant. But that's what he once was. 'I did all the standard middle-class things,' says Redmond, who was born in the Dublin suburbs. 'I worked in an insurance office for a while as well. I did that kind of thing for six or seven years and it nearly drove me insane.'

In spite of his lugubrious, deadpan manner, Redmond's stand-up material is surprisingly jaunty: lots of pauses while he gazes wistfully into the middle distance. 'There's one thing I've noticed in life,' he might venture, 'and that's how paranoid a person up a ladder gets if a complete stranger starts climbing up after him.' Or: 'Do you think it's possible to recover your sexual

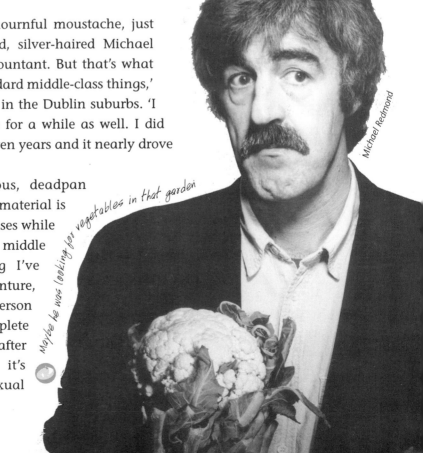

Michael Redmond

Maybe he was looking for vegetables in that garden

dignity if you are just about to get into bed with your lover and she notices a piece of wayward toilet paper sticking out of your bottom?'

In his late 40s, he is older than most of the comics he shares bills with because he was a late starter, and did not get up on any stage until he was 30. 'Billy Magra opened a comedy club at the Sportsman's Inn at Mount Merrion in 1982, and I decided to give it a go because I'd been on the dole and I was writing a couple of scripts for RTÉ, radio things. I was getting around £15 for scripts, and I knew I'd never be able to make a living as a comedy scriptwriter, not in Ireland, anyway. But I never had any great yearning to be a stand-up comedian. I just did it out of desperation more than anything else. I'm not an extrovert. Even now, if I was offered a big fat writing contract, it wouldn't bother me if I never performed again.'

After his first timid sortie into performance comedy, Redmond did a few nights with Kevin McAleer at Dublin's Project Arts Centre and then went back to writing as part of the team working on Dermot Morgan's ill-fated sketch show for RTÉ. After that debacle he headed for London. Success on the comedy circuit followed – 'I think that because of my age people thought I had been doing comedy for a long time, but basically I just had this 20 minutes' – and he started to make TV appearances.

In London then, says Ian O'Doherty, 'the English comedians were a product of the time and a lot of the comedy was reacting against the environment, whereas

I'm not worried about going grey, but I wouldn't like to go bald. But even if I did go bald, I wouldn't wear a toupee. Because I think one of the saddest sights in the world is someone wearing a toupee, particularly one of those cheap ones that are two different colours, and it's really obvious. I actually got into a fight about toupees recently. I was in this pub and I was a bit pissed and this bloke came in. It was pretty obvious he was wearing a toupee. I didn't really mean any harm. I merely suggested that he take it off while he was indoors, otherwise he wouldn't feel the benefit of it when he went out again.

What's the point of wearing toupees when they're so bloody obvious? It's the same as people with artificial legs – they're fooling nobody.

I shouldn't really take the piss out of people with artificial legs, because my grandfather had an artificial leg, but he lived to be a ripe old age – he was 86 when he died. But he shouldn't have been allowed to take part in a bungee jump at that age. All the same, he might have survived the jump if they'd tied the cord around the other ankle. It was a strange sight watching the wooden leg springing back into the air. We have a video of it. We watch it every Christmas . . .

Michael Redmond

the Irish lads were just a product of their own demented imaginations. I suppose it was that, sandwiched between the agit-prop comics who barked at you and were members of militant Labour, and the whole holier-than-thou trend, the idea of a guy like Michael Redmond coming out with utter nonsense – but inspired nonsense – would have been exciting. It's impossible to imagine Redmond going on stage and saying "Margaret Thatcher – what a bitch".'

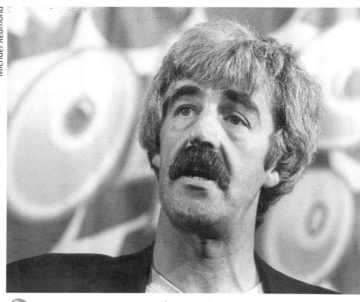

Michael Redmond

Comedy's most mournful moustache

Redmond's stage character in those days wore an old mac, Peter Cook-style, and had a wonderfully funny but meaningless catchphrase: 'People often say to me . . . "Hey you – what are you doing in my garden?" ' He doesn't do it any more. 'I don't wear the mac now, and people look at me strangely when I say it. It didn't go down well in a couple of clubs and I think people thought it was a dirty old man in a garden kind of thing, which it wasn't meant to be at all. You write and invent material all the time, and then some of the older stuff just stops working as your style changes slightly, and you shed it.'

After a few very successful years around the English clubs, when he gained a reputation as a kindly 'older brother' figure who was always happy to give a hand to fledgling Irish comics trying out their wings on the London circuit, he returned to Ireland in 1992, then moved to Glasgow a couple of years later. 'My girlfriend comes from there and we have a couple of kids. I do a few gigs in Glasgow and Edinburgh and I go down to London as well and get over to Ireland as often as I can.'

In 1994 he played the incredibly boring, monosyllabic Fr Stone in an episode of the first series of *Father Ted*, and had a bizarre experience a couple of years later when a commissioned series he wrote for BBC Radio 4, *Eamonn, Brother of Jesus*, was dropped four days before transmission, after it had been flagged in the *Radio Times*. 'It was recorded, and a few weeks before it was due to go out, the original person who had commissioned it retired and they got this new guy in who saw the name of the show in *Radio Times* and shit himself and he pulled it just on the basis of the name. I thought it was hilarious, really,' he says in his soft, sad voice. 'It wasn't in the least outrageous – I'm not the kind of comedian who sets out to shock people. The whole joke was that the Holy Family was Irish, but I didn't realise that even the

> If you are a Catholic, you are led to believe that masturbation is a mortal sin, so if you commit a mortal sin like masturbation and die without receiving confession, you'll go straight to hell and eternal flames. Which is a bit of an incentive to stop wanking, to be honest with you. But usually not enough. But what would happen if you masturbate one night and jump out of bed in a panic and run to confession and are knocked down by a bus on the way and killed and go straight to hell and eternal flames? I used to get round this problem – I masturbated in the confession box.
>
> *Michael Redmond*

title was emotive because it could have implied that the Virgin Mary wasn't a virgin – I hadn't thought of that. So I did it as a stand-up show at Edinburgh instead. But you'd have to be a very strict Catholic to be offended by it.'

He's still doing stand-up, still writing. 'I've got a couple of screenplays done, but so have lots of people. Until something happens with the writing, I'll carry on doing stand-up, but it gets harder over the years and the ideas are slower coming.'

On the subject of slowness, what about those pauses? 'Whenever I've seen myself on TV or video I've always thought to myself: Just get on with it, for fuck's sake.'

Ian MacPherson

'I went from having a low profile to having no profile'

The first wave of British 'alternative' comedians – Rik Mayall, Ben Elton, French and Saunders and others – moved successfully into the world of TV sitcoms and sketch shows years ago. A number of today's top Irish comics are taking the same route. And who can blame them? As in sport and rock, comedy is mostly a young person's game and, also like those occupations, it has had its casualties. You don't hear much these days about Ian MacPherson, for example, except from other Irish comedians, who speak of him with awe, or *Irish Times* writer Brian Boyd, who says: 'I would put him above anybody. Dylan Moran is the only one who can touch him.'

MacPherson is of the Michael Redmond and Kevin McAleer generation, one of the comics who worked with Billy Magra in those lean 1980s before the Comedy Cellar and the Edinburgh triumphs, but while Redmond and McAleer have each retained a profile in the business, MacPherson virtually disappeared over the past few years. Stand-up comedy never rejected MacPherson; he disdainfully turned his back on it, and retreated to write. Today's world of corporate gigs and big money is anathema to the man who went into comedy because he considered it to be a progressive art form. 'I couldn't do stuff like that because of the type of material I did. It would just rub these people up the wrong way, because any time I see money or authority I just say the wrong thing, and that's the nature of what I do. There was one gig I did which convinced me that I had to get out of the stand-up circuit, in which every single person on stage, including the compère, all the other acts and two open spots, made a joke about Linford Christie's penis, and the thing that frightened me about it was that the audience laughed every single time. And I just thought: comedy has gone away so far from what I was about.'

Ian MacPherson

He's the genuine article, but he's awkward and difficult.

Boyd was there that same night at London's Comedy Store in the mid-1990s. 'He was doing gags with a fourth wall, which is a very theatrical sort of gag, and is only for a certain audience. I was sitting beside a table and it was a stag night and the party had a blow-up sheep – a sheep-shagger-type thing – and they were looking at Ian thinking "what's he going on about?" and Ian was talking about Beckett and Heaney. Not that I want to portray him as being a sort of fusty academic – I mean, he *is* a comedian, after all. I thought the stuff he was doing was genius, but the audience didn't take to it – it was very oblique, really. He's the genuine article, but he's awkward and difficult.'

Awkward and difficult, certainly. Another MacPherson story, recounted in William Cook's book *Ha Bloody Ha*, has him going up to David Baddiel of TV's

> People say to me 'Ian, do you remember where you were when Kennedy died?'
> I was only eight at the time, but I do. I was leaning out of the sixth-floor window
> of a hotel in Dallas. With a rifle. Funny how things like that stay with you.

> I had a long-term relationship with a young Muslim girl, and you know, even today I often wonder what she looked like.

Fantasy Football, a comic then famous for his masturbation jokes, in Edinburgh and saying with elaborate sarcasm: 'It's the great David Baddiel! Let me bow to you!' MacPherson hated the coarsening of alternative comedy. 'The audiences started getting bussed in from Essex, which is always a bad sign!'

He's humorous about the changes: 'My audience has gone somewhere else and they haven't told me, so I have to find them again. They disappeared out the back. I realised people who wanted to see stuff like mine were not the sort of people who'd want to sit through the other comedians who were on the bill because it was a different type of comedy. For instance, I never swore on stage. Everybody was saying fuck, fuck, fuck, and it actually got laughs from audiences, and I thought – I'm not going to do it.'

Even in his first days in London in the early 1980s, MacPherson was hardly a comforting or jolly presence on stage. 'I used to get a lot of abuse for being Irish, and it was patronising. It wasn't necessarily people hitting me, but it was people being patronising because they assumed all Irish people were stupid. This would be on the stage as well as in everyday life. I used to sometimes put it to them: I'm actually more intelligent than you are. I was quite open about it because I was doing an act that was intelligent comedy, and English people who were sympathetic to me used to explain it as – well, they can see that your stuff is above their heads, so they're then saying "you're stupid" as a defence mechanism.'

There might be young comedians today, happily coining it on the circuit, who would sneer at such a principled and self-defeating stance – 'Come on, Ian; get real.' Well, you can't get much more real than a council flat in Sheffield, which is where Ian MacPherson was living in early 1999. But he is not a defeated or particularly embittered man. His first book, *Deep Probings: The Autobiography of a Genius*, was published in September 1999. And the way he described it gives a flavour of the man and his work: 'The book is essentially about this character Fiachra MacFiach who destroys the lives of everybody around him in pursuit of a slim volume of three poems he has written. His parents' house burns down, his little brother dies, because in Irish households at the time you were supposed to pass the food on from one to the other. He's got loads of brothers and you throw the food from one person to the next. Only, because he's totally selfish – he's the second youngest – his little brother, he discovers later, has died from malnutrition. It's quite cruel in its own way. He is obsessed with his own genius. A couple of people who have read it say it's not a novel, and I'm quite happy with that. To me, it's more like a Buster Keaton film, where the character wandering through the world doesn't

notice that buildings are falling around his ears because he is just in pursuit of his muse, basically.'

Nor has he entirely abandoned performance comedy. 'I've retired from doing the club circuit because it went into joke competitions about sex and football and it's not my scene any more. I haven't actually retired from performing. I've done readings from the book with bits of comedy among the readings and it's actually been stunningly successful and there are parts that I read where people laugh at nearly every line, because the character's so mad and you immediately know the man is a nut. The response has been extremely positive. Because the guy is such a self-obsessed prat.'

As a planned stage show that ties in with the book, he plots the story – essentially a monologue in diary form – 'about Fiachra MacFiach writing the book which I've actually written'. The character is a recluse in a flat in Sheffield, writing the book, and a parish priest suddenly knocks on the door . . . eventually the whole of Ireland ends up in the flat. 'It's a one-man show, obviously – I'm not going to have the whole population of Ireland on stage, so I'll be doing all the characters. Basically, if you're from Ireland you can never escape it. I'll be performing the piece, but because MacFiach is a recluse I'm actually spreading the word. I'm not taking credit for having written the book – he's written it.'

MacPherson, who was born in Clontarf, Dublin, in 1952, started his working life as a teacher and went into performance comedy through fringe theatre. 'You weren't getting any money for it, so it was a question of standing up on your own.' He did some gigs but 'there was no circuit in Ireland at that time, so I developed my stuff on the London scene, and came back to Dublin to do some gigs. I used to do four characters, and then I realised that they were all facets of my own personality, so I put them all together and from then on what I did in stand-up was essentially a character based on my own failings. What comedians do is they look for the worst aspects of humanity and take the piss out of it. There wasn't anything happening in Ireland and there was a huge movement in London at the time. Basically, it was a revolution in comedy. It was totally different to punk, but it had the same quality about it. My ideal audience would be an intelligent Irish audience and that is why I moved to London, because everyone was over there.' The profile of Irish emigrants had changed from rural to third-level-educated – 'the whole Irish emigrant scene had changed dramatically in one generation. A lot of the people I would play to would be Irish, but actually living in London. I know that Barry Murphy and the other guys started at the International Bar a little while after that, and that has

> So I took my triangle out busking. I tried a five-movement classical piece, but the two-hour pitch was up before it got to my note. I tried switching to jazz, but the triangle is not a jazz instrument. There's nowhere to put the cigarette.

been very positive for Irish comedy because it is something that has been there every week, which is what it needed. But when I started, you either did it in London or you didn't do it – or else you were a cabaret comedian, which I wasn't.'

He made a name for himself on the London circuit and with Edinburgh festival shows, but the 'alternative' scene was changing. 'It did change an awful lot. It has become – the term "mainstream" is probably a bit unfair – but it became pretty much money-oriented. When I started, it was people doing it because that was what they *needed* to do. Then managers came in and the whole situation changed dramatically. And now it's a huge business. Sometimes I feel a bit like the old blues musicians who helped to start something off and then the white boys came and made the money out of it.'

Although in his stand-up he had set pieces, some of it was extemporised or jotted down an hour before the show. In the late 1980s a reviewer called him 'comedy's answer to James Joyce' ('I didn't know James Joyce was a question,' was MacPherson's response). Although his material was surreal, it was delivered more in funny 'bites' – close to conventional gags – than in stream-of-consciousness ramblings. 'When I was on stage doing the stand-up, my stuff was very spare. I worked with Eddie Izzard a lot and I always used to say that I envied him a bit because he used to write a line and it became a novel, and I wrote a novel and boiled it down to a line, and it always seemed pretty unfair.'

MacPherson still regards himself primarily as a comedian, in a rather austerely classical sense of the word, and talks about the differences between himself and his friend Owen O'Neill. 'Owen, to me, is not a comedian. I'm a comedian; he's a storyteller. We used to talk about this and he's quite happy with the situation. I think Owen wants to say something that articulates something about his feelings about the world, and what I want to do is say the *funniest thing possible*, so there is a difference. I'd lie about anything just to get a joke.'

There have been bleak times in his personal life. He moved first to Edinburgh to get his children away from London, and then to Sheffield so he could commute to do gigs. 'Generally speaking, I would advise women – or men in the case of it being the other way round – never to marry an impoverished comedian, because it leads to all sorts of problems. That covers most of my relationships.' Now alone in Sheffield writing – 'the people are very friendly and there are lots of things I like about it, but I don't feel that my soul exists here' – he considers moving back to

Pascal was our French student lodger. He used to follow my mother around the kitchen practising his phrases. 'You are very beautiful woman. I would much like to passionately make love with you.' Pascal was 12. This infuriated my father. 'For God's sake, Pascal. How many times do I have to tell you? Don't. Split. Infinitives.'

London or Dublin: 'The only problem is how I could earn a living there.'

He has enjoyed many triumphs – he wrote a full-length play, *The Man Who Boxed Like John McCormack*, about Jack Doyle, which was performed at the Cork Opera House and the Olympia in Dublin before touring Britain in 1980; he won the first *Time Out* Comedian of the Year award in 1988; his autobiographical radio play, *All You Need Is Frank*, was produced – 'I auditioned to play the part of myself and the producer told me I wasn't right for the part! So they got Barry Lynch to do it'; and he wrote and performed a 10-minute Working Title Productions film – called *10 Minutes* – for Channel 4 in the early 1990s.

Ian MacPherson

There have been professional setbacks, too. His pilot sitcom *Woodcock* was broadcast in 1995, but in the way of these things, 'the guy who produced it got promoted and wasn't interested any more'. MacPherson has written a number of sitcom scripts, and was disappointed that one in particular has not yet seen the light of day. He wrote *Lights Out* with himself, Michael Redmond and Sean Hughes in mind – 'it was set on the last manned lighthouse in Europe, and there's the guy who's trying to get away from the world – he's been there for 15 years, and that would have been me, and he has this character foisted on him, who is Sean Hughes, who irritates the shit out of him, and then Michael Redmond is the guy on shore who wants to make the place automatic. The Riverside Situation Comedy Festival people loved it because it was totally nuts.' But one TV executive decided against it

'There was one gig I did which convinced me that I had to get out of the stand-up circuit.'

'because he said it was too like *Father Ted*. I made the very pertinent point that if you got a programme about three Anglican priests off the coast of England, and then you got something about a lighthouse with a couple of fellas running it, nobody would make any connection. It's because it's Irish, and you can see the sea beating against the shore or something. It was all rather difficult, but I realised there was no point in me trying to break into TV comedy because the type of stuff they were interested in doing wasn't really my style of comedy. I'm more likely to get a break on radio or with a low-budget film script, though another TV company is interested in *Lights Out*. But I have great hopes for the book. To me, it's a cross between Seamus Heaney and Frankie Howerd.

'Some comedians have got books coming out, and they tend to come out quite quickly, on the basis that they have been on TV or whatever, and that's the way the

> I'd like to leave you with an example of my integrity. I was recently offered a TV advertisement by the Irish Tourist Board. I said 'I'll only do it if it presents the Irish in a realistic light. None of this Blarney crap.' They said 'It's six thousand pounds. English money. You'll be finished by noon.' I said 'I'll do it . . . if I can keep the leprechaun suit.' Integrity. Goodnight.

business works, but I went from having quite a low profile to having no profile, so the book was published because they think it's a good book.'

Comedy happens in clubs and pubs; often, as in MacPherson's case, it is made up on the spot, and unless it is being recorded or filmed, it vanishes as the last echo of a laugh dies away. Ian MacPherson is an innovative and interesting Irish humourist, and his voice deserves to be heard more often. Brian Boyd tells a poignant story. 'At Edinburgh I was having a drink with Ian and a young Irish comedian came over to us and I just presumed that he knew Ian and it turned out, as we were talking, that he didn't and I said "Oh, this is Ian MacPherson". And the comic went "Wow!" But I was shocked that this comic didn't know him by sight. There's a kind of jazz feel to him; he's like the Muddy Waters of Irish comedy. But I'd be careful about over-sentimentalising that sort of thing – he was, and is, a very good comic.'

Up in the cellar

'We got by on our £12 a week or whatever – spuds, rice and Bovril'

As McAleer, Redmond, MacPherson and Magra were ploughing their sometimes lonely comedy furrows, a new crop of talent was ready to spring up in their wake; well, actually, they were mostly at school, probably preparing for their Leaving Certs. A number of key people went on to study communications, an enclave of artiness in a sea of techie faculties at Dublin City University, north of the city. At the time it was one of the few places in Ireland you could study communications or journalism. And it was there in the mid-1980s that a number of comic talents gravitated towards each other: siblings Kevin and Anne Gildea, Dermot Carmody,

Ardal O'Hanlon and Barry Murphy. None had any ambitions except to study in some indefinably 'creative' field that gave scope for self-expression, and the vagueness of the communications degree suited them admirably.

Anne Gildea, O'Hanlon and Murphy were in the same year and Kevin Gildea and Carmody were a year ahead. Kevin Gildea: 'I remember Anne introducing me to Ardal, saying "This is my brother, he's funny; this is Ardal, *he's* funny." '

Barry Murphy: 'I wanted to do some kind of film course and that was the closest thing to it at the time, in that it was a great course and you didn't have to do anything. There was a debating society that had died before we arrived and we set up a spoof debating society. The debates were great crack and loads of people turned up for them and we were asked to do guest debates at various colleges – just to go in and talk complete nonsense. The motion might be "What do you think about the United States' intervention in Korea?" or whatever, and we'd come along and say: "You can have five different kinds of shit, essentially." '

Kevin Gildea

Mr Trellis (from left): Ardal O'Hanlon, Kevin Gildea and Barry Murphy

Anne Gildea liked to watch O'Hanlon in action at these debates: 'I always remember him getting up in this huge lecture theatre at University College Dublin and he had this look in his eyes like he was going to cry and he went: "Someone has given me the wrong motion for this debate." And everyone was shocked, because he was up on the stage and they didn't realise it was going to be comedy. And he went: "But I shall continue with the speech I have written – that Ireland is like a big chip." And he did it so seriously, and he had arguments like: "Have you ever heard anyone walk into a chip shop and ask for two Irelands and chips?" It was the most ingenious thing and it was so much like stand-up now. Ardal was doing that when he was 18, and so was Barry. They were so funny and so natural and so confident. Ireland was such a different place then; there was no money around. Everybody who studied communications seemed to go on the dole when they left college.'

O'Hanlon, Gildea and Murphy were no different. Anne went to London and the others hung around together, drinking as much as they could afford and talking vaguely about the possibilities of extending that college comic flowering into other fields. Murphy got into conversation with the slightly older Karl MacDermott at a comedy show at the Henry Grattan pub. 'I just thought Karl was fantastic because

Dermot Carmody

'It's increasingly less of a laugh once you trundle past 30'

Very thin, with bulging eyes and a fashionably wasted air, Dermot Carmody is a remarkable-looking man. As much a songwriter and guitarist as he is a comic, he provided most of the musical interludes in early Cellar days and is an influential figure in Irish comedy. The son of a Protestant clergyman, he expanded out of the Cellar and away from Mr Trellis, performing his comedy routines and bittersweet songs all over Ireland and Britain, basing himself in London for a period.

Carmody collaborated on musical/comedy shows, starred in a comic TV *Romeo and Juliet* and made many appearances on RTÉ. He also became familiar to viewers through TV commercials which capitalised on his unusual features.

He became disenchanted with the comedy scene as he grew older, and in 1997 told us: 'This is my 10th year doing stand-up. And unless you are fanatical, and there are very few people who are actually that fanatical and purist, who have a real passion to do stand-up, or unless you are a monomaniac or you get a big break of *Father Ted* proportions, then at some point you will go: I don't want to be doing comedy clubs for the rest of my life. I have no interest at this stage in dragging my carcass around either the college circuits in England or backwards and forwards from here to there. I'm far more interested in other things.'

The 'other things' included a growing interest in computers, as he explained two years later. 'I started my involvement in the Internet in late 1997 and did my first commercial site at the end of '97. My first site was, of course, the Comedy Cellar site, which I still take care of and host on my own servers now. I was sick of standing in bars amusing people for a living. Performance is stressful, and I don't imagine it comes in any more stressful flavour than stand-up comedy. Travelling to gigs and staying in B&Bs is fine when you're in your early 20s, but unless you are lucky enough to rise to sufficient prominence that the standard of everything goes up a notch, it's increasingly less of a laugh once you trundle past 30. Indeed, it probably wouldn't have been much different if I was playing nice theatres and staying in plush hotels – I know Ardal, for example, gets tired of being away from home.

'I performed well into 1998, but I knew I would have to concentrate on my web design business sooner or later. I never retired, I never bowed out. I would never be so daft as to say "never". But for the time being I always say no to enquiries.'

Yesterday Yesterday

Sometimes I sit with my head in a towel
And remember the day when we both used the trowel.
The garden was lovely and life was complete;
We had meat and potatoes and jelly to eat.

Chorus:
Yesterday, yesterday
Where are you now?
You were small and repetitive
Like a child counting one cow,
Like a billion bright birdies
Who've gone to the shops
Yesterday's over;
We've eaten the chops . . .

he was the first person I'd seen with lines, so I said, "When did you start?" and he said he'd been doing it for ages, which was a lie – he thought I was from TV or something. I was going to manage Karl and get him gigs in pubs. I did get him one gig and he didn't even have to do it because nobody turned up, but he got paid and I thought that was great.'

Murphy and O'Hanlon were living on Marlborough Road in Donnybrook, and on Sundays Gildea and MacDermott, with Carmody, who had spent the summer in London, would visit and discuss comedy and, in the words of the fatalistic MacDermott, 'lament our fate and throw used teabags at the fireplace'.

Influenced partially by TV's *The Young Ones* and *Saturday Night Live*, which were picking up on the live comedy cabaret scene in Britain, they decided to set up their own club, and started to write sketches and investigate the possibilities of a regular venue. O'Hanlon recalls that when they were 'outlining our manifesto in the early days, we saw ourselves as sort of the equivalent of German intellectual radicals and we had all these ideas about shaking up comedy and society. It was a reaction against, or an alternative to, what was there or what was available to graduates then: you had to emigrate, or you had to take Mac jobs or you had to get your hands dirty in some way, and I think we really did want to live some kind of bohemian existence.'

They found a small, narrow room with a little bar above the International Bar on Wicklow Street, long a traditional watering-hole for Dublin's artists and writers and a regular haunt of *Hot Press* magazine's staff and

Kevin Gildea

'We all just put a load of names down on a piece of paper and Trellis was there and we liked it.'

contributors. The pub had the right kind of raffish air. And so it happened that while one 'school of comedy' was socialising downstairs, another was doing its thing upstairs. They persuaded the International's Simon McEvoy to let them use the room once a week for a tenner – which they didn't have, and never ended up paying – and began to make plans. They decided on a name for the club, the Comedy Cellar (you had to go upstairs to it) and after putting a number of possible names for themselves in a hat, the four of them – Murphy, Carmody, O'Hanlon and Gildea, MacDermott having withdrawn somewhat – came up with Mr Trellis the Mormon, later shortened to Mr Trellis. The name owed nothing to the character in

Trellis: a leap into the dark

Flann O'Brien's *At Swim-Two-Birds*, says Murphy: 'We all just put a load of names down on a piece of paper and Trellis was there and we liked it.'

'We were just a bunch of people who thought they were funny and wanted to perform,' says O'Hanlon. 'People talk about the scene back then, but there was no scene. Just a bunch of young fellas sitting around in the pub and wondering where their next pint was going to come from.'

Their first night at the Comedy Cellar was in February 1988. 'We'd been talking about this for months,' continues O'Hanlon. 'We were going to set up a comedy club, never really believing it would happen, but it did eventually and it was great to see. When I got up on stage for the first time, I trembled for about 10 minutes. It went well, but I was wetting myself, quite frankly. My legs were just quivering and my hands were shaking and it was an awful experience. But as someone who was always quite shy, and certainly reticent, it was really exhilarating. The audience were very tolerant because they realised it was a first night. They were there through word of mouth; it was mainly family and friends, there to have a good time and support this new venture. And then the following week we went on again. In fact we told the same jokes for five years to the same audience and they still came back for more! They were masochists!'

The Comedy Cellar started attracting a small but faithful audience, and MacDermott occasionally returned to the fold. 'Karl treated us with complete

making it up as they go along

In 1991 the Cellar was joined in its International home by the Comedy Improv. What began with some improvisation workshops on Thursday nights in the City Centre quickly became a performing group on Monday nights in the International. The core group were Michelle Read, Ian Coppinger, Paddy Hickey, Dylan Moran, Eddie Bannon, Sue Collins (later a Nuala), Neil Doherty (a Scottish actor/musician), Elva Crowley and Conor Lambert. Says Ian Coppinger, a backbone of the group and an excellent improviser: 'The International is a great place – they give you a lot of leeway. For the first couple of years there was nobody turning up, yet they always paid a barman to serve in the club. And there are full houses on Monday nights now.' The skills of the group have developed over the years and it is a well-regarded troupe – latterly the mainstays include Coppinger, Read, Brendan Dempsey, Joe Rooney, and Bannon; Paul Tylak and John Henderson guest regularly. In a comedy environ that is much busier, it is obviously harder for performers to commit, but improv has been very good in developing other comic skills, too. Improv gives comic performers confidence, says Coppinger. 'With improv you have to write, direct, produce and edit everything in your head instantly, and not only that but key in with what everybody else is doing. It also helps your ability to deal with heckles and to write. There's no better feeling; it's just incredible, because you're working with other people and you've having such good fun and what you're saying is off the top of your head, and it's brilliant to be in the situation where you're making people laugh with something you've just thought of half a second ago.'

disdain for the first few months,' says O'Hanlon. 'He thought we were just students who weren't there for the long haul at all.'

The Cellar, from the start a club run *by* comedians *for* comedians, always received great support from the International Bar, but 'we were making a loss for a long time,' says Murphy. 'In 1989 I was living with Ardal but I had to go home to my parents in Clondalkin, we were making so little money. On a good week we'd each get £12.' Carmody says: 'I distinctly remember the first door-split in double figures – having had a pint *and* a tenner. It was a few months into it and later on, when we really got going, we used to make 20 or 30 quid on the door and there would be buckets of people on. The intention always was to do it professionally.'

Kevin Gildea: 'In the first six months the audiences coming along didn't know about comedy, and we didn't know what we were doing, so the audience and us were learning at the same time. It was an amazing set-up because they were telling us what was funny and we were learning about what was funny from their

Joe Rooney and Paul Tylak

THE QUACKSQUAD

'We went over to New York,' says Joe Rooney, 'and this girl, a journalist at *Hot Press*, she set up a few gigs for us and she'd booked us into a place called the Pyramid Club, which was a real kind of performance art-type venue, not a comedy club. And the guy who went on before us was reading a poem about the Holocaust – he was a Jewish guy – and it was really heavy, and then the compère came on afterwards and said: One way to wipe out a race is to gas them to death and another way to wipe out a race is to take their wheat and leave them with blighted potatoes. And now, from Ireland . . . '

And onto the stage pranced the Quacksquad – Rooney and Paul Tylak – wearing ridiculous, brightly coloured wigs, and they proceeded to sing an absurd song about a potato. Not a Famine-type potato, rich in social and political significance and bearing with it all the sadness and woes of Ireland. It was just, er, a song about a potato.

Rooney and Tylak, who created the Quacksquad in 1990, still often appear as a double-act but also have separate careers. Rooney, a musician and singer, does solo stand-up – sometimes as eco-warbler Fergus Scully ('Really good Celtic vibe here tonight . . . I'd like to dedicate this song to the lovely lady sitting at the front. I'd love you to have my children. They're all outside in the Hiace'), stints as Scribbler O'Donoghue with Ding Dong Denny O'Reilly and the Hairy Bowsies, and immortalised himself for *Father Ted* fans as Fr Damien (Damo) Lennon, the gurrier curate who leads Dougal astray. In 1998 and 1999, Tylak, who is half Sri Lankan, commuted to England at weekends for a regular cameo as a priest in BBC1's *Noel's House Party* and has also developed a curious solo act where he plays a Sri Lankan father who is trying to come to terms with modern life. 'It's really funny,' says Brian Boyd. 'He's stage Sri Lankan in the way that some comics are stage Irish. He brought it to London and he was booed off stage because it's very touchy stuff. Paul Tylak is like Paul Whitehouse and Harry Enfield in one person; he can do amazing accents.'

The mention of Whitehouse is apt. The Quacksquad were doing *Fast Show*-type humour right from the start – lots of zany characters, silly voices and quickfire sketches. Rooney: 'We kind of met around Dublin, on the streets. I'm from Co. Meath, near Slane. Paul grew up in London but his mother's from Cabra and his father's from Sri Lanka. He moved over here when he left school. I was in a serious New Order-type band, Guernica, and he wanted to do comedy and asked me to do it but I wasn't mad into doing it. Then

the band broke up and I went for it. We did a video production course and we got work out of that from *Nighthawks* around 1991–2. We put a video together on the course and we sent it in to RTÉ and we started to get work there. We were in the Underground club in Dublin and then in Charlie's Bar on Aungier Street – it's a pub that keeps changing names. But that only lasted for three weeks or something. The stage had to be brought in – it was just a thing we found round the back – it was a pallet or something, and on the third week somebody had done a shite on the pallet and so we didn't bring it in. So that was the end of the club.'

The Quacksquad appeared regularly in Dublin clubs and bars and devised a bizarre and surreal sitcom, *Flatheads*, in which they played student-types sharing a flat, used as inserts in an RTÉ series, *Rant*. They also made *Messers Tylak and Rooney*, a comedy travelogue which was one of the launch attractions for TV3.

reaction, and they were learning what they liked from what we were doing. I've never seen a more democratic audience/performer relationship.'

After a while Dermot Carmody decided to concentrate on solo performance, a mixture of his own comedy songs and character humour. 'I effectively worked for a long time as a detachable adjunct to Trellis.'

So what exactly did Mr Trellis do? Well, there were sketches and improvisation and cod quiz shows and phone-in programmes, and each of the three usually had a solo spot: manic, cackling Gildea in a variety of guises; stolid O'Hanlon as the Man Who Knows Things or Community Man – 'I think the self-effacing aspect of the persona probably developed from my nervousness onstage; it was like this really rigid, very nervous character because that was actually how I felt at the time, and it kind of stuck' – and Murphy with his gentle, wry, charming set-pieces and his blue book of routines and whimsical poems.

There was *Minimalism – The Quiz Show* and *The Phone-in Show* with Pat Phone-in (Gildea), a ridiculous take on endless radio phone-in programmes. (O'Hanlon: 'Hello, Pat. I think it's a disgrace the way the government is in cahoots with the communists!' Gildea: 'Are you a loony?' O'Hanlon: 'I am indeed.') Quiz show competitors would win prizes, like a photograph of a weekend in New York for two. O'Hanlon would offer fragments of his philosophy of life: 'I was just thinking – love is fickle. And I'm in love at the moment. But I'm not any more.' Underfunded Irish films about inner city crime and decay were parodied. There would usually be a *Tales of the Unexpected* spoof, and movies would be re-enacted through the medium of synchronised swimming.

'We did stuff about car washes,' says Murphy. 'Ardal and Kevin were in big huge overcoats and they were the car wash and Dermot came along in a car and I was a petrol pump and Dermot went into the car wash. Those kind of sketches. They were ridiculously contrived.'

It was all very ramshackle and at times amateurish, but there was also a brilliant inventiveness. As comedy creators, the balance between them was perfect. 'Kevin would write beautiful one-liners,' says Murphy. 'Ardal had a wonderful sense of quirk. And I kind of put a structure on it. We'd get an idea and I'd put some gags into it and Kevin would put some *cracking* gags into it, and then Ardal might bring it somewhere peculiar.'

Ian Coppinger

Tiny ('5ft 2in – a ridiculous height for any adult to be') Ian Coppinger is adept at improv and stand-up, and is also a writer, having penned most of the sketches for the RTÉ series, *Couched*. For years he toiled around clubs and festivals, either on his own or as part of the double-act Fat Man's Picnic Basket with school friend Paddy Hickey – they did their first show in school at 16 and started properly with an open spot in the Comedy Cellar in 1990. He describes them as heavily influenced by Monty Python and *Fawlty Towers*; one of their early sketches was the daft *homme avec handkerchief*, where Coppinger danced with a hankie to music while Hickey shouted stuff in French (you had to be there). A founding member of the Comedy Improv, for three or four years Coppinger combined comedy with his day job in shipping, before making the break. Eventually the double-act drifted apart (though they still do the occasional spot) and Coppinger's stand-up struggled to find a style.

More recently he has found his feet as a writer and performer. His stand-up is now polished and funny, and he was excellent supporting Ardal O'Hanlon at the Cork Opera House in 1998; that year he performed in *Young Gifted and Green* at the Edinburgh Festival and appeared in the BBC's *Stand-Up Show*. Coppinger, along with Hickey, wrote some material for O'Hanlon when he hosted that show, at a time when O'Hanlon was under pressure because he was writing a novel and his wife was expecting a baby. 'I found it odd – especially because I know Ardal so well. It's weird – there were jokes I'd written for myself and never did, and which suited him better and became his jokes. I was probably as nervous as he was – waiting for laughs. Ardal felt weird doing it as well, because it is not something he would ever normally do.'

Improv hones a comic's reactions: Coppinger was doing a lunchtime gig in 1998 for about 500 students and within minutes a member of the audience had an epileptic fit and fell out of his seat. Coppinger called for the house lights, and was stuck on stage for 10 minutes while the student was given medical help. Coppinger resumed his act with: 'Well, I always get them rolling in the aisles.'

ACME

Gildea agrees, but feels that Murphy is being modest. 'I think he's playing himself down there. I remember initially Barry came in with the most amazing batch of completed scripts. Then we'd tweak them a bit, but some of them were all there. He also brought in frameworks which we subsequently filled in. Definitely my forté was looking at stuff and funnying it up, and Ardal certainly had that surreal, quirky, oblique thing. In some ways Dublin could be not very nice – it could be quite closed sometimes – but there were three of us and we had a brilliant Fuck You attitude; we knew what was funny and each of us had the strength of the other two people.'

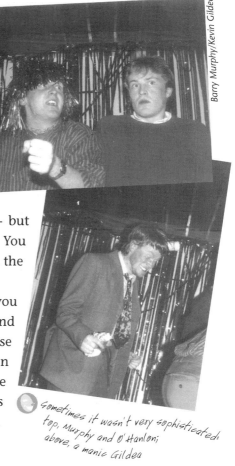

Barry Murphy/Kevin Gildea

Sometimes it wasn't very sophisticated: top, Murphy and O'Hanlon; above, a manic Gildea

Murphy: 'What Trellis did pick up on was that you didn't need jokes. If you have reference points – and particularly nowadays TV reference points, because people are more televisually literate than they were in the 1970s, for example – if you have that, and the rhythm of the humour, you can play around with it; it's like using different chords. You still have to put in "winners" that everyone is going to like, but you can play around with other notions as well.'

Gildea: 'The best times were when Barry came in with a loose framework or an idea, and there would be the three of us sitting around and going "and then you could do this", "no, you could do this", and there's a real buzz going. I really miss that, because that is the ultimate in creativity, I think: here you've got three people who are all on the same wavelength and you can't wait to say something, and you think that's as far as it goes and somebody says "no", and it's like suddenly this stuff is coming from nowhere and it's really exciting. And you're quite spoiled because that's what it began with and I found it quite hard when I went on to work with people I'd never met before because it was always associated with such an intimate thing – it's a friendship as well.'

It could be pretty fraught, too, says Murphy. 'Kevin and myself were sloppy and Ardal and Dermot were organised, and it was very difficult to maintain it as a group. It could have fallen apart at any moment, but it lasted for six years. The biggest buzz was doing a gig down the country to a bunch of people who had never seen stand-up before, or live sketches, and getting away with it. In 1991 we played to a whole roomful of people in Kilkenny with beards and corduroys who thought

Barry Murphy

Mr Trellis

SAUSAGES

Contact: 682172/592779
100 Monastery Rd.,
Clondalkin,
Dublin 22.

An early Mr Trellis publicity card

they were coming to see some Flann O'Brien piece. When it didn't happen, and we were doing our stuff with cardboard cornflake box swords, we still got a round of applause at the end.'

The lads had little acumen when it came to publicising their efforts, and a crucial development in the public perception of the Comedy Cellar came about eight months after it opened in the portly shape of Alex Lyons. Unlike the others, Lyons already had a career, as an advertising copywriter, and had done bits of comedy at Trinity and the College of Commerce. 'Dermot Carmody couldn't make it one night and through some contacts I was asked to go to the Cellar to fill in. I got hammered and some mates from advertising came along to support me. That was in early 1989, and I got totally bitten by the comedy bug.' But it needed to get attention. 'I was working for a very high-profile advertising agency at the time, Saatchi and Saatchi, and I knew that it's very hard to advertise something that has no value to it. No matter what they say, you can't write about something that has no intrinsic value, and I just knew by being in the Cellar that this was a really dynamic kind of idea. It was a new thing that wasn't happening anywhere else, and there was a great spirit of camaraderie at the beginning because there were so few of us doing it. Some nights we would outnumber the audience. It was often very unsophisticated, but the atmosphere was good. And I thought: this place needs publicity. So I sent out a brief to all the top agencies for a poster – a proper brief, you know, like you would for anything.'

The Comedy Cellar poster – a laughing face on the head of a pint of stout – was designed by John Flynn and in 1990 won Best Indoor Poster and an ICAD Gold Award, beating off opposition from the Abbey, Gate and Druid theatres.

The poster, a few TV appearances and some upbeat reviews – notably one in *In Dublin* magazine by cartoonist/writer Tom Mathews – began to put the Comedy Cellar on the map, and Trellis started to groom new, younger talent. In the early days Comic Soufflé, two actors who did character comedy, would occasionally perform. In 1990 Ian Coppinger and Paddy Hickey – the Fat Man's Picnic Basket –

did their first open spot; within a couple of years Dylan Moran, Eddie Bannon, Morgan Jones, and the Quacksquad (another double-act, comprising Joe Rooney and Paul Tylak) were performing. Also gigging in the Cellar in the early 1990s were Brendan Dempsey, Conor Lambert and Mark Staunton. Later generations to pass through the Cellar 'school of comedy' included Andrew Maxwell, Jason Byrne, The Nualas, John Henderson, Bob Reilly, Paddy Courtney, Patrick McDonnell.

Another new face in the early 1990s was Michelle Read, who had moved to Dublin after working on the London comedy circuit, which she says contrasts with the 'nursery' style of comedy-nurturing in the Cellar: 'Somebody can be on stage at the Cellar for five minutes being unfunny and the worst thing people will do is start shouting or ordering drinks. The Cellar was a kind of hotbed, and it was really supportive. You can get a gig very quickly and you can do a lot of gigs quite regularly. I mean, look at Jason Byrne. Jason is gifted, but would he have developed in the same way in London? He spent a lot of time with his anorak round his head on the stage of the International with people going "*What are you like!*" It was really hit and miss.'

Dylan Moran: 'I always remember that in the Comedy Cellar, where I learned my stuff, and where most of my Irish contemporaries did, the audiences were really wonderful – although they had a breaking point, mostly they would sit there and watch anything. Which is what you want

Barry Murphy

1 TRELLIS SONG
2 MIGUEL
3 GAMESHOW
4 SEX CHANGE
5 SOCCER
6 SPIKE I
7 BERTILLONS
8 BERNARD TUCKER
9 BENJY I
10 CHAIR
11 BUS CONDUCTORS
BREAK (5 mins)
12 BALLAD OF THINGY
13 FARMERS
14 BENJY II
15 PARAMECIUMS
16 BARRY
17 DANNO
18 THADDEUS O'S. G.M.F.
19 IRISH
20 SPIKE II
21 COLOSSAL PERVERT
22 GLENROWDY
23 CARWASH

MR TRELLIS SHOW
INTERNATIONAL
12/4/88

Running order for a Mr Trellis show in April 1988, two months after they opened the Comedy Cellar at the International Bar

Alex Lyons

The roundy John Goodman lookalike has long been part of the Dublin scene as comedian and backroom organiser. He was part of the first, hesitant gropings towards a legitimised comedy club at the Cellar and is regarded as a reliable performer with a talent for impressions (notably Captain Kirk), funny accents and strange noises. His devotion is such that he is often to be found in clubs where he is not appearing to encourage young talent. Lyons has always had a first career as a top-level advertising copywriter. Because of his work and support over the years, he was given a Lifetime Achievement Award by the Cellar in 1996.

when you are at that point. But in England it's hit them, hit them, hit them, and if you don't hit them, you're off the stage.'

Barry Murphy points out how crucial – and revitalising – new talent was to the Cellar: 'When Dylan arrived, and when Jason arrived a lot later, it was very exciting. That's what pushed it along. It was lonely for a while.'

As Mr Trellis became well known 'we started to get a bit more confident,' says O'Hanlon, 'travelling around the country doing colleges, arts festivals, a little bit on radio and TV, and we started performing sketches on *Nighthawks,* albeit in a very tacky sort of fashion. We were first and foremost a live act, and by then we had dropped the sort of sub-Python humour and we had found a voice of our own and we were excited. We played everywhere there was to play in Ireland, every field, prison, you name it – barns in Armagh.'

The waiting pig.

MR TRELLIS
– the mormon

COMEDY SHOW
international bar
tuesday march 8~ 8:30pm
adm: £2.00 / 1.50 unwaged

Barry Murphy

Back in the Cellar, they may sometimes have been performing to only 40 or 50 people but, says Murphy, they always felt they were playing to their peers, particularly since the other comedians sat in front of the stage (the notion of dressing rooms was laughable; the Cellar, which can hold around 70 people, doesn't even have a microphone or stage lights). 'If *they* were laughing at you, you knew you were along the right track. If any of us are honest with ourselves, we have to say that right from 1988 to 1994, if anyone was onstage, whether they were a hardened pro or they were onstage for the first time, if Kevin Gildea laughed at the gags, then they'd keep the gags. It was because of the integrity of his comedy. When Kevin laughed, you could see the comic onstage smile. They were chuffed. It was unspoken, but everybody sensed it.'

The Cellar developed a cult status of sorts as the world of Dublin comedy opened up and British acts, over to play other venues, took note; Eddie Izzard in particular championed the Cellar in the early days, did the odd spot there and even attempted to set up some London gigs for Trellis, which didn't come to pass; it was to be slightly later that two members of Trellis would move to London as solo performers.

All the comics enjoyed a drink, but for Gildea, who still admits to 'nerves and

Morgan Jones

Jones is a small – he has been known to refer to himself onstage as 'a dwarf' – writer, actor and comedian who has returned to stand-up in the late 1990s after a period doing voice-overs and advertising. A Dubliner, the son of a journalist and a dress designer, he did comedy at college (where a friend and early co-performer was Sean Hughes), and became a freelance photographer, broadcaster and magazine journalist before going full-time into comedy and acting.

He was a scriptwriter and performer on Network 2's *Nighthawks*: targets included the Pope, Dublin media priest the late Fr Michael Cleary, RTÉ reporter Charlie Bird, Anthony Hopkins, Jack Nicholson and many others. Being able to do such a multiplicity of impressions sets him apart from most comics of his generation (he was born in 1967) – as he puts it: 'schizophrenia pays'.

In 1992 he left *Nighthawks* and went back to stand-up. There followed a role in the RTÉ sitcom about journalists, *Extra Extra Read All About It*, one of the most atrocious programmes ever offered to the Irish public under the comedy banner and an embarrassment for all concerned. Although the quality of the show was hardly his fault, a period of understandably low profile came next, followed by his return to stand-up in 1998 with a slightly different and sexier image – designer stubble, floaty hair, tight trousers and silky, full-sleeved blouse. He landed a good running part as Tommy Tiernan's unemployable friend in Channel 4's 1999 series, *Hewitt*.

lack of confidence', it all got a bit out of hand, and after one particularly drunken outburst he was barred from the International – although Simon McEvoy turned a kindly blind eye for six months while the others smuggled him up the back stairs.

Gildea was always Trellis's wild card. 'I remember doing a golf club gig once and the average age was about 50 or 60. It was going really well, then I started my stand-up, and I didn't do it on purpose, because in those days when I started doing something I had to continue with it because it was the way I remembered things. So it dragged me into this stuff that was basically about Satanism. Then I got to the bit about the good thing about Satanism being that nobody reads the paper down the back during Mass – "Well, would you, when everybody's up at the front sucking the devil's cock?" There was complete silence. And the lads were really mad because it took us about 10 minutes to pull it back. That was a funny moment.'

Barry Murphy: 'I look back on the early days with rose-tinted spectacles. I'm a complete romantic. I think that's where a lot of the beauty lies. It's a very cynical, horrible business, ultimately, and it's now being maintained by ego and money.

Brendan Dempsey

This baby-faced giant is an experienced stand-up, improviser, actor and MC. Laconic and laid-back, he has an easy charm and his material gracefully details life as a young single man. His screen credits range from *Couched* and *Separation Anxiety* to a part in the slightly corny hit Oirish movie *Waking Ned*. Along with Morgan Jones, he ran an early club called the Comedy Zone in John B's in the Gaiety theatre; latterly he has been running the show at the Cellar.

And I think that what we were doing in Trellis was a beautiful thing. It was like 1970s football as opposed to football nowadays. You had your Charlie George, George Best-type characters then, and now you've just got six-foot German goal-scoring machines. And in Irish comedy that was the last time that lovely things happened. And we got by, on our £12 a week or whatever – spuds, rice and Bovril.'

The mellifluous-toned Murphy started to get lucrative advertising voice-over work, but for the others, spuds, rice and Bovril had ceased to be enough by 1994 and the Cellar had stopped being such a 'beautiful thing'. Ardal O'Hanlon: 'I think that where I differ from other colleagues is that I didn't see it as particularly great in itself. I thought it had the potential to be great, and that's what really frustrated me and prompted me to leave as soon as I could. It was supportive, but that had a flipside as well in that it induced a kind of complacency, which in turn affected the turnover of material, and I think people always felt they were a bit better than they were because they hadn't really played anywhere else; they hadn't really pushed themselves and tested themselves. I felt comics had to go to London and pit themselves against others, just to test themselves and to see if they were any good. It was a frustration I detected right through the comic circuit; people were at each others' throats at 5 o'clock in the morning at Blazers nightclub; there was an unhealthy atmosphere. So, while I share the idealism about the early days of the Comedy Cellar, after a few years of this, people started to bicker and get just a little bit frustrated at the lack of progress. Everybody's ambitious, and ambition isn't a bad thing; it's a very healthy thing as long as it doesn't turn into some kind of green-eyed monster, and I felt I was being sucked into that, too. We were working once or twice a week for no money, on the dole, sort of living from hand to mouth, and there came a time when I thought I would have to pack it in, and abandon all my principles, or go to London, where the streets were paved with comedy gold as far as I was concerned.'

Alex Lyons: 'Barry is really sentimental about the Comedy Cellar. I really believe in it but I'm not sentimental about it. It was chaotic when Ardal and Kevin and Dylan went to London at first because there just weren't enough bodies on the ground to replace them. It was tough for Barry when the others went away because he tried to hold the reins there.'

As the founders of the Comedy Cellar moved on – Gildea to success on the London circuit, O'Hanlon to undreamed of heights of TV fame, Murphy to a career as a radio voice and TV face in RTÉ, new blood came into the Cellar. But the nostalgia and sentiment about the club sometimes annoys Brian Boyd: 'I was there in 1990 when it was three men and a dog kind of thing, and it was good fun, people doing it for themselves. But every one of them wanted to get out of it. In some ways

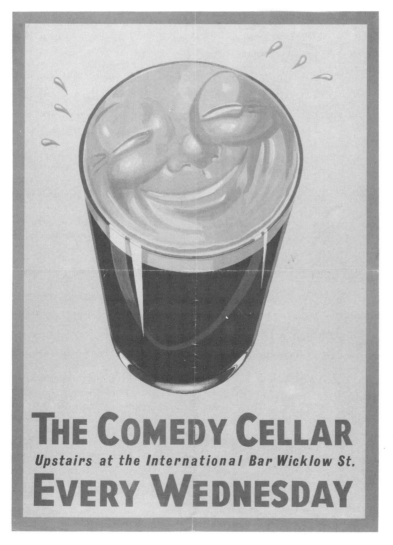

Alex Lyons

THE COMEDY CELLAR
Upstairs at the International Bar Wicklow St.
EVERY WEDNESDAY

The famous Comedy Cellar poster, designed by John Flynn

the veneration of the Comedy Cellar is detrimental to Irish comedy. It's actually quite ridiculous – the Cellar now is a very different thing to what it was. How important is the Comedy Cellar now? It's nostalgia really, isn't it?'

Mark Staunton

The self-described tallest comic in Ireland is indeed pretty lofty – one of his 'impressions' was of the film *Towering Inferno*, which involved him simply standing there while he flicked his lighter. One of the core of Dublin comedians for a number of years in the early days, he had a phlegmatic presence and downbeat delivery, and usually wore black. In 1991 he and Dermot Carmody set up Too Too Solid Flesh, an early Irish comedy booking agency – 'we had meetings with all the comedians and quickly realised it would be easier to set up an agency representing ex-Serb and Croat mass murderers'. Also a film-maker, the creative Staunton wrote and directed a black and white short called *The End*, screened at the 1994 Dublin Film Festival and later expanded it to a feature called *Separation Anxiety*, which starred so many Irish comedians and comic actors that, like a bit part in *Father Ted*, it seems to have taken on the mantle of rite of passage, or badge of honour. It was due for cinema release in 1999. Staunton, now working in Canada in film and video production, returns regularly to Ireland, when he usually hooks up with the Comedy Improv.

Authors' collection

Mark Staunton (left) talks to Conor Lambert during production of Staunton's 'The End'

But all the same, says Lyons: 'It's been consistently there for 10 years and once in a while it does get back to that atmosphere it once had. There is still that feeling about the place. It's given a platform and it's totally unpretentious and it's never been into money. Money has never been a reason to play there, so there's a bit of magic about it, a bit of pedigree, a bit of prestige. If it was a theatre, it would have produced Liam Neeson and Gabriel Byrne. It's an extraordinary record for a small room above a pub.'

Ardal O'Hanlon: 'It had its own magic, I appreciate that, and it shaped all of us in some way. And, despite its humble origins, it was a huge influence on modern Irish comedy. I'm immensely proud to have been involved with it.'

Barry Murphy

*'An MC is like a bass player. You're pushing the melody along,
but nobody really sees it'*

Tall, good-looking and honey-voiced, Barry Murphy has been called the Angus Deayton of Irish comedy – and, while he lacks the British TV personality's supercilious manner, he has a similar potential to do well in the mainstream market, and in many ways he is already there: his soothing tones have been helping to sell things to the Irish public through radio ads for many years now.

If one word sums up Murphy, it is 'smooth'. He is the support act most visiting comedians ask for; they know he will charm and cajole the audience into a good mood in the first half. He is Ireland's most skilful comedy MC, able to pull together a diverse or unruly collection of talents into the semblance of an organised event. As MC or opener, he has worked with Shane McGowan, Milo O'Shea, Eddie Izzard, Jack Dee, Lee Evans, Dr Feelgood, Nick Cave, Sean Hughes, Therapy, and his friend Dylan Moran. He is married to the actor and singer Flo McSweeney, and they have a small son.

If all this sounds a bit bland, the subversive streak in Murphy's make-up breaks through often enough to reassure us that he still retains the edge so often seen in those early Comedy Cellar days. Then he looked a bit like a chirpier version of Neil in *The Young Ones* – an addled hippie with shoulder-length hair, but more laid-back than anxious. While the hair has changed,

Barry Murphy – comedy's middle-man

the cool, supremely confident style hasn't, and he isn't afraid to use some of his material from those days. He prowls the stage, always in control, and uses a large blue notebook to 'remind' him. He rarely tells jokes.

Like so many Irish comics, Murphy had his spot on *Father Ted* – he was the

salesman who sold Ted the tea-maker that broke Mrs Doyle's heart in the Christmas special. But his real impact on TV has been two-pronged. On one of RTÉ's few recent big comedy successes, *Après Match*, parodying sports commentators and others, Murphy makes a wonderfully monotoned Frank Stapleton, and writes the material along with co-performers Risteard Cooper and Gary Cooke. Where *Après Match* had a large, mainstream audience, his other RTÉ baby, *Couched*, was aimed at a smaller catchment. Stuck in a mysterious, darkened room, he and Mark Doherty, the nameless protagonists (echoes of Beckett, or even Kafka?), flick through TV channels – to find sketches, mainly written by Ian Coppinger. A 'slow-burner', it was adventurous and promising, and sometimes very good.

Murphy's interest in advertising goes beyond simply doing voice-overs and trousering the cheque; he has won several awards for copywriting, including the Gold Radio campaign winner ICAD, Best Radio Campaign at the Irish Radio Awards and at the Kinsale International Advertising Festival (all 1997), and was winner of the DNAD Silver Pencil Award in 1998.

Barry Murphy

From the cellar to 'Après Match'

'The reason I started in comedy was as a hobby, and it was good fun,' he says, 'and once it became our jobs, we knew we would have to come up with stuff because we had to keep making people laugh, and that's when it becomes a different thing, and you have to love it and pursue it and sacrifice everything for it. I wasn't prepared to do that because I wanted to keep it as a sort of hobby, keep it enjoyable. I find stand-up quite boring, to be honest with you, the majority of it. I enjoy doing it and I enjoy doing improv, but I hate watching it. When the lads went over there' – Gildea and O'Hanlon moved to London in 1994 – 'and I started doing *The End*, it was getting Irish comics on Irish telly, and I was really pushing towards a comedy show, and putting proposals for a comedy department. To an extent that's worked through *Couched* and *Après Match*. I prefer now to do radio or TV and perform stand-up as a hobby. Because I never wanted to be a personality comic. Even doing stuff on telly, I prefer writing to performing.

'I wouldn't pursue my own personality, particularly in comedy, because it's not strong enough. I don't want to get into that whole territory of talking about myself. Dylan Moran is personality-driven, it's his attitude, he's given his whole self over to comedy in some respects. I would be too private; I don't want to do anything about my family, although I did do one joke about my son being born.

'There's less pressure on an MC because people are there to see the comedians and he's just the guy who says "Hello and welcome". But it gives you the freedom to play around – "I can get a laugh out of this whether they like it or not". That's kind of interesting. It's almost like a sub-culture among comics – who's an MC and who isn't. An MC is completely different to a stand-up. A stand-up is essentially someone who goes out there and they're stuck. My attitude to comedy is completely based on the fact that I am a natural MC, and I'm not a natural stand-up comic, and I love the show; I think the show is the thing.

'Take the Cellar. I liked to arrange the acts on the bill, finishing with someone who might not be the biggest name, but someone who was quirky, someone like Patrick McDonnell, and I'd throw that at them. Then sometimes someone would do an absolutely brutal routine and you'd have to go on and get the audience back up again. And sometimes somebody would just have stormed it and the natural inclination would be to get out and surf on the back of that and have a great time, but a good MC will just go on, say one or two lines, get a laugh, and bring the next act on. An MC is like a bass player – you're connecting between the drums and the rhythm. You're pushing the melody along, but nobody really sees it.

'I still don't know what I want to be when I grow up. I'm just happy enough to keep working. I choose what I do very carefully and I've turned down an awful lot of things. People say "You do a lot of voice-overs – you're prostituting yourself" and I say "Fuck off; I'm doing it absolutely out of necessity." I could make a fortune if I did all the voice-overs I was asked.'

Murphy has achieved a lot, carving out a good career in Ireland at a time when the climate was not conducive to a subversive young comic taking on the establishment from within, and he is smart enough and ambitious enough, in spite of his demurrals, to perhaps achieve what he wants and help effect a sea change in RTÉ's attitude to comedy.

Kevin Gildea

*'I once knew a girl who overdosed on the morning-after pill –
she got propelled into the future'*

Kevin Gildea, known also as 'Benjy', has a high-pitched, slightly snidey and sarcastic voice and a crazy laugh. His eyes glint with a kind of manic cynicism, and the unconvincingly ingratiating smile he manages to arrange on his rosy features fails to eliminate the impression of a fallen cherub, expelled into the outer darkness for some unspeakable transgression, probably involving sex.

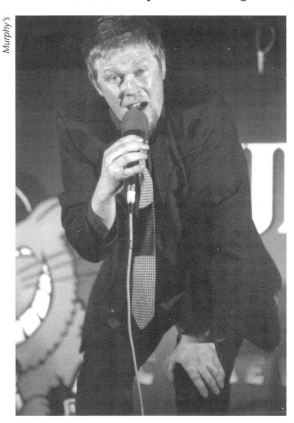

Murphy's

Gildea: frank about his insecurities

Sex, in fact, plays a big part in his sometimes sicko stand-up routines, and it is a subject he says that he is 'very interested in'. In his Mr Trellis days, however, his material was more surreal than it is now, and often involved a character called 'Fuddy Duddy', an old Dublin storyteller with a long piece of toilet paper glued to his chin as a beard: 'I was supposed to do James Joyce's shopping once but I couldn't make head or tail of the shopping list,' Fuddy Duddy would say.

Gildea, known for the excellence of his one-liners, plays the British club circuit, with frequent trips back to Ireland for gigs. In 1999 he was a writer and star of *Haywire*, an ingenious futuristic sketch show for BBC2, and also writes with The Nualas – his sister Anne and girlfriend Sue Collins make up two-thirds of the musical parody group. His stand-up style is clever as he pretends to solicit questions from the audience: 'What's that? When was my first sexual experience? Cheeky! Well, let me see . . .'

'Comedians,' he says, 'are outsiders to an extent.' In his own case he means it literally. He was born in Levenshulme, a suburb of Manchester, in 1964, and the

Here's some good advice. Never have sex with your best friend, because it's always a mistake. I did that last week. The next morning I was so embarrassed. I thought 'Oh no, I've had sex with my best friend!' I couldn't look at him. I couldn't talk to him. I couldn't feed him. I couldn't bring him for walks . . .

family moved to a rural part of Co. Sligo when he was about five. Although his parents are Irish, as a child he felt 'very much an English person in Ireland initially. Another thing was that we didn't go to our local national school; we went to my aunt's national school seven miles away. It was brilliant really, but one more remove from the local community, and on top of that we didn't have a very happy personal life there. So those three things brought the comedy out an awful lot more. At one stage I was thinking that was the only reason the comedy existed. I don't think that's so now, but it drew it out and it became a huge device for surviving and escape.'

As a child Gildea wrote what he calls 'little stories', and Anne remembers him standing in the kitchen of the farmhouse when he was seven or eight, wearing their dad's wellies and telling her a joke he had just made up: 'My friend died when a leaf fell on his head. It was attached to a tree at the time.'

Gildea discovered the magical poetry and children's stories of Spike Milligan, whom he sees as a hugely formative influence. 'I loved his silliness. His madness is so all-embracing it actually stretches to create an entire world, the Milligan world. Jason Byrne is a huge fan, and in what Jason is doing I can see the connection with Spike – crazy, free association stuff, stuff that is so crazy that it often doesn't have the roots of a gag, it's just mad.'

He has had a measure of success since he moved back to England in 1994 – he appeared in the sell-out *Young, Gifted and Green* show at the Edinburgh Fringe the same year, and appeared in *Father Ted, Live at the Comedy Store* (C5), *Stand-up Show* (BBC1), and has written material for Alexei Sayle.

Although he is frank about the insecurities that once made him drink heavily, he is tough enough to operate effectively on the English circuit and, unlike many of his contemporaries, still enjoys stand-up immensely. He regrets that some of the purity has gone out of comedy: 'In London, it's a lot more like a career, so you get people looking at it and saying that could be a good thing to do, rather than

105

having to really *need* to do it. I think it's good in Ireland. People are able to get in to the Laughter Lounge; they don't have to hang around as long. But I'd hate to be starting off in London now. They have whole nights of open spots – they're putting all the open spots onto one particular night and some clubs don't have open spots any more. In comedy you need a ladder, places to start off, and you need middle ones to develop up to the top of the circuit. In London to an extent they could be taking away the middle rung. And potentially that's dangerous for the long-term development of comedy.'

Gildea has a good career in Britain, but Barry Murphy, who now has some influence at RTÉ, would love to see him and his talent back in Ireland. 'He's a very funny man but he's just not fashionable,' says Murphy. 'I wish he'd get back to Ireland. I'm shovelling away here and my position in the equation, if you like to call it that, is to work between people like Kevin and RTÉ. All I want to do is facilitate people like Kevin; I want to work with people who are not really acceptable to the establishment. There would be a lack of trust in people like Kevin; he would be perceived as a stand-up with little experience of TV. He doesn't sell himself. And he shouldn't need to.'

Gas crack

Billy Magra came back to live comedy in 1991 after working since the mid-1980s as a producer/director in TV, mainly in music and youth programmes, first in RTÉ, then for Channel 4's *Wired*, and then with independent music and video producer Windmill Lane in Dublin. He was on the creative board of the planned new TV station, TV3, which, armed with the licence to broadcast, asked Magra to spend the months before the launch date developing local comedy. The TV3 plans collapsed, but Magra found himself running a new comedy club called the Gasworks, with a blast of early comedy sponsorship from Tennants lager. The enterprise, which set out to develop the local comedy infrastructure on a larger stage, was an ambitious project – an international comedy club every Thursday to Saturday, bringing over British performers, with a bill composed of a British/Irish line-up.

Jack Dee, Eddie Izzard, Jo Brand, Jeremy Hardy, Lee Evans, Arnold Brown, Hattie Hayridge, at that stage mid-ranging live acts in Britain with a solid reputation on the circuit, performed there; many shortly afterwards became household names on

What's on at THE GASWORKS
APRIL 1992

APRIL 1992
Fri 3rd The Open Spot Final with the 6 best new
faces of '92. Winner wins £50.
Guest **Ardal O'Hanlon**. M.C. Billy Magra
Sat 4th "Look Whose Joking" - comedy
improvisation with Barry Murphy, Paul Tylak,
Kevin Gildea & Joe Rooney.

Fri 10th From London Richard Morton with Dillon.
Sat 11th Mary Dermody M.C. Brian Kiernan

Easter Special
Sat 18th Mark LaMarr (London Comedy Store)
& special guest **Dermot Carmody**.

Fri 24th Pom Boyd with guest Frank Twoomey.
Sat 25th M.C. Neil Donnelly (Scot)

TENNENTS Live!
THE GASWORKS

What's on at THE GASWORKS
MAY 1992

MAY 1992- Watch out for the **Tennents LAugh
Comedy Search 1992** (nationwide). The top 4
performers appear on the **Late Late Show 15th May**
Winner receives £500, trip to Edinburgh Fest.
plus shows. Entry form RTE Guide (8th April) & In
Dublin (15th April) or at club.

Fri 1st Dublin Heats. Guests Carl Perrse &
Sat 2nd The Quacksquad

Fri 8th Dublin Heats. Guest Alex Lyons.
Sat 9th (All proceeds 8th May to People in Need)

Tue 12 Dublin Final (8 acts). M.C. Billy Magra

Wed 13 National Semi Final - The 12 acts
compete for Friday's Final
Fri 15th Closed (Late Late Show 9.15pm)

Sat 16 Winners Party with Special Guests.

Fri 23 Tennents LAugh / Late Late Show
Sat 24 THE WINNERS SHOW

Fri 29th The return of **Jon Kenny** and
Sat 30th **Pat Shortt (Whole Show)**

What's on at THE GASWORKS
JUNE 1992

JUNE 1992
The Best of London featuring

Fri 5th **Nick Revelle**
Sat 6th & Guests.

Fri 12th **Mark Hurst**
Sat 13th & Guests.

Fri 19th Johnny Immaterial.
Sat 20th & Guests.

Fri 26th **Bob Mills**
Sat 27th & Guests.

NOTE;
All June shows include guests and MC (t.b.a.)
discovered during the Tennents LAugh/
Late Late Show Comedy Search 1992 (see May)

The promoters have done everything to ensure
that this programme of events is accurate. Please
check local listings or with the club closer
to the date.

Three months of top acts at Billy Magra's Gasworks in 1992

the back of TV exposure. As support, MC or later headlining were some of the Irish names on the circuit – Ardal O'Hanlon was the first Irish comic to top the bill. There were occasional open spots, a Sunday night 'gong show' at one stage, and joke competitions. The evening always closed with Monty Python's 'Always Look on the Bright Side of Life' as signature tune – and that was a signal of one of the club's difficulties – the place had to be cleared swiftly for the following nightclub and failed to properly develop its own identity. This was Magra's second attempt to bring his experience of marketing and promoting rock bands to comedy. The Gasworks, says Magra, was his attempt 'to try and professionalise the scene, not to try and overtake it. Comedy was at that stage underground and got around by word of mouth. Nobody gave a damn if it was reported in the press.'

Magra says he sensed that the Irish performers needed a challenge – 'it was all very comfortable' – and the Gasworks was an attempt to pull the audience and then start to give the Irish acts spots on the mixed bill, as well as to develop a comedy audience. For the young Irish comics, the club was another venue, and a chance to see and meet a range of British acts, forging connections that were later to prove useful when some of them moved to work in London. 'There was always a

Magra brought over club stars like Arnold Brown, Jack Dee and Jo Brand

plan. There is always a cycle, and comics have to learn,' says Magra. Comedy Store veteran Arnold Brown, who headlined at the first night of the club, gave a masterclass; Magra organised an improv workshop in the Project.

In 1991 he produced a one-off show in the Olympia called *The Entertainment Party Conference*. 'My strategy was to produce a show in the Olympia highlighting all the best of the newish or new performers, mixed in with Dermot Morgan, Shay Healy, Paul Malone, the Joshua Trio, Sean Hughes, Karl MacDermott, Ian MacPherson, Michael Redmond, Mr Trellis. Dermot Carmody opened. It was presented by Gerry Ryan and Dave Fanning and it was Sean Hughes's first real performance, about a year before he won the Perrier.' Magra later co-managed Hughes for two years. 'We had members of the Pogues and Paul Brady and Ronnie Drew – far too many performers – it ran for about three hours. That night we were also announcing the opening of a club at Whelan's pub in Dublin, a club in Bray, a club in Dún Laoghaire. It was there as a showcase. And in my stupidity I spent about £7,000 and put three cameras on it.' It was to be transmitted on RTÉ, but the timing of a strike at the station meant that it wasn't broadcast. 'Those transmission tapes are lying in a box somewhere at RTÉ.'

In 1991 and 1992 the club hosted heats for the Tennants Laugh, a comedy search in association with *The Late Late Show* (the final was on the programme) and the Gasworks. In 1991 a trio from Waterford won; talented character comedian and actor Pom Boyd was a finalist. Patrick Kielty and Dylan Moran made the final the following year (Brian Boyd and the authors judged the heats; our unanimous choice was Moran), and a bank official, Alan O'Mahony from Cork, won.

In September 1992, Magra organised the Liffey Laugh festival, the first Dublin international comedy festival; these days festivals seem to breed like rabbits, but then this was a brave new idea. In the programme he noted that Dublin was the perfect size for a comedy festival and that he hoped it would be a solid foundation for a more ambitious programme in 1993.

But the first – and last – Liffey Laugh was, in fact, both ambitious and wide-ranging – possibly too much so for a first year. It ran for two weeks all over the city,

with an impressive range – a British production of Spike Milligan's *Puckoon*; an American one-man show, *The Devil and Lenny Bruce*, about the legendary comic's life; Sean Hughes in the National Stadium; lots of other Irish and British stand-ups and improv performers, including a 'Beyond the Pale' selection of non-Dublin performers (the Hole in the Wall Gang, the Galway Comedy Cumann); an audience with Roddy Doyle and seminars on comedy hosted by the likes of Dermot Morgan, Eamon Dunphy and Sean Hughes, and on the future of comedy and RTÉ.

It was stimulating and innovative, but perhaps suffered because it was spread out over two weeks; subsequent, more recent Irish comedy festivals – which have tended to concentrate almost exclusively on stand-up, unfortunately – are generally held over a long weekend.

Magra had vision but was slightly ahead of his time – the arts in general may have been thriving but Dublin was the loser because it was not quite ready for the Gasworks' line up of 'alternative' comedy names that hadn't yet made a huge TV impression. The venue was off the beaten track and in not too salubrious an area, with the result that some nights were magical but at other times the audiences were not great; comedy hadn't the profile with Irish audiences and hadn't yet developed into an entertainment option, along with music, cinema, theatre.

Around the time Magra was feeling a bit burned out by the club in the summer of 1992, and as the sponsorship ran out, he was offered a six-month contract with RTÉ to produce and direct *The Basement*. For a while he ran the club as well as holding down the day job, but bowed out after a few months. 'The carrot was that I

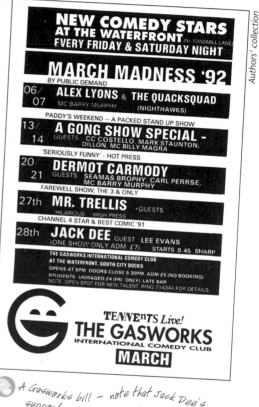

A Gasworks bill – note that Jack Dee's support act is Lee Evans

thought RTÉ was going to be developing a proper comedy department, using *The Basement* as a stepping stone. The logical thing was to be involved in developing other programmes or other artists.' The show was a studio-based comedy series designed basically to fill the *Nighthawks* gap. One of the four resident MCs would introduce a selection of performers from the live circuit. It was the first such programme on RTÉ and, after a shaky start, produced some good shows. But it never did lead to a real comedy department and ran for just 16 weeks. The series producer, Philip Kampff, went on to work on the ill-fated *Newshounds* with Dermot Morgan before that imploded, and later left to work in British TV.

Magra, meanwhile, continued to work at RTÉ – 'I ended up producing a fashion programme' – before getting involved in screenwriting, working in TV in Britain and later devising a sitcom writing course in Galway in 1996–97. These days he is a freelance producer – including *Make 'em Laugh*, a history of Irish TV comedy presented by Gay Byrne – and is in charge of music programming in TV3, the second incarnation.

Billy Magra was a promoter and comedy aficionado, but basically not in it to make his fortune; in fact, 'I lost a lot of money as a private individual without a major sponsor or a safety net for the Liffey Laugh. But I don't want to dwell on the fact – it was stupid on my part not to cut back the festival to one week or a weekend. I went for theatre productions and seminars, I had a vision of what it should be. But I was never a businessman; I never had an idea of building up an empire. I always came in on the creative end. Everything for me grows from how experienced and how adaptable a group of performers are.'

Ardal O'Hanlon

'It is in the realms of boyish fantasy . . . it's a better place to be'

Everyone has a breaking point. In 1994 the members of Mr Trellis were still signing on the dole and living on Barry Murphy's famous '£12 a week or whatever – spuds, rice and Bovril'. Murphy, Kevin Gildea and Ardal O'Hanlon had made the Comedy Cellar their own, and from time to time they also did gigs at, among other places, Billy Magra's Gasworks. There they listened, rapt as children hearing an old sailor's tales of faraway places with strange-sounding names, as top London comedians regaled them at the bar with stories about life on the British club circuit. 'That opened my eyes to what the potential was, what was involved,' says O'Hanlon. 'These people had come over with well-honed acts – and their material didn't seem to be any better, which is what gave me the encouragement and confidence to pursue it myself – but they presented it in a much better way. And they told us about how in London you could work two times a night, three times a night, five

nights a week, seven nights a week. You can go around the country, you can do TV shows. And it was only by hearing about all this that you thought: What am I doing here? What happened was that people started doing voice-overs, or people started – in my case, and others – giving out free samples of Cognac, dressed up as butlers. I did that for a while, and it was soul-destroying. I appeared on *Crimeline* as the victim of a knee-capping. That was the day before I left Dublin. I thought: I have to get out. I have to leave Dublin. This is the nadir of my career here.'

A few short years have seen a dramatic change in the fortunes of our old acquaintance from the Comedy Cellar days, and it is a very different O'Hanlon we meet for a drink at Dublin's Clarence Hotel during a break from filming his latest comedy series. Married to his long-time girlfriend, Melanie, and with a baby daughter, the shy, charming stand-up from Carrickmacross, Co. Monaghan, has become a huge TV star in Britain. When he moved to London he had the nearest you could imagine to overnight success: within his first few weeks on British soil he won the Hackney Empire Newcomer of the Year award, beating 120 other hopefuls, and Spitting Image Performer of the Year. Shortly thereafter his shared Edinburgh show sold out, he was cast as Dougal in *Father Ted*, went on a month-long tour of Australia and played the Montreal Just for Laughs festival. When *Father Ted* became such a huge success, he was ruled ineligible to be nominated for the Perrier in 1996 because he was deemed too well known. However, the same year he won Top TV Newcomer in the British Comedy Awards for his performance in *Ted*. He has toured his stand-up show in Britain, published a novel, *Talk of the Town* (and is planning a second one), starred in the ITV comedy drama series, *Big Bad World* and filmed another series, *My Hero*, in which he plays a superhero working in a sports shop, this time for the BBC.

He has a permanent base in Dublin – 'it's a big castle, with a moat,' he jokes – and commutes to England for his well-paid and high-profile TV work. Tell him that it sounds like an enviable lifestyle and his face crumples a little as he becomes, momentarily, the cautious, wary, uncomplacent Ardal from the so-recent 'old days'. 'Well, you don't have

'When all is said and done, it is the writing that gives you the most scope.'

Dawn Sedgwick Management

to wake up in the morning and be me. I wouldn't wish that on anyone. It sounds grand, and five years ago it would have sounded like a dream, the ideal, to have a place in Dublin where I can rest and play, and work in Britain – it would sound ideal, but . . . well, I'm not going to complain. Give me an inch . . .'

Stand-up and TV acting have made him a household name, but what drives him is not so much a desire to make people laugh but a compulsion to express himself creatively, and writing is what best satisfies that need. He is aware of the conflict, and honest about it.

'Last year I said I wanted to be a writer. I wanted to move back to Ireland and I wanted to write. Now, that's easier said than done. I don't have the kind of discipline to do that. I'm still fickle enough to be seduced by the glamour and attractions of TV and stand-up. It's a fantastic way of life, really – people pampering you and giving you lots of money and attention, and it's very hard to resist. I wish it was easier to resist, because I think writing is a much more grown-up kind of occupation.

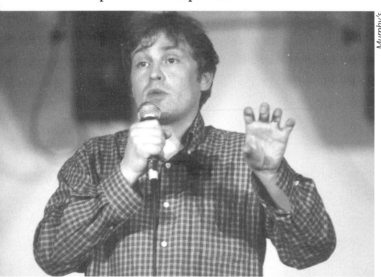

Murphy's

'I'm still fickle enough to be seduced by the glamour and attractions of television and stand-up.'

'It's more dignified – you're sitting at home with people you like; it makes more sense. And it's possibly more satisfying than other kinds of work, creatively. Working in TV you're dealing with other people's scripts and material. There is a certain amount of leeway and a certain amount of collaboration, but you are still interpreting somebody else's work. Likewise, in stand-up you're bound by the conventions of the genre; you have to make people laugh every few minutes. In my case, post-*Ted*, you are playing to mainstream audiences, so you have to keep everyone happy, you have to be very upfront and lively and sometimes you may not feel like producing the goods that night. But I think it is the writing that gives you the most scope, that allows you to say what you want to say. But it's hard to make the distinction, really, because it's all a kind of blur, it's all about finding ways of expressing yourself.'

In his fiction and comedy he draws deeply from the well of childhood. 'It is in the realms of boyish fantasy, and that's what I see a large part of it as. It's a better place to be; it's not the real world, it's creating a fantasy world for yourself.'

Anyway, my name is Ardal and I come from a very big family. There are 17 of us altogether – well, 15 and two imaginary ones. Of course, there's great respect for a big family in Ireland, isn't there? Especially if they all wear matching clothes made out of felt and walk in single file in descending order of height. And coming from such a big family, you would very rarely find us all at the same time in the same place. In fact I'd say there's only three occasions in life when you'd find the whole family together and they would be a family wedding, or a family funeral, or if I brought home a bag of chips.

Ardal O'Hanlon describes himself as a chronically shy child, who would blush when anyone spoke to him. He grew into an equally bashful teenager whose rebellion consisted of not making the most of his intellect at school. He describes a – not unusually – repressed rural upbringing, pleasant but over-protected. He was sent to boarding school at 13. The son of Dr Rory O'Hanlon, later a Fianna Fáil TD and Minister, he was one of a family of two girls and four boys; the others are 'reasonably well adjusted, despite the fact that they work in conventional occupations'. His parents have been very supportive, even if comedy was hardly their first career choice for him. The fact that his father was a politician was 'never a huge problem for me', but the fact that he is a big comedy star may be a 'huge embarrassment for him!' he says, laughing. He never got involved in political canvassing as a child, and says that he is of the 'strong opinion that nobody knows anything. Nobody's right, as far as I'm concerned. The only honest place is the fence.'

His mother, Teresa, shaped his creativity. 'I think it was very important to her that we read. She was a bit of a dreamer in her day as well, and at one time she had notions about acting, which she forsook for the sake of raising a family, so it's something that I'm indebted to her for – that we read all the time. We devoured books. Because of that, I never had any interest in working, or pursuing a career in one of the professions. It was like: how could you? You had read all this wonderful literature. It was ridiculous to contemplate going into the world of commerce or anything like that. It was as if you'd be contaminated by any dealings with the world of commerce. I don't necessarily think that now – I think I'm a far more tolerant person than I was four or five years ago. I still far prefer people who read and go to the cinema and play music – that's the type of company I would seek out. I find it very hard to relate to people who are in the money-making business, for example, even though I probably make more than them now. I'm slightly ashamed of that, but, like anybody else, I love it.'

His stand-up style is gentle, observational, sometimes surreal, in no way hard-hitting or political, and his material is suffused with his small town upbringing. 'I have a tremendous affection for Carrickmacross – that place and those people – and everything I did since I left there, I owe it in a way to them. It's the language I use in my stand-up, it's where I derived my sense of humour.'

O'Hanlon is always likeable on stage. He comes across a bit like a rabbit transfixed in headlights, using his shyness to create an appealing persona. He has strong views on comedy, and on the contrasts between yesterday's performers and his own peers. 'I think the difference is in approach, in intent. That is where the crucial difference between the younger generation of comics and the older ones comes in. The older generation see themselves as entertainers, and if that means taking down their trousers, singing an auld ballad, juggling, or whatever it takes, they'll do it, whereas the younger comics see it very much as a way of life – as a mission. Without wishing to sound pretentious – and that's usually very difficult for me – I see it as an art almost. It's a vocation, or like a hobby that has come to dominate our lives.

'The younger generation of comics look into themselves a bit more and they just try and develop aspects of their personalities, I suppose, or project facets of their personalities for comic effect, and I think it's about investing a bit more of yourself and your personality and emotions and feeling into your act. It's still an act, and there to make people laugh, but I think you put a little more of yourself into it rather than learning a few jokes by rote and saying them. You can get a monkey to do that. It's a skill. I can't tell jokes; I simply wouldn't know where to start. It's not that I don't like them, it's just that I don't know any. As well, with the older style of comic, you see the image they are trying to project is one of great crack, bonhomie, back-slapping golf classics, constantly switched-on gas man. Another distinction between them and the younger generation, some of them anyway, is that there isn't that air of desperation, those bulging eyes. It's important to keep your eyes in your head. There's no need to be switched-on all the time – it doesn't help make people laugh. I can be the most miserable person alive – I can't say I'm happy about that – and if I'm out and about I don't feel the need to be entertaining people all the time, but when I go on stage I will give them the best show I possibly can.'

The part of Fr Dougal arrived when he was well established in Britain. 'Arthur and Graham had seen me perform stand-up and they encouraged me to go for the audition. I wasn't in the habit of going to auditions; I couldn't stand the rejection that actors have to go through time and time again, because the great thing about stand-up was that it had become so fashionable by the time I got to London – it was huge – and if you were handy at it, as I was, the world was your oyster. You were on stage every night, and for the first time people were considering stand-ups for sitcoms, for acting roles, for TV presenting roles; you were on the covers of

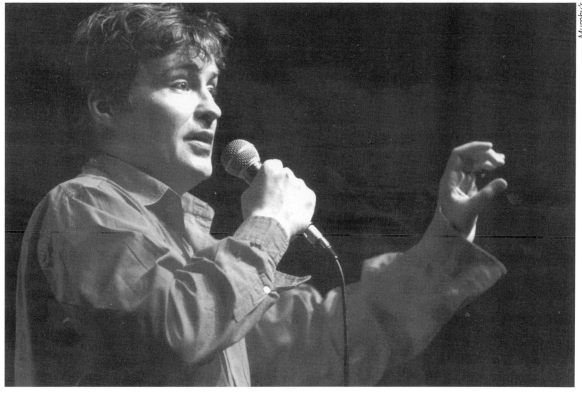

'*I can't tell jokes, I simply wouldn't know where to start.*'

magazines, advertisements. Comedians were happening, so it wasn't unusual then for comedians to be called in, and they said "Are you interested in this part?" and I said "Yes, of course; it's fantastic." I knew the writers and I knew their reputation and I had a look at the scripts and they were hilarious. It was actually the last day of casting – I was called in 10 minutes before they were about to close the door and I read for them and they seemed happy with it. I didn't try and overact or anything, because I wasn't expecting to get it; I just thought it was a nice gesture on behalf of the writers. It wasn't until months later, when I saw the contract, that I actually believed I was going to be in it.'

Mathews and Linehan had spotted the crucial link between the dim, innocent Dougal and the highly intelligent, worldly O'Hanlon – the latter, in his stand-up, sees life through the eyes of a child; the former still is one. O'Hanlon adored the role and the opportunities that came in its wake, but until *Big Bad World* came along, he found himself haunted by Dougal – and he still bridles at physical comparisons. 'First of all, I would argue that I look slightly different to Dougal. So I can get away with it a bit because I don't have ridiculous hair, and without the collar and the rosy cheeks and the gear I can get away with it quite a lot. But people do associate

> !reland has a great reputation as a literary nation, where you walk into any pub in Dublin and it's full of writers and poets. In most other countries they're called drunks. I was on *Desert Island Discs* and Sue Lawley asked me what two books I'd take on to a desert island and I said the first book would be a great big inflatable book and the second book would be *How to Make Oars out of Sand*.

me with him and it's fair enough. Some people, who don't know I was a stand-up before, have their reservations, and as far as my writing a book is concerned they just dismiss it out of hand: how could that dipshit write anything? But I've no complaints about *Father Ted*, none whatsoever, because it was a great break and it was very enjoyable and it's something I'm proud to stand over and I think it's a great sitcom, a potential classic. And I know that as long as I live, I may never do anything as good again. But that wouldn't stop me from doing what I want to do and not allude to my past as Fr Dougal at all.'

After *Ted* he was offered 'a lot of these sub-*Friends* scripts and they just weren't very good and they showed very little imagination. I had been absolutely spoiled by *Father Ted* and I didn't want to follow it up with a mediocre sitcom. I must stress that I don't want to just do TV from one end of the year to another, back to back, one mediocre show to the next – game shows and panel games and chat shows and everything. For me it's very important to resist all that as far as it is practical. I have to do a certain amount of TV if I have something to push, otherwise nobody will know you are doing anything, and that's fine. But then *Big Bad World* came along and it was very different, six one-hour dramas. The characters are much more fully formed than the caricatures of *Father Ted*. It's an acting role. Somebody presented me with this thing and I thought "I don't know if I can do it". I have various theories about acting which I implement, and maybe I disgraced myself and maybe not, but it's fascinating.'

Big Bad World was written for Carlton, the ITV company, by Nicholas Martin, author of *Between the Lines*, and O'Hanlon played a London-Irish journalist writing for a women's magazine and the plots dealt with the concerns of four thirtysomethings. The script was gently witty, with some poignant scenes; the *Guardian* described it as 'a vehicle – shall we say a Renault Clio? – for the Irish charms of Ardal O'Hanlon'. He was working with well-established, trained actors, but the experience held few terrors for him. 'As someone who is a comedian, not an actor, it is fascinating to watch all the different approaches and techniques. If I was a wiser person, I could spout on about acting and my lack of respect for it in a way. I read a book about acting and it said you don't really need training – just speak

clearly and don't bother with anything else; that's your job, and that's always been my attitude to it, certainly through *Father Ted*.'

In *Big Bad World*, the differing acting styles – between trained and untrained actors – were apparent, but O'Hanlon acquitted himself well, and that disparity suited the character he played. 'You don't agonise over it. What's inside you is going to come out anyway, and that's what you trust. But that's not to say everybody could do it if they applied the same principles. You don't learn it, you can't learn it and it's pointless trying to learn it. I've seen actors practising every little gesture, and they're going to be extremely disappointed when every little tic, every little inflection, isn't in. That, to me, is too studied an approach, so the only way – for your own sanity – is to say "Well, I've got to go in there and do this stuff" and hope that you concentrate enough and get it right. It all comes back to being a stand-up. If you've done that, then nothing else can faze you really. Also, it's a great safety net to fall back on – this is what I *do*, you know? I don't have to go through that horrendous pressure every day of going to auditions for plays and TV roles and constantly getting knocked back. My view is that I stay at home and write comedy. I've convinced myself that I don't care. I've persuaded myself that I'm a comic, and if someone wants me to do something else – well, maybe I will. I primarily see myself as a stand-up.'

O'Hanlon's *Father Ted* colleague, Frank Kelly, thinks there is more to it than that. 'Ardal is a funny man. He's also a very clever person. He masquerades as a lackadaisical, laid-back person, which in a way he is – he doesn't go in for stress. But he actually has a terrific observational capacity, and he has that rural thing of watching and listening, and a slowness and a cuteness that he puts over cleverly. And if you watch Ardal, he will do eight different things with his face and his eyes in a few seconds. There'll be disbelief, wonderment, credulity, let-down, sadness – he'd do the whole range in a few seconds, and you can't do that without a good brain. That's not just instinctive.'

His novel *Talk of the Town*, published in 1998, was, he says 'kind of an over-reaction, probably, to the whole Fr Dougal image, and there was also some left-over bitterness and anger that I had about growing up in rural Ireland and it was very important to get all that off the chest.' It concerns the agonies of a small-town 18-year-old living in Dublin in the 1980s, for whom everything goes horribly wrong. 'I would be far more interested in the next book I'm writing,' he says, 'which is more of a satire.'

Some Irish comedians, envious of his meteoric success, have called him 'jammy', and O'Hanlon is acutely aware that luck and timing have played their part in his story. 'There's so much money around. That was a huge eye-opener to me when I left Ireland because I was on the dole when I was there and on the dole when I went to London five years ago. I never thought I'd have any of it, any of the

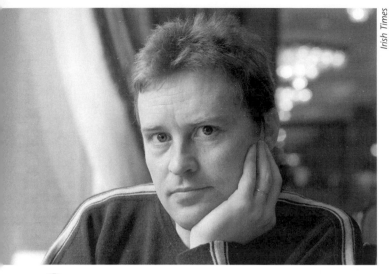

'We're just hilarious, really . . .'

cake. But it just makes everything a lot easier. Remember that when it happened to me I was 28, 29. I wasn't star-struck at that age, I was jaded and cynical about everything when I left Ireland – I think Ireland does that to you. Certainly, when I left for London my eyes had been opened and I had no illusions. Any attention that came my way at that time was too late for me – I wanted that attention when I was 22, when I was single. Fame was a not unwelcome side-effect, but for me it has always been the work. The only thing that has ever been important was the gig, the audience reaction, the gag I wrote that day – did it work?

'I'm very focused in that way, enjoying the whole process from beginning to end, and I suppose that I was getting completely bogged down in it all, and it wasn't until a couple of years ago, when I got married and had a child, that I was able to scale it all down and just enjoy the whole thing a bit more. Before that I was preoccupied with it all.

'I still think people in Ireland don't know that I'm a stand-up. In Dublin they probably do a bit because I've done the Olympia and the Gaiety, but I've appeared very little around the country, really. And people associate me with *Father Ted*, though that's not a source of regret or anything. I left Ireland long before this current boom in stand-up. But I just love coming home and not having to do any work.'

Asked why he thinks Irish comedy is so popular now, the answer he gives is typically O'Hanlon – a touch of the diplomatic politicising learned at his father's knee, an honesty, a bit of insight and, finally, one of Dougal's flat statements of fact: 'I suppose one of the things about Irish humour is that it infiltrates every walk of life. People conduct business only after they've slagged each other off or exchanged jokes or wound each other up in some way. Slagging is a particularly Irish thing. I hate to say this, but we're not that different to the English, really. It does happen in England, too – maybe it's not as pronounced – but there is something about the way that humour is a currency in our exchanges in Ireland. But you can theorise until the cows come home and it won't get you anywhere. We're just hilarious really, and that's all that matters.'

Karl MacDermott

Ireland's leading James Finlayson impersonator

Who on earth is James Finlayson, and what has he got to do with Karl MacDermott? Well, the latter, one of Ireland's most elusive and beguiling comedy talents, occasionally impersonates the former, the bald-headed, beady-eyed, apoplectic old coot with the bristling moustache who terrorised Laurel and Hardy in some of their most famous movies of the 1930s.

Why does McDermott feature him, plus other film buffy names – like Ethel Merman and Peter Lorre – in his act? His explanation is that when he was a teenager in Galway in the 1970s – single channel-land – he never saw the TV shows – *Monty Python, Not the Nine O'Clock News, The Young Ones* – that influenced a generation of comedians. Nevertheless, he thirsted for comedy, and took it where he could find it. 'That's why I love the old stuff, because it's the only stuff I could see. RTÉ used to show Bilko, they used to show the Marx Brothers, Laurel and Hardy. There was no new comedy on RTÉ.'

These ancient but timeless comic images lodged in his mind, and as he matured they became incorporated into 'real' life for him – current affairs through the eyes of Groucho, for example – and that is how he came by his unique style: monologues that deal with either events of global magnitude or personal significance but remain rooted in the 'other' world of Hollywood. Not all his characters belong to Tinseltown's past, though; Robert de Niro,

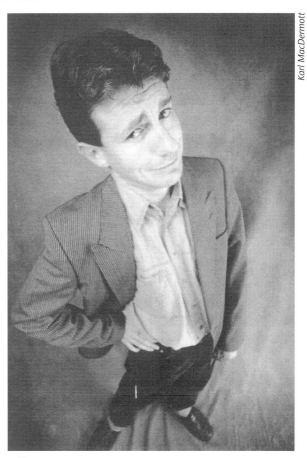

Karl MacDermott

'I'm a good performer, but I make my own rules.'

Laurel and Hardy are no match for MacDermott's hero, James Finlayson

'but Karl MacDermott's stay in Klaus Barbie's Bolivian bathroom is a highly entertaining romp through original material. MacDermott is an exhausting, one-man cabaret show . . . strange but watchable. A welcome new face.'

There was another show, *Monrovia Monrovia*, which premiered as part of the Dublin Theatre Festival in 1991 and in early 1992 MacDermott embarked on a tour of comedy venues in London, an experience that proved disillusioning for this gentle, thoughtful comic; if he imagined that London audiences were sophisticated enough to catch the more obscure of his old movie references, with the mood set by scratchy Al Bowlly records before the act started, he was soon disabused of the notion. 'Cheap stuff that gets a huge response depresses me. The audiences don't discriminate. A lot of it is gutter, and maybe that's what you should do – go gutter; that's the secret of comedy. I did presume there'd be a big enough market for quirky, slightly less mainstream references.'

He describes *The Mahaffys* as *The Simpsons* meets *Ballykissang*el, and that is close to the mark in some ways. Karl MacDermott created the world of Tubberbiggle, and the Mahaffy family. Cora (Pauline McLynn), the Mammy, runs the B&B and shortens trousers. Her husband Jack (MacDermott assuming a 'Daddy' voice) is a driver for the local bus company, Gus's Buses (later Roche's Coaches). Son Kieran is a student; the other son, Malachy, doesn't do much with his time, other than say 'what do you mean?' in a teenage angsty kind of way. Aunt Ena is a wonderful creation – her only communication is a high-pitched manic giggle. Other regulars are Fr Des Hennessy (Conor Lambert) who appears to host every single programme on Tubberbiggle FM, and twin brothers Lar and Finbar Lamarr (Jonathan White) who run Lamarr's Bar and are never in the same place at the same time.

Commissioned by BBC Scotland through Radio 4, and recorded in Dublin, it was cleverly and tightly scripted, with a standard sitcom structure, and managed to set up characters and situations – main and secondary plots – in 15-minute episodes and still be offbeat and funny.

Another script of Karl MacDermott's, the short film *The Big Match*, directed by Martin Mahon, was shown at the 1999 Dublin Film Festival and later on RTÉ. A comedy about a man who is obsessed with football, and who also has a heart condition, MacDermott enthusiastically 'talks it up' – 'It's more a scone than a soufflé. It's the *Heaven's Gate* of short films.'

The Eeyore of Irish humour is characteristically pessimistic about today's comedy. 'There are so many comedians now and it's become an industry, like pop music, where people go "Hey, I wanna get involved in that because it's sexy". It's all about image, what you wear on stage. Mark Lamarr – very strong image. I'm personally not too sure he's got much of an act, but it's a very strong image – he's got the hair, he's got the look, and that's the way comedy is going and I think it's a bit tragic. Lots of their act is banter with the audience – for me, that's not comedy. I'm a purist. That's why I never really hit the stand-up thing. Somebody said once that a stand-up is like a cowboy trying to organise a herd of wild bison into a pen. It *is* like that. You've got to tame these people. Great stand-ups are guys who can cope with any development in the environment, whereas I never really had that ability to go, "listen, call that a hairpiece, missus?" or whatever. That was actually one of my better heckle responses! I was too mercurial, too many things, too many influences – a pot pourri.'

MacDermott is greatly admired, in a kind of despairing way, by most other Irish comedians. One, commenting on his attitude to other comics on the bill, says: 'He's like one of the guys from the Sunshine Boys' – adopts crazed Walter Matthau whine – '*He's giving me the finger . . .*' Barry Murphy says: 'He's a great performer, more an entertainer than a true comic. He was around when the attitude changed and the big money started to come in and the camaraderie went. Karl was one of the

mainstays of the Cellar and was much loved by Trellis, by Dermot, by Alex and Dylan, and then this new breed of comic came along and Karl was kind of pushed out of the Cellar by this newer breed. But I love Karl. It's a sad story, but it's self-inflicted to some degree.'

Ardal O'Hanlon says, with an affectionate smile: 'He's Woody Allen's twin brother, isn't he?'

MacDermott is busy writing film scripts, and his stage work is confined to occasional stand-up rather than one-man shows these days, which is a loss. He explains with typical moroseness: 'It's a totally different era. I do the odd gig now, but it's like I'm Gerry and the Pacemakers and we're in the punk era.'

The Nualas

*'To cover up the ticking of our body clocks, we're
wearing soundproof knickers on stage tonight'*

You could almost be in Las Vegas. Three young women in spangly short red dresses skip on stage to wild applause. There's glamour and perfect harmonies and sexiness. But what about those awful dark-rimmed glasses they're wearing? And are those *runners* on their feet? One minute it's a song about wild sex on a Spanish holiday with Manolo (who turns out to be Anto from Ballymun). The next they've gone all rural, with references to Never Mind the Bullocks.

The Nualas, Ireland's all-girl supergroup, agricultural Spice Girls on acid, have created yet another little world of their own, and it's one with a delicious duality. On the one hand Nuala, Nuala and Nuala are nice, naïve country girls – sort of Irish Nana Mouskouri meets the Singing Nun types – who in some incarnations live on a farm but have this musical sideline. On the other they are very much today's women: strong, ironic, sexually aware. 'We're Catholic country girls but we're hip to the groove. We're sexually open, but we have the country earthiness. It's a real

nineties thing.' That's Nuala Anne talking about what they're at. It's a parody of a sort of Irish girl who may never have really existed, and an accomplished comedy musical act as well. Their songs are sung with the deepest sincerity but are mostly totally absurd, as in 'Donald', a yearning paean to the actor Donald Sutherland:

> *I go out shopping and I seem to see your face at every till.*
> *I load my car up, I reverse and you're the child I almost kill.*
> *And in the churchgrounds when I'm walking I look up and you're the bell.*
> *And in confession Father Pat says that he fancies you as well.*

The Nualas are Anne Gildea, Susan Collins and Susanna De Wrixon. Anne and Susan have been Nualas from the start (they were associated with the Cellar, having worked in comedy/drama/music for some years before Nualification); in late 1998 Susanna took over Nuala 3. The ironic prudishness married to worldly earthiness is more than just a good joke: The Nualas are fine singers and accomplished actors, and they work hard to get the parody right. Gildea: 'We are relevant because we tie in so many different cultural things, quite by accident. We really have our fingers on the pulse in a way – there are so many girl bands around now. But we're a bit older, a bit heavier, a bit hick. Look at Ireland now; economically we have this confidence. When I went to England, being Irish was different; now, it's the hippest thing in the world. And Irish people are really, really confident about their identity now, and we express that. Women love us when we make jokes about Weight Watchers. One of the biggest laughs is when we mention the girdles we're wearing, and Sue used to pull her dress tight over her body and say

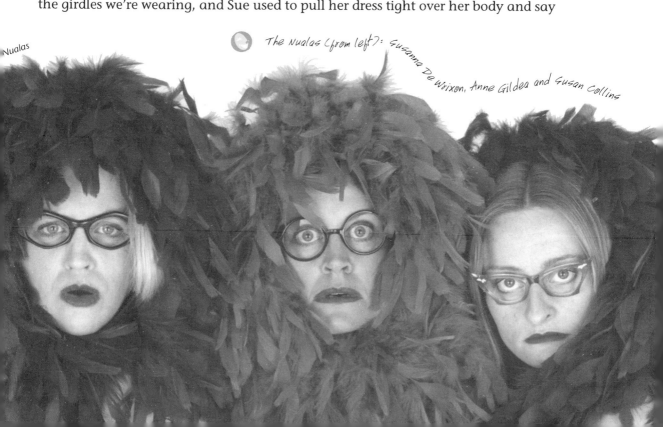

Nualas

The Nualas (from left): Susanna De Wrixon, Anne Gildea and Susan Collins

– No way would I have gotten away with wearing this dress on stage without my girdle. Then she'd stick her belly out.'

The act is specifically Irish, but also international. Anne: 'It's like nurses getting up on stage, but they're true to their roots.' When Anne Gildea was at college with Ardal O'Hanlon, Barry Murphy, Dermot Carmody and her brother Kevin, she, too, took part in the humorous college debating. 'I remember when I used to debate, I'd spend ages writing my speeches, quite wordy speeches, and it kind of flowed into a character I do in my stand-up called Máire Ní Prátaí – Maire, Daughter of Potato.'

For the Gildea children, the move from Manchester to Sligo was difficult. Anne was five and a half (their mother, from Mayo, still lives in Stockport, a few miles from Manchester). 'It was a small farm, a lot of hard work. Quite different to Manchester. I remember coming back and Dad taking us up to the bog on the second day. Can you imagine being a kid, going from Manchester and then you're suddenly standing – I remember, in my big wellies – on the huge mosses? It was a completely alien world and I hated it.' For how long? 'For ever.'

After finishing communication studies in Dublin in the late 1980s, she went to London. 'I had to get away from this, it was too depressing, and that's why I went to London, straight after college. As soon as I left, they started the Comedy Cellar.'

She temped, then went on the dole, did some drama courses, toured England and South Africa with a theatre-in-education project, went to Moscow with a youth theatre company. Back in London she set up another theatre company, Doris Karloff, with two other women, did some street theatre and comedy sketches, then left them and started doing stand-up on her own. It seems interesting and varied, but she says: 'The whole story of London sounds like I did this and I did that. But I was living in a squat in the Elephant and Castle. I was so poor, I did the shittiest jobs in the world, like cleaning on a building site, and working as a wench in a restaurant. It's so different now. I think that Irish people are used to a higher standard of living now, too. That's my story . . . it's a story of poverty!'

After going to drama college in London on a scholarship, she returned briefly to Ireland before moving back to London with Dermot Carmody, her then boyfriend. 'I went through a mad comedy phase in London for a year, just doing tons and tons of gigs and hacking away, doing loads of stand-up.' The relationship ended, and she came back to Dublin in the summer of 1994, wrote a show that fell through, met Susan and others involved in comedy, did stand-up and other bits and pieces, worked on Gerry Ryan's TV show on RTÉ.

The Nualas happened at just the right time. 'The Nualas was my saving grace. I felt: there should be something more than what I'm doing now. I still feel like I'm being busted around by the winds. Then The Nualas came together, and it was the most enjoyable thing.' Collins, too, confesses: 'I never really found my comedy voice until The Nualas.'

126

The group came about by accident in early 1995: 'At a party one night,' says Collins, 'we started messing around, had a few drinks. Tara Flynn got the guitar out and we were the last three left in the kitchen, food all round us, just jamming. We had the same sense of humour. We decided to meet up and see if it would work on a serious level. We got some songs together and booked our 10-minute slot in the Comedy Cellar.'

A friend of Gildea's made them tee-shirts with furry hearts on them. 'We bought the cheapest runners we could find,' she says. Collins: 'Gold runners for five quid each, and we all had little black skirts.' Anne: 'We were sitting in Tara's kitchen. I had done an improv show two weeks before where Mark Staunton called Michelle Read Mairead, and then by mistake he called me Mairead, and I had to say "we're the two Maireads". Subconsciously, we thought of that. Someone said we should be

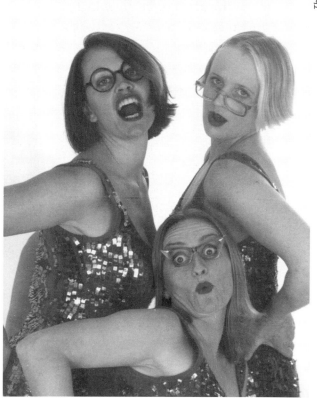
They create a world with a delicious duality

nerdy, and then someone said we should all wear glasses and someone else said we should all be called the same thing. Nuala was more resonant, and we liked the idea of being real sensible girls. It happened quickly, really organically.'

That was the basic genesis, but, in fact, The Nualas were born out of misery and depression. Gildea says, with feeling: 'The preamble to The Nualas beginning was I moved back to Dublin, and had split with Dermot. I was devastated and struggling along. Susan's mother was dying, and then died. Kevin had moved to London. I remember before The Nualas started, me and Sue being so depressed together – sitting in Abrakebabra on Baggot Street so depressed we couldn't talk.'

Collins: 'We had nothing.'

Gildea: 'Everything was really, really black.'

To add to her grief after her mother died – her father died in the late 1980s – for various reasons the entire estate was lost, and Collins had no money. 'I was working as a performer with really nothing. And it was huge depression. Kevin [Gildea, her boyfriend] and I have always had a very strong relationship and we still have, but

127

Nuala 1: This week we're talking about dealing with an audience. Audiences are essential. Never underestimate the importance of an audience. An audience can be the difference between a packed gig and an empty one. A band needs an audience like a tea towel needs a wet cup. But remember, you have to show them who's boss.

Nuala 2: If the crowd is very rowdy, just remember: you're the one in control. You're the one holding the mic. So just swing it out in the direction of the trouble-makers and give them a good wallop on the side of the head. That'll usually shut them up.

Nuala 3: Sometimes 'punters' fire things up at ya when you're on the stage. Always remember, these missiles are meant as a compliment. For instance, Chris de Burgh's audience throw Spam up at him. He loves it!

Nuala 1: One of the most important questions a band has to ask themselves is, should I jump off the stage and dive in on top of the audience? The answer is – it depends. Don't dive off the stage if: One, you're an opera singer, particularly one of the fat ones.

Nuala 3: Two, if it's an all-seated gig.

Nuala 2: Three, if you think the audience mightn't catch you. This happened to the Pope once in St Peter's Square. It was terribly embarrassing, and he really damaged his ecumenical helmet.

from The Nualas' BBC radio series, programme 5

he had to go to London. He had no money to come home to see me; I couldn't go over to see him. Jesus, to try and scrape together the fare of 70 or 80 quid at that stage – no way. We didn't know what to do. That actually probably was a real driving force, and when The Nualas came, we smelt it – that audience – that was the drive.'

The act, while retaining an anarchy of sorts, appeals to a wide cross-section of ages, and while it can be sharp, it is never vicious. They make no bones about the fact that The Nualas are a commercial proposition; the act started organically, but once they smelt that success they went for it in a focused, organised and professional way. The idea was clearly different. Their comic characters were appealing, the songs catchy and clever, and the musical standards high.

'When you mention The Nualas to any of the other comics,' says Collins, 'I warrant that a little glimmer of a knowing smile will come across their face. It's a commercial project. Some of the others have said "we always thought you guys went off and did your own thing and made it work". I don't know if resentment is the right word, but there was some feeling among stand-ups that we were doing

Whelan's pub and gaining our own fanbase and audience there in a way that none of the comics had ever done.'

When they did their first gig at the Cellar, they had no idea how things would go. Collins: 'Everyone was so excited for us. It represented the energy and the newness of people doing this brand new thing in the Cellar.' Things were hardly an instant success for The Nualas, but certainly some amazing things happened to speed them on their way.

Some time that July, they were in a restaurant debating whether or not to go over to the Edinburgh Fringe on spec, but decided against it because they had no money. But a stranger, eavesdropping on their conversation, came to see them in the Baggot Inn that night and said: 'I think you're great. I heard your conversation and I think you should go to Edinburgh.' His line was: 'I don't need another waterbed. I'd rather see you guys go to Edinburgh because I've been to the festival and I think you'd be kind of special, and something that would go down really well.' He rode over to Gildea's flat on a moped with the air tickets and a cashcard with £500 in the account. They promised never to reveal the name of their mystery patron.

So they went off to Edinburgh, says Collins, 'with a guitar. And we had no proper place to stay. We slept on floors, and we walked around Edinburgh for a whole week, doing free gigs wherever we could. And we stormed every single gig.' They got a spot in the Gilded Balloon and after that a series of gigs. 'It was the innocence of it and everything,' Gildea says. 'We had a feeling that the gods were smiling on us. It was the right thing – we were very lucky we had fallen into it.'

There followed a stint in the Dublin Theatre Festival Fringe – a 'Christmas Special' in October – and a run in Andrew's Lane Theatre. They returned – officially – to Edinburgh, where they sold out and got rave reviews. In 1998 they performed at the Melbourne Comedy Festival, the Adelaide Festival, the first Singapore Comedy Festival. The talk on stage about how their lives are now full of 'stretch limos, stretch jeans – and stretch marks'. 'We are very sophist – travelling the world. Part of that Irish supergroup set of Boyzone and B*witched and Big Tom and the Mainliners, the Corrs and all them.'

They wrote and recorded a six-part comedy series for BBC Radio 4 with Paul Tylak which they are following up with a second – less music, more sitcom based – series. They performed a live show – in a double bill with Jason Byrne – for Radio 4's New Year's Eve broadcast and in 1999 had a long, successful season at Dublin's Tivoli Theatre and two month-long runs at the Drill Hall Theatre in London, a big bid for British success. 'It was a bit of a culture shock coming back, but we eased in slowly. I was driving the tractor a bit too fast for a while – and Nuala's favourite bullock didn't recognise her, we were away so long.' The dizzy heights of a London run were clearly all a bit too glittery for the bitter (and twisted)-sweet trio. 'We

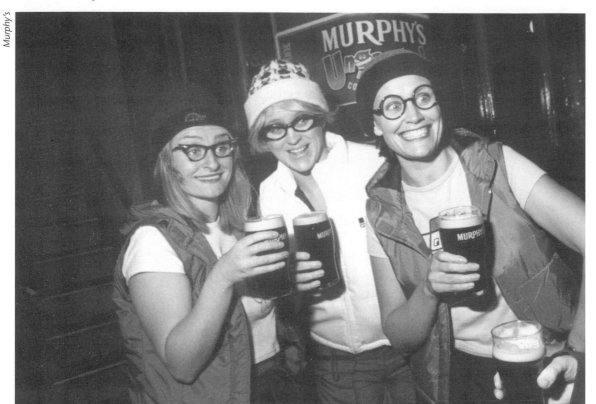

'In The Nualas we have found a way of articulating women's experiences in a funny way'

started smoking in London. We did all sorts of things, very mad. We started doin' coke in London,' Nuala says matter-of-factly. 'We started shooting up.' Along the way they secured separate Irish and British agents, and worked hard, writing new songs, developing the between-song banter.

Susan Collins's mother, who was so ill during that desperate time when The Nualas were born, was Audrey Parke, the leader of the RTÉ Symphony Orchestra. Susan's parentage was doubly musical: her father was Archie Collins, leader of the viola section. She was born in Portadown, her father's town (her mother was from Ayrshire), and grew up mostly in Dublin. It was towards drama that she, one of five children, was attracted, and after a stint in the Dublin School of Acting she worked as a straight actor. Funnily enough, she recalls Rebecca Roper, an early tutor, urging her towards 'comedy and music'. But 'I was disgusted at what she said. I wanted to be a serious actress. I couldn't believe it; I didn't know what she was talking about.'

She went to the Cellar with some other drama students and 'fell madly in love with Kevin Gildea'. Soon after they got together, he mentioned some improv classes at the City Arts Centre. She and Eddie Bannon (a customs clearance officer she had met at the Cellar) went down and signed up. Two weeks later she was performing with the Comedy Improv at the International. But while she enjoyed the improv, and found it wonderful to work in, 'I didn't have the confidence to really shine in improv and I think I took everyone by surprise when I joined The Nualas. It was my way of saying: actually, I am funny and I always could have been. I think I put myself into a little box in the improv.'

Gildea comments: 'It's so hard for women to articulate their experience in stand-up on stage – it's just not quite as acceptable. Often guys don't think it's as funny. But in The Nualas we have found a way of articulating women's experiences in a funny way that's not in-your-face. It's a perfect format for getting across funny aspects of women's lives.'

Collins: 'It does challenge – we're taking the piss out of ourselves, we're taking the piss out of the whole "women" thing but we're still remaining strong on stage, we're not being wimpy.'

Gildea recalls how in their Edinburgh show they had a line: 'To cover up the ticking of our body clocks, we're wearing soundproof knickers on stage tonight – and nearly every review took that as the theme of the show. That, and songs about men and relationships' – whereas their songs cover a whole range of silly topics, from Curly Kale (the girl with the cabbage for a head) to a cycling nun.

Susanna De Wrixon, the newest Nuala, also comes from a drama and music background – her father was a tenor. Born in Limerick, she was involved in drama in UCD, did a theatre diploma in Trinity and street theatre. By coincidence, De Wrixon had the same music teacher as Gildea and Collins – 'Sheila McCarthy; she's the best vocal trainer in the whole world,' says Gildea. 'She'd murder us for smoking,' says Collins, guiltily stubbing out a cigarette.

De Wrixon's career followed twin tracks in straight theatre and music – singing with a group called Will Swing. She first saw The Nualas in the Da club, where she was performing in a Kurt Weill cabaret show. As well as performing with the group, she was manager, which was a strain. 'And the beauty with The Nualas is that's not a strain for me any more. It's more creative.' She, too, has known the grind of poverty associated with life in the performing arts. 'I've done it for years in straight theatre – no money, rehearsing for six weeks, doing Shakespeare for a two-week show and getting £30 at the end for two months' work. You do it for the love of it. But professionally I absolutely understand where these two are coming from and I'm the exact same. Even though it's not a comedy background, it's still getting up there and performing, and in your guts you love it.'

Says Nuala Anne: 'It's a bloody hard thing to come into a group. I mean, we're

bitches! You know there's been two other Nualas – the rumours are all true.' 'It's like the drummer out of Spinal Tap. We burn her with the curling tongs,' says Nuala Sue. Nuala Anne: 'This is the first masochist we've had! All we needed was a masochist Nuala.' 'That's right,' says Nuala Susanna, 'Jesus, you should see my back! I can hardly get up in the mornings.'

The third Nuala was originally Tara Flynn, an actor who did some improv and singing, too. Later, comic actor Karen Egan replaced her. De Wrixon laughs about joining a ready-made concept after Egan left – 'I joined at a really good time! All the ground work was done and I slotted in!' But clearly it was no joke learning The Nualas' songs and being thrown straightaway into high-profile gigs.

And she did fit in. 'What I like about The Nualas,' says Gildea, 'is when we do a really good gig, we celebrate together, we share with each other. We share on stage, it's the magic of three people on stage.'

Next stop Las Vegas?

A Funny Business

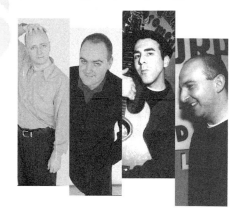

One day you wake up and realise that the whole world has changed, almost without you noticing it. It was not a sudden transition from a handful of performers ploughing away on the fringes of Irish comedy for a few quid, to the situation where Irish comedy is cool and sexy and making plenty of money. These days Irish stand-ups do big British tours; there were over 30 Irish acts at the Edinburgh Fringe in 1998; the annual international comedy festival in the small city of Kilkenny is thriving, and any number of smaller festivals are sprouting up; Irish comedians have moved into British sitcoms and films and several are diversifying into fiction writing; Linehan and Mathews are in huge demand for TV comedy.

Kilkenny's famous castle

How did all this happen? The truth about this 'explosion' in Irish comedy is that it is more an explosion of interest and recognition – also there was an earlier wave of comedy in both Dublin and London. Things were cosy but unadventurous, perhaps, in Dublin, and nothing very much was changing; 'It's easy to be a big fish in a small pond in Dublin,' comments Eddie Bannon, 'and that's the way it was for a while. Five or six comedians were at the top and they weren't making that much money and they were happy where they were and did the same routine every week and everybody was happy to watch that.'

Then something started to happen. Mr Trellis split up and individual members took the boat. Ardal O'Hanlon, Kevin Gildea, Dylan Moran and Dermot Carmody moved to London in 1994; Anne Gildea was already working the circuit there, and the Gildeas, O'Hanlon and Carmody were among the 16 finalists in the Hackney Empire Comedy Newcomer that year. They all did well: O'Hanlon won first and Kevin Gildea was joint third. In a way, that kicked off some recognition in Britain, because the exposure meant sustained work in clubs for the Irish comedians in the 'second wave' in Britain (the first being the Redmond/MacPherson generation).

Moreover, the comedians themselves realised they were good. 'England had a huge reputation in Ireland for being really one or two steps up,' says Bannon, 'so when people went to England they realised, this isn't as difficult as it's made out to be. Because of the nursery nature of Irish clubs, the talent was well developed and Irish acts started making names for themselves in London. And the money followed.'

This had an effect on those who stayed in Ireland, too; they started to sharpen their material and think about comedy as a career. Bannon reckons that, rather than a sea change in Irish society or anything momentous of that order, there was a change of attitude by 'the comedians themselves – saying "right, I'm grown up now and I'm 26 and I can't live my life like a 19-year-old". And a lot of them went across to London and started to make it over there and become big names and the people who were left back in Ireland were going "oh, am I going to be like this until

Bord Fáilte

Kilkenny: nooks and crannies

I'm 40?" A few people became a bit bitter because they couldn't be bigger than they were. Some people just reached the limit of where they wanted to go with this whole student thing, and some people just shot up.'

Simultaneously, Mathews and Linehan had moved to London and were writing scripts for the big names of British comedy, followed by *Father Ted*. The first episode was broadcast on Channel Four in April 1995. Over the following three years, a wider audience's perception of Irish comedy changed. This complemented live comedy in that almost every young (and some older) Irish stand-up in existence seemed to crop up in *Ted* at some stage (there were a lot of priestly roles to fill!): Ed Byrne, Jason Byrne, Kevin Gildea, Barry Murphy, Michael Redmond, Joe Rooney, Patrick McDonnell, Graham Norton and many others.

Those comedians also started to go to the Edinburgh Fringe, which has in recent years become a *de facto* comedy trade fair. A Perrier Award guarantees access to an enormous step up the comedy ladder. Sean Hughes won in 1990, and went on to TV fame in the shape of *Sean's Show*. Karl MacDermott took his innovative one-man shows over in 1991, 1992 and 1993, to some acclaim. This was the build-up to a full frontal assault by Irish comedians from 1994 onwards.

For a time it was like the Eurovision – an Irish act seemed to win, or nearly win, the Perrier every year. In 1996 Dylan Moran got the Perrier and the So You Think You're Funny? award went to Tommy Tiernan. Graham Norton was nominated in 1997 and in 1998 Ed Byrne was on the Perrier shortlist, along with Tiernan, who

actually won the award, and Michelle Read's show *Romantic Friction* won a Fringe First. In 1999 David O'Doherty won So You Think You're Funny? and Sean Hughes and Owen O'Neill a Fringe First. Many other Irish acts have cut a dash in what is a crucial forum for attracting agents, TV producers, talent scouts, booking agents and promoters.

Says London agent Dawn Sedgwick: 'Edinburgh now has a lot of internationals and Americans, so that's why it's really important to get your acts seen. Tommy and Jason were both spotted in 1998 by casting agents from the US. All the TV bods in London, who throughout the year can't be bothered to get off their backsides, will go because everybody is there in one place.' In 1998 Edinburgh was 'really swamped by the Irish comedy scene, a little bit too much. I think there's only a point in going if you're in a good venue and you've got the backing. Because you're up against so much.'

And then the cat laughed . . .

Meanwhile, back in Ireland, someone had 'a mad idea'. Richard Cook, artistic director of the Murphy's Cat Laughs Comedy Festival in Kilkenny, says when they were first planning it in 1994 there was 'a sense of absurdity surrounding the whole venture'. Cook, who runs the Bickerstaffe Theatre Company with Lynn Parker (they moved to Kilkenny and set it up from scratch in 1992), came up with a completely daft notion with Mike McCarthy. An American performer and writer who started his career with Chicago's Second City comedy group, McCarthy is associate director of the festival, and sources American acts for the Cat Laughs. It seemed crazy to imagine that you could have an international comedy festival in the medieval city of Kilkenny (population about 20,000), in the south-east of Ireland, and attract big US names like George Wendt (Norm in *Cheers*), movie star Bill Murray, Emo Phillips and Dan Castellaneta (the voice of Homer Simpson), as well as top British acts – Paul Merton, Jo Brand, Rory Bremner, Jeremy Hardy, Alan Davies – and a whole

sex, drugs, drink — and comedy

Billy Magra: You need a certain degree of intelligence to succeed and to enjoy your life as a stand-up comedian, how to handle yourself offstage. If you make it, it's a large amount of money in a 25-year-old's, 30-year-old's pocket. Of course, there is an element of late night activities – sex, drugs, rock 'n' roll; that's what gave it the edge, especially in the late 1970s and 1980s, and still now.

Brian Boyd: The main socialising place in Edinburgh, the Gilded Balloon, opens for drinking from midnight to 4am, and there's an early house called the Penny Black that opens at 5, so by the time you walk there from the Gilded Balloon it's open, and I remember clearly going to the Penny Black at 7 in the morning and seeing Ed Byrne, Tommy Tiernan, Barry Murphy – it's just normal. And we were there until 11. When Kevin Gildea was drinking, I'd leave him at the Penny Black at 11 in the morning with three pints in front of him. It's intense and heavy, but it's great fun, too.

The first thing you ask when you get to Edinburgh is who's not talking to who. There are fights. Someone is shagging someone else's girlfriend. Someone had a punch-up last night. Someone said someone else was a bastard and his act was crap and got punched. That sort of thing. There is a more serious drinking thing with some comedians but, again, it's a stereotype – the 'tears of a clown' kind of thing. Everyone wants to hear it – the man who makes us laugh and then walks home alone. There would be the same proportion of drinkers among actors or musicians. The nature of the jobs attracts certain types who have a higher statistical probability of drink or drug abuse. How often do other people finish work and someone says: 'Great – here's a pint?' It just doesn't happen. I also think that with comics there's a lot of self-mythologising. It's a bitchier world than acting, I think, especially over ripping off gags. The newer comics don't seem to drink so much. They're different these days; they're more mature. There's also a collective wisdom, where they've seen what drink has done to a few of the older comics.

Ian Coppinger: Edinburgh is like a mental kick in the teeth. You're out every single night drinking. Exhausted; don't eat much; doing shows – a fantastic time. You're in bits, in pain. But it only lasts four weeks.

Dermot Carmody: Another factor is drink. There's an awful lot of it in the comedy business, and since I stopped drinking two-and-a-half years ago there have been two relevant side-effects: 1. There's a lot more drink to go round everyone else who is in comedy and up for it. 2. Drinking establishments and drinking people are a tad tiresome for me to be around.

Comedy actor Pauline McLynn and her husband Richard Cook, artistic director of the Murphy's Cat Laughs Comedy Festival

raft of other performers, known and unknown, for five days over the June bank holiday.

People may have expected the worst that first year, but they got the best, and the Kilkenny festival has grown and thrived and built a reputation among comedians and audiences for quality performances and a relaxed atmosphere. Cook puts it down to their early decision not to have a competition associated with it, and to the fact that TV crews are discouraged from filming inside venues. The aim was to have a festival that was not dominated by the business of comedy, as other international festivals are, where performers were not 'auditioning' for TV roles, trying to impress agents and competing for awards.

Agents acknowledge this. Dawn Sedgwick: 'Edinburgh is still the business ground at the end of the day. Kilkenny is a big chance for the TV industry in Britain to go on expenses, saying "thank you very much for the weekend". You don't expect any work to come from it; you go because you're supportive of the acts.' And, indeed, people have commented that attempts to 'do business' did not work.

The idea originally grew out of the success of Bickerstaffe's production of *Macbeth* in Kilkenny Castle, and the desire to take on another big project, one which

would have broad appeal. Cook: 'I was racking my brains, thinking: there's an arts festival, a jazz festival. Looking back, it was obvious. Journalists were crying out to write about something different. Audiences were dying to go to something different from being herded into big mucky fields and queuing to go to the jacks. It was different and it was important for us to make sure that the quality they experienced was good.'

Cook knew little about comedy; he went to Edinburgh in 1994, then hooked up with Noel Faulkner, an Irish former stand-up who runs the Comedy Café, and Peter Graham, of the King's Head, both in London, who helped with booking British acts and assured comedians of his *bona fides*. Mike McCarthy was an essential element of the festival from the start – 'Kilkenny wouldn't have happened without him'. He'd met Cook while doing improv workshops at the Gaiety School of Acting in Dublin, where Cook was administrator. His link with American performers has made a distinguishing mark on the festival. His role is even more crucial latterly because TV means that lots of the British performers are familiar to Irish audiences, and it is the Americans who bring a breath of the fresh and unusual. 'He's a performer in Second City, ringing up his mates to come to Kilkenny, but it wasn't too difficult getting them! He's a writer, a great performer, a very funny guy.'

When he was in Edinburgh, Richard Cook had been 'seduced' by what he saw of stand-up – 'I thought I would love to get that quality and bring it to Kilkenny, and I was also aware that the liveness and the immediacy was something that you could never reproduce in the theatre. Trying to look at contemporary Irish culture is frustrating, because by the time you've got the show up things have moved on, even in the space of months.' Once the idea took root, 'I was really confident that it was going to work but I didn't know how well, or even if it would work on the scale that we wanted it to. As they say, Irish comedy isn't appreciated because so many people tell jokes in the pub – formalising the art is often sneered at because Irish people are witty. Comedy defines the culture of the country.'

Kilkenny, far from a mad place entirely to stage an international festival, turned out to be perfect. Cook: 'Comedy and fascism work well in small venues. Kilkenny is a small venue and I knew that the bulging at the seams thing was what would make it.' He got together a motley collection of spaces – rooms over pubs, hotel function rooms, nightclubs, a school hall. 'I went and said: Look, I've got this idea – can I book? Getting the venues, getting the comedians, then getting the sponsor on board, all of it dovetailed quite neatly. It was a lot of work, but I just saw it as a huge challenge and I had such a belief that it would go well because I knew how unique it was going to be.'

Nominally a city, Kilkenny is more accurately a large town, with two main, very long thoroughfares, at right angles to each other, with smaller streets and alleys off them, leading to interesting nooks and crannies (ideal for love trysts and furtive

spliff-smoking). The place is full of pubs large and small – indeed, one stretch of Parliament Street has about six or seven small pubs in a row. One of them is Cleere's, whose back room – the original home of Bickerstaffe – is one of the festival venues, and across the road is the Watergate Theatre, the city's recent purpose-built theatre, which generally hosts some bigger names in the festival. Off at another angle, across from Kilkenny Design, the renowned craft workshops and shops, Kilkenny Castle overlooks the town. Its magnificent grounds are ideal – in fine weather – for whiling away the daylight hours before the comedy starts. And when it starts it *really* starts: in up to 10 venues at perhaps two-hour intervals from 6pm until very late there are comedy gigs large and small. In between acts people stroll between venues, maybe stopping for a pint or a bite to eat. Then, after it's all over, the festival club goes on until the small hours. Like a lot of Irish festivals, it is something of a cultural and alcoholic endurance test. Alongside the big names are hidden treasures on secret bills, offering a diverse array of funny, obnoxious, daring, dull, challenging, offensive, skilful or freakish humour.

Cook: 'The first year three or four of us ran it, and we had two eccentric box office staff. At 6.50 on the first Friday of the festival I was in the office and the three

why comedy makes good business sense

Billy Magra: If you are a promoter in a club, or you have a room to sell liquor with a small stage, a rock band is trouble. They arrive at half-four or five o'clock, they trudge equipment up, they sometimes blow fuses. They've got people running around upstairs and someone has to go up and watch the bar. They keep on asking for more things – they want different lights or whatever. And then six different people have to be fed, or you have to look after them, and they have to be paid. You have to invest in sound equipment and earn that money back. But with a stand-up comedian the promoter can open the doors and switch on the lights, sell the tickets and get the people in, turn on the music and all you need is a spotlight and a microphone. So promoters right around Britain and Ireland twigged, and now there's a vast amount of competition in the stand-up comedy area. There's Murphy's, there's MCD, Pat Egan, Carroll's – they can put an ad in the paper for Ben Elton or Jasper Carrott or Ardal O'Hanlon, Dylan Moran, Sean Hughes, and they will still sell tickets at £10.50, £12.50, £15.50, and the overheads are so much less than for a band. And if they have to pay for flights and hotels, then they have a maximum – a star comedian may bring a lighting engineer or another technical person and maybe one other person, so the promoter pays for three hotel rooms, as opposed to a band, where you need somewhere to put equipment, plus 11 hotel rooms.

Comedians' football matches are a big part of Kilkenny, providing some of the most ludicrously unfit-looking teams in the history of the sport

administration phones rang at the same time and I knew that meant trouble, because the box office was closed. I picked up the phone and there were no lights in one of the venues; picked up the second phone – there were no seats in another venue; picked up the third phone and there was no sound in that venue, with 10 minutes to go. It could have gone two ways. The artists knew something special was happening and they were very relaxed about it and the audience just took it all in their stride. It was definitely the most exhilarating few days. Jon Kenny of D'Unbelievables, very drunk one night after a great gig, gave me a big hug and said "You've done a great thing for Ireland". I'll never forget that year; it was incredibly moving, staying up till 6am, smoking, drinking, *into* the whole thing, turning up at the Clubhouse Hotel and an old porter giving us drink on the stairs of the hotel till seven or eight in the morning.'

The first year may have been a massive success, but Richard Cook personally lost £70,000. 'I knew it might lead to huge debt, but I didn't realise how big it was going to be. But I knew that something special had been created. I knew that from the comedians, from the audiences, from the critics who said it was something really different, so I felt great. That's what carried me through. I was very upbeat at the end of it. It was just money.' He gradually paid the £70,000 off, and in 1997 actually made a little for himself.

That first year 'our main sponsor was Smithwick's, to a small extent, mainly through a deal that Guinness had done with the publicans where the latter would support whatever they chose to support, so it was all done through kegland.' The following year he approached Murphy's, which was developing a profile as a comedy sponsor. 'Then I announced in Kilkenny, which is a Smithwick's brewery town, that Murphy's were on board, and almighty shit hit the fan – extraordinary stuff.' He stuck with Murphy's, and the company has sponsored the festival since 1996. They have been good, supportive sponsors – 'They just said "here's the money, do nice things" ' – although, naturally, the aim was to maximise publicity for its brands.

With a success – even if not financial! – on Cook's hands, the following year had to match or better 1995. 'Every year it's been slightly more difficult. In 1996 it wasn't too bad; expectations were met because more people went. The year 1997 was difficult. For the first time I felt it had turned into this massive monster of an event which I had very little control over. In 1998 I was particularly pleased with it because we scaled it back and didn't have any one host or star that the festival was hinged on. People's expectations after 1995 and 1996 were just enormous.'

Murphy's

Chatting at Kilkenny – comedians Mark Doherty (left) and Dermot Carmody

But Cook is aware that you can have overkill, and his idea of the festival's development does not involve continual expansion. He says he wants to maintain standards, not allowing quantity to swamp quality. Indeed, the city of Kilkenny has tended in more recent years, as the success and word of mouth grew, to be somewhat swamped, and almost unable to cope with an influx of up to 30,000 extra people turning every spare bedroom into a bed and breakfast.

'There's a lot of people who go to so many festivals because it's crack and it doesn't matter what it is – I want to root those fuckers out and I want the people to come that are just really into comedy. I want the comedy to remain the centre and the core of the festival and then I believe that people will still continue to come. And I've no interest in the people who might go to see comedy, but if it's fine stay outside drinking. They have no interest in my passion – I've no interest in their drinking habits. I love the idea of people coming back to something because they had a good time, rather than because there's massive media coverage of it.'

Cook talks about scaling back. For the 1998 festival the sponsorship budget, excluding advertising, was '£127,000 – that's a lot of money for an event that lasts five days in a city of 20,000 people. I said to them that for 1999, £87,000 is fine. We've got to be more discerning now about who plays the festival, because otherwise the audiences are going to come back and go "oh yeah, same faces". The 1999 festival had fewer comics on the bill, in a bid for the 'discernment' Cook talks about; it also included some innovations – an open-topped bus tour of the city hosted by comedians, and a mini-festival of cartoonists.

'There's a limited number of stand-ups. It does become increasingly difficult to keep motivating yourself to be as dedicated and committed to your chase for new talent. Because the more bad comedy you see, it does get to you after a while. Pauline [McLynn] has said that jokes are like umbrellas – they don't really change, they just keep getting passed around. Then when you do see something original you go "yes, I'll have that, please". You have to keep being thorough in your research and also go to places whose comedians wouldn't be as exposed in Ireland – like Canada, New York.

'Kilkenny is a great place. The size and scale of a massive event in a place as small as Kilkenny is what makes it. You wander around, and there's Paul Merton having a cup of coffee, or you bump into Dan Castellaneta, or there's Norm walking down the street, or Woody Harrelson in the queue to buy a paper.'

Money talks

Kilkenny started and thrived because of a developing audience for comedy, which had been stoked by the success and profile of young Irish performers, but it also in turn further supported comedy and gave it an added zip and attraction. All this led to a recognition of comedy by audiences – which were growing, in Dublin and further afield. And with audiences came more money for performers – sometimes rock 'n' roll-type money. You hear figures like two grand, six grand, 10 grand and more, for the bigger names, such as Moran, O'Hanlon, Kielty and Tiernan in large city venues. Whereas in the mid-1990s comedians might get 30 or 60 quid for their 20-minute club slot, the money went up to nearer £100, and £160, the going rate

in London, for the Laughter Lounge. Dawn Sedgwick: 'From the Irish perspective, the budgets that people assign to it are becoming on a par with theatre and probably more, and production costs are so much less.' And with the money there, comedy is no longer always a path to impoverishment via creative fulfilment, but what is often scathingly called a viable 'career option' for the people with the skill and the bottle to do it. Naturally, there are some who are high on bottle and low on skill – Ireland also has its fair share of comedians who are indifferent, lazy or repetitive.

And the venues increased all the time, some coming and going, but a lot with staying power, so that an Irish circuit developed. In Dublin, clubs include comedy at the Da Ha Ha, in the Da Club, Ha'Penny Laugh and the Battle of the Axe at the Ha'penny Bridge Inn, Murphy's Corduroy Comedy Club in the Norseman pub, the International Comedy Club. A new venue, Vicar Street in Dublin's Liberties, hosted the Guinness Sit Down, Stand-Up Comedy Festival in March, and D'Unbelievables later in 1999. Outside Dublin, too, clubs sprang up – in Galway Cillian Fennell and Pierce Boyce set up a club in the early 1990s (Fennell later went on to work as producer of *The Late Late Show*, where his interest in and support for new comedy was evident), and later MC and comedian Gerry Mallon continued with a successful Sunday night club in the GPO nightclub with visiting British acts, Irish comedians and occasional open spots. In Cork Brian Coughlan has run City Limits, which has a terrific reputation, in the Ashling Hotel for many years. Meanwhile, in the North, Jackie Hamilton set up the Empire Laughs Back club in Belfast in 1992 and, later the Crack's 90, which has since closed, in Derry.

The audiences are there to support these regular clubs, as well as the huge crowds for the big gigs, and the media interest in comedy sometimes seems like overkill. From a business point of view it makes sense – comedy is cool, the revenues are there in a buoyant economy, and the set-up costs for stand-up are considerably lower than for live music or theatre. And along with the audiences and the money came sponsorship. The comedy audience is generally young – 18 to 45, a mixture of students and working people, who have disposable income, so it is obvious territory for sponsors, and especially alcohol and cigarette companies, whose budgets bulge in a bid to attract that target category.

The first real comedy sponsor was Tennant's, which sponsored Magra's Gasworks club in 1990 and 1991, and Harp sponsored some comedy tours in the early '90s, but it was in the mid-1990s, along with the bigger success, interest and audiences, that other sponsors have come to dominate – Carroll's sponsored the Irish heats of the So You Think You're Funny? competition, campus tours and the successful mini-comedy festival as part of Dublin Theatre Festival's fringe. But it is Murphy's which has come to be synonymous with comedy in Ireland, starting in 1996 with the second Cat Laughs. It also sponsors individual gigs, a series of

successful campus comedy tours, clubs like the Corduroy and the GPO (but not the Cellar yet!), comedy feature pages in *In Dublin* and *Hot Press* magazines, and the first comedy-dedicated venue in Ireland, the Laughter Lounge, which opened in January 1998.

In 1998 Murphy's took another step by organising, in conjunction with promoters MCD, a series of 'Ungagged' mini-comedy festivals, held over long weekends in Kinsale (Co. Cork), Cork city, Galway and Dublin. Along with up to four or five headliners in big venues each weekend – people like Patrick Kielty, Paul Merton, Ben Elton, Tommy Tiernan, Dylan Moran, Ardal O'Hanlon, Rob Newman – there are 'pub trails' with mixed bills of lower profile Irish and British acts. The Murphy's sponsorship is generally seen as hands-off – in other words, they do not censor or try to dictate terms but have been financially very supportive in return for an association of their name with a cool, new and popular entertainment.

But Richard Cook, who has his own viewpoint and is never a man to mince words, says: 'Ungagged is Murphy's trying to plug the shit out of comedy, which makes sense for them strategically. And MCD would put three dancing carrots on the stage if it was worth their while – they're a business, a commercial management, and they've teamed up with Murphy's. I'm not interested in doing anything like that – the same acts appearing in all these different places. What I want is that when any comedian comes to Kilkenny they feel it's a really special gig, unlike any other that they do during the year. What Murphy's are in danger of doing is overkill. If they're smart, their association should be with bits of magic and comedy. I have a relaxed view. I don't begrudge Murphy's throwing money at these things. If it works for them, it works for them, but I know, looking at it, there's no magic there. I don't view it as a threat; if anything, in a live context it's probably opening up people's perception of stand-up – the more people that go, at least they become aware of it.'

Comedian Dara Ó Briain also sounds a cautionary note about the fickle nature of the comedy business: 'The one big fear is that this really is a Celtic Tiger industry at the moment, and once the economy goes we will be seen as luxury goods of the highest order. And it is a bit monopolistic at the moment – there's just a little too much Murphy's, so if they get a whim that live music is the new comedy, then that could close us down. There'll be a shake-up at some point, but no less for people who run rickshaw companies in Dublin. And on the scale of importance, maybe comedy is slightly below rickshaws.'

Not-so-secret agents

Along with the rock star crowds and the rock star money for some (and decent pay for the rest, so it's finally possible to make a living in Ireland from comedy), came the rock star agents. Well, perhaps not rock star agents, but the sprinkling of British agents representing Irish acts has increased, many of the top agencies have been courting the acts that are seen as the most successful, and a new Irish agency is doing good business.

Way before the present boom, back in 1991, Dermot Carmody and Mark Staunton's attempt to organise a co-op, Too Too Solid Flesh, aimed to get better deals for comics. Carmody: 'Comedians – a tight-knit and tiny band in Dublin certainly at that time – were sick of feeling hard-done-by at the hands of promoters. Mark and I tried to set up something that would be run to the benefit of comedians. We had a master plan involving a small circuit in Ireland which would benefit everyone in the long run. I think some people thought we were just getting gigs for ourselves – a misapprehension which arose from the fact that Mark and I went on loss-making initial outings to venues around the country. Basically, we were on a hiding to nothing – everything, including us, was probably just not developed enough at the time for the venture to work. It was worth a shot.'

But that was then. Today comedy is bound up with agents. Of the British agents, Dawn Sedgwick has been most associated with Irish acts. Her independent agency handles a small number of performers on whom she concentrates a lot of attention to strategically plan a career rather than act merely as booking agent. 'We always tried to keep the agency very small, dealing with people whom we think are going to be really big – I don't see the point in taking on 100 acts and only 10 of them making it. So I'm quite choosy, not in an arrogant way, more in a cautious way. When I didn't see any acts in Britain whom I thought had the "X factor", I suppose it was natural for me to look to Ireland.'

She also seems to go for performers who have the potential and intelligence to diversify – into fiction-writing, TV and film acting. 'We have a more personal management, to try to bring out the best in people – we're not interested in just putting them on TV straight away, just to get them on it – we want to try and give it a structure.'

In her 30s and quiet-spoken, she is known as a formidable person to deal with; having her steer your comedy ship keeps you off the rocks. She keeps in close

contact with her charges – talking daily on the phone with some of them. 'They call her Mammy,' remarks one comedian about a couple of her acts, adding that in Edinburgh she bought one a woolly jumper because he had come ill-prepared for the Scottish summer.

She started to handle her first Irish client, Ardal O'Hanlon, soon after he moved over to London and won the Hackney Empire competition. 'I booked him a gig as a favour because one of my oldest, best friends in Ireland recommended him. A friendship emerged before a work thing and I suppose for Ardal it was a natural progression, because I was helping him.' O'Hanlon proved a hot and successful comedy property. 'That really gave me a foothold in the Irish scene, because it was the year he came over that the others were testing the water in Britain and Dermot Carmody and Kevin Gildea did very well in the same competition. So the second wave of the Irish explosion happened that year because of the three of them doing so well in the Hackney Empire – and it was such a strong competition. I started going over to Ireland quite a lot.'

Tommy Tiernan and Jason Byrne she took on a few years later. 'When I spotted Tommy first in Kilkenny, he was very new and raw. I kept an eye on him and took him on four months later. Jason I saw the same year and waited until he was ready.' Colin Murphy was a more recent addition to her books.

'It wasn't a conscious thing of leaning on the Irish side – although, to be really upfront, no one else was doing it – we took on people whom we thought were good. But the reality is that we did lead the market because no other agency was doing it. But it was purely by chance; it wasn't a case of "hang on, we'll do this for a special niche", but we ended up having it anyway.' Sedgwick also handles some work for Joe Rooney, and, as well as TV shows, produced *Young, Gifted and Green* for the Edinburgh Fringe for several years. 'I suppose that's why my name is connected with Irish comedy – because we bring over new acts and give them a platform.' The Edinburgh shows were a package – 'selling it by a clever-clever title was a business thing. The Irish theme is so strong. There are more gigs now in Ireland, but at the time it was just starting the Irish performers were so advanced, compared to Britain, considering they didn't have the opportunities. That's what I found interesting and that's what caught my eye – when I saw Tommy and he was brilliant after four months of performing. I think the comics see it as a career, not just something they want to do to have a good social life, and now other agents have picked up on it, so there's a bit of a spotlight on them.

'There are more opportunities in Britain if that's what they want to do. From a business point of view, obviously it's good for me to have them over here working but I actually think it's sad that all that talent is in Ireland and it's prepared to let it go. Which is why we formed Third Screen [a TV production company] to try to do co-productions between the two countries. We were keeping our foot in both camps,

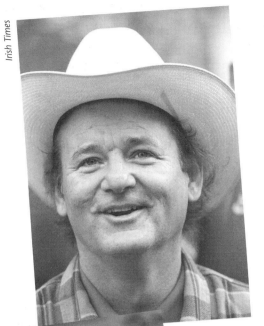

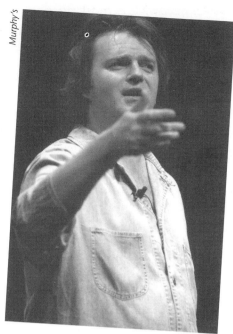

Guests at Kilkenny have included movie
star Bill Murray, Paul Merton and
George Wendt, 'Norm' from 'Cheers'

for the artists as well. From my point of view it's important for the likes of Tommy and Jason that they do keep their profiles up in both countries, because I don't see the sense in just taking them away from Ireland.'

On the appeal of Irish comedy, Sedgwick says that 'I don't know, thankfully, any established Irish comedians who actually don't do any really interesting lines. There is a natural wit I've noticed in the comedians and the ability to relate stories, but they don't go for the common denominator. They all have that literary tradition, and I don't mean that to be a cliché at all – that inherited eloquence with words – and they are very bright. I suppose it's making themselves heard in what was once a conservative country but is now progressive in all ways, not just in entertainment. The world is suddenly waking up to the fact that the stereotype of Ireland, tucked away somewhere, where everyone is very twee and wears green, doesn't exist. Suddenly it's – Christ, all this talent in a small country.'

Dawn Sedgwick is most closely associated with Irish comedians, but she is not the only London agent to handle Irish comedians: Dylan Moran and Sean Hughes are both with PBJ, the Hole in the Wall Gang with the Peter Stone Partnership, Graham Norton and Mathews and Linehan with Talkback, The Nualas are with United Artists (as well as Irish music agent Pat Egan), Andrew Maxwell with Real Talent.

And in early 1999 an Irish-based comedy agency was set up by Flee – Carolyn Lee – and Peter O'Mahony, who owns the Laughter Lounge. Flee, who had worked in music, arts festivals and especially comedy in her native Australia and in London and Scotland for 10 years, moved to Ireland in 1997 and married Eddie Bannon, whom she met when he was performing in Melbourne. 'I realised that there was absolutely nobody who was representing comics in any way,' she says. 'They were all managing their own diaries and getting ripped off on fees, not getting publicised and not many being able to go to Australia or do gigs in London. I became an agent for Eddie's friends and started out with about five of them.'

Quite separately, Peter O'Mahony of the Laughter Lounge, having found how hard it was to book some of the Irish comics – 'if you wanted to book 12 people, there were 12 different phone calls' – thought an agency was an obvious idea. They got together and set up ACME (Acme Comedy Management and Exploitation) – a title picking up on the search for excellence (as well, perhaps, as the cartoon connection!), initially taking on a dozen acts that they felt could develop a larger profile – comedians including Ian Coppinger, Mark Doherty, Dara Ó Briain, Deirdre O'Kane, Barry Murphy, Joe Rooney and Brendan Burke.

The move was generally welcomed by the comics. 'Flee came in with no hidden agenda and people got to know her and trust her before the company was started, and the same with Peter,' says Bannon. 'As a comedian you test the water to see how good or honourable people are and Peter and Flee were trusted by comedians. And they have a feel for what Irish comedians want – English agents just try to push you on gigs, it doesn't matter where they are – you could be travelling from Cardiff to Newcastle, and there's not too many of them sitting down and thinking: What is good for this particular person to get involved in?'

Flee echoes this: 'I say to Irish comedians not to do that circuit around England because continually going round and round you see the comedians get a bit bored with their delivery. They're not really learning or writing new stuff, they're just catching trains every day from one end of the country to the other, whereas here things are well spread out. There are lots of tours going on; Murphy's are a nice sponsor and Carroll's sponsor stuff, too.'

The impetus for Murphy's Laughter Lounge came from the venue rather than the idea. O'Mahony, whose background is in printing and telecommunications, and who was initially based in London, was offered the chance to buy the old Screen at O'Connell Bridge cinema in central Dublin, which had been empty for four years. He wasn't sure what he wanted to do with the building, but over lunch with friends in London, brothers Andrew and David Tyrell and comedian Malcolm Hardee, who run the Up the Creek comedy club there, he came up with the idea of a dedicated comedy venue. Central to the club were both the Murphy's sponsorship and the link with Up the Creek. The latter, for some practical advice – not to stint on sound or lights, keeping the stage as low as possible to minimise the feeling of distance between performer and audience – and the fact that they were able to 'tag onto' the English club, 'as if we are an extension of the London circuit'.

'Malcolm has been able to sell a trip to Dublin as "well, you'll be getting the same money as you would in a London club" with a good weekend in Dublin and a guaranteed three nights' work,' says O'Mahony. 'And Dublin has such a reputation as a good-time city that we've had no resistance in getting top comics.' Interestingly, London gigs were the lowest paid in the UK in the late 1990s – figures like £170 a night in Jongleur's, £160 in the Comedy Store – because there were so many acts there and it was easy to get to gigs. So for the Laughter Lounge, bringing over top British acts, such as Bill Bailey, Boothby Graffoe and *The Fast Show*'s Simon Day, has been more manageable than a promoter acting alone.

The club is open Thursday to Sunday, with a capacity of around 350. It still has cinema seating (including double seats), with a bar and standing room at the back. The stage is wide and the backdrop is the yellow exterior brick wall of the building, complete with heating pipes – the real thing. There is no backstage, which means comedians generally hang out at the bar area behind the seating, and walk up the centre aisle to reach or leave the stage – 'it's like a boxer coming up,' says Bannon – which is a great unifier for the audience and comic . . . unless they've just died, of course.

It attracts a fairly diverse crowd: about 40 per cent group bookings through telesales, 20 per cent visitors – they distribute leaflets in hotels, and the rest a regular following. With £10 entry, it's generally a core age-group of 22–35. Interestingly, whereas O'Mahony originally thought the ideal bill – usually an MC

plus three comedians – would always include two British comics, he is finding that more Irish acts do well at the top of the bill – performers like Doherty, Ó Briain and Bannon.

'As time went on, we found that really good Irish acts were more popular than anybody we could bring in from overseas. English acts put bums on seats, but audiences enjoy the Irish lads more. Our big problem in programming the Laughter Lounge has been that we've had bills where we've had a really good compère and a good Irish act in the middle sandwiched between two A or B list English acts. But if they like the compère and they like the middle act, the last act from England, no matter how good he is, can die, because the crowd likes the Irish comedians – bring them back, we want to hear more about when we were at national school, or whatever.'

The friends of Eddie Bannon

A new concept was discernible in Dublin comedy in the late 1990s – 'the friends of Eddie Bannon'. A brash, shaven-headed, motormouth Dub, one of the most confident performers on the circuit, Eddie Bannon continued as a mainstay of the Comedy Cellar when a number of the regulars left for London in the mid-1990s, and spearheaded the wave of new comics that filled the gap. In the process he introduced a number of his mates or old schoolfriends to comedy, among them John Henderson, Paddy Courtney and Bob Riley.

Eddie Bannon: motormouth Dub

However, it was at Billy Magra's Gasworks a couple of years earlier that Bannon first caught the comedy bug. 'I worked in a customs clearing place, and I never wanted to be a comedian. I had just turned 26 and I did a list of things I wanted to do by the age of 40, to look back and say "I did that" rather than just go blandly through life, and getting up on

Murphy's

John Henderson: cued-in

stage was one of them. I wrote a five-minute piece and rehearsed it and rehearsed it and rehearsed it and went up to the Waterfront for a competition and it just got me like that. I came off feeling that it was just the best time I'd ever had.'

Bannon, who has toured Australia twice, is an experienced stand-up and improviser, and also a skilful MC. 'The audiences in Ireland are special; they'll really get into what you are doing. It's very personal. If you look as if you're genuine, and you're putting some effort into what you are doing, nine times out of 10 they'll go with you.' In 1999 he diversified from stand-up to bring a solo, more theatrical show, *Big Fat Dog*, to Edinburgh.

Tall, easygoing and white-haired in spite of his youth, John Henderson is an amiable presence somewhere around the middle of any bill, and more recently has operated effectively as a kind of straight man – or, at least, a solid buffer against the madness – for Jason Byrne. He has also written material for Byrne, he and the moon-faced P.J. Gallagher constituting an old-fashioned 'troupe' for the manic, red-haired clown. Dubliner Henderson, who enjoys a reputation for unflappability on and offstage, and started his working life as a jeweller, went into comedy at the suggestion of his best friend Bannon. He came third in Channel 4's So You Think You're Funny? competition in Edinburgh in 1996 and TV appearances include *Couched*, BBC's *Comedy Nation*, Channel 4's *Comedy Lab*, ITV's *Big Talent Show* and, naturally, *Father Ted*. After success in Edinburgh, the *Scotsman* commented: 'His

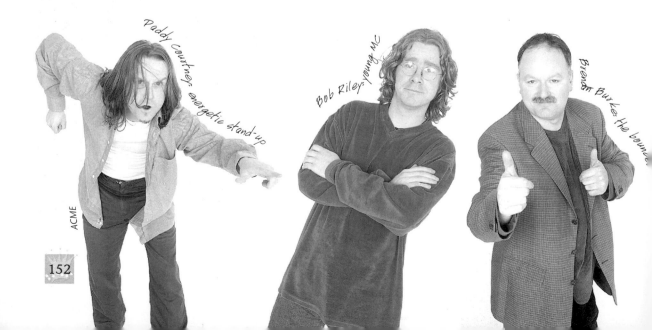

Paddy Courtney: energetic stand-up

Bob Riley: young MC

Brendan Burke: the bouncer

ACME

faint air of the Irish entrepreneur clinching the deal adds to his iconoclastic charm'. 'I've no idea what it means either,' says Henderson.

Paddy Courtney is a useful and energetic all-rounder and Bob Riley is probably the best of the younger MCs. Many other comedians are also familiar figures at the clubs, pubs, festivals and college circuit. Brendan Burke, in his 40s, is a former lab technician who started comedy later than others on the circuit and has often taken an entrepreneurial route, organising gigs himself. He operates on two levels – his middle-of-the-road material about drinking and its associated adventures, and celebrated high-energy 'barman' and 'doorman' routines (essentially an entertaining mime act of a barman pulling pints, and a bouncer admitting people and turning others away) can appeal both to young people at comedy clubs and to an older audience at corporate and golf club gigs, sometimes with a partner, the veteran impressionist Gerry Lavelle.

Deirdre O'Kane: big in Turkey

Deirdre O'Kane is an accomplished and established stage and screen actor who started making the transition to stand-up in 1996. A finalist in the BBC New Comedy Awards in Edinburgh in 1997, she is one of the few Irish female stand-ups in a world which tends to attract more men than women, for a variety of reasons – social expectations, the requirement (which more men seem to meet) for a thick skin and doggedness, even foolhardiness, in the face of criticism and death on stage. O'Kane's stage experience has stood her in good stead and she is a confident and relaxed performer, with an occasional wicked streak.

Amelia Crowley: character comic

Patrick McDonnell has a nice line in fear and loathing in Co. Louth, and often portrays a gormless character with a rich fantasy life – encountering The Prodigy at a

Patrick McDonnell: fear and loathing in Louth

153

Barry Glendenning

Barry Glendenning: Offaly's favourite funnyman

GAA club, or Oasis on the bus. He had a spectacular part in an episode of the last series of *Father Ted* as Eoin McLove, the heart-throb country singer who claimed he could have people killed, and who didn't want Mrs Doyle to come too close because he didn't want to 'catch menopause'. Amelia Crowley, who combines comedy and acting, has a keen ear for accents, which she uses in her character comedy; she was a regular on RTÉ's *Couched* and appeared in *Upwardly Mobile*. Lanky Noo Yawker Des Bishop does a mean Cork accent and brings an adrenalin-fuelled technique to the sometimes too laid-back Irish scene. Offaly's favourite funnyman, Barry Glendenning, a *Hot Press* contributor, latterly joined the list of journalists turned comedians, before taking the boat to try his luck on the London circuit, documented by regular missives in *Hot Press*.

Solicitor and comedy writer and performer Michael Mee, from Cork, became a comedian at 30 and has a quiet, downbeat presence. Mayoman Gerry Mallon took to the stage at Galway's comedy club when the expected MC didn't turn up in 1992 and eventually ended up running the show as well as being resident MC at the extremely successful club at the GPO. He also writes a humorous column for the magazine *Magpie*.

David O'Doherty, younger brother of better-known comic Mark Doherty, was the big success story of 1999, beating 500 other acts to win the So You Think You're Funny? competition at Edinburgh and was also runner-up in the BBC New Comedy Awards. A very original performer, still in his early 20s, he specialises in quirky observation and daft songs at a portable keyboard.

David O'Doherty: 1999 winner

Dara Ó Briain

'I think all comedians have a need for the love of strangers at some level'

Dara Ó Briain is one of the most confident and quick-thinking comedians on the Irish circuit, and he has successfully carved out a career spanning live and TV work. He is able for the rowdiest audience with his breadth of knowledge and razor-sharp come-backs; as a compère he can ride on the troughs and swells of the crowd, extemporising very funny material out of the ether; and he comes out with the best one-liners as a regular star of RTÉ's satirical panel show, *Don't Feed the Gondolas*.

Ó Briain looks like a funny bloke – more Tommy Cooper than Tommy Tiernan. He's tall and inclined to portliness, prematurely balding (he's still in his 20s) and with something about the nose, mouth and chin that remind one of Mr Punch. But he's an ingenious wit rather than a comedy clown.

Like several other comedians in this book, Ó Briain, who comes from Bray, Co. Wicklow, first got the notion of making people laugh for a living when he joined a debating society at college, in his case University College Dublin, where he studied mathematics. 'I think all comedians have a need for the love of strangers at some level, whether they will admit it or not. It's a question of validation. I did as much at college as I could – I ran a newspaper for a while and I did all sorts of film projects. I was always very interested in the public side of things, always pitching myself in front of a crowd. So I came into the circus without having to go through the shock of speaking in public for the first time. But I got a huge buzz off it and found I could "read" a crowd fairly well, which is why I MC a lot – I like to get into conversation with the crowd, which is like debating really.'

In 1994 a friend set up an alternative cabaret club in the Dublin suburb of Ranelagh in a

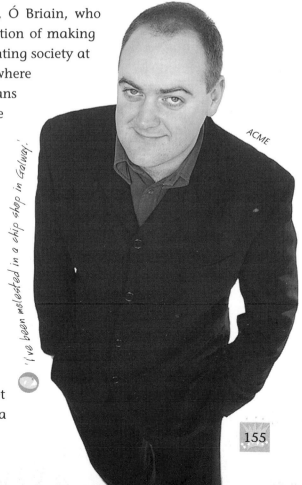

ACME

'i've been molested in a chip shop in Galway.'

I was forced to endure piano lessons for years because my parents told me that when I was older I'd really regret it if there was a party and I couldn't play an instrument. My mother and father obviously never saw the whole rave thing coming.

restaurant called Chubang's and Ó Briain 'did about three or four eight-minute bits in which I stood nervously hugging the microphone and doing one-liners'. If the young mathematician-cum-aspiring comic attracted little attention there, it was perhaps because the rest of the acts were so bizarre. 'A brother and sister would come on, and she'd read poetry while he played guitar, or people would do plays in among the audience. It was very pretentious, and there were some nights when a young woman unrolled herself from tinfoil while reading poetry. She'd arrive in her normal clothes with the roll of tinfoil and she'd go to the jacks behind the stage and roll herself up in tinfoil and then hop towards the stage when she was called. It was a weird place; they dug out the strangest artistic community in Dublin.'

As well as performing stand-up all over Ireland and two series of *Gondolas*, for three years he wrote 'Get a Life', a sarcastic, funny column for the *Sunday World*, which earned an unsettling endorsement from a right-wing Irish campaigner, Nora Bennis, when she said 'I do like a nice bit of humorous writing' in a radio review of the papers one Sunday. He also appeared on an RTÉ children's programme, *Echo Island*, for three years. 'I was lucky that I got in on a kids' thing. It wasn't comedy, but I still learned a lot about working in a studio.'

In 1998 Ó Briain had a successful first run at the Edinburgh Fringe with John Henderson as part of the *Full Irish Breakfast* show at the Gilded Balloon, and it was there that he learned something about himself that a person less secure in their sexuality might find disconcerting. 'It went very well and it got some very good reviews. And one agent who saw the show came up afterwards and said "Yes, I liked the show, especially the grey-haired guy" – which is John, obviously – "and the gay guy". I apparently have a camp aspect to what I do, which I didn't realise. I was

The movie *Titanic* was a perfect example of how America views the Irish. We're basically third class passengers. We're expendable, but of enormous sentimental value. They hate to see us go, but – Jesus, didn't we dance well at the start of the film! My God, Paddy, if you could just breast-stroke as well as you can jig, you'd be laughing now . . .

delighted – if it improves my dress sense and conversational skills, it would be wonderful!' He followed it with a successful run at Edinburgh in 1999.

Ó Briain enjoys working on *Gondolas,* which is similar to the BBC's *Have I Got News For You,* with Sean Moncrieff in the chair and journalist Brendan O'Connor as the other regular panellist. A variety of celebrities – from Twink to Michael D. Higgins to Galway drugs campaigner Ming the Merciless – also appear. 'I'm not involved in the whole team – I just go in on the day. I have a chat with them during the week about who's going to be coming in and where they will be around the country and what kind of topics might be coming up, and then I just go in on the day and get nervous and do the stuff. It's popular among students. With 15 to 25-year-olds we're very recognisable, so it's a hassle, which I wasn't expecting it to be at all. I know that my level of celebrity in Ireland is small, but all this stuff about how people like Julia Roberts can come to Ireland and nobody will go near her – clearly, Julia Roberts doesn't buy fish and chips from the same places that I go to. I've been molested in one chip shop in Galway – somebody shouted out "Don't feed the bollocks" while grabbing my testicles. And you can't hit them because they will take it badly.'

Ó Briain says his rapid turnover of material is because 'I get bored easily doing the same stuff all the time. Edinburgh cured me of that to a certain extent because I had to hone it and make it neat and do it over and over again, and I learned the professional worth of doing that. But I couldn't stand doing the same material all the time. It's like debating – if you were in a debate and you told the same joke twice, they would give out to you. I hate the thought of somebody sitting there and thinking: I've heard that before.'

He is more open than most when it comes to assessing the appeal of stand-up. 'You do it for the worst kind of reasons really. I'm sure there are some who claim that they do it for artistic reasons, but most of them do it because it's such a rush.'

Mark Doherty

'I'm very uncomfortable in most situations, so it's like an extension of that'

Doherty is one of the most unusual talents to have emerged in Ireland in the past few years, and is not afraid to use hesitancy and lengthy pauses, making audiences sometimes impatient for a punchline – which is invariably worth it. Slim and beaky-faced, he looks a little like Ichabod Crane in the old Walt Disney *Legend of Sleepy Hollow* cartoon.

This cartoonish appearance – he often adds to the strangeness by wearing an old-fashioned flat cap – is perfectly suited to his material, which is in the tradition of surreal non-sequiturs, but with his own idiosyncratic spin. He often seems to be lost, or tangled up in the mechanics of actually articulating a routine, until you realise that he is bringing an experienced actor's skill to stand-up, and the hesitancies are timed with precision. 'Sorry,' he might say vaguely, 'I contradict myself a lot.' Or, when lost down the byways of some comic musing: 'What was that question again?'

He co-wrote and co-hosted RTÉ's *Couched* in 1998 with Barry Murphy – 'I'm a big fan of Beckett, except that he wrote beautifully and we write about poo' – but he perhaps remains a comedian best treasured live. Asked about his halting, meandering style, he says: 'I don't know. I think it's pretty close to my personality. I'm very uncomfortable in most situations, so it's like an extension of that, and then obviously layered on a bit for effect or whatever. I found it was working early on, that sort of delivery. I just built on that and found a lot of the writing that I did suited it, so it's not like a creation, it's not all put on.'

ACME

If you touch an electric fence on purpose, does it still count as a shock?

From Sandymount in Dublin, he did an acting course after he left school and worked in fringe theatre for various companies, including one called Essential Theatre – 'dreadful title, but it was extremely meaningful at the time' – before trying his hand at comedy. In 1994 he went with his sister to the Comedy Zone club, which was run by comedian Brendan Dempsey. 'I was at school with Brendan and I didn't know he was doing that, so I just met him again after 10 years and he knew I was acting and asked me if I had ever thought of doing a comedy slot. I think I was a bit pissed and I said yeah and he said OK, I'll stick you down. He put me down for a gig three weeks away, so I had to come up with some kind of a routine. I came up with five minutes and that went very well, and there was an offer of another one. I just started getting more of that really. And I started getting paid, which was nice. I was earning no money at all on the fringe, so I started doing more comedy.'

He is a talented comedian, and one who obviously has potential, but far prefers acting and is fairly snooty about stand-up: 'The comedy thing is a very silly way to try and make a living. It's a loony profession. It can be a lot of fun, but a lot of the time there's no real art involved in it, it's just playing to a room full of pissed punters, and you're just trying to give them a laugh really. The reason that I started doing it was to do things that I thought were really funny but then that changed, and once you start to become more professional about it you realise that those gigs are few and far between, and that most of the time you are just booked to entertain a roomful of people, and either you can do it or you can't.

'Most comedians start to play it more and more safe, and they find something that works and they start sticking with that, and the reason that most people got into it in the first place disappears after a while. The ideal thing for me would be to try and make my money somewhere else, and not rely on stand-up comedy. I think once you start to take on responsibilities, once you start to pay a mortgage out of it, everything does change. The ideal situation, really, is to have no responsibilities, so you can just be true to what you think is funny, and if people go for it great, and if they don't – tough, that's a shame.'

But surely that kind of idealism is the dream of any artist? 'That's where most of the great stuff comes from, those people who are absolutely true to what they are

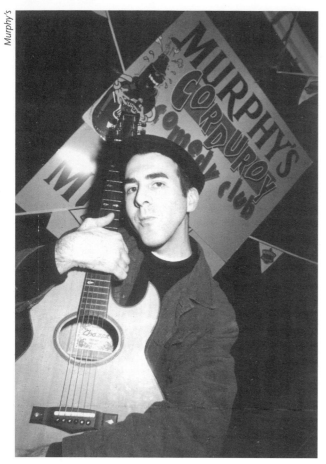

'I'm a big fan of Beckett. Except that he writes beautifully and we write about poo.'

doing. One of my great heroes is Dylan Moran. His writing is wonderful, and I think he's one guy who has converted people round to his way of thinking, and now he can play to a roomful of drunken people and they *will* give him the time and the room to expand his ideas. That's a great but pretty unique position to be in.

'A lot of the stuff that I write and have written is wordplay rather than straight jokes, and if there *are* jokes, it is taking the formula of stand-up comedy and bringing it somewhere else, or turning it inside-out a bit. And a lot of that material is not the most accessible for people generally. People like to hear jokes and they like to hear stuff that they can understand easily rather than have to actually sit down and concentrate. I don't mean to sound arrogant about that, either. I'm not doing anything very new, but these are the things that I find funny, and I just hope that people will give me the room to try them out, because they are good ideas. But if people have had six pints and they're sitting in a big audience, then they just won't go with it.'

Before the lugubrious Doherty became too bogged down in the misery of it all, it was suggested that being a highly regarded comedian must have some compensations, and he brightened a little. 'Certainly, when I'm doing auditions now, I'm a lot less scared than I was. When you stand up in front of a room of jarred people, it gets rid of a lot of fear. It's not the same as standing in front of a panel of three or four theatre people who are not drunk and who are not going to heckle you.'

RTÉ and comedy

Laugh? We thought we'd never start . . .

There's an episode in Steve Coogan's 1998 BBC series *I'm Alan Partridge*, where the eponymous, self-deluding pain-in-the-hole is having a meeting with two visiting Irish TV executives to pitch them a particularly awful idea for a new show. The RTÉ types are played, with a modicum of acting skill, by two mates and writing colleagues of Coogan's, Arthur Mathews and Graham Linehan. Everything goes appallingly and tastelessly wrong for Partridge, so that the executives flee, thinking he's a self-obsessed nutter. It's a very funny episode about a very bad broadcaster. Ardal O'Hanlon, laughing at the memory of it, comments that 'the only difference is that RTÉ *would* have bought the show'.

The more success Irish comedians have had – at home or abroad – over the past few years, the more embarrassing it has been for the station, and there is a broadly held perception that RTÉ is crap at comedy. As a general statement, that has truth, although it is not the whole truth, and there are mitigating factors.

First, not all RTÉ comedy is terrible. There's been *plenty* of good stuff. There were 12 glorious years of *Hall's Pictorial Weekly,* when the Minister for Hardship and his cronies lambasted the government, and Mickey and Barney drank tea from their saucers; some bursts of the perceptive raconteur Niall Toibin in the 1970s; Rosaleen Linehan's mischievous magic; the hurley-wielding madman, Father Trendy and

Ah, the good old days . . . Frank Kelly and Eamon Morrissey in 'Hall's Pictorial Weekly'

Rosaleen Linehan: a rare spark

innumerable other Dermot Morgan treats, as well as the Candid Camera-type tricks on *The Mike Murphy Show*; plus the undoubted triumphs of *Scrap Saturday*; the imaginative and innovative *Nighthawks*, broadcast late at night on Network 2 between 1988 and 1992, which included a lot of quirky sketches that drew on and developed the talents of those working in live comedy; *The Basement*, which followed the untimely demise of *Nighthawks* in late 1992 with studio-based comedy acts; *Nothing To It*, masquerading as a careers advice programme; the bold puppets Zig and Zag on *The Den*, a gem of anarchic madness hidden in children's TV; *The End*, tucked away in late night weekend presentation on Network 2.

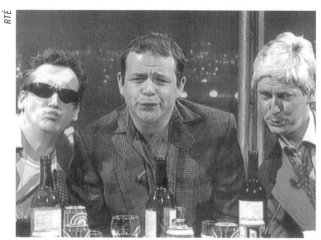

RTÉ

Something stirring in the sports department (from left): Barry Murphy, Gary Cooke and Risteard Cooper in 'Après Match'

Latterly, initially hidden away in sport, *Après Match* has been confidently doing its own thing, hilariously parodying well-known sports presenters and others; it has lately been extending its success – going 'on the road' to make a spoof documentary and expanding into a pilot of *Après Winfrey* for a primetime RTÉ1 slot. The contrasting *Couched* – an imaginative step in the right direction, a programme consciously not aimed at a wide, catch-all market, has opened up the possibility of an original sketch-based show; those other puppets Podge and Rodge have been developing a cult following for their black doses from the disused psychiatric institution; the surreal *CU Burns*, RTÉ's big sitcom success, which, because it is made in Irish and shown on TG4, unfortunately loses a large proportion of the population; *@ last tv* with its stylish and humorous tilt; and *Don't Feed the Gondolas*, which seems to get reasonably free rein as a satirical quiz show that can be witty if sometimes a bit puerile. And radio comedy seems to be developing of late, with the *Short Circuit* team filling a satirical gap, and possibly looking at TV work.

It's not a bad list, and it's by no means exhaustive. But there have been such embarrassments – *Leave it to Mrs O'Brien*, *Molloy*, *Extra Extra*. Desperate ideas, dreadful scripts, hopelessly put together, despite the fact that some talented people have been associated with them. The now demised *Upwardly Mobile*, the most recent RTÉ middle-market sitcom, started badly, and although it improved somewhat in later series, perhaps the damage was done. It was a poor idea to start with, and was properly slated by critics. That said, its ratings were good, with a general family audience and an even male/female and working/middle-class spread of viewers. 'I

have great affection for it and I can understand why Irish people like it so much,' says Ferdia MacAnna, who was brought in as executive producer after the first two series, and introduced some new writers. 'But I can understand the criticisms. The first season wasn't great but I think the criticism was very unfair more recently. I think it has worked quite well. But it's mainstream, it's not hip, and most of the critics writing about it would be looking for something different.' And something different it definitely wasn't. In common with a lot of RTÉ output, it took no risks.

Anarchy for children (and adults): Zig and Zag

But at last perhaps RTÉ does seem to be trying to stop the rot. In 1998 MacAnna, who was also producer of the innovative *Couched*, piloted three sitcom ideas, one of which may have future legs. As one comedy actor has said: 'They're piloting anything at the moment.' MacAnna comments: 'The only thing I will say in RTÉ's favour is that it just doesn't have any money. I wish it had a million quid to spend on comedy. About eight or nine sitcoms start every year on BBC and ITV and only three of them survive, but when you go back to the stage where they are piloted, there may be 30 pilots knocking around. To my knowledge, RTÉ has only ever done two or three pilots in its entire history.'

The problems with RTÉ basically have been:

Bureaucracy and lack of an infrastructure. RTÉ is a small, civil-service-oriented station without a history of comedy production, so it doesn't have the infrastructure or tradition of talent and experience. Plus, RTÉ has no specific comedy department; comedy is produced under other umbrellas – variety, drama, light entertainment, sport, young people's programmes, even presentation. MacAnna describes himself as working unofficially as a comedy development unit, in that most comedy scripts come through him, and Kevin Linehan of young people's programmes and variety has also been heavily involved and supportive of comedy production. But MacAnna points out: 'I could be appointed to *Crimeline* tomorrow.' Comedians who have done some work in RTÉ comment that crews which 'last week were working on the gardening programme' are this week making comedy programmes and that the place is full of restrictive practices.

The basic problem, says Billy Magra, who has worked in TV production both in and out of RTÉ, is 'there's still a lack of commitment to develop a comedy department. They have a sports department, a religious affairs department, current affairs – which means that people who are heading the department and producers

in the department know about the subject and have been trained in it and have a background. One of the things there has never been in RTÉ is the ability to find raw material and spend months training and developing the whole psychology of how to write and perform for TV. In all the time I was involved in comedy clubs in Dublin, only one RTÉ producer turned up and that's because he knew Jack Dee's manager. But nobody ever came early to the new talent nights or the best of Irish performers shows and sat and watched, because nobody had a brief, and I find that astounding.'

In the mid-1990s a BBC/RTÉ Joint Script Development Fund was set up, amid a lot of hoopla, to encourage young writers to develop scripts, but it eventually came to nothing. In British TV there are departments specialising just in sitcoms, or sketch shows, so there is a bank of knowledge and experience. In RTÉ, says MacAnna, it's 'hit and miss' because there are no Irish sitcom directors working in Ireland. Directors have occasionally been hired from England, but 'they have to build up from the basics every time'.

'It's very difficult,' says Magra, 'to walk into the office of a department head and have a coherent, knowledgeable discussion about comedy. They all want it to work, but it's very difficult to get the ball rolling when you know the person who holds the purse strings and the power has no real blood passion for it as a form or medium of entertainment or communication.'

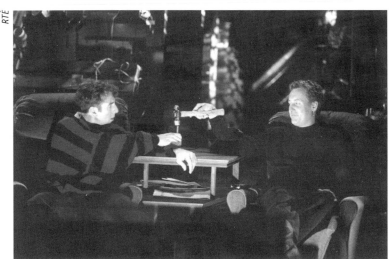

RTÉ

Trying to nail down a comedy policy:
Mark Doherty and Barry Murphy in 'Couched'

Barry Murphy, who has been involved in some of the more innovative recent RTÉ programmes, says it has involved 'a lot of banging on doors for me personally. I had to go through young people's programmes and sport, and finally you get into the variety department, which is where the budgets are.'

Pauline McLynn is critical of RTÉ, but 'that's not to slag off Ferdia MacAnna. He's great, but he gets all of it to do. And he's encouraging and he puts his neck on the line, but you can't do it all yourself. They need to have a department.' And to know what's funny: 'There was always the thing where you'd have somebody you thought had absolutely no sense of humour saying: Do you know what would be funny here? When you heard those words, you just ran behind

a bit of sticky-outy wall and banged your head against whatever was available, because you'd know that it *wouldn't* be funny.'

Frank Kelly, who has worked in RTÉ for over 30 years, almost from the station's start-up, says that 'it was set up in a semi-state way and it was staffed administratively by "people in good jobs", many of whom had university degrees or a background in the media, but they actually didn't have a grasp of comedy or humour. This is going back . . . I have never seen any real comprehension there of the genre of comedy. This may be true of other stations, too. Maybe in a bigger melting pot you have a bigger chance of finding somebody. But it is very much chiefs and no Indians. I mean, the number of marked parking spots has increased as the number of programmes they made declined. There's an Acting Assistant Head of Potty-Training in there at this stage, you know. A whole branch of RTÉ is devoted to information technology, but I'm not seeing many new programmes. There's a bureaucracy there, and bureaucracies become self-perpetuating and are a bit oppressive. They don't let things happen. And I think that a lot of the people making decisions are not from a show business background.'

Barry Murphy echoes some of that: 'It's not really the case that RTÉ has a corporate approach to comedy – although that is a lot of comics' attitude to RTÉ. They imagine that there's a big corporate structure and that they just had no time, or didn't know. But the truth is that it's all down to individuals – because some individuals don't work at all, and others do the work of three people – that's the way it works, and until that system's broken, and it becomes more organised . . . But the thing is, you find good people within it. It takes a long time, though. It's a case of finding the people, rather than RTÉ having a certain approach to comedy. Funds and people are being mismanaged there, because there are some tremendously talented people at RTÉ.'

To start to right that situation, Magra suggests that RTÉ should look at the 'common sense attitude of using the radio station as a nursery for TV, specifically in comedy, for writers and performers and for trying out formats'. He points out how the BBC has successfully used radio to develop ideas that later moved to TV – producers such as John Lloyd started on radio and went on to *Not The Nine O'Clock News*; Steve Coogan's *Alan Partridge* and *The Day Today* were initially on radio, as was, earlier, *The Mary Whitehouse Experience*. ITV and Channel 4 do not have radio stations to use in the same way, but RTÉ doesn't make the most of the possibility. Magra says there should be a strong relationship between the variety departments in TV and radio, so that a proposal can be tried on radio to see if there's an audience, then built on. 'RTÉ has never attempted to do that in a managed way – the entertainment departments in radio and TV don't even speak, don't even relate to each other – one doesn't even care what the other is planning. It's not a mad thought – I suppose to a certain extent it happens all over the world – but RTÉ has

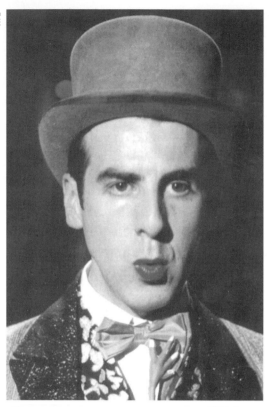

Life's a circus: Mark Doherty in 'Couched'

no hesitation in aping formats from the BBC. But the fact is, the BBC's commitment to using radio as a prelude to TV has never been looked at, but that has been the source of huge success for the BBC – I don't think there's one performer now who's established who hasn't done pilots for BBC Radio 4.'

Timidity. Much of what the station has produced has been safe, consensus TV that takes no risks and is designed to appeal to the widest range of people, and often ends up pleasing few. Or else they're copies or cheapo versions of programmes that have been on British TV, and suffer badly by comparison. Middle Ireland, which seems to be the target audience, is often left uncharmed by the comic offerings.

Anything with the merest hint of danger is met with timidity by RTÉ. The station is perceived as dominated by the old P&T (Posts and Telegraphs, the department whose aegis it used to come under) ethos, and to have a civil service mentality. In some ways you can see why they play safe – when something as mild as Tommy Tiernan's routine about how a child interprets the Crucifixion provokes uproar among the über-religious, and leads to a suggestion of prosecution for blasphemy, what can you do but laugh?

Says Magra: 'It speaks for itself that *Après Match*, the biggest comedy success of 1998, came from the sports department – I'm not trying to be clever on this, it's just a matter of fact. That, for me, says it all.'

Peter Howick, journalist and ex-comedian, reckons that 'RTÉ deserve their knocks. They don't want anybody to complain about anything. Nobody's going to complain about some folk band, but if some guy is cracking gags about something and they get complaints, they just wet themselves. And you have the political angle – it's a great pity a semi-state station was the only avenue for Irish comedy; if there had only been some commercial channel. The fact that these guys had to go abroad to make it is an indictment. But it may have made them better comedians.'

Reputation. RTÉ's reputation may at this stage also be something of a self-fulfilling prophecy; *Father Ted* was never offered to the station as a script, despite stories about it turning the idea down, but RTÉ took long enough to buy it when it came up for sale as a series, and its quality and success have been an obvious embarrassment for the station. The biggest satirical success RTÉ has ever had, *Scrap*

Saturday, has, if anything, grown in stature since it was dropped – along with the rumours about political interference and the nature of the RTÉ/Dermot Morgan relationship.

Upwardly Mobile, says MacAnna, 'evolved basically because RTÉ's history in the sitcom world had been about as successful as, say, the *Titanic*'s history with icebergs. It was not just failure, it was disaster after disaster. And for a nation of people who pride themselves on their humour, it just wasn't good enough.'

On the other hand, points out Dara Ó Briain, 'A lot of RTÉ's public reputation comes from the print media – and there is always competition between the two media. I always find that it's a little hypocritical, because they become cant, these criticisms of RTÉ, they become traditional things – why did you let *Father Ted* go? and that kind of stuff, none of which is actually true.' Plus, he says, 'there's been a lot of bitching in the stand-up community about RTÉ, saying that they were on shows that weren't funny, as if it is somehow RTÉ's obligation to capture their essence, which is automatically funny. But I don't think there is anything vainglorious about RTÉ's failure to do comedy. I don't think they've ever gone "listen, we're really good at comedy" and somebody has had to point out to them that they're not. I think they've bravely tried to make a few things that haven't gone well.'

Richard Cook says *Couched* 'should have been given more time, resources, tender loving care at crucial stages. I'm quite cynical about that project because there was an awful anti-RTÉ backlash post-Dermot, and *Couched* got the green light. I think there was an element of – "fuck, we know nothing about comedy, let's get something going. Barry Murphy is good, Mark Doherty is good, they're two comedians who are well-known and well-respected on the circuit – they must be good." I mean, how many holes have to appear in the road before somebody fills them in?'

Poverty. The running joke – or prevailing wisdom – is that Ireland keeps winning the Eurovision Song Contest and so RTÉ can't afford to make any decent drama or comedy. RTÉ is in a healthy financial position in some ways – it has both a licence fee and advertising revenue, though that is capped by government, and therefore falls between two stools in terms of a public service/populist remit. But Ireland is a small country, and the national broadcaster cannot but suffer by comparison with some of the best broadcasting in the world, right next door.

Couched — ouched!

Sir — Having received much hype about it's alternative and controversial nature appearing on our TV screens the half hour comedy slot "Couched" has managed to stimulate my humour in one small way. The notion that someone in RTÉ has deemed this inconsequential drivel to be progressive programming brings a smile to my face and a shiver to my spine. God save us from Irish intellectuals.

Rathmines Road, Dublin 6

A letter to the 'Irish Independent', 18 November, 1998

 God save us from Irish intellectuals

167

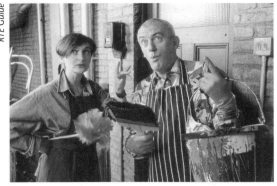

Anne-Marie Hourihane and Shay Healy in 'Nighthawks'

'The one thing I would say in its defence,' says Ó Briain of RTÉ, 'and it's an empty defence, is that it makes very few programmes because it has a budget to make very few programmes, and it's going to make even less once they have to give £19m to the independents, so we're going down the road – we're squeezed. We're trying to make *Don't Feed the Gondolas* with, I think, one quarter of the staff that *Have I Got News For You* has and we do OK. But the show could be a lot more polished and, if we had the luxury of more time, we'd have much better stuff. There are very ropey editions of the show, but it is working on an extremely tight budget. But drawing a comparison with an American sitcom is mad because it's not like with like – it's a million dollars an episode for an American sitcom.'

An entire season of *Upwardly Mobile* (above-the-line costs, for scripts and actors, rather than studios) was around £300,000 for 15 or 16 episodes. 'That would pay for about half an episode of *Father Ted*,' says MacAnna. 'That's the kind of level you're dealing with. Maybe some people would prefer half an episode of *Father Ted* to 15 *Upwardly Mobiles*! In *Couched* we had 50 grand, and that took two years to develop. The time to put an infrastructure into position was the last 10 or 12 years, and we didn't do it. We should have been developing writers and taking risks.'

And risks cost money – Howick offers the opinion that the reason Dermot Morgan's project *Newshounds* bit the dust was because it was risky legally, and would have cost too much – that it was 'dropped because of meanness, not fear'. Pauline McLynn, one of Ireland's brightest comedy talents, says 'I think one of the problems is the monopoly they've had for so many years, and I think it's taken them a long time to cop on that there is going to be competition and they *do* have to supply a quality product. But at least there's an effort being made now and they're spending some money on it, and they *do* have money; they make profits every year.'

In terms of developing talent and putting an infrastructure in place, says Magra, radio is so much cheaper to produce than TV, and should be 'one of the central things in developing a national comedy voice, because you can try out five or six formats on radio, and it's not a huge loss if four don't work. But if you take the two that do work and move them into TV, by then you have a trained group of writers and performers who have made their mistakes in radio, who have seen how it develops. The thing about developing writing and performing skills on radio is that you're really honing in on the spoken word, so by the time they move into the

visual end, the script – which is the most important, and what's been weakest – has been developed properly. If you build up a following on radio and you move to TV, then that following goes with you, so it's not a big jump.'

And that allows an infrastructure to develop: 'I've always thought in frustration that there should be a comedy department in RTÉ and that part of its brief would be to liaise between radio and TV. A comedy department needs a long-term brief and a budget to develop – it's all a cycle, and RTÉ has never looked on it as a cycle of three to five years.'

Radio has, in fact, been producing some innovative work, with Anne-Marie O'Callaghan as Controller of Radio 1, developing a new sketch show, but it remains to be seen if it is in the context of a grooming process for TV.

Poor writing. Writing is central to good comedy, and poor writing, diluted by too many cooks, is where RTÉ has often fallen down. As Frank Kelly describes it, 'the difficulty with RTÉ is that they've tried to create comedy by committee, and comedy doesn't work that way. It stands or falls on whether you think something is funny or not, but there isn't a formula.' Pauline McLynn: 'Lots that RTÉ gets wrong is in the writing; they don't seem able to find proper endings. Now, with *Father Ted*, if five words were changed in a script it would be a big thing.' But she says that this does show up 'why Irish comedians are so successful at the moment in England – a lot is to do with the writing. They do really structured shows. Tommy Tiernan's show that won the Perrier was just so perfectly put together, nailed

Fun for all the family in 'Upwardly Mobile'

down. Ed Byrne's show, where he deconstructs *Cosi Fan Tutti*, again, is very carefully written. And they all talk about writing – it's not a free form jazz expression. And I think writing is the big success of Irish comedy. And that's what seems to be wrong at RTÉ – they're just not employing the writers.'

Richard Cook: 'When RTÉ changes and evolves and opens up as the last of the great fucking monoliths to evolve in this country, then I think people will not feel a natural tendency to move and work in England, but also to send their material initially to Channel 4 or BBC for a halfway decent media production.'

Ignoring talent. In other words, RTÉ has ignored talent, and talent, in turn, has turned its back on RTÉ. The thing that most draws ire is that there has been such talent in Ireland, and RTÉ has rarely successfully harnessed it but has allowed it go abroad, where British TV stations lap it up and nurture it. Agent Dawn Sedgwick says ruefully: 'RTÉ let so many people go, though, didn't they? They didn't seem to want to do anything. Newer networks like Channel 4 are keener on building

people's profiles. RTÉ didn't seem to have a sense of – if we give them this, then we'll build them and build them and build them. It seemed a bit all over the place, whereas now they seem to be going: "Hang on, we should be keeping our own".'

Richard Cook feels events like Kilkenny have shown up the station's inadequacies (though he would, wouldn't he?). 'Kilkenny has certainly sharpened the focus on comedy and RTÉ's inadequacy and I think that's a good thing. Five months before the festival Channel 4, BBC Scotland, Wales, would all be on, asking when's the programme coming out? Two or three weeks before Kilkenny I would get RTÉ going 'would you throw us a few tickets for whatever?' They should have been crawling around Kilkenny spotting where the talented people were.' Tommy Tiernan echoes this when talking about performing early on in his career, and says how different it was for comedians starting out in Ireland, compared to Britain – in Ireland you were never nervous that some talent-spotter from RTÉ might be in the audience . . . because they never were.

Says Cook: 'They are indifferent – the worst of all emotions. There is so much originality that just gets twisted and not allowed to come out through the national broadcaster. It's not that Graham and Arthur didn't give RTÉ the option. The real point is they would *never* have given them the option. They're grand lads at RTÉ, just civil servants; they're there programming bits and pieces. A dog with a mallet up its arse would know more about comedy.'

Ouch! That may be a painful note to end on, but we live in hope, and, indeed, expectation and faith, that the situation will improve . . .

Irish Times

Frank Hall: Magic comedy memories

GIFT OF THE INTERVAL

The Interval

Two for the road

And now a pause, while we chat to two men who have little in common with the rest of the comedians discussed – or, indeed, with each other – except for the basic fact that all stand on stage and make people laugh. Brendan O'Carroll and Noel V. Ginnity are both extremely successful, but their constituencies lie outside the remit of this book, in parallel comedy worlds far from the Cellar, Kilkenny and the Edinburgh Festival. Each has his own slant on the new comedy that has developed over the last 10 years in Ireland.

Dubliner O'Carroll is a household name and probably the country's most successful comedian. He could be categorised as a 'working-class Dub' performer, and early in his career specialised in blue comedy. He has since broadened his style, with a high turnover of work, and become something of a one-man comedy industry: he has written (and directed) films, plus novels, stage plays and radio shows. Angelica Huston directed the film of his book *The Mammy*, released in 1999. The son of a Labour TD, the only woman elected to the Dáil in 1954, he is one of 11 children. His stand-up can fill the biggest theatres in Ireland, and he has acted in films and hosted a TV game show.

Ginnity, from Kells, Co. Meath, has been in the business for 40 years and is a veteran of the cabaret scene. In his leprechaun jacket – he owns the one originally worn by Jimmy O'Dea in *Darby O'Gill and the Little People* – knee-breeches and green bowler hat (with a flower on the brim), he is a familiar figure at Dublin's Burlington Hotel, where he has appeared in summer cabaret over the past 20 years. For much of the rest of the year he works in the United States.

Brendan O'Carroll

'How's your wobbly bits?'

'I believe there are three areas of comedy. There is satirical comedy, and I think that's very serious comedy. Alternative comedy shouldn't be middle-of-the-road; it should be about two cabbages having a conversation, and being able to draw the

comedy out of that – surreal situations. And there is middle-of-the-road, which is what I believe I am – you know the punchline is coming, you nearly know what the punchline is; it's the way the guy is telling the story that makes all the difference. I would see Dylan Moran or Owen O'Neill in a different category to myself, and Dermot Morgan would have been in a different category again, to me and to them. There's very little

Irish Independent

Brendan O'Carroll, one-man comedy machine

crossover at all. The people who would have gone to see Dermot Morgan wouldn't have come to see me, and the people who come to see me would have thought that Dermot Morgan was stupid, because they wouldn't have been tuned in to his act. And his audience would think that I was ridiculous.

'Now everybody is more affluent, and alternative comedy depends on discontent for people to enjoy it. I play a gig in the Gaiety Theatre and I have 1,500 of an audience for three weeks. People who play the International Bar are as good comedians, if not funnier, than me, but because of the nature of the comedy they do, they will barely get 60 people into the International Bar. I am the most marketable of them all. The middle-of-the-road – that's the most marketable end of comedy. They are the *least* marketable. They depend on people coming to a show to think. I don't actually depend on my audience to think. It's not that they are not a thinking audience, but my audience expects to come to see me and switch off. I'm the action movie. Let it wash over us. My comedy just comes at you; you don't have to go "That was a clever one" because I'm not trying to be clever. But I think that they want their audience to think about what they are saying, and that's more about being clever than being funny. I don't mean that in a bad way. Their style depends on them being clever in what they do. I personally find a lot of them hilarious – I personally get it. I know what they're on about. But my comedy is middle-of-the-road.

'When I was young I didn't even understand what sexism was, because I was brought up in a household of women. A woman once told me I was a sexist bastard, and I told her I didn't know what it meant. I told her if she could tell me what was sexist, I wouldn't do it any more – I'd change it. I'm willing to learn. I saw her the next week and said "You told me I was sexist" and she said "Yes, you are" and I said

"What do you mean? Why am I sexist?" And she said "You used parts of a woman's body to get laughs. The fact that a woman has tits, making her a titty woman." And I said "That's true. I do that. But I also do the same with men." And she said "Ah well, that's men." And I said "Now, hold on a second. I can only be sexist to women? I'm sorry, love, that doesn't hold any water for me. I can only be sexist to women? That's bollocks." I believe that 99 per cent of people who talk about something being sexist actually don't know what it means. If you come to any show, not just mine, with a specific agenda, you will see that there. If you come to my show to hear me say "fuck" then you won't hear anything else. But if you come to hear me tell stories, you won't even hear me say "fuck" because it's part of the story, the language.

'The audience have to believe that you actually don't give a fuck. Because if audiences think you care, they nail you. You've got to have this attitude: Fuck you! If you don't have that attitude, they'll eat you. And you have to deliver the attitude with absolute conviction, and if you don't they'll gobble you. And so they should.

'I did a positive mental attitude course about 13, 14 years ago on which I based the play *The Course*. And one of the things that I heard there, and you'd go "Oh, this is crap", was that everybody doesn't get up in the morning happy and in good form. You have to spend the first hour of the day looking in the mirror and pretending to be happy. And they guaranteed that at the end of the hour you *would* be happy; that if you pretend to be happy, you would be happy. And that's what I do on stage. I pretend to not give a fuck, and you know what happens? Very quickly you *don't* give a fuck. You are battle-hardened, and when they hit you, you hit back. You become unafraid.'

Noel V. Ginnity

'The fear, the fear, the fear, the fear . . .'

'I'm lucky to have arrived at this stage in my life not mentally destroyed. I suffered. It made me an alcoholic, or it helped to. It was the worry of what I did. I don't know if it's the same for these younger lads nowadays, if they feel tortured the way I did: drinking if I *didn't* have to go to work, drinking if I *did* have to go to work . . . the fear, the fear, the fear, the fear.

'I've been lost in the last 10 years. Shake a tree nowadays and 20 comedians fall out. They're falling off the back of trucks, like. *Hah*! All through my life comedians were the scarcest commodity of all time. I lived at a time when there weren't 12 professional comedians in the whole of Ireland. *Now there's a hundred and eighty-four thousand of them in Dublin alone*! You go into a restaurant and they tell you stories while you're trying to eat your pizza! *Hah*! Down in Milano's restaurant I saw a guy and he wouldn't last 30 seconds in any place I worked!

'When I talk like this, people think I'm jealous because something has happened and I've been left behind. But I do not understand it. The whole psyche of people today has been changed by what they get. And what they get are these alternative boys who are funny for 30 seconds and then they go on with the greatest load of drivel! It is incomprehensible! I find it such a mysterious thing. I've seen this fellow' – he names a well-known Irish comedian – 'and he's as funny as fucking cancer! He's as funny as a burning orphanage! Where in the name of Jesus could you put these guys? *Hah?* Could you put them in a pub in Donegal tonight and let them do an hour? Could you put them in a pub in Trim in the County Meath and let them do an hour? For people who are half pissed drunk? I am really amazed at what I've seen.

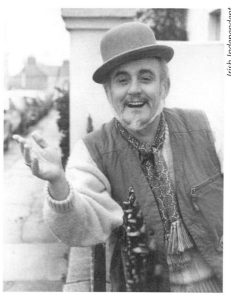

'These new lads are quick enough to criticise me.'

Irish Independent

'I believe that young people today are getting this stuff shovelled into them by the media, by the papers. If you get nothing else, this becomes the norm. "This is what you laugh at now because it is what we tell you to laugh at." They advertise jeans and women go out and buy them, and they advertise shirts and men go out and buy them, so it's not beyond the bounds of possibility that when they consistently show you comedy of one nature on TV, then that's what the young people are going to think is the norm for comedy. I can see very little in any of the Irish comedians. I don't follow them avidly, but if I bought a book 40 years ago, and I read it and I understood it, and I buy the same book today and read it, I still understand it.

'But with comedy it seems . . . in spite of my lack of education, I'm quite worldly wise and of normal intelligence, and if I talk to any of my contemporaries, anyone in my age group, anyone 40-plus, they don't know what these guys are on about. Now, why has life changed so much? These are funny men – supposedly – and we don't know what they are talking about. We do not know why it is funny! *Hah!* These new lads are quick enough to criticise me if I tell gags about Casey and Murphy.

'Their routines invariably start "When I was at school I ejaculated, and my mother said: You shouldn't ejaculate, you should wank." All this nonsense! It's fucking nonsense! All my life I've just told simple gags with beginnings, middles and ends that people understand. If I had the facility to use "wank" and "fuck" and "bollocks", I would have been a huge comic , but I didn't want to do that. I had an art, and I could look this way, or that, and put naughtiness into the gag. But now, unless you say "fuck, bollocks, motherfucker, cunt", you are not doing any business.

'That Joe Pasquale fellow' – he's talking about the squeaky-voiced mainstream comic who has had some success on British TV – 'was on the Royal Command Performance, and out of the blue he says "Hey you, what are you doing in my garden?" Where does that leave you? Are you rolling around the place laughing? Now this Joe Pasquale – and they had a two-page interview with him in the *Sunday Times* – traced the origin of this gag, and this is the best gag that he's ever heard in his life, back to this Irishman, Michael Redmond. "Hey you, what are you doing in my garden?" Now I can say it, I can dance it, I can piss it, I can do anything with it, *but I can not make it funny! Hah!* Hey you, what are you doing in my garden? Oh, Jaysus . . .

'I cannot understand the dress code, where it says you must have the shitty end of your shirt hanging out over your jeans. That's the stage code, for starters. I learned that when you go on you are presenting yourself to the people and you have to present yourself in the best possible way. *Why have they got their shirts hanging out?*

'*Father Ted*? I thought it was a load of infantile crap! One of the phrases was "Ah go on, go on, go on, go on". That only becomes a catchphrase because it's pumped out every week. And "Feck, arse, girls" by some cobwebbed priest. To think that that should be even remotely funny. What? What? *HAH!*

'What I do at the Burlington is just the same as Tommy Tiernan crucifying Jesus. It's all entertainment. Entertainment is when you draw the curtains back and you're on. You're projecting yourself to the people for some kind of adulation and, eventually, your wages. But I think the wages probably come last.'

'If he could channel that vitriol into his act, it would be stunning stand-up.'

Ardal O'Hanlon

Taking the Boat

The emigrant trail

Ireland is an emigrant country; deep buried in the national soul, God help us, is an emigrant sensibility. And a post-colonial sensibility – so Ireland tends to acknowledge her own strengths only when others have first done so. Irish people have had to emigrate down the years for various reasons, and Irish comedians are no different. A generation of comics – Redmond, MacPherson, others too, went to London in the early 1980s; they worked in Ireland as well, but they were the first wave of new comedy emigrants. A second wave went in the mid-1990s. Going to London, the centre of the British 'alternative' comedy circuit, has long been a fact of life for Irish comics, and the 'nursery' aspect of the Irish comedy scene has meant, as Billy Magra says, that 'the Ardals and the Seans – not Owen O'Neill, because he started over there – but Tommy, Dylan Moran, they can go through a two- or three-year rehearsal in Ireland for going to Britain, if they have ambition and they use it well'. It's not that the ultimate ambition is to go to Britain: 'The ultimate ambition is to be in control of your work, and to do that you have to have security, you need to be paid. So when you enter the UK market you are entering a business.'

So, while in the late 1990s it became possible at last to forge a career in new comedy in Ireland, people will continue to emigrate or move between the two countries.

But there is a group of Irish performers who did not emigrate to seek their comedy fortunes; rather, they went abroad for other reasons and first took to the stage away from the home turf. Subsequently, many have returned if not quite as conquering heroes, then as performers who are recognised in Ireland but have attained that status elsewhere. In this section we find people such as Owen O'Neill, a divine talent who salvaged his soul and imagination from the grip of alcoholism on the building sites in London and in comedy; Ed Byrne, who went off to college in Glasgow to study horticulture and found that he was a comic instead; Jimeoin, who, as an emigrant in Australia, started with a club open spot; Sean Hughes, who first performed in Dublin but made his name in Britain, which he sees very much as home; Andrew Maxwell, who started off, like so many, in the Comedy Cellar in Dublin, but works the British circuit now – his lifestyle is typical of young comedians who take the boat; Graham Norton, currently British TV's king of camp. Michelle Read represents emigration in the other direction – a formidable and versatile talent who comes from Norwich but has made her home and career in Ireland.

Sean Hughes

'Life is shit, and the only things that get us through it are anticipation and afterthought'

Comedy is not the new rock 'n' roll, and never was, but Sean Hughes is the first Irish comedian to have been treated like a rock star. The name of the 1990 show that earned him Ireland's first Perrier Award, *A One Night Stand with Sean Hughes*, has a rock and roll flavour to it, and when Channel 4's *Sean's Show* provided a bigger platform for his brand of post-adolescent angst the following year, he was fêted like a one-man Boyzone when he returned to Dublin for sell-out shows at the Olympia

Theatre and the National Stadium. Hughes embraced the lifestyle all right – what 23-year-old wouldn't? – but he quickly became aware that his 'comedian as sex symbol' image would become constricting after a while. 'There were a lot of screaming kids and that really did my head in a bit,' he says. 'I was signing autographs for an hour after the shows, and I was grateful that they were coming to see me, but I didn't really want to play to 14-year-olds. I stopped doing *Sean's Show* because I would have been in that situation for the rest of my life.'

 A bit like a puppy dog himself. Sean Hughes in early days

Hughes is still a star comedian, but over the past few years he has worked hard on lowering his profile – his stand-up has matured into darker, themed shows and in 1997 he wrote the well-received *The Detainees*, the first of several novels he has in the pipeline. He does two regular weekend chat and music radio shows that are broadcast in the London region and has consciously avoided over-exposure on TV, except for a regular stint as a team-captain on the BBC comedy music quiz show, *Never Mind the Buzzcocks*,

which he does to keep his face before the public and for the money: 'It's not something I'm particularly proud of. I don't want it on my tombstone. After *The Detainees* was published, I got hundreds of letters and one I got – I love it when people suss me out – was like "I love it and PS: Why *Never Mind the Buzzcocks*?" He sussed me, and fair play to him. I'm never going to pretend that *Buzzcocks* is great

– it's just very easy, lazy TV and it's quite good for what it is, but I'm never going to champion it.'

Not that he is particularly bothered even by the financial side of things. He lives in a terraced, tastefully decorated house in London's Crouch End, remarkable in that it gives no hint that the occupier is an entertainer: no pictures on the walls of Sean with this star or that, no awards on shelves, just the kind of busy, comfortable environment that any single guy in his 30s might enjoy. He doesn't lack for companionship, though, with the two dogs and a cat that remind one of his earlier, pet-oriented stage persona. 'I live very frugally,' he says. 'I bought this house for cash. You hear about bands like the Bay City Rollers living on council estates 10 years down the line and you think: what went wrong there? I'm not flamboyant. I'm not going to be a Champagne Charlie and end up on the scrap heap.'

Flamboyant he certainly is not. Glum, more like. Some people comment that he can at times be difficult or uncooperative during interviews, but when we visited his home he was relaxed and as upbeat as anyone suffering from a bad dose of flu can be. 'I've had it for ages. Usually my metabolism throws off illness quickly. I once had cancer for a day.'

He makes no apologies for his bleak attitude to life: 'I could be misconstrued as being a misogynist when I'm actually a misanthrope, and there's a big difference. When you write novels and you've got all that hatred, the female characters come across worse and people think you've got a problem with women, but it's not that – I've got a problem with the race in general. I'm well into equality; I hate everybody. I have a lot of friends, but if you look at it from an outsider's point of view, the human race is not a pretty sight.'

Novels, awards, top TV shows and even high-profile journalism – he wrote a weekly music column for the *Guardian* – it's a long way from a teenager named John Hughes in Dublin who worked at the local supermarket in his school holidays and was, in his own words, 'working-class fodder'. But, then, as he also says: 'The arrogance of youth really helps.'

John Hughes (he became Sean because there was another John Hughes on Equity's books) was born in London and his Irish parents moved to Dublin when he was five. 'They came over to get work and wanted to bring me up in Ireland so there would be more angst in my comedy. We lived initially in Whitehall because of my granny, and it was pretty working-class. Pretty shitty memories – not a time I look back at with great fondness. Then they bought a house on the other side of the city and about two years after that we moved to Firhouse. I had problems with my psyche when I first came to Ireland because I had a Cockney accent, and when I was at school the worst slag-off was "shut up, you Brit, you". I went to Rathmines Senior and that was where I really grew up and met some like-minded people.'

Performance had a shaky early start. 'Well, I did some stuff even at primary

I used to play football and you'd be lined up waiting to be picked for the team and you didn't want to be the last one picked because everybody would think you were a wimp and you'd try and bribe them and say 'I'll give you some chewing gum if you don't pick me last.' And the two captains are saying:

'Gizzo, my side.'

'Whizzo, we'll have you, mate.'

'Tizzo, our side.'

And I knew I didn't stand a chance, because my nickname was Wanker.

'Sharon-o, my side.'

'Debbie-o, my side.'

And they'd say: 'You can't play today, Sean, because there's an odd number.'

'Fair enough, I'll go and write some poetry or something. I know, I'll take my dog for a walk. Come on, Patch – we don't need *them*.'

'Sean . . .'

'Yes?'

'Patch is picked.'

from Sean Hughes's early stand-up

school. The ones who were really good at English got to do *Oliver!* at Christmas, and I wasn't good enough. I was just in between the good ones and the sick ones, so they let me do some sketches and I did that classic – I'm being ironical! – one of three of us pretending to flick TV channels, which I thought was a hoot when I was eight. I always wanted to do stuff like that. I was in a double act at Rathmines with Morgan Jones. That was quite sweet. We did this Christmas concert, just compering. I remember being quite horrible, actually, because I had been watching Bob Monkhouse the night before and he had this American comic on who did a great joke and I pretended to Morgan that I had made it up and I said "No, you do it because you're much better", and he did and people went "We saw that on telly last night". I do have a bit of a playful, evil side. As Hitler once said.

'Then I did media studies in Parnell Square, again with Morgan. They made us do a double act as an entrance qualification and we performed some kind of show for them. The guy said "Didn't I see you doing a gig in Tipperary?" We hadn't done it and we didn't answer, and he said "Either you did or you didn't". We said we did. They let us in and we fell apart a bit and then I did a double act with a guy who became a DJ, Nails Mahoney. The music show *TV Gaga* was on RTÉ and they had this day trip to see how the cameras work and they said they were short of people. We said we'd been doing this act for years, when in fact we'd never done it before.

It was quite a buzz, really – 18 and doing a live show. We were shit, but we thought we were brilliant.

'Then myself and Brian Conlon started to go to the Underground club in Dame Street, supporting bands. I remember supporting the Pleasure Cell, a band who were all reformed alcoholics, and so were all their fans, so that was a great gig. We used to do what every double act does – *Star Trek* material – then we got quite popular and went over to England and started to do the circuit, which was quite brave. For the first gig we were at a college and they loved us and we thought this is the beginning of fantastic stuff. Then for our second gig we died on our arses and Brian went back to Ireland. So I had gigs to do as a double act and I got on stage and I was really bad. But it was quite a good learning process – a steep curve!

PBJ

🌑 *Hughes and friend*

'I went back to Ireland and did *Megamix'* – a club-based music programme on RTÉ – 'where I just played the barman. The part was really talked up, but it was just me giving people drinks. It was fairly decent money, though, for what it was, to get me a start. Then, basically, I got 10 minutes of material together and talked Michael Redmond into going back to England, and we lived together in a one-bedroom flat in London and started doing open spots. And because Michael has those great one-liners, it was hard, because people loved him, really adored him. We ended up playing the Comedy Store and that helped me because I had to work quite hard, because I was never really into jokes – I was more into observation. It was quite hard living in Michael's shadow for a couple of years.

'Once I got anywhere half-decent, the circuit was tedious and I hated the conveyor belt comedy where five comics would go in and variate on the same subject, and that's when I decided to write a show for Edinburgh. I was never a great club comic because it takes me 20 minutes to get going. I used to be scared when I started doing arts circuits and I was beginning to make a little bit of a name for myself and there were beards in the audience and I'd go, "God, he's 50 – what can I possibly tell him about life?" That was my attitude. Before Edinburgh, I did a show with Steve Frost which was a laugh, but I decided I'm never doing the circuit again – I took a big risk and decided I was going to say more personal stuff, which really wasn't happening at the time.

'Even with the radio shows I do now, you start off going "Hey! Hi!" And then you think: Jesus, if you're not going to be yourself, you're going to be caught out. And when I did the show that I won the Perrier for, I just said "Let's see if I'm supposed to be doing this; let me be myself for the first time", and I was very philosophical about it. If it doesn't work, it's not meant to be. And I was just surprised by the whole thing when I won. I was at the Oblong Room at the Gilded – a terrible room – but people loved the show. Comics are blasé about awards, especially the ones who don't win, but I really can't stand awards; I have no time for them whatsoever. I don't think you should be judgemental about art. I know that's a crap word to use as well – "just tell 'em a couple of fucking jokes – what's your problem?"'

'I've always sounded wanky in print saying "let's make them laugh but let's make them think as well", but to me an entertaining night out is like a rollercoaster of emotions. Perhaps I can find a better metaphor – I *am* writing a novel at the moment. But if you haven't got a voice, it's just a nine to five job, and that's why I can't understand how people like Bob Monkhouse still get a kick out of stuff. I mean, the guy is 70 and I'm 33, and I know I can write a joke that will make you laugh, but the rush is gone from that now.'

Hughes maintains – with some justification – that there was plenty to think about in Channel 4's *Sean's Show*, which he was actually offered just before he won the Perrier, although at a casual glance it seemed the merest frippery. It opened with Hughes in the bath, singing 'It's Seanie's show, la-la-la-la, it's Seanie's show, doo-doo-doo-doo', but it did contain many innovative features that brought the viewer onto the set, with walls that were obviously fake and transitions from one scene to the next being effected by simply hoisting up part of the set, revealing the next one. Hughes often carried the script around with him, sometimes to prove to one of the many eccentric running characters that they would survive until the end of the programme. There was much to admire in *Sean's Show*, but it sometimes displayed the kind of arch knowingness that gives post-modernism a bad name.

He played his then-familiar role of overgrown adolescent, forever mooning about the flat and pining for Susan, his unrequited love, making constant spurious telephone calls to her ('bye-bye, bye-bye, bye-bye . . .'). He had a box of memorabilia devoted to Susan: 'Ah, there's the chewing gum I found under her desk. And the first cup of tea we ever shared together. You say stupid things to the person you're in love with, like "Here's all my money". I know, I'll ring her up . . .'

Hughes says that he was never given credit for the issues he brought up on *Sean's Show*: 'I'm a big vegetarian and I did an episode where my character was a meat-eater and he fancied a girl who was a vegetarian. He was trying to get rid of this chicken and the chicken became alive, and this sheep became alive, and for kids it was letting them know that this was what you were really eating. And we did

> The best thing about being Irish on holiday anywhere in continental Europe is that you can run amuck. You can shit, piss, swear your head off in the street and all the locals will go: 'Fucking English.'

young Irishman living in London, and how fashionable Irishness is over there, with theme pubs and so on. 'One day it's a balti house, the next day they've painted it green and called it Shitty McFuckerty's.' Although he had won the audience over, he still sensed something he didn't care for: 'Don't patronise me. There's nothing worse than dying in an arts centre. At least in a rough pub you don't get critiqued off.'

He is a Protestant from Roddy Doyle territory, Dublin's Kilbarrack: 'I've never faced any sectarianism at all. When I was a kid, if there was ever a hint of it, my mates, who were all Catholic, would tell them to fuck off, like "He's our Prod; get your own".' He attended the liberal Mount Temple School, where he was the class clown – 'a typical bollix' – and, with the support of his family, started working in the Comedy Cellar and other Dublin clubs when he was just 18. Ardal O'Hanlon: 'I remember Andrew Maxwell sitting in the front row of the Comedy Cellar like a little pup. I think he used to sneak off from school to come to the Comedy Cellar and he sat there week after week. So he was absorbing it all. He was almost ready-made, then, when he started.'

He moved to London when he was 20, armed with a list of clubs and numbers provided by O'Hanlon, and started off at try-out nights. 'It's like a whole night of open spots. It's free in and it's usually midweek, and it's a miserable notion. I did a load of them and, God, the collection of weird people. Most of them were, frankly, mentally ill. Rambling without any sense behind it. Crying on stage. One woman has been around for years and she gets nowhere and she says "Oh, don't hate me; I'm sorry" on stage. There are people who break down on stage. They have sadness in their lives and they've seen somebody go on and be cheeky about, say, wanking into a window, and then they go: "Oh great, I'll just offload everything that's in my heart onto the crowd."

'I saw this old guy, he was just like an old Irish digger – you know, curly hair and big, ruddy face – and he went on and he had two planks of wood with shoes nailed across them, like "I'm here with all my invisible friends, and we're all going to dance for you". It was really sad. But, luckily, the likes of Ardal, Dylan and Dermot Carmody recommended me. They were saying to club people: "Oh, give him an open spot; give him a half spot." '

English club-owners know that Maxwell will register immediately, whoever else might be on the bill. Sometimes he gets instant attention by opening with a deafening digeridoo-like noise he makes by growling into the microphone, something which 'has absolutely fuck-all to do with the rest of my act'. In spite of his youth, he knows the British club scene inside-out. 'When you go into rooms sometimes, you go "No, I'm not going to let you just stare at me. You *are* going to wake up." I've been in some nightmare places. This fucking club in Norwich or Ipswich or somewhere – I walked in and it was packed. No stage, nobody had paid in, they were all watching football on the big screen, and there was a weird strippers' podium above the actual bar, and it wasn't high enough. I'm only little, so I would have been shouting over people's heads while they're watching football. I just went "Fuck it, it isn't worth it", and that's the only time I've ever walked away from a gig.

'If an audience has woken up and is ready, then stand-up can seem like the most natural thing in the world, and people will say: Oh God, it's like he's talking off the top of his head. But if it's totally dead, stand-up just sounds like the most bizarre, stylised way of speaking altogether. People are going: Huh? What's he talking about? Now he's talking about something else. You start to feel really conscious of it. You say to yourself: If I was standing amongst these people, I wouldn't say: "Hey, have you noticed the way . . . ?" It sounds weird.

'The main thing at gigs is to have fun: It may not be funny, ladies and gentlemen, but it *will* be fun. Sometimes they will not have responded at all, and you may be the last act on and you can say to them: I'm the last act, ladies and gentlemen. You can sit and stare at me, like you did with the other acts. But now the whole thing is depending on me, the whole success of the night is riding on me. And that relaxes them; they realise you can cope.

'It's very rare that my nationality becomes an issue. I do lots of material about it, and every so often someone does go mad. You see, comedy is about going out at night to pubs, going out drinking, and in some of the larger clubs, which are rowdier, there is a higher proportion of working-class and lower-middle-class people in. Now drinking working-class and lower-middle-class people in Britain, a big proportion of them are Irish or of Irish descent, so if anyone shouts "Piss off, you Paddy" – which has happened to me – the audience has rounded on them. I don't need to do anything.

'With English audiences, if you show them who they are, they just go: That's us, that is. Then you're OK. If you hold a mirror up to them and go: Look! Have a good look at what's going on there, that always relaxes them. But you have to produce the goods, you know? It's not that it's rough, but there's only so many times you can bullshit. That's the English way, particularly London: I've paid in 'ere, mate, know what I mean, and I wanna larf. I've had the wife in the earhole all fuckin' day. I

I'll tell you about the best football chant I ever heard. It's fucking genius. There was a team in Northern Ireland and just a couple of years back they had a star striker called Felix Healey. Like with any other team on earth, when he scored a goal the whole crowd would go apeshit and chant his name. 'Hea-*lay*! Hea-*lay*! Hea-*lay*!' Fairly standard. And then some genius came up with the idea that whenever he scored a goal everyone would sing 'Away in a Manger'. Five hundred blokes, singing:

> Away in a manger,
> No crib for a bed,
> The little Lord Jesus
> Lay down his sweet head.
> The stars in the bright sky
> Looked down where Hea-lay! Hea-lay! Hea-lay!

don't wanna sit here listenin' to any old cobblers – give us some gags. Which is OK; I don't mind that; I don't necessarily think that's a bad idea.

'By and large, being Irish is an advantage, because English audiences assume Irish people are funny. Maybe sometimes for the wrong reasons: "You Paddies, always sayin' sumfink stoopid, putting yer shoes on the wrong feet." And you show them. There's a gag I do sometimes. I go: I'll be living up to all the stereotypes this evening, ladies and gentlemen. I'll be selling ponies outside later. Yeah, selling ponies . . . and having a higher standard of education. I just let it drop. And I say to them: Tell me it's not true.

'I write new material because I get bored with what I'm saying. The repetition gets to me. I've done TV, and I don't mind it, but there's an awful lot of shite on really. I'm just happy doing stand-up in clubs. It's always an adventure; no two nights are the same. I've seen so many colleagues and compatriots go on TV and it's taken all the sting out of their funniness – and I *know* that they're funny. And I imagine people sitting at home on a Tuesday evening going: He's shite.'

He hears a station announcement and leaps to his feet, swallowing a last mouthful of tea. We gather up our bags, coats, tape recorder and trot after him across the concourse. At the ticket barrier he turns to say goodbye. 'Ah, this is it, the glamour of showbusiness. People think it's much more exciting than it is. You have to enjoy it – there are comedians who are really miserable even though they're earning a fortune. You do 20 minutes in Edinburgh and the *Guardian* calls you a comic genius and you believe it! That's what I find bizarre. I think we should just try and have fun. Don't get me wrong – sometimes it pisses me off if I travel for hours just to get to a gig and you're just standing around in a pub kitchen waiting to go on and then you die in your hole. It ain't all happiness then, and I've had some gigs like that. See you.'

And he is gone . . .

Kevin Hayes

Comedy's Irish teacher

Affable Kevin Hayes, from a Waterford farming background, has a novel approach to working as an Irish comic in England – he 'teaches' Irish history. In his stand-up he has lines like: 'James Connolly was so badly injured in the Rising that he couldn't stand up to face the firing squad, so they shot him strapped to his seat, and he thus became the first armchair republican to die for his cause.'

His one-man show, *Beyond the Pale (A History of Ireland)*, which humorously covers Ireland from the Vikings to the present-day situation in the North, attracted attention at the 1998 Edinburgh Fringe. He explains: 'It was stand-up doing history, with jokes all the way through, but at the same time I was able to tell people things they didn't know and stuff about Cromwell and how Northern Ireland came about. Because most people in Britain don't have a clue. It's not their fault – they don't learn it at school. They're taught nothing about Irish history and they have no idea why Catholics and Protestants are the way they are, so I was able to enlighten them a little about that and give them a laugh at the same time. It was mainly a comedy show, but with a bit of information there as well.'

Kevin Hayes: history lessons

Hayes left Waterford at 17 to study civil engineering in Dublin, and went to Britain in 1985 to find work. He was an engineer for six years, then lost his job. He had been interested in comedy – strictly as an audience-member – for a long time and, with the desperation of the unemployed, tried an open spot in 1991 at the King's Head in London's Crouch End. 'I did a gig and somebody paid me and it was a revelation for someone to pay you to get up and tell gags. It was never a career thing when I did it first, but it is now. It was different then – there wasn't TV around, there weren't so many big clubs; it was just people getting up and seeing if they could do it, whereas now people go into it straight out of school or college – they do comedy so that they can get onto TV and it's a lot more commercial and corporate.'

In 1995 he was in *Young, Gifted and Green* in Edinburgh with Ed Byrne and Andrew Maxwell, and the following year the trio went to Australia with the show.

A busy and successful comedian, Hayes mainly works the British circuit, but occasionally comes to Ireland for gigs. 'I'm not very extrovert and I never was,' he says. 'I don't think I'm the typical Irish storyteller, trying to be the centre of attention.

'Irishness is trendy in Britain now and people are interested, whereas when I came over first it was quite the opposite and people were suspicious of the Irish because some people couldn't distinguish between the Irish and the IRA. I didn't get any outright racism, but I used to get little comments about "your boys" and all this crap. And that's why I wouldn't have done comedy when I came over first, because I wouldn't have had the nerve to get up in front of a group of English people and talk about being Irish.

'When I first started I based my act on the fact that I was Irish in England and a lot of the audience wouldn't know about Ireland, and you could kind of make up stuff and they'd go "oh really, is that true?" Whereas in Ireland you can't because they know what you are talking about. Part of comedy is getting people's attention by telling them something they don't know. In England it's a bit of a novelty, being an Irish Catholic.'

> British people sometimes have these misconceptions about Ireland – for instance, they use the phrase 'the luck of the Irish'. Whenever I hear that phrase I think: 'Luck of the Irish? Hang on . . . invasion, conquest, colonisation, famine, mass emigration, sectarian strife – how jammy can one small nation be?' That's why we don't do the Lottery – we're afraid we'd get lucky and end up owing Camelot 25 million quid.

Michael Smiley

The ultimate streetwise comic

With his shaven head and earring and fast, direct, tough-talking presence, Smiley, from Holywood, Co. Down, is the ultimate streetwise comic. His stand-up material often backs up that image – drugs, rave music (including a very funny mime act of dance moves) and youth culture.

Seamus Cassidy from Channel 4 said of him in 1995: 'Smiley has a forceful charm with just the right edge of menace, a great line in observation and he knows how to pull an audience with him

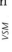

VSM

. . . I believe him – when I hear him on stage, I really feel like I'm hearing about his life and the world he inhabits, rather then pretend relationship angst.'

He has combined that upfront stand-up with a form of edgy storytelling that draws on his own experience to form loosely autobiographical pieces. Now in his mid-30s, Smiley moved to London at about 20 and worked for a period as a cycle courier – cycling is a long-time obsession of his – before taking to comedy. He has performed *Confessions of a Catholic Buddhist*, a sometimes poignant story about growing up and his schooldays, at the Edinburgh and Melbourne festivals. *Re: Cycling*, about the disintegrating life and times of a London cycle courier, was the second part of a trilogy. Smiley brought a new one-man show – *The Parting Glass*, the unhinged reminiscences of a man left behind at an Irish wake – to Edinburgh in 1999. He is also a team captain on TV's comedy quiz *Saints and Scholars*.

Michelle Read

An Englishwoman abroad

It's been pretty much a one-way traffic in comedians; Ireland is a small country, with larger, culturally dominant and financially more rewarding neighbours. Air travel's cheap these days, so lots of performers manage to make a comedy career with a foot in two camps – emigration doesn't have the same awful finality it used to, and we're all cool and cosmopolitan, right?

There is one striking example of traffic flowing the other way – Michelle Read, actor, writer, comedian and Edinburgh Fringe First winner. This sparky, creative Norfolk woman has neither Irish connections nor blood, but moved over in 1991 with her then-boyfriend, Michael Redmond. They split up; he couldn't settle back in Dublin, but Michelle, on the other hand, says: 'I immediately went, Oh man, this is my spiritual home.' And she's still there.

She had been an established stand-up comedian and actor in London; but had to start from scratch in Dublin, and her career has blossomed and broadened. She has moved on from stand-up and is a founder member and player with the Comedy Improv at the International every week. Most significantly, she has written, produced and performed two funny theatrical pieces, *The Lost Letters of a Victorian*

These days Owen O'Neill rarely does pure stand-up, and then only in top clubs, but for years he gigged all over London. His material ranges from general stand-up – musing on how in 'Humpty Dumpty' the basic problem was that 'they shouldn't have given the horses first go – imagine giving a horse an egg to fix'; to more stories about his grandfather (how, when he's asked why he's drinking so fast – 'I'm drinking fast since the accident.' What accident? 'I was in here last night and some fucker spilt my pint') to more political stuff.

'Working in Britain with the kind of political and social material I did in stand-up, with my northern accent, could be dodgy. Say a bomb had gone off in England and you're doing a gig that night . . . people are more sensitive to it. Two weeks afterwards you can do the same material and you'll get a big laugh, but on the night . . . that's why I always acknowledged the fact that it had just happened. And the way I looked at it was that I'm Irish living in London, and a bomb under a car doesn't just suddenly think: Oh, there's an Irish guy walking along over there, I won't go off just now. I'm telling people that we're all in the same position, and the fact that I happen to be Irish has got fuck-all to do with it. I think the IRA were a bunch of bastards, killing people and murdering people, and sometimes I get these hardline republicans saying that I shouldn't be talking about these things, that I should be talking about the other side, which I *do* talk about as well. But I think the IRA has hijacked republicanism. I don't want to get into a big political thing, but they have. There is a lot of republican stuff that I agree with, but you can't agree with it today because people will say you're in the IRA.'

Owen O'Neill

In early stand-up days

GENUINE COMEDY TINGED WITH THAT RARE POIGNANCY BORN ONLY OF THE BEST HUMOUR — THE SCOTSMAN

O'NEILL IS SHARP AND VERY FUNNY — TIME OUT

HE MAKES IT ALL LOOK SO EASY BEAUTIFUL COMIC TIMING — THE LIST

Eventually, his stand-up comedy segued into doing the one-man shows; the first, *Stand-up and Hide*, he describes with hindsight as 'a bit of shambles'. A combination of stand-up and stories, it was, unlikely as it may sound, about O'Neill learning to jive. 'When I was 16 I spent three months learning how to jive because I was in love with this girl and she could really jive. I couldn't, so I took these secret jiving lessons. I used to tell the other lads lies about where I was going. This guy

called Wesley McCracken taught me how to jive and he was brilliant. He was in his fifties and he was an old rocker, and we were in this old barn up the road with a cassette tape recorder.' For the end of the show he hired some professional dancers in 1950s gear: 'I said: Thank you very much and goodnight, and the exit doors kicked open and these two came on – 'Good Golly Miss Molly' – and grabbed members of the audience and everybody started to dance.' In 1991 he co-wrote *Patrick's Day* with Sean Hughes, a good friend and regular collaborator. They also worked together on their 1999 Fringe First-winning plays.

In 1993, O'Neill created a show called *A Bit Like This*. 'I came on and I did five minutes of stand-up and then I said, Thank you very much and goodnight, and I went off. Two sections of the stage were lit: there was the stand-up side with the microphone and then the other side was lit up with a couch and a fireplace, and that was my home and I came in and said, How're you doing? It's really nice to come home in between gigs. And I took my shoes off and sat down and talked to the audience about – well, everything: where I came from, and I used to read a few poems, and there was an old boy next door and we had some banter through the wall, because he was a bit of a lunatic. And that show was about growing up and my family. It was quite gentle stuff, just me telling stories, and I'd do about 50 minutes of that and then and I'd say I have to shoot off now and do a late-night gig. Comedy, eh? And then I'm on the other side of the stage and I do exactly the same material that I opened up with, because I was in front of a new audience. It was just like letting people in on the whole thing of stand-up comedy and how you write.'

Ian O'Doherty calls Owen O'Neill 'the one great comic genius to come out of Ireland in the past 15 years'. Is there more of himself to be uncovered and laid bare for black, comic effect? 'I'd say so, yeah, but it takes me a little while because things are buried, and then something will trigger off an idea – like John Shuttleworth did – or my brother might say something. At the moment that hasn't happened, and I'm looking for something or someone to unlock the door again. I've done three shows, which were all quite autobiographical – that's about six hours of material, which is quite a lot – that's three novels as far as I'm concerned. I may have written everything, but I don't think so.'

year and I worked for the students' union. I was on the entertainment committee and I used to do things like organising the karaoke. I ran for vice-president and I used to do all these speeches and jazz them up with a few jokes – making student politics fun – and then I started getting asked to go to other student unions to do talks, so I kind of got a taste for it then.

'That all ended after a year and I was set adrift and I worked as an office temp and I opened a comedy club in Glasgow, in a pub I used to drink in. They used to put bands on, so I suggested doing a different thing – having a comedy night. It was called the Comedy Cellar, funnily enough. Every Wednesday night for around three months, just hosting it. I got paid nothing. The bar took all the money off the door and they paid for the comedians that I had booked and I just did it for the experience. It worked out very well for me, because after three months I had about 20 minutes of rather ropey material that I had made up and I was able to take it to London.

'Being the host is a good way to get experience because you don't have to be that funny, but because you would get the same audience coming in every week, you were forced to do something different. You are only the MC, so if you die on your arse, you just say, Right, the next act is . . . '

So, in January 1994, 'I packed my comedy knapsack and moved to London and started doing all the open spots. And on the London circuit you get up and you do your five minutes, for nothing, and if they like you they invite you back and you might do 10 minutes, and they pay you. If they still like you, they invite you back and you do 20 minutes, and once you're doing 20 minutes everywhere, the rest of your career kind of takes off.

'But it's a very tough thing to get going in because your first few gigs – you're shit; it's as simple as that. And it's like any profession. When you first learn to drive, you're shit. You can't just say I fancy being a plumber and then instantly be able

If anybody here's thinking of moving in with their boyfriend or girlfriend, get them to move in with you. You may think it's a simple thing of semantics, but it's not. If you're there first – whether you're a man or a woman, so I'm not being sexist – you're in a much better position, because living together is all about compromise. And if they move into your place, you can be pretending to compromise *when you're not*! They didn't know what you were like before they moved in, so if she comes in and says 'Ed, you left a dirty plate in the sink,' you can say 'Yes . . . but I've stopped shitting in the bed.'

to lay pipes. You have to learn your trade. But in any other profession – a doctor, or whatever – they get to learn with just a few other people there, teaching them. In comedy the only way to learn is in front of a crowd of people going: You're shit. So it is a very difficult thing to get going in. You do need to have either a very thick skin or be quite masochistic. And I think I have a mixture of both.'

He writes about 40 minutes of material a year. 'If you can write that, that's good. If you're a musician, that's like an album a year, and I think it's probably just as hard to write comedy as it is to write music.'

He has had astounding success for someone so young – the festivals, the sell-out shows, the foreign tours, the TV offers, the Perrier nomination in 1998. Where does he go from here? 'Well, like everyone else, I'd like to do less work for more money. And the thing about this game is that the more famous you get the less work you have to do and the more money you get, so to that end I'd be quite happy to get a sitcom, because any acting I've done I think is a piece of piss. I can't cry on cue, or any of that shite, but I can do comedy acting. I did a bit on *Father Ted*, but every Irish person who ever told a joke has done a bit on *Father Ted*. If you take Ardal O'Hanlon, he's a good stand-up who then landed a role in a sitcom in which he excelled and became very famous and was able to go on tour on the back of it. And that's the perfect situation, because if you only get famous doing stand-up, by the time you get to the stage where you can fill a stadium, everybody has heard your material already. So it would be really nice to get famous tomorrow and then just be able to do a huge tour and do the best material I've written over the past five years, but I can't. So at gigs now I just do the most recent material, because people have heard the earlier stuff.'

Ed Byrne may be frail-looking, but ambition doesn't come made of much sterner stuff. He's working on his sitcom ideas . . . all part of his comedy life plan.

He reckons that if he hadn't moved to Glasgow, he wouldn't be a comedian at all. 'If I had stayed in Dublin, I wouldn't have gone down to the International and tried out there. It just wouldn't have occurred to me to do it. I might have fancied being a comedian, but I would only have been frustrated if I'd stayed in Ireland. But if you go to another country, you can do it easier.'

Graham Norton

'As I always say, the main difference between a straight man and a bisexual is three and a half pints of lager'

Graham Norton is now so famous through his Channel 4 shows and BBC appearances that he no longer needs to set out his stall the way he did at the start of his career. 'Yes, I *am!*' he would tell the audience then. 'You don't have to be Desmond Morris to work it out. Wake up and smell the cologne!'

In the mid-1980s, after a stint idling around in San Francisco and formal training as an actor at London's Central School of Speech and Drama, he began doing character-based monologues – *Mother Teresa's Grand Farewell Tour, The Karen Carpenter Bar and Grill, Charlie's Angels Go To Hell, Crazy Girl* – around London's pubs and Britain's smaller arts festivals. 'Friends said to me – you're an idiot – you're making no money at all; you're just trawling around arts festivals. Do stand-up and you'll make some money. And it worked, because people don't know what to do with you if they can't put you in a box. What's Graham Norton? Comedy performer; he does bits of radio. But once you are a stand-up, a gay stand-up, they know precisely where you are. It's perfect.

'If you don't acknowledge it, it's almost like being caught out – and also I'm very camp, so it was the easiest thing to make jokes about to an audience. When you start doing stand-up you talk about the experience that is closest to you, so for me it wasn't like: shall I be an Irish comedian or a gay comedian? But certainly those were two options that were open to me. But experiencing my life as a gay man was much more to the forefront than experiencing life as an Irish person. So I do very little about being Irish.

'Sometimes it's easier with a straight audience. Gay audiences tend to nod off if you stop talking about being gay. That seems to be the only interest they have. But if gay people come into a comedy club, they'll be waiting a long time before someone talks about the gay experience. A couple of years ago I remember I went through a phase where I thought: God, if I use the word *gay* one more time, I'll scream. And I *am* gay – so how are *these* poor people feeling? So I started writing more stuff that wasn't just about the gay experience, because that is such an easy trap to fall into, to do a set about "the difference between gay people and straight people is . . ." jokes. That would bore me, I know, so I started writing stuff about general "lifey" things. That's why I talk to the audience, too, because that opens it up.'

And talking to the audience is what this witty and likeable Dublin-born comedian does best, especially if that audience is longing to be embarrassed or bursting to reveal outrageous sexual secrets. *So Graham Norton*, which had a second season on Channel 4 in 1999, was a bizarre mix of stand-up, a post-modern *Mrs Merton*-style chat show (in the sense that guests sometimes don't get the basic joke), telephone calls to unsuspecting people, visits to outrageous websites and wild audience confessional. Norton – crop-haired and rather tough-looking – might open a typical show by swooping onto the set to ask 'm'lovely new friends, th'audience' to stand. Then a process of elimination begins: 'Stay standing if you've ever injured yourself during sex,' he might cry, or 'Stay standing if you've ever had sex at an office party.' Conditioned by all the *Jerry Springer*-style talk shows on TV, a surprising number of people are prepared to disclose their most intimate secrets. On one show a woman told him she had been caught on a security camera going into a toilet to have sex. 'Fair enough,' Norton told the rest of the audience reasonably. 'She's a class act.' Prizes are awarded for the most forthcoming punters: 'You've revealed so much about yourself tonight, we have a special prize – a free day out at a lovely nudist colony!'

Often the prizes act as a link to a guest. On a 1998 show he told a man who had boasted of having sex with numerous women: 'No one goes away empty-handed on this show, so next time you feel like sex, get this out of your bedside locker. It's only a photograph of m'first guest – Ian McCaskill!'

And on trundled the small, dumpy former BBC weatherman, a nice man and a good sport, though clearly apprehensive. As well he might have been. Norton picked up his 'Teddyphone' – he is fond of novelty phones – and called up a sex line, randomly selected from a magazine. 'Hello, is that Mistress Dominique?'

'Yes, it is.'

'I've been very bad. Me and m'friend Ian.'

'Well, in that case, I think you should be down on your knees. I'm going to punish you. I'd like you to take your trousers down.'

McCaskill: 'I'm used to humiliation . . .'

Norton: 'I think my friend Ian has just come. There's a warm front moving over him.'

> There was a man begging in the street with a card that said 'Homeless'. When I passed him he shouted after me 'I know you! I've seen you on TV!' I said to him 'Excuse me, but exactly *how* homeless are you?'

213

Another toy to play with

In another show he had an appalled Ivana Trump, with the aid of an official interpreter from the European Parliament, chatting to another sex-line, 'Greta mit der Grossen Titten', in Germany. Honor Blackman, Kylie Minogue, Joan Collins, Roger Moore, Nanette Newman, the formidable Grace Jones and Bo Derek (who was asked to smell the audience's shoes) were on the show, many of them well on top of the situation, others looking bewildered or embarrassed.

An excellent moment came in his 1998 Christmas show, when LaToya Jackson was a guest, and she talked about how she and brother Michael, brought up as Jehovah's Witnesses, still used to proselytise from door to door, even when he was very famous, wearing heavy disguise. Adults didn't recognise him, she said, but children usually did. 'Must be a sixth sense,' deadpanned Norton instantly.

But even when he's at his most mischievous, you know that Graham Norton isn't going for the kill and, indeed, he has a reputation as one of the most considerate performers in the business. He genuinely likes people, and chooses his targets carefully. 'Ivana Trump was a perfect guest. She didn't get it and she was very good, because she's so far in a world of her own, she doesn't get *life*.' But he's aware that 'the guest that doesn't work so well is the guest that doesn't get it, but is sort of fragile, so you can't take the piss. I could take the piss out of Ivana, she gets *that* much, she knows that people are laughing for some reason. Nanette Newman is a sweet woman. I like her and I did want her on the show because it struck me as a funny idea that she be there. But she was too nice, and you couldn't have a go.'

Children are like farts – people quite like their own.

A major dispute during the first series was over Kylie Minogue's appearance. The producer 'became obsessed that I show pictures that were published in a paper of her on holiday with her top off. He wanted me to get the newspaper out and show these pictures, and I didn't want to do that. I didn't feel comfortable doing that – it just seemed really tacky. This woman is sitting there and I'm going to be taking her tits out. That isn't exactly research; it's just 20p for a newspaper. He wouldn't take no for an answer. He kept coming back, and I kept saying no. So it sort of escalated, but I won.' Kylie was annoyed 'because she knew they were trying to make me do that. She was fine with me because she knew I refused, but she was pissed off because she knew that they were trying to put her into that situation. But no one else has left the show upset, and I hope that is the way it will stay.'

Away from the camera, Graham Norton isn't particularly camp; he gears up for outrageousness once the 'pink light' goes on in the studio. He describes himself as 'middle class, but in that classic Irish sense where your parents spend a lot of money so that you're not their class any more'. His father worked for Guinness, so the family moved around a lot, eventually settling in Bandon, Co. Cork, where he went to secondary school. But because of all the moving, it doesn't feel like home. 'I've no particular feelings for it. I don't hate it or anything. It's just a place for my parents. I have a sister and she lives on a farm – she's a big noise in the Green Party, agricultural spokeswoman or something.' There was certainly no showbiz tradition in this Protestant family. 'It came out of nowhere – the showing-off gene pool!'

He didn't discuss his sexual orientation with his parents. 'The first conversation we ever had about it was in 1998, when I had done some TV thing. It was never a big trauma. It makes me annoyed that I didn't come out to them, and my line was always – look, they know, and I know they know, and they know that I know. At the same time, there's something about not actually using the words, not actually acknowledging it, that means there is a semi-awkward dancing around, and I'm annoyed that I didn't do it earlier. Maybe it's an Irish thing, I don't know, but it seems like there's an emotional illiteracy. Even straight people don't talk to their parents about sex, and there is an embarrassment about going home to your mother and saying I'm pregnant even if you're married and everything is fine. It's still disgusting and – I'm so sorry and, yes, *we did, we did.*'

He studied French and English at University College Cork, then 'ran away' to a hippy commune in San Francisco, where he lived for a year. He decided to study drama at the Central School of Speech and Drama, London, where he realised he couldn't do serious theatre – 'I was all right at light comedy parts, but deeply shit at anything else. People laughed at anything I tried to do, which in the beginning is very upsetting, because you're desperate to be Hamlet. Then you realise that all those people are rather jealous of you being able to mess around and make people laugh.'

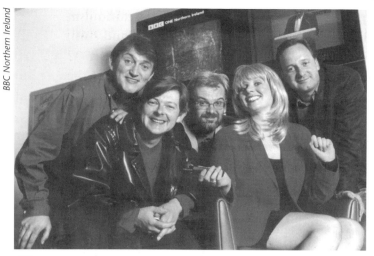

Moving into popular comedy – the HITWG in the BBC studios

it as opposed to us saying it – so Uncle Andy can say things, because we all know he's a sectarian bigot anyway; the Shinners are saying their thing; the cop is saying his thing – it's not actually the Hole in the Wall Gang saying here's what we think; the characters are doing it.

'Once you get onto TV, then you get into a different area, because, no matter what they say, and the BBC would deny this, the only thing they're concerned about is ratings – and a satire show will get so much of an audience and then it will stop, because a lot of people aren't really interested in satire, or they don't understand it, or it's not their bag. The BBC wanted us to do popular comedy; they wanted to get good ratings, that involves having to . . . it was put to me like this: You don't want people to have to swallow the *Guardian* to watch this show. With the result that you do tend to tone it down and fine-tune it. With the live stuff, you get a different type of audience.'

Audiences, rather than delighting in the 'other side' being slagged off, often get most enjoyment from the familiar – in west Belfast, people nudge each other and say 'that's you up there'; when Billy Hutchinson asked them to do a show, they included a routine where Orangemen insist that their traditional route is through the audience, and force everybody out of their seats while they march to the stage for a speech about Protestantism. 'It's something that they're used to and identify with – they know people like that,' says McGarry.

Quinn, from west Belfast – Gerry Adams territory – McGarry from north Belfast ('also Gerry Adams territory, but more middle class'), and McDowell, the 'token Prod', from Jordanstown, outside the city, met as students in Queen's University. They created 'bad sketches' for a law review and Quinn wrote 'plays that weren't very good and used to persuade these boys to be in them'. When McGarry was made president of the college Third World Society – there were no members and the other two made themselves vice-presidents – they staged some one-act comedies to raise funds for the Ethiopian famine in 1984, and for Oxfam and Amnesty. 'Then we realised if we did this for ourselves, we'd make a lot of money. So it evolved that way,' says McGarry.

A group of 12 went to the Edinburgh Festival in 1988 and did some 'heavy satirical sketches about central American juntas and US foreign policy, and what a

bastard Ronald Reagan was,' says Quinn. The reviews were negative, but while they were there, they got some good advice from the Absolutely crowd (the Scottish cabaret group that Jack Docherty was in). 'They said: there was some good writing and good performances, but you should ditch half your cast, and if you want to take it seriously start talking in Belfast accents and write about what you know,' says McGarry. The result was a slimmed-down, five-member Hole in the Wall Gang, with the three writers also working as lawyers for several years, doing mostly live shows. The name was a spur-of-the-moment lift from the film of the same name, but presents problems – it's overlong, 'plus,' says McGarry. 'we're all in our mid-30s now and we're still in a gang – let's go to our tree house and drink lemonade!'

They got a 'wee break' from Radio Ulster in 1990, doing a three-minute satirical piece every week for *Talkback*, the local current affairs programme. In 1991 they did a six-week radio show on the station called *Perforated Ulster*, which won a Sony award; it was mostly satirical and included an item that was to grow into *Give My Head Peace*. The serial was compiled into a one-off Radio 4 special, then they persuaded the BBC to make a TV version of it. Says McGarry: 'It took years. We messed about for years because we all had proper jobs, and trying to get the BBC to do anything . . . though they're far, far better than UTV, who don't make programmes, and RTÉ, who don't make comedy programmes. There's only one broadcaster on the island of Ireland who's prepared to do anything vaguely risky, and that's BBC Northern Ireland. There's no point in going to UTV and saying "I've a great idea for a satirical comedy". RTÉ doesn't want us. *Two Ceasefires and a Wedding* was one of the most popular programmes, we won an award for it and huge audiences, it got a network broadcast on BBC2 to the whole of Britain, a great review in the *Daily Telegraph*. It was offered to RTÉ and they said: No thanks, we don't think it would be relevant to our audience. For fuck's sake, I don't know.'

Two Ceasefires and a Wedding, broadcast in May 1995, won a Royal TV Society award for best regional programme, and the lads finally gave the day jobs up in 1996. These days 'the books are full for a year and half, which is more than Shorts can say'.

Billy the policeman is having a secret relationship with Emer, a Catholic, and the two of them are up on Cave Hill having a snog.
Emer (*stops*): Billy, do you not think you should be wearing some protection?
Billy: Yeah, right enough, good idea.
He puts on a bullet-proof vest and a flak jacket.

from 'Two Ceasefires and a Wedding'

Pushing the boundaries of what you can be funny about in a conflict situation is 'a fine line, and a skill,' says McDowell. You can't make a joke about a bomb going off and people being killed – 'it's not funny' – but 'you can make a joke about the politics that made whatever people decide that was an excellent thing to do. Their justification.'

They hope to make a series called *Comedies of Error* – starting with *1798*, their spoof of the rebellion – a satirical/surreal take on big events in Irish history, 1916, the Famine and so on. The difficult thing is breaking out of the North. They have made a radio series called *Half Sketch Half Biscuit* for BBC Radio 2 which is 'more surreal than anything we've done. It's just funny. We satirise the Taliban, who are regular characters in it. We do *Psycho*, with Norman Bates bringing his emaciated mother to *The Antiques Roadshow* to see what she's worth,' says Quinn. A TV pilot has also been made.

But with British TV companies they have found themselves between a rock and a hard place. When they submit an idea aimed at a network British audience rather than a specifically Irish one, says Quinn, 'they go: this is brilliant; we've seen some of your tapes and you're very talented; very good stuff. My problem is, you're Irish aren't you? Can't you do something that's a bit more Irish? You shouldn't lose your Irishness. So you go and put some Irish into it, and they go: this is wonderful stuff, some brilliant writing in this, my problem is this: it's too Irish. Squaring that circle is rather difficult.' And you get what they call 'the old "me-cock's-fell-off" excuse – they might as well tell you that as tell you anything else: the script is great, but unfortunately me cock's fell off and we don't get any new ones till Tuesday.'

The Hole in the Wall Gang broke down barriers and started to satirise real life in the North, and others followed. But in a changing political environment, obviously satire changes, too. In this context, says McDowell, 'our comedy can't just be presented as "he's a Prod, she's a Catholic" type of thing. We're moving on to do something different. The targets have changed, there's no doubt about it. Doing a Proddy and Catholic thing would have got more laughs in the past than it would get now. People go yeah, heard that. And that's healthy, and it's actually got more subtle. Things have shifted onto the hypocrisy of institutions.'

Patrick Kielty

'There's nothing to fear in mainstream and, in fact, it's not a bad place to be'

Can a young Irish comedian operate successfully in two worlds – enjoying the glamour and glitz of mainstream British TV stardom while continuing to tour as a stand-up, performing the kind of abrasive, subversive material that he could never use on the box? That is the balancing act Patrick Kielty attempts. After a number of notable TV successes, in 1998 the clean-cut lad from Dundrum, Co. Down, hosted the BBC's weekly Lottery show, a ratings topper, with Anthea Turner – a long way from his start in 1992, taunting the hard men on both sides of the sectarian divide as resident MC of Belfast's Empire Comedy Club.

Not that Kielty sees the word 'mainstream' as any kind of pejorative. 'Mainstream is now almost like a vampire-type word – people go "wooooo". And it's funny, because I learned a few years ago that there's nothing to fear in mainstream and, in fact, it's not a bad place to be. I don't mind being modern mainstream, if that's what people want to call it. I think in stand-up you can still have an edge and in TV do your mainstream stuff.'

You want both?

'I do want both.'

It's a very hard thing to do.

'It *is* a very hard thing to do. Somebody said to me recently: What you're doing is very brave, because you are neither one thing nor the other and you don't seem to care. I said, What do you mean? and they said: Well, you're not pitching yourself as highbrow and you're not looking for that type of theatrical critical acclaim, and at the same time you're not low-brow mainstream, and it's almost like, what are ya? Are you a tabloid act, are you a tabloid TV person, are you a tabloid comedy act? But you're not, because you seem sharper than that, and yet you're not looking for things

©Paddymania

David Hull Promotions

229

like success in Edinburgh. I don't do Edinburgh. I don't want a Perrier. I never did. I'd much prefer to be doing a prime-time show on Saturday night on TV.'

So which of those things are you?

'*I don't know!* I'm throwing all these things out to you and I haven't got an answer. There is a schizophrenic streak in me – I overdose in TV and I overdose in stand-up. When I sell out a stand-up show because of the TV profile, I actually love sucking people in on the innocence thing and then hitting them over the head. I'm not saying that it's inter-galactic mega-satire I'm hitting them with, but I just like, you know – Come in; I'm the man who did the Lottery show. I bet you never thought I'd say *that*, did you? I quite enjoy that.'

On stage – these days at huge venues like Belfast's Waterfront or Dublin's Olympia, on tours in between his TV work – his act is an odd mixture of hard-hitting political satire and standard, high-quality, if often laddish, more general material – about relationships and with lots of tit jokes. He does, indeed, seem to delight in shocking people. He is a very polished live performer, and his slim frame darts about the stage in Mister Showbiz style.

Kielty is still in his 20s and is blond, well-groomed (a good-teeth-clean-body sort of lad), handsome and boyish, attributes that probably helped protect him back in the early 1990s when he was standing on the stage of the Empire hurling savage insults at the men with blood on their hands. But those men, from whatever side, knew something about young Paddy that maybe made them pause, something he rarely talks about; he has been known to walk out of interviews when the subject was raised. It is, for most of us, the unthinkable. In 1988, at the age of 45, Patrick Kielty's father, Jack, a businessman, music promoter and leading GAA official, was murdered by the Ulster Freedom Fighters, shot six times in the head and neck.

In late 1998, as the peace process was moving along, one of the men allegedly involved in the murder was given early release. Kielty spoke publicly about how he felt about it to Gay Byrne on *The Late Late Show*. 'The way I look at it – and the reason I don't like talking about it – is that there are 3,000 other families in the North who are in exactly the same position as me. And I don't really think that I should be holding myself up and saying, listen to me and I can talk about this and

Everyone is now talking about peace in the North, and building a future in the North, and we're coming together and we're building this and we're building that . . . I don't mean to worry anyone, but the last thing we built in Belfast went down with Leonardo de Caprio and Kate Winslet hanging off the back of it.

I have a right to, purely because of what I do . . .We all know that people are going to be released early and one of the things about an agreement and about peace is . . . everybody says that there is a price for peace, but I find that everyone names their own price for peace. And therefore the unionists say: there is a price and this is our price and we can't go beyond this. And the nationalists say: this is our price and *we* can't go beyond this. And I think that the price of peace is about that' – he gestures a small amount – 'much further than everyone's so-called price. And I think that it's up to people and the families like me – if we're prepared to go the extra bit and to put up with something like that, then I just hope that everyone else is prepared to go that wee bit harder and make it work.'

David Hull Promotions

He spoke rationally, sincerely and strongly, and it was almost as if you could see his psychology training, as well as his innate intelligence and personal strength, showing through in how he deals with this most personal of tragedies, just as it does when he talks about his career.

Dundrum is a small village on the coast, and Patrick was the middle of three brothers. The boys learned to swim in the harbour, played Gaelic games and football and tennis, and cricket up in the castle in the summer. 'I think people who are middle class like to

Mainstream – it's not a bad place to be

think they are working class,' he says. 'My mum and dad came from working class. We were middle class, but we had come from working class. I'm in the middle, no sisters, which was a good thing. Because you don't have the hassle of looking at lads, knowing the way you think, thinking of what they want to do to your sister. It makes it easier. It still is quite a ladsy house.'

The comment puts some of his comedy in context, but also makes one reflect on something said by a family friend, who came to the school when he was told, at the age of 17, about his father's murder: 'This is very, very tough, but you have to be a man.' The psychologist in him might read a lot into that.

Though his father was in the business, Patrick had no particular ambitions to be an entertainer; it was something that started to evolve when he was studying psychology at Queen's. 'I never thought: I want to be a comedian and that's what I'm going to be. I think anyone who has that type of focused determination either turns into a not very nice person, or it goes badly wrong and their life is in pieces because they are so focused on the one thing. And everything is such a fluke to actually get anywhere, especially in what we do. What happened was that I was doing some comedy in Queen's, doing the odd stand-up gig in the Students' Union,

and it went well, and the lads said I should go for a talent competition in the Union and I won.

'Whenever I've had to make decisions, I've always been blessed with a wee bit of success just at the time, and it pushes you a little stage further, and that's continued with me. I was doing comedy at Queen's and someone told us there was a competition at Billy Magra's club down in Dublin, and the lads said: we'll hire a minibus, fill it with beer and we'll go down. I was going: I'm not sure. They went: If you don't do the fucking competition, we can't go on the beer. So I said OK, and we went down and I got through the heats and it progressed to the point where I was going down for the final on *The Late Late Show*. The *Late Late* was on a Friday and the psychology exam was starting first thing on the Monday. So I thought I'd bring my books to Dublin and study all week and do the *Late Late* on the Friday. Now, at that time *The Commitments* was the groovy thing around town, and Guns 'n' Roses were playing at Slane, and I went to the nightclub, Lillies Bordello. It was something a 20-year-old student from Belfast had no concept of – you arrive and the Commitments are drinking over there, and Slash from Guns 'n' Roses is over here, and you're kind of thinking: Psychology exam's on Monday. You know what I mean?

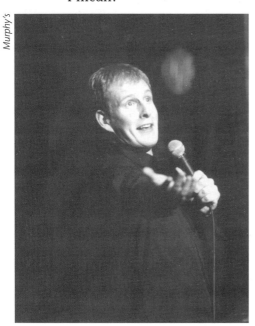

Murphy's

I overdose on TV and I overdose on stand-up

'So off the back of my experiences in Dublin came the opportunity to book the comedy club at the Empire with Jackie Hamilton. That was the year I was finishing the degree, and the five of us who shared a house in Belfast, none of us had jobs. We were all going from skint student status, so it was going to be a while before we earned that graduate 15 to 20 grand a year job. And what happened is that over that space of time I started to get gigs. So, while they were on the dole as unemployed graduates, I was getting 50, 100 quid a week doing two gigs, then suddenly it turned into three, then it was four, and by the time they started applying for jobs, I was making as much money at the comedy as they were starting out as graduates in jobs. And I thought, hang on a second here. Loads of people end up in life doing something they're second-best at because they're afraid of doing what they are best at. I'm not going to do that. I'm making the same money as the guys are and I'm doing exactly what I want to do and what I enjoy.'

Many of those gigs were at the Empire, or in Derry. The hard men of Northern Ireland, be they Catholic or Protestant, were not overawed by visiting English

> What IRA are they talking about? There's so many of them now, isn't there? There's the Real IRA, the Surreal IRA, the Continuity IRA, the Provisional IRA, the Official IRA, Low Fat IRA, Diet IRA, I-Can't-Believe-It's-Not-The-IRA . . .

comedians. In Derry Jenny Eclair was told that if she ever came back, she'd go home in a box. Dominic Holland arrived at his hotel to find a man shot dead in the foyer. Donna McPhail was hissed when she made the common and uninformed mistake of referring to Derry as Londonderry. 'What the fuck is this?' she bravely responded. 'A comedy club or a council meeting?'

Local lad Kielty fared better, but plying his trade as a comic wasn't exactly easy. 'Any other comic in any other part of the world would do what's in the news,' he told the *Guardian* in 1994. 'But if Sinn Féin is in the news that week and you direct your jokes at them, people come up after the show saying, tonight you told six jokes about Sinn Féin and none about the unionists! I did a gig in front of a Catholic audience and everything was going grand. Then I told a joke about Gerry Adams, saying he should be the new football manager of Northern Ireland; then, when they were stuffed 5–0 at home by the Faro Islands, Gerry could say "Well, although I am connected with the team and I do sympathise with what they are trying to achieve, I have no direct control over my players" . . . It was fine up until that point, because I had been doing jokes about Protestants.'

He played gigs in unionist areas, as well, often starting his act with the words: 'Hello, I'm Patrick Kielty – and, yes, I am a Fenian.' One heckler informed him he was a member of the UVF. Kielty told the audience: 'I know what you're thinking. He's in the UVF, my name's Paddy, and how the fuck am I getting out of here?' Of those days, he said: 'They respected me because I didn't go into their territory and pretend to be something I wasn't. I went in and faced it.'

Given Kielty's looks and quickness of mind, it was inevitable that TV offers would start coming in. He fronted the successful UTV youth series *Sus*, and was then given his own Friday evening show on BBC Northern Ireland, *PK Tonight*. He fronted Channel 4's *Last Chance Lottery* game show, which attracted 1.5 million viewers, and the BBC's *After the Break*, which poked fun at foreign TV commercials. He took part in the award-winning BBC Northern Ireland special *The Empire Laughs Back* and attracted huge attention when he co-costed 1995's *Comic Relief* with Ben Elton, Lenny Henry and Jo Brand. He won the Royal TV Society Award for Best Newcomer, and became a household name in Britain in 1998 with *The Lottery Show*. In the

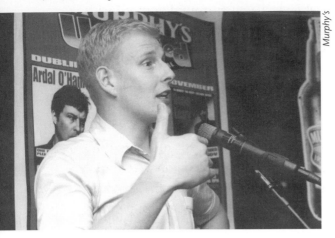

'If you don't like it, switch over to Cilla'

middle of all that he formed a production company, Green Inc. In 1999, when Gay Byrne retired from *The Late Late Show*, where Kielty got his first TV exposure, he reportedly turned down the chance of hosting the long-running RTÉ programme, instead opting for a half-hour networked BBC1 comedy/chat show, *Patrick Kielty Almost Live*. It was probably a wise move to say no: anyone would find direct comparison with Byrne difficult, and although an experienced mainstream TV performer, Kielty's experience is mostly at the shallow end.

Kielty's humour has had to adapt to British TV. 'There is an element in middle England that makes middle England tick, and there are decisions you have to make. If you want to play BBC1, you can't offend those people because they make up a vast majority of the country. So you must decide: do you want to be a BBC2/Channel 4 act and play to a million and a half people, or do you want to go for it and play to 10 million people?

'I'm happy to use live stand-up as my release valve for the edgier stuff that I want to say, but if you look at mainstream TV and stuff like *The Big Breakfast*, the presenters aren't saying anything controversial – they don't because they can't. I'm happy that there are two things in my life – one is TV, and you do that one way, and the other is stand-up, and you do that another way. The notion of bringing both those together means you're neither one nor the other, and effectively you're in a state of limbo. It's not about blanding yourself down and it's not about dumbing down, and it's not about highbrowing-up to do stand-up. Even with the mainstream acts, you go to see Jim Davidson live and he's going to be offensive and there'll be lots of swearing, and then you watch him on *Big Break*, or *The Generation Game*, which gets 10 million viewers, and he's just a cheeky chap. It's the nature of TV.'

Offstage, Kielty is relaxed and immensely confident without seeming in the least conceited, and analytical and serious almost to the point of gravity. 'I was never funny offstage and people generally find me a disappointment. I get one of two things whenever people meet me. They either think I'm a bit sharper than I appear on TV and actually have more to say and am slightly more intelligent than they gave me credit for, or they think, God, your man's not very funny for a comedian!'

He enjoys the trappings of fame but is acutely aware of its pitfalls, which is why he continues to value the opinions of his brothers and old college friends. 'You try

and surround yourself with realists, because whenever you surround yourself with yes-people, then suddenly you start believing in what you're not. The TV stuff I do is light entertainment; it's not brain surgery. It's chewing gum for the brain. You can only hope that you take someone's mind off a really bad day for the hour that you're on TV. It's not *The South Bank Show*, it's not *The Late Show* with Mark Lawson, you know what I mean? It's actually about going out there and trying to give people a few laughs. If you don't like it, switch over to Cilla.

'You do a TV show, and you finish it, and during the show you're writing yourself wee notes, and whenever a show finishes you see if you've enough material for a one-man stage show – if you have, you go and do a show and the live stuff keeps you sharp, so, effectively, whenever you go back to your TV thing, what you're bringing is a sharper way of thinking. You are equipped, you can get a line, whereas if you just do TV you are in this stale vacuum of presenterland. With stand-up, you are tapping in, and sucking in energy, and that helps you.'

Colin Murphy

*'It was unbelievably tiocfaidh . . .'**

'Everybody talks about the Empire being tough, but the Crack's 90 in Derry was the *really* rough one. There was a priest thrown out for flinging ashtrays like frisbees at this English comedian who was on one night. He was pissed, shouting "Ye heathen bastard!" and he had to be manhandled outside by the bouncers. Another time a comedian was dying badly on his arse; they really didn't like English comedians – to be honest, it was one of the most sectarian clubs I've ever played, it was unbelievable – and a guy at the front got up while your man was talking, walked to the bar and bought a pint for himself and a pint for his mate who was sitting at the table with him and then bought a third pint and walked back to his table again and said to the comedian: "C'mon, get down here. Leave it – have a bit of dignity. C'mon, I've bought ye a pint. Come on. Sit down, big lad. It's not working."

'It was that kind of place – they just didn't care. It was not a pleasure to play it. Comics would come over from England and they would storm it the night before at

* *'Tiocfaidh ár lá' is an Irish expression meaning 'our day will come'*

There's no reason to fear it, it's just an audience

the Empire and then they'd go to the Crack's 90. And the audience – unless it was about Derry, they didn't want to know. It had to be specifically about Derry. "Telephones? Telephones? Don't know what you're talking about." Then if you said "Derry telephones" they'd go "Ah, *Derry* telephones – that's grand." In the joke competition, the entries were the most sectarian stuff I've ever seen. I couldn't read them out, even though the whole audience agreed with what was written on them. There was no way I could have read them out and gone home and slept that night. It was unbelievably *tiocfaidh*.

'There would be members of Sinn Féin in the audience. Mitchel McLaughlin was in the audience one night. The manager said "Look, I don't mean to panic you, but Mitchel McLaughlin is in the audience. I thought I'd let you know in case you are doing any stuff about the Shinners." And I did have stuff about Sinn Féin and I went on and did it anyway, and there was almost an element of *Goodfellas* about it – people looking round to see if Mitchel was laughing before they would laugh themselves.

'Another time I was with Paddy Kielty at a leisure centre – a huge venue – and Billy Hutchinson came in. The PUP were in, and he was sitting there, and I was doing this material about guys with flying jackets and the man who was doing the lights said to me before the show "There's a guy in the audience with a brilliant flying jacket – it's brand new, it's absolutely sparkling. I'll pick him out with a spot if he doesn't put his hand up." So I started the material, and the spotlight went on to this man and the new flying jacket was glowing, and he had a moustache and the tattoos, and he's sitting about three rows in and I'm asking him questions and he's shaking his head, like "no, no, no – leave it, you don't want to go there". I'm saying "stand up, show us your flying jacket". Then the lights widened a bit and Billy Hutchinson was sitting next to him – he was Billy Hutchinson's minder! And I thought "Oh fuck – walk off, do something else".'

Colin Murphy, tall and muscular, with a sternly handsome, freckled face, looks like the kind of hard case who could take on rowdy, heckling audiences at the

Empire and the now-defunct Crack's 90 and win – and it's true. Odd, then, that this most confrontational of comedians began his working life in the altogether more rarefied and delicate world of graphic design, working on illustrations for magazines such as *Elle* and *Cosmopolitan*. 'I was doing quite mad things with paper and paint,' he says of those days. 'It was for stuff that magazines found it difficult to illustrate and they couldn't get a photograph for. You have to use your imagination a hell of a lot to make an illustration for, say, hay fever interesting.'

Murphy was born in Downpatrick in 1968. 'It's small town, parochial, like any other small town in Ireland. As Tommy Tiernan says about Navan, a cultureless hole of a town. Big shopping centre. It's a Catholic working-class town, basically, with a very small working-class Protestant bit, which is basically one street, and a small middle-class Catholic and Protestant bit. I'm Catholic – I was an altar boy, the whole thing. From the age of 13 I wanted to get out of Downpatrick. I didn't have any bad traumas there, I just felt the need to get out and do something.'

Murphy went to Bristol to study art for a year in his late teens and then moved back to the North and made his home in Belfast, where he still lives. He had always been drawn towards the stage and began to act with Sightlines, a Belfast theatre company. After being introduced to improv at a student drama festival in 1990, he got the taste for comedy the first night he went to the Empire just after it opened in 1992, and has been in the business ever since he plucked up the courage to do an open spot there. Over the past few years he has worked regularly as compère at the Empire, had a three-week run with two other Irish comedians at the Edinburgh Fringe, toured Ireland with his friend and fellow Empire comic Patrick Kielty, appeared on many TV programmes for Channel 4, UTV and BBC Northern Ireland

on terrorists being released from jail:

First thing they have to do is go to the dole office and sign on. And the second thing they have to do is go for a re-start interview. And a re-start interview is basically careers advice. Fucking careers advice! For ex-terrorists! Can you imagine an ex-IRA man standing in the middle of the dole office saying 'Hello big lad, how's it going? The war is over and I have laid down my weapons of war. I've been gone for a few years – any job will do. Obviously, something in electronics would be nice.' Can you imagine walking into Power City, or Dixons, and there's an ex-IRA man trying to sell you a washing machine? 'How're ye doing? See this here washing machine. It's, er, white, as you can see and it's good for washing clothes and that. It's front-loading and semi-automatic – *fully* automatic, I'm sorry!' Or microwave ovens. 'It's white, as you can see. That's the . . . er, timer.'

and played a part – as a comedian – in the acclaimed movie *Divorcing Jack*. He was also in the four-part BBC drama series *Eureka Street*, based on Robert McLiam Wilson's novel, and in 1999 took his act to the Melbourne Comedy Festival and to Edinburgh.

That first visit to the Empire in 1992 had a profound effect on him. 'I went to it the second week it was open. I saw something about it on the TV news and I had to go. I walked in and thought that it was the best thing I'd ever seen in my life. I was totally blown away by it. I'd never seen a live comedian before. When I walked in, I thought all these people must be really famous and that the audience knew who all the comedians were. But, in fact, they'd never heard of them. I thought it took years and years before you could get up on stage. I didn't know that all you had to do was ask and you could do an open spot. But there was an open spot and Jake Junior was on and he stormed it and I thought it was brilliant. There was a joke competition at the end of the show, and whoever won the joke competition won four bottles of beer, and I won.

'The friend I was with said I should do an open spot, and in the week before me doing the open spot another friend got me drunk and persuaded me to compère a comedy gig in Queen's, and so my first actual gig was compèring for a whole night. I died a bit, but it was all right. And the next week I went to the Empire and did an open spot and it went really well and I got offered a gig compèring three nights a week – Harp Lager used to run a circuit. There were three comedy circuits around the pubs in the North in those days, so in theory you could do nine gigs a week. But after the first week I realised that you had to have new stuff every week. So for about a year, a year and a half I did that, writing new material and dying on my arse two out of three gigs.

'You have to be very stupid or very thick-skinned to do it. Maybe one thing would work, and that would give the impetus to it. But I really loved it and I got loads of encouragement from the more experienced acts. Dylan would come up and say "keep going, keep going. This is what happens." And as soon as you knew that was what happened, it was OK. But if you hadn't known that Dylan and Owen and all those people had often failed at the start, you would have given up. I would slowly build up 20 minutes of material around the circuit and then I would go to the Empire – they wouldn't have seen all the stuff that had died over the previous three weeks – and they'd see the 20 minutes that had worked and they would think you were a comedy genius. That's the way everybody does it, but I didn't know that at the time – I thought I was being very clever. Doing the Empire made all the others worthwhile. The International in Dublin was just like . . . a room. So if you're talking about which you'd rather play – the Empire, in front of 250 people, with a mic., and storm, and be carried out shoulder-high, and be paid for it, or the International, where 30 people might think you were very amusing – I'd rather do

the big gig. I went straight in from nothing. I was getting £30 a gig or something and Jake was getting £60 on the other circuit. Jake asked me how much I was getting paid one time and I went "I'm on £30 a gig!" and he just pissed himself. I thought £90 for three gigs was spot-on, and I was doing my illustrations and teaching at the same time.'

A quick-thinking and sometimes head-on comedian, with a quieter, more observational style as well, Murphy obviously enjoys the boisterous audience interaction and slight air of danger at the Empire, and he was there at the height of what he calls 'Paddymania' – when Patrick Kielty was still performing there after his huge TV successes. 'The Empire is heckle city, and I had to get used to them from day one. Sometimes I do clubs in England and there might be only 70 people in the place and they don't want to interact in any shape or form; they just do not want to be involved. You can't ask them a question; they won't talk. "We're here to be entertained – entertain us." They're not being nasty about it; they're very positive and very nice, but they're not as immediate or direct as they are in Belfast in letting you know whether you are going well or not. There, if they don't like you, they let you know about it quick time. If you don't get them

Murphy's

From 'mad things with paper and paint' to heckle city

within three minutes of being on stage at the Empire, you're fucked; they will kill you. But if you get them in the first three minutes, that's it – they will love you. The Empire is not really a tough venue if you know how to approach it. It's a bit of a shock if you're used to 70 people politely clapping, but there's no reason to fear it – it's just an audience.'

While Murphy, who says he is politically disaffected, doesn't shy away from talking about sectarian issues – he deals in topicality, and still lives in Belfast, commuting to London weekly for gigs, so it is inevitable – he tries to get a universality into his act. 'If something annoys me, I don't give a monkey's. I do the same whether I'm in Ireland or England. Basically I do material that travels. I don't want to do stuff that only works in the North, because I don't want to just stay here – there isn't enough work. I want to stay in Belfast, but I don't want to only work

here and do stuff that nobody else understands. But there is loads about the North that is very funny, and it does travel. I change at least five minutes of material every time I do a gig because I get so bored with it. Otherwise, why do it? You might as well go and work in a bank if you want to do the same thing every day.'

Or work as an illustrator? 'I just gave it up. I haven't done any illustrations for three years. I'm too busy being a comedian and writing.'

In 1997 Colin Murphy was signed up by Dawn Sedgwick. 'I'm happy with her rather than other agents, who are just happy for you to gig, gig, gig until somebody comes along with a TV show that needs a presenter. It made a huge difference straight away. Before that I was ringing around London clubs to get open spots and they didn't know who the hell I was and I'd fly over at my own expense and do five minutes and not get paid and they'd say "We'll ring you" and they never did. Now I'm doing auditions for TV parts and gigging all over the place.'

Like some of Sedgwick's other clients, he has also turned his hand to fiction: his story 'Red Isuzu' was published in the clubbing generation collection *Shenanigans: An Anthology of Irish Writing* in early 1999.

Murphy's

I'll take on anyone

Murphy loves the blackness of Northern Ireland humour but has sometimes been disconcerted by the bluntness of people who accost him in the street. 'They love building you up and then pulling the legs from under you. I had a guy come up to me one day when I was just minding my own business, doing the shopping, and he came up and went: "You're . . . you're . . . you do . . . don't tell me . . . Empire. You do the . . . comedy . . . the comedy . . . the compère thing at the Empire. That's right! That's right! That's right! I know you!" ' He pauses. ' "You're fucking shite!" And he roared it at the top of his voice and walked off laughing and left me standing there with my shopping. That's what they love doing in Belfast.'

THE GIFT OF THE GAG
STORYTELLERS

The Storytellers

Many Irish comedians are storytellers, to a greater or lesser

degree, and to close our bill we present some of the best —

the young man whose easy charm cloaks a sly anger . . .

the boisterous, zany duo whose tales are steeped in black, black

humour . . . and a master storyteller who needs no introduction.

Tommy Tiernan

'I'm very interested in that – being a preacher'

When Tommy Tiernan's face is in repose, he looks like the angelic altar boy he once was, eyes wide with innocence, framed by curls. Then those eyes crinkle as he smiles, and you see the gleam of mischief. And as far as Official Ireland was concerned, for a few weeks in late 1997 this gentle storyteller was something akin to the devil incarnate.

What happened was this. Navan's Tiernan was the 1996 winner of the Edinburgh Fringe's Channel 4 So You Think You're Funny? competition, and he was asked to do a spot on *The Late Late Show*. Singer and religious campaigner Dana (now an MEP) was also a guest on the show. He did a perceptive and funny routine about a child looking up at Jesus on the cross, which he had been trundling around the pubs and comedy clubs for months, to much acclaim from young audiences.

After the routine there were 300 enraged calls to RTÉ and Tiernan had to stay in the hospitality room until one in the morning to escape viewers who had actually driven to the RTÉ studios in Dublin to sort him out. The next day there were calls for Tiernan and the station to be prosecuted for blasphemy, a criminal offence under the 1961 Defamation Act. Host Gay Byrne issued a fulsome apology on his show the following week. A church spokesman said: 'This mocked the very fundamentals of Christian faith. The phrase "the Lamb of God" is used to refer to Christ as the redeemer. The Crucifixion is central to the divinity of Christ and it was grotesquely mocked.'

An unrepentant Tiernan told the *Irish Times*: 'There are people who are like burglar alarms. If you touch on an issue that they hold impossibly close, you set off their sirens and they go mental about it. I'm committed to a notion of personal freedom. I try to combine honesty with a wild sense of fun. I'm not going to be bullied by people I feel don't fit into my idea of Ireland as a generous, pluralist and joyful country.' He added that RTÉ should be renamed PPTV – Pontius Pilate TV.

Tiernan was not prosecuted for blasphemy and the whole affair died down (perhaps the various objectors copped on to how mad they were going to look if charges were brought). The deliciousness of it all lies in the fact that he embroidered on the episode for the stand-up act that won him the Perrier Award at Edinburgh in August 1998.

The star of Channel 4's *Hewitt*, Tiernan, who is actually quite spiritual and fascinated by religion, says he sought divine guidance on the night he shocked the nation. 'On my way into RTÉ I was trying to decide what bits of material to do. The stuff I eventually did always goes down very well live. I was thinking to myself "Will I do them or not?" and I asked God to send me a signal. Then I walked in and I discovered that Dana was on that night, so I reckoned that must have been the sign I was after.'

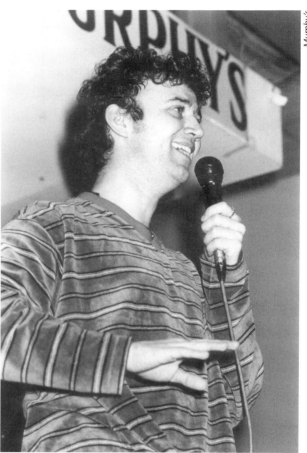

Tommy Tiernan loves performing – 'I am completely comfortable on stage,' he says with candour and without pride. In 1995 he decided to quit acting and become a stand-up. In 1996 he was still signing on the dole in Galway. In 1998 he won the Perrier, was earning figures like £6,000 for a single gig and performed in the TV special to celebrate Prince Charles's 50th birthday. 'Things happened very quickly for me,' he comments in understatement. Not bad for 'little Tommy Tiernan' (as Gaybo called him in the apology) from Navan.

Shortish, cherubic, charming and attractive, in a big venue he dispenses with the comedian's usual crutch of the microphone in his hand, but with a mic. pinned discreetly to his lapel he stalks the stage, owning it, loving it, gesticulating expressively. He builds up a story, setting the scene, describing the participants, what they look like, what they do next, using silence creatively. His acting experience shows. This man knows what

Making mischief since he was this big?

he's at. 'I've always been attracted to stand-up, the heroism of it. It is one person talking, their ideas, and it can be a noble thing.'

And there is a confidence in the way he develops his performance. 'I'm getting more confident in stand-up all the time. I never write anything down. I go on stage with an idea, like the Latin story' – a routine about his Latin class in school – 'which started off at about two minutes long. And you go back and you revisit it while you're on stage. I seem to be able to see more clearly when I'm on stage than off. The Latin story was eventually about 15, 20 minutes. It develops more organically

243

on stage. You cut away anything that's superfluous. Some nights you might go on and throw in a new sentence here and there and you think: I feel compelled to say that, but really it's not necessary or interesting, so I won't say it tomorrow night. It develops line by line, image by image, because that's the way I work and usually it's quite tight and organic. It's the easiest way for me to create – I'm not very good at sitting down and writing stuff out. You get ideas and you think you'll go with them because they seem funny.'

He talks about stand-up in a way that shows he feels it is not a limiting form, but a free one. 'I saw the film *The Apostle* recently – it's about a preacher. There's a bit at the beginning where they show clips of different types of preachers just doing their thing. And Ardal told me he went to see Bill Hicks and it was like seeing a preacher. When we were in America last year I loved watching the Christian preachers on TV walk around, because it's a performance. And they talk for an hour, an hour and half. They are such professionals, and they take you up and down. I'm very interested in that, being a preacher. Just in terms of holding people's interest with your words.'

He seems transfixed by the solo notion; at another time he talks about Jesus – 'We're sold this thing of the lonely male hero, one man and his word against the world.' It should be no surprise, then, that this cherub with a twinkle, the one who so alarmed the righteous among *The Late Late Show* audience, has had a spiritual quest, went through a long and seriously religious phase and at one time considered becoming a priest.

'I had a pretty profound Catholic experience when I was at boarding school. I really became obsessed by it. The way some people got into CND and some people got into punk, mine was Catholicism, and I just went for it. It was all the fantastic ideas about a life other than the one that is sold to you at school, a lifestyle other than the materialistic one. And that is so idealistic, you know?' This was the mid-1980s. He had left St Pat's in Navan after failing his pre-Leaving Cert exams and was sent to board at Garbally in Ballinasloe, Co. Galway. 'I wasn't very good academically. I think the highest mark I got was 22 per cent or something. It was because I was bored shitless in school. I used to say to myself that if I didn't do my homework, tomorrow would be more interesting. That was my twisted logic. I remember thinking that I owed it to myself to make school more interesting and the only way I was going to do it was by not doing my homework. And I just got into trouble, and it wasn't even enjoyable trouble.'

In Garbally he took a fit and 'decided as part of the Catholic thing that I wasn't going to do my summer exams in boarding school because I thought the education in Ireland wasn't very good. I was seeing this girl in Ballinasloe. It was a really good summer – I told everyone I was going to leave, and when I told the teachers and they asked what I planned to do, I said I would set up all these organisations to help

the world, and I started this magazine in boarding school. They said fine, great, well done, and they threw a big party for me at the end of the year. I used to hitch up to Ballinsloe from Navan for the summer to see this girl after I had left. Then my report card came home and the head of the school, who is now a bishop, Bishop of Clonfert, said "Tommy didn't do his exams; what's going on?" And I said I was going to leave school and try and live this happy life. And my father said "OK, go and do it", and I got really scared and said "eh, maybe I won't then". My dad calls me a martyr without a cause. So I had to reapply to get back in to do my Leaving Cert.

'I went back to school and split up with the girl I was going out with, and after that I became really depressed. The Catholic thing was weighing me down like a ton of bricks and I became morose and humourless. I was obsessed with the fact that I was a bad person, and wanted to do the right thing all the time. I wasn't doing the wrong thing; I was just very depressed. And as part of my Christian duties, I would visit the huge psychiatric hospital in Ballinasloe, St Brigid's. I used to visit this ward full of old men every day after school. All these men had been in the hospital for 22 years or something, pumped up with tablets. And I was in there talking for an hour every day and it was dreadful. It did me no good whatsoever, but it was the idea of "you should be helping people".'

He paints a picture of teenage angst, searching for the truth, a code for life. 'I think I was interpreting the Catholic thing on my own. I got these tapes that were circulating around the school, all these hymns from France. After study I used to go into a room on my own. The priests were delighted. I went into this prayer room at 11 o'clock when everyone else was in bed, and I used to listen to this music, and I'd

I read a lot of the Bible. I'm a big fan of fiction. I was browsing through the Book of Revelations on the beach – Maeve Binchy and me Book of Revelations – about Judgment Day, if there is such a thing, when we're all raised up from the dead and we head into O'Connell Street to be judged. There'll be extra buses and taxis. The busmen are after making their own arrangements. My theory about Judgment Day is that life is hard enough. I think that as human beings we're good people, most of us. We're OK. I perform a lot in England, and I'm amazed when I'm over there that Protestants are born in hospitals, unlike most Catholics, who are born in sin. I don't fucking buy that for a minute. And on Judgment Day, when we're all gathered together, looking up at this divine creature, who is telling us 'You were good; you were bad', my intention is that if the first words out of the divinity's mouth aren't 'Well done. You came through that'; if those aren't his first words, I'm just going to *go* for the fucker.

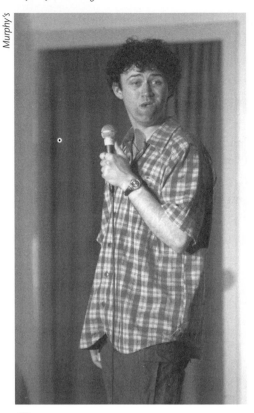

Murphy's

The Navan snee-her

be kneeling there praying. All this literature which I wasn't equipped to deal with – all these theologians writing all about how to be a Christian. Idiots, basically – always turn the other cheek, always do this, always do that. I was reading this, saying OK, this is what I'm going to do. I became wingless; I was just depressed and down.'

Then one day 'I read this poem called "The Collar" by George Herbert, and the opening of the poem is "I struck the board and cried no more. I will abroad." And I remember sitting in English class one afternoon, and I just said "Fuck it, I'm not doing this. I'm unburdening myself from all this shit." '

He still had 'an essence of it', though, and 'I hooked up with the Redemptorists and went on a retreat. The head of the Redemptorists visited my parents and said "Tommy is thinking of joining up". In the end it was all tied in to getting into university – I did the Leaving Cert but I didn't get enough points. So they were saying you'll have to repeat your Leaving Cert.' It is unclear whether the prospect of having to apply himself to study was the most off-putting thing.

In the tradition of Dave Allen and comedians like him, Tiernan has a problem with authority, and church authority particularly. 'It just annoys me, the arrogance and the presumptuousness of the church. That really makes me angry, and it's because it's such a wonderful idea. The church is just fat Irish bachelors. Their declared connection to divinity – that's a farce. It's probably because I have a passion for that idealism; I mean, I'm an idealistic person and that's why I get so annoyed at it.'

But the spiritual quest continued after school. He decided to join some friends who were living in Cork, where he worked with the Simon Community – 'I had ideas about becoming a social worker.' Then the summer he turned 19 he went to the Aran Islands, joining Fr Darragh Molloy, a Columban priest who had set up a community of prayer there. 'It was a kind of a 24-hour retreat, just people living together. They grew their own vegetables and they had a newsletter and I just found that very romantic.' So he went out and stayed in the cottage. But it lasted only 10 days. 'I realised that it wasn't for me; the lifestyle was just a bit too . . . particular . . . for me and I moved out and I got a job in a youth hostel on the island and got a place to stay. Then the summer was over and I met my girlfriend. She was going

to Galway to go to university, and I said OK.' So he moved to his adopted home of Galway in 1988.

Although he is famously trotted out as one of the comedy kings of Navan (Dylan Moran and Navan Man, Today FM's resident comic persona, being the other two), Tiernan has, in fact, lived in a few different places. The oldest of four – he has two sisters and a brother – he grew up in Co.Donegal. When he was three the family moved to Zambia – his father is an agricultural advisor. They were in London for a short while, and moved to Navan when Tiernan was seven. He left at the age of 16. He's two years older than Dylan Moran and went to the same school, St Patrick's, where they were both taught by Ritchie Ball, an unusual teacher who had a profound influence on them. 'I was talking to Dylan the other day and he said to me "Can you imagine how proud Ritchie is now?" Dylan debated a lot in St Pat's and he also took part in the devised drama stuff. The seeds are sown there, where you're shown that it is possible to live life creatively in terms of work. That's what I got out of Ritchie: *you can do these things.* I'm sure there's 50, 60 ways other than that, but it was definite that you can do this. I was hoping to do some work with him, actually. I'd like to work with him on my stand-up – to get pushed into areas that I wouldn't think of – for him to say "why don't you talk about this, why don't you do this?" I'd like that kind of a stimulus. He's in his early 40s. He would have been 28, 29 when I was there, my age now. I remember the first day he came into school. He said, "Right, lads, my name is Mr Ball – you can call me Ritchie or Mr Ball, I don't care." We were like "Wow, who is this guy?"

'I wouldn't have been the funniest guy in the class by any stretch – third or fourth funniest.' He grins. 'There was a league table, and I slowly but surely would work myself up. I think funny is something you learn. It's patience as much as anything else. If you wait, something genuinely funny will occur to you to say. In school I would have been more eager to be accepted – slightly more gushing. I would not have been the class clown – I once told a teacher that nobody in the class liked her because she gave us too much homework in first year in secondary school. I always did these things, looking back, to get approval for being some kind of renegade.'

In Galway, at 21 or 22, he joined the Galway Youth Theatre and devised projects. He was an actor for a few years and a founder member of the innovative comedy group Flying Pigs before trying his hand at stand-up in 1995. 'I did a collection of new stories that I wanted to try out. That was the big thing – doing your own show in the King's Head, Galway, was "wow!" They knew me, anyway. So I did one in October and one in December. Two different half-hours. They weren't that good, you know, but at the end of the hour, I had about 20 minutes of really good stand-up together. So I came to Dublin and I first gigged in the Comedy Cellar in January 1996 with that polished material. Things happened really quickly. I was

asked to go on *The Late Late Show* that May. Then I did Kilkenny, then won So You Think You're Funny? that summer. Started gigging in London then. Got a tour of Australia and New Zealand, did a film, back on *The Late Late Show* – the second time was just like a chat. There always seems to be a momentum. The film was *The Matchmaker*, with Denis Leary. I had a tiny part as the village idiot. I was like the idiot who belonged to the village idiot; I was über-idiot. It was good to work with Denis Leary – I also supported him when he was in Ireland.'

Tiernan says comedy is like music. 'There's a certain rhythm to things and if you change the rhythm, the laughs don't come. If you're saying something that's funny, there's a definite rhythm. If you break it, it doesn't work. I remember Eddie Izzard saying once, when you start off – because he doesn't write things down, either – that your material starts off as lava and it's all over the place and you're trying to create it and eventually it becomes tighter and tighter and tighter and you find the definite sentence to make it funny. At that stage it's like a rock. If you add an extra word, it's amazing how you could fuck it up, you know? Say the sentence "he should have been in some other class making shovels", and if you change it – it's amazing how the rhythm can – "he should have been somewhere else with some other people maybe making shovels with his hands" and it's laughter, but it's not really . . . it's the way you say it as well as what you say.

'I always think I follow the line of least resistance. Stand-up suits me very well because, although I think about it an awful lot, I don't have to labour. I can get on stage with an idea and see where it goes. I'm not lifting stones. It's not really work, you know? I love it, I love staying in hotels, I adore the lifestyle. It's such an easy life.

'I think one of the dangers is that you can become so interested in being popular that you become mainstream, and you lose your power. That's the only danger I see. The thing that gives you your edge. And in order to retain that, you have to remain in the underbelly of things. You get people like Bill Hicks, who didn't really make it as a TV personality, and his stand-up at the very end was just so powerful. I think for comedy to stay alive, it needs to be coming from the left field, the curve ball.'

Tiernan, like other Irish comedians, has branched out into fiction, and spent much of 1999 working on his first novel. Religion, of course, plays a major part in the narrative. How could it be otherwise? At the British Comedy Awards in 1998 he won Best Stand-Up Comedian. Accepting the award he said, twinkling as ever: 'This is for the small people of Ireland.'

D'Unbelievables

'We found there's this great funeral culture'

When you ring up their production base in Limerick someone says 'D'Unbelievables' office'. You can't help but grin. Jon Kenny and Pat Shortt *are* D'Unbelievables. The name comes from their two characters, utterly talentless but supremely self-confident wedding musicians, in *One Hell of a Do,* a show which ran and ran, around the country and out of it. Smugly imagining themselves to be at the cutting edge of cool, the two ageing, pot-bellied lads would introduce themselves as 'Tom and Jerry, D'Unnnnn-believables', complete with tacky, synchronised hand-sweeps.

That early 1990s show was about – if it was 'about' anything – a band arriving to do a gig at a shambolic, drunken country wedding, and Kenny and Shortt did what they had done for a number of years with their adrenalin-fired, audience-involving comedy – they toured it over the highways and byways, much like the 'fit-up' theatre companies in the 1930s and 1940s. They brought it to big towns and small towns – pubs, village halls, sports centres, even a cattle mart. They took it to the cities, too, and abroad – Britain, the US, continental Europe.

We are not talking about urbane, ironic stand-up here, which is not to say their act is not insightful or, indeed, in ways witty and ironic. It is loud, rowdy, inventive and energetic, the story painted in broad strokes, full of

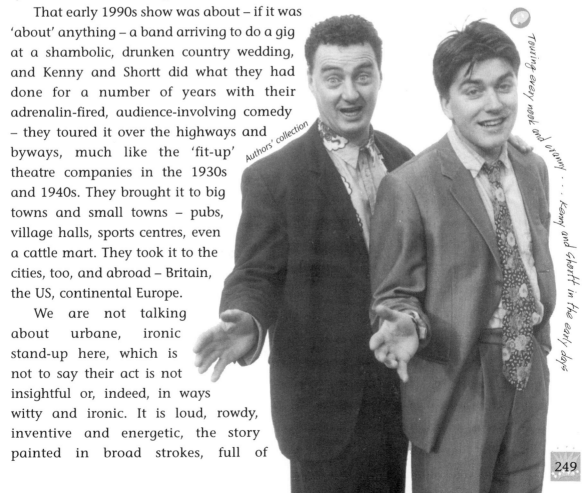

Authors' collection

Touring every nook and cranny . . . Kenny and Shortt in the early days

recognisable character types – but with subtleties and darker shades.

What Kenny and Shortt do is build a rough narrative, like the story of the D'Unbelievables playing at John and Mary's wedding, paid for by the rich American uncle, complete with guests like gossiping Auntie Josie, Uncle Martin who lives 'over' (in Britain) and whose life, it gradually becomes poignantly clear, is dreadfully unhappy and lonely.

The show then *becomes* the wedding reception, with the audience as guests, even figuring in the photographs. Kenny and Shortt play all the main characters, dragging reluctant (and otherwise) members of the public into the fray to contribute to the merriment – the bride and groom, for example, are picked from the audience, dressed up, photographed and included in the action.

The costumes and props are exaggerated – Tom and Jerry have beer-belly stomachs attached, and Jerry's headpiece involves an elaborate wisps-of-hair-brushed-over-bald-head contraption. The show is both theatre and comedy, but very different to other Irish acts; the style bumps into a variety of traditions, marrying parody, mime, *commedia dell'arte*, panto, harlequinade. The parody is

'One night,' says **Shortt**, 'there was a guy on before us with an organ and a drum machine and there was another guy out front dancing, with black slacks, dancing around like John Travolta. And he was a devout fan of the guy with the drum machine and used to follow your man everywhere. He said "Your man's brilliant – I go to all his gigs." And your man was fucking brutal! So when it came to creating Tom and Jerry, D'Unbelievables, we remembered him and he was incorporated.'

Kenny: 'Some people couldn't believe that we'd come on and do a full show and they thought there had to be a support act. I remember a night outside Waterford, and supporting us were three fellows – one was in a wheelchair, one had a stammer and the other was blind. A Sunshine bus dropped them off before the gig. There was something physically wrong with them all, and they were just atrocious!'

Shortt: 'Afterwards, one of them came up to me and complimented me on my saxophone playing – "Oh Jaysus, beautiful sax playing. Beautiful. We used to have a sax player ourselves." I said "Is that right?" And he said "Yes. We lost him to a céilí outfit in Waterford!" There was fierce rivalry between them, I'd say! The lead singer had a stutter. He was all right when he was singing, but when he came off, he'd come over to you and he'd t-t-t-t-t-talk -l-l-l-l-like th-th-th-that.'

Kenny: 'Even if you didn't like their music you couldn't say they were shite, you know? God love them, you'd nearly give them a gig – "ah feck it, give them a gig" – because you felt so sorry for them.'

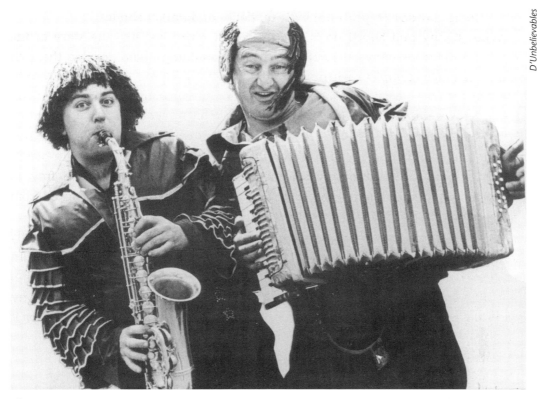

Tom and Gerry, D'unbelievables – the wedding band from hell that everyone wanted to see

sometimes gentle and affectionate, sometimes strong; it is celebratory not patronising, grossly exaggerated but still underscored by basic truths. It is also disciplined and tightly structured behind the action. And, most of all, it is uproariously funny, leaving audiences exhausted with laughter at the end of the evening.

Because of the unusual genesis of the duo, their distinctly Irish, rural-based material and style, and the way they toured to every nook and cranny of the country, Kenny and Shortt's story is a very particular one, identifiably and intrinsically Irish, rather than an adaptation of an imported form. It also involves some great yarns about their days on the road.

'At one gig in the sticks,' says Shortt, 'a rotten venue, we asked about the room to change in. The manager said "Follow me" and we went through the kitchens – you know those places that are like a maze of doors and corridors, hotels with bits and pieces added on to them over the past 70 years. We went out the back door and it was lashing rain and we ran across the yard into this shed and there were cows in there! And we said to the manager: "You must be fucking joking!" And he said: "If 'twas good enough for fucking Niall Toibin, 'tis good enough for ye!" So we changed in the barn.'

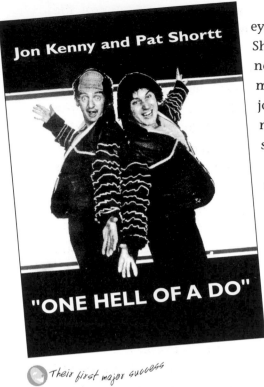

Jon Kenny and Pat Shortt

"ONE HELL OF A DO"

Their first major success

Kenny, tall and fidgety with piercing pale blue eyes and curly black hair, is from Co. Limerick, and Shortt – more compact, stiller, stockier – from neighbouring Co. Tipperary. They started as a musical act (Shortt, on saxophone and accordion, joined Kenny and his guitar), touring the country, mixing gags with the songs. Gradually the comic side took over, but not via the comedy club circuit.

Shortt: 'We approached comedy through the showband scene. Because we started out as musicians and worked in bands, that was the obvious route as far as we were concerned. We went out and worked – the thought of waiting around for RTÉ to give us a spot didn't make sense to us at all.'

From the beginning they had tackled their craft in a different way, undertaking extensive tours to make an unsubsidised living. Kenny: 'In the early days we did realise that there was a gap in the market for something like what we were doing. There were theatre groups and they weren't actually reaching an audience. They were probably limited by their very name and by their structure. We knew that there was an audience out there and it was a question of getting out and approaching it in a sort of commercial sense. And I think that's what stood to us. In the early days it wasn't a financial success, it was a risk, but there was a market that people weren't getting at. And the theatre groups may have been highly funded, but they weren't reaching that audience.'

They would take the month of January, perhaps, off from touring and devise a whole new show for the road. Shortt: 'Instead of running a show for, say, four weeks, like a theatre company would do, we would run it for two years and take it everywhere, instead of doing just a small circuit.'

Something about *One Hell of a Do*, which they put together in 1992 – the broad humour, the familiar characters, the universality of the themes, the audience involvement – caught the public imagination, and it ran for well over the usual shelf-life of their shows. The gruelling tours around the sticks in the early days had paid dividends.

Kenny: 'When we started getting into bigger, more mainstream venues – the Everyman Theatre, the Opera House in Cork – for us, as a comedy duo, it was happening. And when it did happen, and we played the Cork Opera House, people were amazed – people sitting above in administration saying "We don't really know

these guys". We didn't have a very high profile, but what stood to us was the amount of ground work that we had done in the rooms behind pubs all over the country.

'For some of our audiences, it was as if they'd been with us down the years and it was like "Jaysus, the lads are playing the Opera House" and they'd follow us into the big venues. They were coming in from north Cork, from east Cork, from west Cork – all the little towns we'd spent years playing. And the same in Limerick – when we came in to play the Belltable, they came from all over the county.'

Shortt: 'At that time there was no *Father Ted*, no *Hall's Pictorial Weekly*, there was nothing in that style of humour, which would be Irish-based madness, you know what I mean? There was none of that happening on TV or in the theatre anywhere, so we were doing something that no one else was doing at the time, so when we did hit Cork city, it was the only chance people would get to see entertainment like that. At that time, we were just about the only comedy act down the country.'

They hit the big time in the mid-1990s, and their recognition factor spread. These days they are comedy icons, have had parts in *Father Ted* (Shortt was Tom, the island psychopath, Kenny the Eurovision presenter) and acted in films. A series of Lotto ads they made for radio and TV in 1998 was funnier than the whole of RTÉ's comedy output at the time, provoking a new catchphrase – 'tha's ray-att' (that's right). Then, in an unexpected move, they were cast in dramatic roles as homicidal brothers in a Galway's Druid Theatre Company production of Martin McDonagh's acclaimed play *The Lonesome West*, receiving excellent reviews. This sudden and successful dark streak in their careers was lightened somewhat by the Christmas 1998 video *D'Video*, which topped Ireland's best-selling chart, selling more than 110,000 copies over the holiday.

The 'look' of their myriad characters is very important. 'I think our stuff doesn't come to life until we have physically created the characters, after the writing has been done,' says Kenny. 'And we do use people we've met in our travels. You're struck by these people and you think "He's a character" and there'll be something in the way they walk or the way they look and you use all those things.'

When they had wrung every drop out of *One Hell of a Do*, the lads devised another show, *I Doubt It, Says Pauline*. This time the setting was the parish of Glengooly where they arrive to do a show and discover the local hall has been double-booked with the local 'gala evening'. . . which is the opportunity to portray the eccentric characters of a small town (who then present the 'gala'): Joe, who still lives with his Ma, Pauline; the karate-loving priest Fr B. Lee; the ranting GAA trainer; Snotzer the schoolteacher; and the butcher (cum grocer/publican/undertaker) in blood-soaked coat.

One of the more surreal scenes involved bringing up three or so women from the audience for a sandwich-making competition. So, while peripheral action with

other members of the audience is going on in the foreground, there's a trestle table behind with the 'competitors' buttering mounds of sliced pans. Most people co-operate with the requirements, although there is the occasional oddball.

Kenny: 'Where we get the best laughs is when people come up on stage and they don't say a lot but they're really "in there" – this thing that you're doing. Like in the sandwich-making competition. Think about it – you bring up three women from the audience and you ask them to make sandwiches. "You know your place, women – make the sandwiches" kind of thing. And I come out on stage and I get this nudge from Pat and I'd look down and they'd be cutting the crusts off them and making them into little triangles. And they're oblivious to the fact that there are 600, 700 people looking at them and they're up on a stage making sandwiches . . . for *what*, like?'

Shortt: 'One night I got badly stuck. Normally, my line is that I go up to the ladies and say something like "We're going to take a short break now because there's another act coming on. If you'd like to take your seats and take your sandwiches with you . . ." And usually they're glad to get back to their seats and they exit fairly swiftly. But one night a woman wouldn't go: "No, I'm waiting for the judging." And no way was she budging. And Jon is waiting to come on, and the crowd is puzzled, and I have no lines prepared. So I had to go through the whole lot and test them. And we had no prize or nothing. It was a nightmare.'

Their last show, *Dat's Life*, which opened at Dublin's Vicar Street in early 1999, and has toured since, had echoes of *The Lonesome West* in that it also involved brotherly rivalry in a small Irish town. Shortt's aspiring local politician is bullied at home by Kenny's austere, domineering brother. The boyos run the local pub, and the 'plot' concerns how they attempt to hijack – for commercial gain – the wake of an American blues singer who happened to drop dead on stage. The familiar mix of small town characters and outrageous plots, it also has some surreal touches – the donkey and horse commentating on the funeral, a monologue by a permanently windswept mountainy man.

Kenny and Shortt, who are in their 30s, come up with the concept, write the script and make all the decisions. A friend, Terry Devlin of Limerick's Island Theatre Company, often sits in and offers suggestions and advice. Shortt: 'The shows are kind of workshopped, for want of a better word. We sit down first and we'll chat about ideas and we'll have a few pints and a bite to eat and it's a very loose start – we'll mostly be having a laugh ourselves. And then we'd start getting a bit more formal about it and sitting down. And we'd maybe hire a hall and start improvising and making notes about the characters. And that's a long, slow process, where you nearly start turning off the characters because you think they're not funny any more – you're flogging it to death, like. And then you find you spark off something; you really click on something that works.'

Jon Kenny buttonholes an unsuspecting punter in the audience in 'One Hell of a Do'

Ah for feck's sake, how're ye keeping, Mikey? Hah? Jaysus, Mikey, great auld local turn-out, hah? Great auld local turn-out. You wouldn't get a bike into the carpark, Mikey. Hah? Ah sure Jaysus, the carpark is widged, hah? Widged.

Are you well, Mikey, you are? And how's your mother keeping, Mikey? Jaysus, I heard that, Mikey, yeah. The chesht was at her there for a while, wasn't it? Ah jaysus, Mikey, I've always said it, and from nursing my mother, she used always say it, whatever the feck was in it, if there was one thing you couldn't shift it was the chesht, hah? Whatever was in it, the fecking chesht would stick to you, d'ya know what I mean? Shure 'twas an awful dose.

But funny enough, Mikey, my mother was telling me there about your mother. Your mother's mother would have been Long herself – she was Long before she was Casey. Didn't she marry into the Caseys? But them Longs, now Mikey, correct me if I'm wrong now, Mikey, didn't they come out of the Bog of Ballinamona? The Longs, by Jaysus, Mikey, that's where they came out of.

That was auld damp, soggy ground, hah? Jaysus, sure Mikey, they suffered an awful lot . . . auld TB and auld consumption, auld pneumonia, auld colds, auld flus, auld runny noses, auld bad backs, wet walls and wet ground, auld misery and misfortune and rain and misht and fog and bog and rock and brambles and briars and muck and dirt and crawling and scraping and misht and muck, fog and rock and more wet and misery and bog and rain and more misht and darkness and misery and crawling and scraping and hunger and misfortune and misery and rain and dampness and bullrushes and pulling and dragging.

(Pause)

And, feck, they were happy, though, Mikey, d'ya know what I mean?

Kenny: 'We both work on the same character, to see if my interpretation would be different to Pat's. You have the character and you have the script and you have to think "How does this character work?" You can look at him on a page, but you have to move him, and you take the dialogue that you have scripted and you start to work with it and then you put the script aside and you let the character take over, how he reacts to this, how he reacts to that. And you find that if you do get a handle on the physical side of him it's much easier to write for the character because you have really pinpointed him.'

255

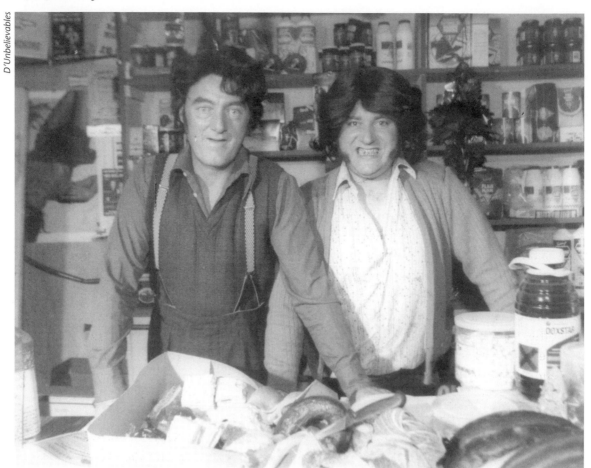

Shop local – from 'D'video'

Shortt: 'What is the character trying to say? Each character has to say something. Even if they're saying nothing, they're saying *something* . . . know what I mean?'

Kenny: 'People ask us how much is scripted and how much is ad-libbed and, in fact, it's all tightly scripted and cued, but we allow ourselves space within the boundaries for something unexpected to happen, but you have to get back on track because you have only five minutes before the next bit. You can push it by maybe a minute, but that's all. Otherwise it throws everything out of synch.'

One of the elements in *Pauline* involves a quiz about great local funerals ('name the odd man out at Mary Jo Sweeney's funeral'). Comedy surrounding death and its rituals is very close to the bone of Irish humour and its sometimes black madness.

Kenny: 'When we were putting together the funeral sketch – the quiz about deaths in *Pauline* – we found that there's this great funeral culture . . . "Do you know

who she is, now? Who would she be related to?" And it's all just matter-of-fact. And there's usually a great turn-out for a funeral.'

Shortt: 'Loads of people go to funerals of people they don't know at all. And when we were doing our research, we met in a pub before a funeral, and because it was our first outing we were given the tips, about what you do. Don't go to certain members of the family if you don't know them. Meet the coffin on the way in. We were told these things by people who go to funerals all the time just for the drinking sessions.'

Kenny: 'So we were primed. It's an art in itself. The hearse is about to be taken from the house, right, and you shoot up before they can grab the coffin – because you know the bearers are definitely members of the family or close friends – and you get in quick with the handshake – "sorry for your trouble" – and then you don't need to go up and meet the family at the removal; you've already met them and your presence has registered. And then you can go to the pub and slip out just in time to greet them outside the church again. And then it's back to the pub with the family and you can stay drinking until all hours, because a pub will normally serve late if there is a funeral party in. Or you can go back to the house and drink there.

'There were these two lads I knew, and they were self-employed and at the weekends they'd go off on the tear and on the Monday they'd have no money left and they'd get the newspaper to see what funerals were on. And they'd look down the list, and they wouldn't go by the names or anything, they'd go by the area. "Anglesborough. They're mad there; it'll be good crack there. Kilteeley . . . no. We'll go to Anglesborough. There'll be a good session." And they'd hop into the car and off they'd go. Absolutely weird. And if any relatives ask them who they are, or any other questions, that's where the Irish imagination comes in.'

Shortt: 'The older the deceased, the better, because an older person would obviously have known a lot more people. When my grandmother died, there was a woman came in and nobody knew her at all. She leaned in and she kissed the corpse. And my stepmother and my old man were there at the front where the family are and she squeezed in between the two of them and she said "He went very white in the last few days, didn't he?" She was at the wrong funeral altogether!'

Kenny: 'The best we ever came across was: we were on our way down to a gig in Waterford and a friend of ours in Cahir lives only down the road from Black Tom's pub and we'd always stop in and say "How're you doing?" So we were travelling down early to Waterford – it was a college gig – and we pulled up and our friend said "Come down to the pub quick; there's a wake going on." And it was unusual in Tipperary, because you'd usually associate that kind of wake with the North, not with the South, although you might see a bit of it in Kerry. And we were told that this guy died in England and he left £3,000 and specified that he wanted to be waked in Black Tom's pub for three days, which is the standard wake.

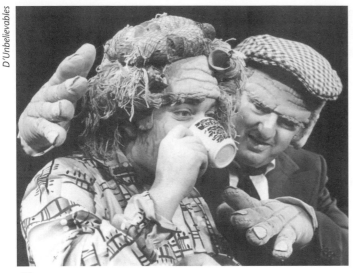

D'Unbelievables

'I doubt it,' says Pauline

'So we went into the pub and two men in black suits met us at the door and shook hands. There was no music and everything was very quiet. There were fags on a plate and sandwiches above at the bar and there was a drink on the house for everyone that arrived. There were hushed tones and a woman was there sobbing away and there was a coffin above with candles around it. This was day three. And at the end of day three the coffin was to be opened for the last farewell and there was to be a session that night, and there were musicians hired and all. So we fecking belted off to Waterford and did the gig and belted back because at 12 o'clock the coffin was going to be opened.'

Shortt: 'And as we arrived at the pub, there were people coming out and vomiting outside the door and we got inside and there was this awful smell. Our friend, Kelly, told us that the session had been going on all night since about 6 o'clock and the place was stuffed to the gills.'

Kenny: 'Everybody thought they were going to get free drink, but there was no free drink coming . . .'

Shortt: 'And when it came to 12 o'clock and they came to open the coffin, the boys let off some stink bombs. The coffin was empty – the whole thing was just a set-up!'

Kenny: 'It was done by the boys we had met at the door earlier, and when they opened the coffin and this terrible smell seemed to be coming out they said "Lookit, your man's been dead a week in England and he's been here three days now and there's no ice. . ." And there was no body at all. All the people – the mourners and the keening woman – had been hired. It was the best scam I ever heard. Everyone was outside on the footpath, puking up. And the smell was revolting – imagine being in there and your imagination working overtime – the worms and everything. The guy who set it up bought the coffin in Cork for 80 quid and that's what gave him the idea.'

Shortt: 'And he wanted no financial return; he wasn't in it for money – it was just for the crack of doing it.'

Kenny: 'Pure madness. You have to have the bit of madness, like, you know?'

Dave Allen

'May your god go with you'

There he is, the top of our bill. Walking towards the exclusive little restaurant on Holland Street in Kensington. Cream mac flapping in the wind, poppy in the lapel, hair – silvery now – a bit wild, glasses. A little shorter than you might think for a comic giant. He comes in, smiles, shakes hands and neatly arranges his two pairs of glasses on the table. No cigarettes, though; even though they were once a trademark, he gave them up years ago. 'I just realised it was crazy spending so much money killing myself. It would have been cheaper to hire the Jackal to do the job.'

We're on Dave Allen's home territory. The enormously successful Irish humorist who revolutionised the way comedians in Britain presented their material in the 1960s and 1970s, now approaching pensionable age, lives in the leafy opulence of Kensington, on a street of beautiful three-story Victorian townhouses, lots of them adorned by blue plaques marking the illustrious people who once lived there. He divorced in 1983, and his four grown-up children are often around. His life is comfortable – Kensington

Dave Allen

Tree brothers: Peter, David and John O'Mahony in Dublin in the 1940s

Gardens and Holland Park are nearby and there's a good range of facilities, he says, including a nice cheese shop and an excellent butcher. There's a Cypriot food store, too, where he gently teases the owner about Turkish figs. You wonder if this is about as controversial as he gets these days.

Yet this is the man who scandalised countless people in the 1970s with a sketch which involved the Pope doing a striptease; who was banned from Australian TV for a year for telling his producer on a live show to go away and masturbate and leave him in peace to continue an interview instead of going to the adverts; on

There's a point at which your kids grow up, too. The girl will bring the boy home for you to meet. And because you've talked in kind of liberal terms all your life, you have to follow this through.

'Daddy, I'd like you to meet Paul.'

'Hello, Paul.'

Grunt.

'Can I bring Paul in, Daddy?'

'Yes, of course you can.'

'Yes, but can he stay here?'

'Yes, of course he can. He can stay for dinner.'

'No, but I mean – do you mind if he *stays* here?'

'What do you mean, *stays here*?'

'Stays in the house.'

'Doesn't he have a house of his own? Why does he have to live here?'

'Because I'd like him to live here.'

'Well, where is he going to stay?'

'He'll stay with me.'

'What? In your room?'

And that's it! The bastard's in! And they take over. She loves Paul. Paul's an arsehole! I come down in the morning, he's drinking tea out of my cup. Reading my paper. Eating my food. And not only that, but he's humping my daughter! And I'm out in the garden, feeding her bloody rabbit!

whose shows RTÉ placed a *de facto* ban in the 1970s; who upset Mary Whitehouse in 1984 with a humorous account of a post-coital conversation; whose use of the word 'lavatory' on *The Ed Sullivan Show* on American TV in the 1960s was objected to (innocent days indeed), for whom the BBC apologised when, in 1990, he used the word 'fuck' in the punchline to a joke – an incident about which questions were even asked in the House of Commons.

A Goliath in terms of controversy, ratings and influence, he opened comedy up from the traditional gag-setup-gag structure by introducing a more laid-back, personal, storytelling style, in Australia, and later on British TV shows such as *Tonight with Dave Allen* and the hugely successful *Dave Allen at Large* – a mixture of sketches and sit-down comedy. And behind that calm façade, as he paused to sip his whiskey, or flick cigarette ash off his immaculate suit, he was angry – quietly and humorously furious on the subject of political hypocrisy, or church domination or, in fact, all forms of authoritarianism. His stance has earned him the role of a godfather of comedy, a cult status of sorts, and the admiration of today's generation of young Irish stand-ups.

These days he hardly ever appears live but occasionally releases a comedy video; on one such he opens by saying he has retired, but that every so often he has to do a bit of work to keep himself in the style to which he has become accustomed – 'a bit of an Irish retirement, actually'. But lest you think he has gently subsided into village life in the city, Dave Allen hasn't *quite* retired – that was just a gag, he insists. Yet in recent years he has certainly cut down his workload; he does the occasional TV special, and he accepted a Lifetime Comedy Award in 1996. He has ideas for programmes he wants to do, that are gentler than his acerbic one-man shows – for instance, a storytelling series he has planned where all the tales have a weird or funny or supernatural twist at the end. He paints a lot, 'which gives me satisfaction for myself, it's a kind of outlet. If I'm motivated, sometimes I do political cartoons, but they're a bit black; dour, not jolly.'

But he doesn't want to tour. 'I spent all my life travelling. There were times when I missed certain points in my children growing up which I deeply regret. I always used to take off their summer holidays and Christmas and Easter when they were home on holidays. But you get on airplanes and arrive in theatres and get into hotels and after a while you just kind of think: what am I doing? And you're working for

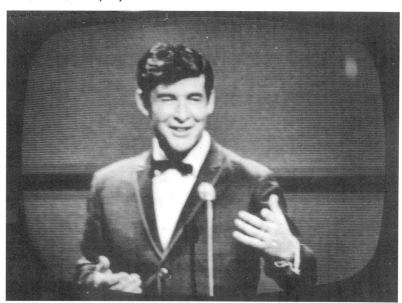

Dave Allen

Dave Allen's first appearance on 'Sunday Night at the London Palladium'

something, and you're well paid, and you invest it in a nice house and you're never there. And I've reached that point where I really don't want to travel.'

His material as an older comedian is very much that: 'It's a kind of reflective thing. The longer you live, the more you understand yourself; you understand your emotions, and your dishonesty or your hypocrisy. You're continually changing. Between 20 and 30 you don't really notice any changes and between 30 and 35 you probably notice one or two, then 40 . . . but there were all kinds of things I was becoming aware of. Even to this day . . . my eyebrows, which are getting quite, quite long. If I leave them there, they'll take off. So you begin to look at yourself like that. And then you kind of ruminate about what you were like when you were young, so

there's material, not necessarily self-engrossed, but you begin to look at yourself – or at least I begin to look at myself – and you become aware of things.'

He presents a wry portrait of a comedian at this stage of his life, with skin sagging, tufty hair springing from various unexpected parts of the face, forgetting where he's left his glasses, being annoyed by younger people, rueful, occasionally even mildly cantankerous. Nearly always the most uncompromising of comedians, his public utterances have always been his personal preoccupations, and that is why Dave Allen is still relevant, on the rare occasions we are lucky enough to catch him.

BBC

Changing the Paddy stereotype

In conversation he is a hard man to keep on track – you think he's rambling off the point, but then you remember that this is a performer who has built a career on chat, and you realise that he's showing by example, rather than feeding you an easy quote. If he doesn't have much to say on the subject of comedy itself, it's perhaps because he is a little like the reporter he once wanted to be: he simply tells people about funny things he has seen, putting the spin of a natural story-teller on them. 'I don't know if there's somebody out there, some god of comedy, dropping out little bits saying "Here, use that, that's for you, that's to keep you going".'

Of course, sometimes in the old days Dave Allen just sat there and told straight gags, and occasionally they were a little sexist or smacked of paddywhackery. It would be rewriting comedy history to pretend that his solo material consisted entirely of insightful, observational monologues about life. But it must be remembered that when Allen started on British TV, in the late 1960s and early 1970s, Arthur Askey was still a big name. The top TV stars included Benny Hill and Dick Emery, and 'youth comedy' was represented by Jimmy Tarbuck. That was the era in which he was operating, and to survive he had to play by established rules. What was important and ground-breaking about Dave Allen was that there were rules he chose to ignore.

He says comedy should always be irreverent, and his take on life has always been so. He remarks early on about the huge changes that have taken place in

Ireland since he left at the age of 20, how the church is not nearly so powerful, the political scandals. 'The hierarchy of everything in my life has always bothered me – to this day I'm bothered by power, people, whoever they might be, whether it's the government or the policeman in the uniform or the man on the door – they still irk me a bit. From school, from the first nun that belted me. People used to think of the nice, sweet little ladies . . . they used to knock the fuck out of you, in the most cruel manner they could. They'd find bits of your body that were vulnerable to intense pain – grabbing you by the ear, or by the nose, and lift you, and say "don't cry!". It's very hard not to cry. I mean, not from emotion but pain. The priests were the same. I sit and watch politicians with great cynicism, total cynicism.'

Allen has always had a reputation for slagging Catholicism, which was one of the reasons he caused so many storms. Being brought up a Catholic, and being educated by nuns and priests during an extraordinarily closed era, obviously had an effect. 'Dublin has been fairly secular for years. There's always been a kind of fighting objection to the church – priests coming around telling women who've had 15 children to have another six. There's always been an angriness with the economic poverty of people in Dublin and the church's attitude towards money itself. I remember going to Mass as a child and being absolutely astounded when they used to read out the donations that were made, from – I was going to say the dock, but from the pulpit. And the woman who had no means and who probably gave up 90 per cent of her money was subjected to the most bizarre cruelty. Mrs O'Toole has given 10 shillings, and people would go "10 shillings; a holy lady", and all that. And it whittled down, and some gave fourpence, and the poor person in the corner of the church being ostracised by fourpence – "hope you can do better next week". Jesus.' (His voice has got lower here, with the horror of it.)

'The people you never laughed at in Irish society as a kid were the church, whether it be the Catholic Church or the Church of Ireland. It was all right to *snigger* at the Church of Ireland, but certainly not to laugh at the Church of Rome;

When I smoked, I thought all non-smokers were a pain in the arse; now I'm a non-smoker and I think all *smokers* are a pain in the arse. It's amazing how the world changes. I really don't like people blowing smoke on me, and even if they don't blow it on me, it's in my hair, in my jacket. I walk up to people and they say: 'Oh, you're smoking again, are you?' I had an argument with an equally determined smoker as I was a determined non-smoker. I said: 'I'd be grateful if you didn't smoke – I don't like the nicotine, and it's dangerous.' And he argued: 'I'm inhaling the smoke into me, it's only a small residue that you get; it's not much.' And I answered: 'I drink quite a lot, but when I'm finished I don't piss on you.'

 Walking on water, and why couldn't he?
A sketch from a 1970s show.

the police – you couldn't take the piss out of the police; you couldn't talk about judges, they were all respectable people and I've used that ever since. Lawyers discuss things with each other through "my learned friend"; they don't say "the learned people" in the court. Then there's your honour, his lordship, and the judge – you stand up when he comes in. The same thing with the church. The reverend, the very reverend, his holiness, your grace, the venerable, his holiness – he is holy, holy. How do you address this person? You say his holiness and you nod or you genuflect. If somebody said his name is Mildred, and he was a fellow in drag, you'd laugh at him or you'd enjoy his company.'

But Allen is angry about ordinary people's apathy, too: 'They fuck up all the time, no matter who they are, where they are. I'm not talking about politicians, I'm talking about people on the ground – somebody's battering their brains because of religious differences or tribal differences. The majority of people, all they want to do is get on with their lives, live it and find somebody they love and bring up a few children that they can admire, make some little mark and get the fuck out of it. If you take places like Rwanda, Congo, Albania, Macedonia, Greece, Turkey, Northern Ireland, Southern Ireland – people are creating differences all the time, instead of trying to find some sort of maturity.'

And if you feel angry, and are expressing it, you need the right words. 'I'm a believer in the language, I'm a believer in using language, and there's only certain ways of saying things. And being a Dubliner . . . I had a friend who used to put fuck into everything – pro-fucking-crastination, O-fucking-Connell Street.' But times have changed; he mentions how when he was watching Rory Bremner on TV recently, and the *Two Johns* sketch ended with 'Fuck off'. And the reaction: 'Nothing. Not a word. I mean, somebody was asking questions in parliament when *I* said it.'

He was unrepentant then, and he is unrepentant now. At the time he explained why it was necessary, in a routine about employees living their lives by the clock and then being presented with one when they retired: 'It's a disdainful word, because it's not a *damn* clock, it's not a *silly* clock, it's not a *doo-doo* clock. It's a *fucking* clock!'

Dave Allen was born David Tynan O'Mahony, the youngest of three boys, in Dublin in 1936. As a child he spent about 18 months in Co. Longford, after the North Strand bombing in 1941. The family returned to Dublin to 'Cherryfield', a large house between Firhouse and Templeogue Bridge, south of the city. It was a very

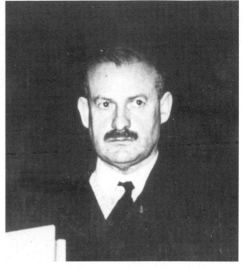

different place to the built-up suburbs of Firhouse today – for a start, their house was surrounded by fields. 'There was one shop and one pub. The family grave is out in Tallaght. I remember Tallaght with the two churches, the Dominican church and the Church of Ireland, which is where my Dad is buried. There was a pub and a hall where we used to go and see shows, travelling shows. You'd have a variety show to start with and then there'd be a melodrama. And every kid in the district would come and we'd all travel three or four miles to get to this place.'

His was a reasonably prosperous, middle-class upbringing. His grandmother was Norah Tynan, the first woman's features editor of the *Freeman's Journal*, his aunt Katherine (KT) Tynan, was a poet. His father, Cullen 'Pussy' O'Mahony, who died when

Dave Allen's father, Cullen 'Pussy' O'Mahony, former general manager of the 'Irish Times'

David was 12, was the colourful general manager of the *Irish Times*. He fondly remembers going into the offices with his father as a child. 'It was always an adventure for me to go because the front office used to go in from Westmoreland Street and they had this wonderful desk which was a deep red mahogany of some sort. And all the lights had green shades, so it was very kind of – night-time, even in the middle of the day. And some of the people there used to wear the old green eye-shades. They used to take me up to the compositors' room and we'd watch all the old machines and the press going. It was great. And some of the old machine men would type out my name in hot metal, so that I could use it as a stamp.'

He remembers the legendary editor, Bertie Smyllie. 'He was a good friend of my Dad's. He and Daddy were great drinking partners. The reputation of the *Irish Times* was very strong; it was liberal Irish, more so than the other papers. My memory as a child was of Smyllie giving me two half crowns on Christmas Eve, which was a fortune.' His brother Peter later worked as a journalist in the *Irish Times*. Pussy was also a drinking partner of Brian O'Nolan (Flann O'Brien/Myles na gCopaleen), then a columnist on the paper, and Allen recalls that his father would have a big party on New Year's Eve (which was also Pussy's birthday) and the boys would watch proceedings from the stairs.

Newspapers were in the family, and in those days 'you didn't go off and make careers for yourself. You tended to kind of take up what the family did. I suppose it

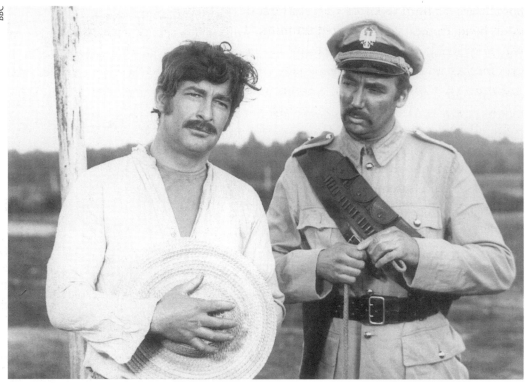

With Ian Burford in one of the famous 'last request' sketches from 'Dave Allen at Large' in 1971

was just easier to follow that line, especially at a time when employment wasn't that easy anyhow.' So Allen started work as a clerk in the *Irish Independent* front office, 'which was a starting point. The thing basically was to get into newspapers and then once you were in the building you'd kind of find which way you wanted to go.' He pauses and laughs. 'I wanted to go *out*, actually.' After a short period on the Drogheda *Argus*, he moved to London thinking of looking for work on Fleet Street. But journalism wasn't a runner for him and he did a variety of jobs, in factories and a stint in Butlin's, and from then on a career in entertainment beckoned.

Dave Allen was brought up a Catholic; his father was agnostic and his mother, from England and previously Anglican, a convert to Catholicism. 'She made an attempt, I suppose, at conversion but really her heart wasn't in it. I went to the nuns in Beaufort out in Rathfarnham and I was informed years later that the mother superior had said that I was never a Beaufort boy. Which is a kind of little badge of honour! Then I went to St Mary's in Terenure.'

He is no longer a Catholic – no surprise there – but 'I'm aware of religion. Brendan Behan summed it up very quickly when he said he was a daylight athiest.

Sometimes it's hard to knock that stuff out of your head from a very early drumming. I was very lucky, I think, because my father and mother were quite sensible. Daddy said make up your own mind when you're old enough, when you've got something to think about.'

So his early religious upbringing, coupled with living in an era dominated by strict state and church control, influenced the direction his material took later on. 'Between de Valera and Dr McQuaid they had such a total, tight rein over everything you read. Have you ever read *The Tailor and Ansty*? It was banned. How in the name of Christ it got banned . . . It is one of the most wonderful stories about a storyteller. To be actually *banned*! And I remember people used to have *Ulysses* in a leather-bound bible cover, and it was perfectly safe, because nobody would ever take it down!'

He pinpoints an incident in his youth which seems to have influenced his approach to life and religion. 'There was a man called Goldman who had built some sort of hut – all I knew about him was that he was Jewish and he lived in the city. He used to come down to this hut beside the Dodder river at the weekend and read and just sit there – just to get out of the city, I suppose. But he was Jewish, and Jews had killed Christ. I didn't even know what a Jew was, but I remember shouting at him across the river – "you killed Christ", or something. I was about seven or eight and I was following my peers. We used to give this man a hard time. And if he wasn't there, we'd throw stones at the hut. And one day I remember I was playing around his hut with another fellow – we were playing touch rugby, and I went to go for him, to touch him, and he stepped aside. And I put my hand out and against the hut and there was a rusty nail sticking out from the inside, so I ran my hand onto this nail. And I came away thinking: somebody's trying to tell me something here. In my mind's eye I wasn't tying up Jesus being Jewish and crucified and that I was Jew-baiting – it wasn't quite that sensible, but it was certainly there in my

Dave Allen ...On Life
A hilarious new collection of the very best of Dave Allen

The longer you live, the more you understand yourself

267

head, that I'd learned that lesson very quickly. I think from there on in I've been absolutely tolerant of any religion, even the wacky ones. I mean, I love religions like the Shakers, who didn't believe in sex – and then wondered why they didn't exist any more!'

Changing tack, he says: 'There were two ladies in my life.' And you wonder what kind of racy story is coming. But the first turns out to be Sophie Tucker, the great American vaudeville star who was always billed as 'The Last of the Red Hot

Mommas'. She worked with him in London when he was a young man and suggested to him that he go to Australia, which is where he first hit the big time in TV. 'I worked with Sophie Tucker a long, long time ago. An absolutely wonderful lady. Great act, great performer, as big-hearted as you could ever get. To the day she died she used to send me Christmas cards and a birthday card. Now here am I – what was I? – a fucking baby comic of 22, 23 years of age and this woman takes me in, and continues a friendship. We used to finish the show and sometimes we'd go back to the hotel and have dinner or a drink. Her brother was down there and she had a wonderful piano player called Ted Shapiro, and she used to talk about the days when she was working for Bugsy Seigel

and Dutch Schultz – you know, all the Mafia, and the prohibition clubs and all that. And if you worked for one, you couldn't work for the other and they weren't beyond cutting the throat out of some singer or performer, or some comic who made bad gags about somebody would find himself with bullet holes in the back of his head. But she was very helpful.'

The second woman also had a huge effect on his career, later, when he moved to Australia. 'I worked with another lady called Helen Traubel, who was the great Wagnerian star of the New York Met, and then did a radio show with Jimmy Durante, in which he sang, and she started a nightclub career from this. She was a huge Scandinavian, big bones, and had a self-knocking sense of humour; she had the best laugh in the world. And I was working with her in Sydney and, again, we used to go out. And I used to talk about Ireland and just being a kid, and she said to me one night, "Why don't you talk about that on stage? Why go out and try and tell funny one-liners? Why don't you introduce some of this? Because it's not only funny, it's good to listen to and it's factual. It's very real." '

Dave Allen thought carefully about her suggestion and reworked his act. And so a style was born, 40 years ago, halfway around the globe, a style that made people think a little differently about comedy, about the power of words, about authority, about the world around them.

other comedians comment on Dave Allen

Owen O'Neill: You knew he was different, because he sat on the stool with a drink in his hand, and he was Irish and he told stories and I used to think: 'This geezer is like my father.' I could really relate to him and he never really seemed like a stand-up comedian. I know he was, but he just seemed like some bloke who had walked out of a pub and into a TV studio, just sitting there and telling you these yarns. He wasn't like Jimmy Tarbuck and all those comics; he was on a different plane, way up there. He was brilliant, and he's still a really good storyteller.

Dylan Moran: I grew up watching Dave Allen, where a lot of the humour is in the telling. He is a hero of mine, obviously, and of nearly everybody of my generation. I think what's great about him is that he creates the illusion of someone talking to you in a bar but actually there is a tremendous amount of planning, because he is a naturally reflective person, and that comes across.

Andrew Maxwell: I thought he was great. I thought he was brilliant. Really funny and, happily, he is one of those people whom you remember as being funny when you were a kid and then you grow up and see them as an adult and they're still funny, or funnier, because you understand more of what they're talking about. And that can't be said of a lot of people.

Ed Byrne: People talk about 'alternative comedy', but Dave Allen was doing that – observational comedy. There was the northern clubs type of comedy – this bloke goes into a bar and etc etc – but when 'alternative' comedians like Ben Elton came along they were doing the kind of stuff that Dave Allen and Billy Connolly had already been doing for years. They would do old jokes but they would do very, very long versions of old jokes in which they would digress into lots of comedy byways. The whole 'alternative comedy' thing is a misnomer because there already were people like Allen, Connolly, Mike Harding, Jasper Carrott, Phil Cool. I used to watch them on TV when I was a kid.

Pauline McLynn: I remember when we first got other TV channels, the BBC and the others, and Dave Allen was one of the things that we watched and you wouldn't *believe* the things he was saying about the Catholic church.

Billy Magra: Dave Allen introduced the Irish voice, and not like Jimmy Cricket, but as a great, great storyteller. And he's a classic stand-up. Brilliant timing. You watch him taking a drink, pausing – how to pace, how to draw out. You can usually tell a great technical stand-up when they deliver the punchline just when you think they're going to do something else. And then there's another one, when you think they're finished. You always felt there was a brain at work. There was a synergy there. He was paid large amounts of money to attack institutions in a most subtle and subversive way.

Alex Lyons: Dave Allen to me was like an uncle – a cool uncle, an Irish guy in a really cool suit. He's never really been recognised here in Ireland. It's funny how he's been written out of things, kind of glazed over.

and a top English comedian's view . . .

Jack Dee: One of my favourite Dave Allen jokes is the one about the guy who goes into confession and tells the priest he had sex 14 times the previous night. The priest asks him who with and he says 'My wife'. The priest tells him he has no need to confess because that isn't a sin, so the guy says 'I know, but I had to tell someone!' There wasn't nearly so much comedy on when I was a kid but sitting down with my family to watch Dave Allen was a real weekly event that features very large in my memory. All those stories and sketches he did probably had a big influence on me. In a way, he provided a blueprint in the back of my mind for the stand-up comedian I wanted to be: sort of sophisticated and sharp. It was mainstream but had an edge. He was totally there in the middle for everyone to watch and yet he was still pushing the boundaries out in his own way. That's how I've always tried to be. At the time he wasn't very conventional: he was doing the sit-down thing. He is one of the few people who found a way of rejigging his stand-up in a way that made it less formal and more accessible for the person sitting at home. And he did those endless sketches which always seemed to feature monks sitting round a table eating porridge silently. He was terribly politically incorrect. He was always telling jokes about the Irish and the Jewish. What I still like about him is his use of language and expression. He was incredibly languid and possessed that singsong accent that is such a gift to a comedian.

from *Later* magazine, July 1999

curtain